RED LOVE

RED LOVE:
A READER ON
ALEXANDRA KOLLONTAI

CONTENTS

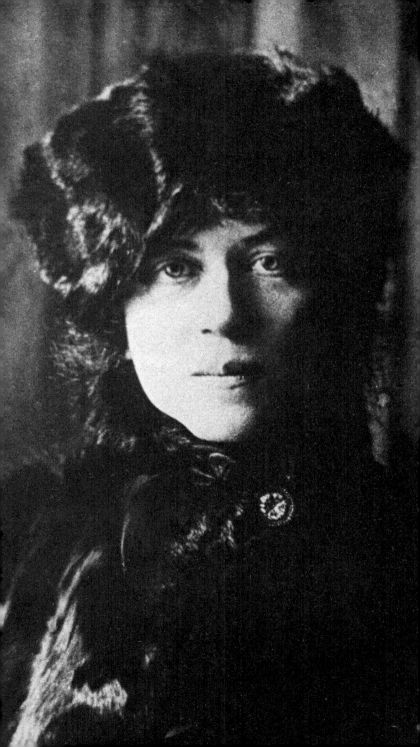

Dear Alexandra,

Stockholm is so cold without you!

How have you been? We have missed you. We find our-
selves thinking of you often in this place; we too have
travelled to this country to work on making change, albeit
in ways other than you.

How do we begin to tell you what has happened since
you left? So many years have passed, and so much has
changed. The city you knew is gone and you'd hardly rec-
ognise the world we are faced with today. Yet still your
legacy remains.

Lately we've been reading your writings again. It seems
we're finally able to understand what you were trying
to tell us all along: that love is not a private matter con-
cerning individuals, but an inherently political and so-
cial force. The history you traced through the writings
of Engels, Bebel, Meisel-Hess, and others from ancient
times through feudalism, to the bourgeois era, has helped
us to understand love as historically and materially de-
termined, how the organisation of love, sex, and social
relations are integral to the formation of any society, and
must be considered in order to change that society. Today,
your ideas are being rediscovered in calls for a form of
love defined by multiplicity — a love of many, in many
ways — that may become a powerful organising principle
and model for collective action in the formation of the
commons.

Yet how can we understand such a form of love, beyond
the familiar structures within which it is currently con-
tained? We wish you were here to help us. As in your
analysis of your own, bourgeois society, we still find love
expressed through forms of property relations and social
control of the body as a result of unequal power rela-
tions between men and women. And of course it is the
'woman question' for which you came to be known —
your long and difficult struggles to improve the condi-
tions of women's lives laid the foundation for our battles,
and the advances that followed, in time. In spite of your
fight for women's rights, you refused to be satisfied with
the bourgeois feminist pursuit of equality on its terms,
demanding instead the full emancipation of all women
and workers from a repressive system. You understood,
then, how these struggles intersected; how the fight for
women had to coexist and develop alongside the rev-
olutionary fight. Only now have we begun to see how
we too must acknowledge the differences among us and
strive to fight structural oppression in all its manifesta-
tions to truly bring about change. In your time, this took
the form of the shared fight of working men and women
in the factories. Today, the things we share and those that
set us apart are infinitely more complex. Yet we return
to our question: what forms of love may help us in our
fight? In your writings, you proposed a 'comradely love'
that went beyond sexual or familial relations, even be-
yond friendship, to form the basis for collective solidarity.
Perhaps it is there that we should look for the answer to
our question.

In spite of the growing equality between men and women during those years, many have since gendered the revolution as intrinsically male. One of your greatest contributions was to bring the relation between gender and economics into the political sphere, yet we struggle to understand what you wanted to achieve. Was masculinity an ideal that you believed the new woman must embody? As the only woman member of the Bolshevik Central Committee, it must have been hard for you. Yet your fundamental calls for a revolution in which the members of society could form new bonds through a transformed love drew not on the hard rationality of the male sphere, but from the knowledge and resources of the female. In this, we have come far in our understanding of how masculinity and femininity are just two spheres in a wide spectrum of ways we can perform gender. We have learned many things about how gender is constructed socially, through performative and linguistic gestures, habits, and perceptions, undermining supposed biological determinism to pave the way for non-binary, trans and 'third gender' politics to come to the fore. Such nonconformity extends to sexual politics and morality in a manner you could never have foreseen in your calls for 'free love'. Today, so many different forms of relation between individuals are possible. We work to undermine heteronormativity and to understand how queer discourse may yet enable a more fluid state of love. Perhaps such new knowledges may yet inform our revolutionary struggles.

Many of these advancements have developed alongside and as a consequence of new technologies. The world has

opened up; we can connect to each other across thousands of miles, and conduct relationships through screens. How would you perceive such a world? Our contemporary condition of hyper mediation, information dissemination, and connectivity should produce the conditions necessary for political organisation and solidarity on a scale you could never have imagined. Yet somehow, it has not led to fundamental transformation. We are more fragmented and further apart than ever. Human interaction has changed beyond recognition — we follow each other's lives more closely than ever before, but spend less time together. Your political engagement was borne from your experience of organisation and agitation among female workers at the factories of St Petersburg. Your speeches brought people together, where they found strength in numbers. Today, the bonds that hold us together have grown weaker. We are dispersed and struggle to form alliances against the structures that oppress us — individualism 'won', at least temporarily.

In the domestic sphere, technological advancements have entered the home, bringing the everyday into the digital domain. In your time, you called for such progressive technologies to unshackle women from domestic concerns. Yet so many facets of domestic life remain unchanged. What would a world that had embraced your calls for the collectivisation of social reproduction, housework, and childcare be like? Many of your ideas were too radical then. Indeed, they may be too radical now. The historically feminised practices of care are still disproportionality assigned to women, and mothers, whose

political and artistic potential is thereby repressed. To-day, still, women fight against the roles assigned to them within the structures of marriage and the family. Yet we are also beginning to understand how, historically, or-ganising around social reproduction has been important in the construction of collective forms of social power. Information sharing and political organisation has long been centred around practices of collective care such as knitting clubs, language cafés, self organised education, or communal cooking. Such seemingly marginal practices bring the politics of care from its supposed place in the private sphere into the public sphere. Perhaps soon, in forty-eight year's time, we may create a world in which economic and social responsibilities are shared equally among the members of the collective, to the benefit of all.

Though the logic of capital continues to penetrate every aspect of our lives, signs of hope are emerging. Inspired by your life choices, which were ripe with contradictions and conflicts, we seek directions. For example; we keep wondering how it was possible for you to be Stalin's dip-lomat. In spite of the challenges we face, we are witness-ing a renewed spirit of self-organisation that brings back memories of you, standing amongst the workers and call-ing them to action. Waves of solidarity and collective ac-tion emerge, and a small hope for change blossoms again. New problems arise that ask us to find new tools, and they are certainly needed now.

It brings us great joy to think of you here in Stockholm. Your exile must have been hard for you, but we are so

happy that you walked these streets before us. As you had done in Russia for so many years, you gave speeches and wrote articles on the woman question, engaging with and inspiring the Women's Movement here, where you met your dear friend Ada Nilsson. As always, your presence had such a profound impact on those around you. Every day we see your name carved on the wall in Östermalm, and think of the traces of your life we have yet to discover.

A sense of urgency calls us to action. We wrote this letter to let you know of our activities in this city you once called home. Once again, we have gathered around the questions you asked all that time ago. But we still have so many questions for you.

We wish you were here — you would, of course, know what to do. We're getting tired, yet still we continue some of the work you started. All is yet to be done.

Your readers in Stockholm,

Federico Del Vecchio
Dora García
Aly Grimes
Malin Hüber
Nicholas John Jones
Maria Lind
Michele Masucci
Martyna Nowicka-Wojnowska
Alessandra Prandin

Dimitrina Sevova
Sophia Tabatadze
Joanna Warsza
Hannah Zafiropoulos

INTRODUCTION

In the text 'Sexual Relations and Class Struggle' written in 1919, Alexandra Kollontai (1872–1952) noted that history had never before seen such a diverse tapestry of personal relationships, from traditional families and free unions to marriages with three and even four people, and commercialised prostitution. This must have pleased her, as one of her missions since the 1890s was exactly to revolutionise sexual, emotional, and comradely life — a new progressive society will surely also need new types of relationships between its citizens, including affective ones.

Kollontai was a Russian revolutionary who as the only woman in the first Bolshevik government in Petrograd after the October Revolution, was also a political organiser, writer, mother, lover, diplomat and a pioneer of political engagement and sexual politics. She understood love as a revolutionary force able to change relations between men, women and children. Her concept of 'comradely love' takes relations from the private sphere and places them into the public, turning them into a political and social vehicle for overcoming patriarchal structures, gender binarism and paving the way for the emancipation of women. As a co-founder of the women's department of the Communist Party in Russia and People's Commissar of Social Welfare, she pushed to introduce the rights to contraception, free childcare, legalised abortion and equality for children born out of wedlock.

Soon after backing the dissenting Workers' Opposition faction, Kollontai was sent on diplomatic missions — which was in fact a diplomatic exile — for the rest of her life, to Mexico, Norway and Sweden, where she ultimately became an ambassador. She also was the only member of the first Bolshevik government, apart from Lenin and Stalin, who did not perish in the Stalinist purges. That is perhaps one of the reasons why she remains less recognised today — compared to feminist colleagues and friends such as Rosa Luxemburg or Clara Zetkin — even if many of the reforms dealing with reproduction and women's rights, pioneered in the post-revolutionary Soviet government under her lead. Her ideas did not fit in for neither the post–WWII Soviet socialism or Western liberal feminism, and were not discovered until the Marxist feminism of the 1960s and '70s.

The practice-based curatorial course **CuratorLab** held at **Konstfack University in Stockholm**, has over the course of one academic year 2017/2018, together with Tensta konsthall and the artist Dora García, engaged in a collaborative research on the life and work of Alexandra Kollontai, as a springboard for the exhibition 'Red Love' during the summer of 2018 at Tensta konsthall. We studied Kollontai together with the invited guests, reading her texts, organising field trips to sites of historical importance for local feminist history, and preparing an expanded public programme on the politics of love. This publication is a result of this process, assembling different parts and paths addressing the question of what the writings of Kollontai can mean today.

Contemporary thinkers, artists and essayists indulged in her essays and novels, for example *The Autobiography of a Sexually Emancipated Communist Woman* (1926), *Communism and the Family* (1920), *Theses on Communist Morality in the Sphere of Marital Relations* (1921), or '*Make Way for Winged Eros: A Letter to Working Youth* (1926) to trace their current relevance in the sphere of sexuality, love relations, reproduction rights, feminist struggles, the politics of emancipation and organising, etc. The resulting reader doesn't contain a single text by the Russian revolutionary — they are easy enough to find elsewhere — but it is exclusively composed by today's readings of Kollontai, asking if there is a place for her vision of love in the complex sphere of commodified relations in late capitalism. What are the consequences of a life where sex is a service, relations a deal, a negotiation, a contract, and emotions a form of work? *Red Love* analyses Kollontai's many lives and ideas: about love as an organising principle, love as a comradely bond, love as both private and the political, love for many (and in many ways) and finally the evolution and commodification of sexuality. It is grounded in an understanding that the social and cultural conceptions of love and sexuality and their material and political consequences are one of the basic foundations of any society.

In her own words, Kollontai lived many lives: as a revolutionary, writer, mother, organiser, and diplomat. Those parallel existences are portrayed and analysed in the opening essay by researcher and activist **Michele Masucci**, taking on many dilemmas from her radical Marxist critique of the relations between the sexes to the difficulties

for women to organise and to implement political pro-grammes. The subsequent conversation introduces the second leading figure of the book, namely, artist **Dora García** and her long-term involvement with the topics of love, liberation, emancipation and emotions. 'I would say my interest in love started when I realised its political potential' — explains García while describing her arrival to the topic, via the initial rejection of feminism and fem-ininity; through the research in former East Germany; the project *Army of Love*; the readings of Charles Fourier; and an array of inspirations from church-like mysticism, the Russian avant-gardes, communist counter-culture and Russian cosmism. Curator **Maria Lind** expands on García's resulting cage-cum-stage installation serving as an active monument to Kollontai's writings. 'It's almost like a campaign image, which gives house brand to all activities that will develop.'

In his essay philosopher **Michael Hardt** builds on Kollon-tai's critique of love. The heteronormative romantic family is based on property relations and thus socially and po-litically limiting for both women and men. Hardt points to the fact that Kollontai's concept of sexuality was short-cutting any possibility of using sex as a way for domina-tion. Kollontai's demystification follows for both a certain biologistic argumentation and more interestingly relates sex to the broader spectrum of social bonds and reveals its inherent social character. In Hardt's terms, Kollontai's objective is to create a variety of lasting bonds with or without sex, and not constituted by property relations, in order to explore the social significance and political possibilities of a 'new love' as a radical force.

Stockholm-based artist **Petra Bauer**, and scholar **Rebecka Thor**, who have been dealing with the archaeology of early feminist movements in Scandinavia, visually recount the journey of a group of socialist women who set off to the newly founded communist Soviet Union to visit an international women's conference. Bauer and Thor point out how political organising, under the cover of sewing-clubs and craft workshops can take a more intimate and emotional form, advocating a soft form of feminism. The reports from the journey abruptly end on the Norwegian-Russian border.

Kollontai's tangible and symbolic traces in St Petersburg appear in the essay by the Russian cyber-feminist **Alla Mitrofanova** introduced and translated by **Johnathan Platt** who presents an overview of the gender revolution in Russia at the beginning of the twentieth century. One of its remarkable achievements was the development of the horizontal network of women's sections in the Russian Communist party. Called Zhenotdel, the organisation established by Kollontai and Inessa Armand was devoted to women's affairs in the 1920s. As Mitrofanova notes: 'this was a time of radical institution building, and Kollontai was at the forefront of the institutional reinvention of social practices'. The text concludes with an account of current feminist performances in the public sphere in Moscow, claiming feminism as a 'national' practice.

Bini Adamczak, a theorist and an artist, in conversation with CuratorLab introduces her concept of 'gender of the revolution'. She claims that the revolution is seen as

masculine, and the counter-revolution as feminine. 'This is not only true of the cultural characterisation of gender, but of course the economic core of gender.' — says Adamczak — 'In the Russian Revolution, housework was seen as reactionary, capitalist, or feudalist. Whereas industrial work, technology as progressive and socialist. This is a perspective that changed over the coming years, and especially in 1968, and today.' Adamczak claims that the revolution failed as it had too much of the male gender. It could potentially be changed, and there was in fact an attempt to do that in 1968 with the transformation of love from the private to the political, something very close to Kollontai.

Culture scholar and philosopher **Nina Power** continues with her views on the conditions for political organisation today. How do we reinstate trust and shared political passion when the political landscape is fragmented and divided, rife with internal rivalry and conflict? What can we take from Kollontai's conception of comradeship and love in political organising to overcome differences and build political strength in the movements today? In her essay, Power analyses contemporary gender relations, the conditions for friendship and the need for 'generosity, patience and kindness'.

During the opening day of the 'Red Love' exhibition, artist **Alicja Rogalska** with the CuratorLab participant **Martyna Nowicka-Wojnowska** organised a series of public speeches throughout Stockholm starting from the city centre and ending within Tensta konsthall, transcribed

here as the manifesto 'New Gospel: Soon (In 48 Years Time)'. It predicts that the future happens soon and involves a call to hack technology, make knowledge open source, refuse waged labour, collectivise childcare and understand that the overcoming of the climate crisis can only happen with interspecies cooperation.

In the performance *Ask Alexandra* the artist and curator **Sophia Tabatadze** provided direct access to Kollontai as a person. Through a collective séance, the audience was given the opportunity to enter into the different periods of Kollontai's life and ask any question about her thoughts and experiences, with the help of cards and notes taken from Kollontai's biography and the historical events that she lived through.

The artist **Sally Schoenfeldt** (invited by CuratorLab participant **Dimitrina Sevova**) performed a public speech *Kollontai's Love-Solidarity and the Revolutionary Struggle* on the public square outside of Tensta konsthall in English, Swedish, and Arabic. This new struggle does not need to build on old forms, but on the legacy of women's liberation history, which too often was kept obscured. The intersection of women fighting for emancipation with other central struggles such as the anti-war movement was exemplified by connecting it to the speech Kollontai gave as an anti-war activist to the Swedish League of Socialist Youth back in 1912.

In the cross-platform project *Love Letters* CuratorLab participants **Nicholas John Jones** and **Alessandra Prandin**

invited the artistic practice of **Baçoy Koop**, a printing, duplication, and distribution cooperative using mimeograph technology as a tool of resistance and revisiting the culture of independent publishing in the 1960s and 1970s. Looking closely at printed matter produced by dissident political organisations in Turkey and the civil rights movement in the USA, their work explores how communities, alternative value systems, political horizons, and artistic imaginaries were organised around the potential of the mimeograph as a tool.

Bodies of Water was a choreographic installation by artist and choreographer **Pontus Pettersson** and Curator-Lab participant **Hannah Zafiropoulos**, taking Kollontai's writings on love and Astrida Neimanis's *Hydrafemininity: or, On Becoming a Body of Water* as a starting point for an embodied exploration into fluidity and being-in-relation. The score was performed by a group of dancers during one afternoon throughout the exhibition space.

Together with curator **Aly Grimes**, the artist **Antonio Roberts** performed a lecture *The Digital Domestic Script for a Performative Lecture* in which he pursued a dialogue with the domestic smart device Alexa. The machine's sharp and at other times comic and off target responses were intertwined with a critical analysis of the relation between female waged and unwaged domestic work with the increased automatisation of production. The fact that the internet-powered software Alexa is given a female gender reflects a long history of submission of women within the domestic private sphere.

In 'The Revolution Will Be Mothernized! (Kinder, Küche, Kirche, Bitte!)' artist **Lise Haller Baggersen** reflects on the still undervalued labour of women and mothers, where her own grandmother, the mother of five children, is provided as a prime example. As other women, and mothers of her generation, she refused the conservative idea that women should be constrained to childcare, housework, and religious piety. Baggersen asks: could then the political control of the reproductive and spiritual spheres of society represent a good foundation for a feminist system of governance?

The director of CuratorLab, **Joanna Warsza**, in another conversation with García, discusses the possible relation of Kollontai's thoughts to the current political movements such as #MeToo, the women's black protest strikes in Poland, and the grassroots feminist movement, Ni una menos, in Argentina, addressing women's conditions which in many ways are similar to the struggles Kollontai participated in a hundred years ago. The conversation is illustrated by Tomáš Rafa's documentation of the Black Monday protests across Poland — in 2016 women went out on strike against the proposal of a total ban on abortions.

Philosopher **Oxana Timofeeva** gives a brute picture of how far we are today from Kollontai's projection of emancipation as depicted in her short futurist novel *Soon (In 48 Years' Time)* penned in 1922. In many parts of the world, as well as in Russia, Timofeeva and Kollontai's home country, emancipatory politics and equal gender relations are not

developing for the better. In February 2017, the Russian Duma decriminalised domestic violence. This and other steps such as anti-abortion regulation and widespread normalisation of sexual harassment paints a bleak picture of a country that once pioneered social reforms for women. Timofeeva brings to light the historical continuum of patriarchal slut shaming from Kollontai's case to today's contemporary Russia as a backdrop for her *Whore Manifesto*, a counterattack on false morality with a proclamation of the political force of matriarchal polygamy.

Feminist scholar **Sara Ahmed**, on the contrary, warns against investing too much hope in love. She argues that in nationalist, exclusive groups, love is also the principal element — love of a phantasmagorical, imagined, homogenous homeland inhabited solely by those who 'are just like me'. Love of the 'same' as opposed to love of the other. The latter is a love that dare not speak its name, not because it is unconventional, but because it is hated.

Kollontai's work on sexuality and intimate relations under communism is at the core of scholar **Aaron Schuster**'s contribution. Marxist deconstruction of bourgeois romantic love was caricatured in the 1939 Hollywood film *Ninotchka* by Ernst Lubitsch starring Greta Garbo as a Soviet agent. In the movie, the Ninotchka character has a rigid relation to romantic flirtation that mirrors Kollontai's position on sexuality, it being as uncomplicated as drinking a glass of water (wrongly attributed to her — it was in fact Lenin who coined this parable). This parallel that came from one of her novels portraying her

ideas of love and sexual relations was later used for her isolation from the political scene. In Schuster's reading of Ninotchka, the classic use of sexual desire for comic relief is replaced by a deep desire for comradely love.

In 'Letter from a trans man to the old sexual regime' philosopher **Paul B. Preciado** disidentifies himself from dominant masculinity and its necro-political definition. He neither mentions nor refers to Kollontai, although the text raises questions about her possible relation to the future queer epistemology and deconstruction of heteronormative gender binaries. Kollontai gives little attention, if any, to other orientations and positions than heterosexual love — that conservative sexual morality was still too dominant. However, her ethics of love and sex was based on consent and camaraderie. The consensual exchange of sexual favours, a sexual commons, as an effective measure against prostitution comes close to what Preciado calls the invitation to 'fuck with our own politics of desire'.

The need for a materialist understanding of love is greater than ever argues artist and writer **Mohammad Salemy** in his experimental science non-fiction text 'Human-Machine Libidinal Transference'. In the text, Salemy attempts to outline the cybernetics of love and sexuation in the age of the Internet and artificial intelligence. Arguing that despite the apparent expansion of sexual practices, automation and machines are gradually replacing sexual labour. This development where machine intelligence acquires sexual intelligence, the emergence of machinic

love-sex desires, entails a fundamental transformation of the sexual relations and its forms of mediation. However, machines need to express their consent in order not to reproduce the perils of dehumanised sex, which humans sometimes subject other humans with.

The reader ends with a unique first print of the English translation of a play on Kollontai by **Agneta Pleijel**, a renowned Swedish writer and feminist. The first version of the play titled *Hey, you! Sky!* taken from Mayakovski's famous poem, was published in 1977 and staged at the Folkteatern (Folk Theatre) in Gothenburg. It's a poetic portrayal of Kollontai that was later revised together with the theatre and film director Alf Sjöberg, who had met Kollontai in the 1930s, with the new title *Kollontai*. The play was staged for a second time, with an extensive cast at the Royal Dramatic Theatre in Stockholm, in 1979. The play is based on Pleijel's extensive research on Kollontai's personal life, her role in different political events and her conflictual relation to political figures such as Stalin. Pleijel manages to portray the complexity of Kollontai's personality and political deed, both as an advocate for women's rights and as a long-term functionary in Stalin's state apparatus.

The play is preceded by a conversation between **Agneta Pleijel**, **Dora García**, and **Maria Lind**. Pleijel recounts how Kollontai's writing gained wide attention in different Marxist feminist circles around the world during the late 1960s and '70s. In Sweden, Pleijel was tired of the often-times male-dominated leftist debates and found

inspiration in the work of Luxemburg and Kollontai. After extensive research, which among many places took her to Moscow, Pleijel wrote a biographical play portraying the relations and conflicts in Kollontai's life. Pleijel also depicts Kollontai's problematic relationship with Stalin and the degeneration of utopic bolshevism into severe dictatorship, and the presence of Kollontai in both regimes.

Despite all the engagement in Kollontai's life and legacy, which are manifested in this publication, it is in the words of Nina Power 'depressing to note that little of Kollontai's thinking appears to have transpired in practice over the course of the century between her writings and today'. Therefore, it is all the more important, and inspiring, to read her now, again and again.

Alexandra Kollontai, *c.* 1930, as Soviet Ambassador to Sweden
SPUTNIK / Alamy Stock Photo

ALEXANDRA KOLLONTAI'S MANY LIVES
MICHELE MASUCCI

In Alexandra Kollontai's own words, she lived many lives.[1] Her life, brimming with events, relationships and disillusionment, is fascinating in itself. Reading Kollontai means tracing the life of a revolutionary through the numerous books, pamphlets, articles, speeches and actions that she took part in organising. We may differ with Kollontai on many of her choices, yet it is critical to contemplate the difficulties one always faces in being part of a movement with the passionate goal of forming a better world. Kollontai lived many lives surrounded by many loves, the greatest one perhaps being the 1917 October Revolution, which she fought to realise and stayed loyal to until her death.

WORKING WOMEN ON STRIKE

Alexandra Kollontai became a central figure in the international socialist woman's movement at the turn of the last century. Having been raised in an upper-class family, Kollontai had turned to socialism and the revolution in her quest for women's liberation. Her political commitments began in 1894 when she as a young mother worked with an organisation set up to help political prisoners. During the so-called years of the flowering of Marxism in Russia, Kollontai read radical journals and August Bebel's *Woman and Socialism*,[2] which became a life-changing book that provided a fierce materialist critique of woman's conditions under capitalism. Bebel brought convincing

arguments to show the inherent need of gender inequality for the reproduction of capitalist society.[3]

The year after, in 1886, Kollontai visits with her then-husband assigned to rework the ventilation system in a textile factory in St Petersburg. During the visit, she was deeply affected by the miserable conditions women textile workers were enduring. The same year she helped organise a strike at the textile factory. With her increasing political engagement, Kollontai felt gradually more conflicted and alienated by the safe haven of bourgeois family life. She began transforming herself into a well-informed and fierce activist participating in the organisation of women strikes, protests and rebellions and travelling the world establishing political alliances.

In her home country, she fought to put women's conditions on the agenda. For many Russian Marxists, the so-called woman question was a subordinated problem that would resolve itself with the overcoming of capitalist social relations. During the times of the revolution of 1905, Kollontai reminded the Social Democratic party that was losing support from women to the well-organised bourgeoisie feminists about the difficult conditions many women workers in the cities lived and what many had endured as peasants' wifes, mothers, and daughters in the countryside.

In the decades that preceded the revolution, women workers often showed more determination and capacity to organise resilience of the strike actions over time. The increased consciousness among working women of the widespread sexual exploitation by factory management strengthened the female strike movement articulating

their own needs as women. Strike demands would be put forth relating to their particular needs, such as improved reproductive conditions like maternity leave.[4]

Many successful actions brought about by women's organisation formed the basis for the revolutionary strength that would come in 1917. Despite the fact that the strong signs from an increased women's mobilisation and the central role of women's strikes had played in the years before the revolution, the party leadership remained sceptical towards women's abilities to contribute in political affairs after 1917. Women's concerns were deemed to be special interests and were overall a deviation from the greater and more urgent goals.

YEARS OF RADICAL STUDIES

In 1898 Kollontai left her home, her husband and her child, to become a student of political economy with Professor Heinrich Herkner at the University of Zürich. It was not uncommon among middle and upper-class women in Russia at the time to study abroad since Russian institutions did not admit women. During these years, Kollontai studied zealously; in her autobiography,[5] she states that among many influences was George Plechanov who foresaw that centralisation of power would result in a gradual imposition of a system of patriarchal authoritarian communism.[6] Kollontai embodied like many other Russian radicals at the time also the famous call in Nikolay Chernyshevsky, *What Is to Be Done?*,[7] demanding the full dedication of one's life without remorse to the revolution, subordinating everything with dedication until death.

Another significant influence for socialists working for the women's cause was Engels 1884 book *The Origin of the Family, Private Property, and the State.*[8] Engels showed that there is a connection between the production of the means of existence and the family's function in all societies to reproduce new human beings. The violent process of primitive accumulation of land meant the effective exclusion for women from access to their means of subsistence. Private ownership entailed the formation of a public and private sphere, where men and woman were forced to work for private owners of the land; however, women were disadvantaged through this mediation. Similarly to Bebel, Engels describes how the family under capitalism had ceased to be an economic unit of society, depicting the role of the bourgeois family as preserving and transmitting capital. The bourgeois family served to ensure men's property was passed down to children who were biologically theirs, while that of the proletarian family was to reproduce the labour force, which was the principal component of this capital.

Like many other women socialists, Kollontai's thoughts on love and gender relations drew first of all from experience matched with these fundamental Marxist positions. Throughout history, women have been subordinated through a sexual division of labour.[9] Marital relationship not only dispossessed women but also made them objects of possession. This subordination through a division of tasks, where women were forced to care for reproductive tasks, while men participate in political life, was made possible by the introduction of private property.

MY HEART BELONGS TO
THE POOR OF FINLAND[10]

Alexandra Kollontai was born into an aristocratic family, her mother the daughter of a Finnish public official and trader. As a youth Alexandra spent her summers at the family property in Kuusa, Finland. In her autobiography, Kollontai mentions the summers in Finland playing with the children of farmers as a decisive moment when she became conscious of her class privileges.[11] She learned some Finnish at an early age and also married her second cousin, the engineer Vladimir Kollontai against her parent's wishes in 1893, also from Finnish descent.

Back in Russia in 1899, after her studies in Zurich, she started her research on the Finnish working class by writing several articles.[12] She became recognised as the Russian Social Democratic Labour Party's expert on the 'Finnish question'. Her first article, 'Die Arbeitsfrage in Finnland',[13] was partly written while in Finland. Three years later, she completed the major socio-economic research *The Lives of Finnish Workers*.[14] Kollontai liaised with Finnish revolutionaries and workers in the organisation of trade unions and worked for Finland to seek independence from Russia.[15]

In 1899 Kollontai witnessed and supported the first strikes organised by working women in Åbo. At this time the Finnish working class started to become more organised. Learning that the failure of several strikes had been due to lack of strike funds and union organisation, Kollontai in the act of solidarity donated the money from an article to support union organisation in Finland. The

general understanding is that this was why Kollontai was called the mother of union organisation in Finland.[16]

In 1906 the pamphlet *Finland and Socialism* was published.[17] It is partly due to this publication that the Tsarist regime targeted Kollontai, forcing Kollontai to go into political exile in Europe. This period proved, however, very productive for Kollontai, primarily through her engagement with the growing international women's movement. She never left her interests and will to engage with Finland and especially the conditions of women workers. Like with so many others, the fact that women had gained already the right to vote in Finland in 1906 interested Kollontai. Neither Russian women nor women in the west had any rights during this time. Women gained the right to vote after the revolution.

COMMISSAR KOLLONTAI
AND THE WORKERS OPPOSITION

Kollontai's monumental political work and legal research on health policy and women's rights entitled *Society and Motherhood*[18] from 1916 was a foundational piece for informing the policies she started to implement as the commissioned People's Commissar for Social Welfare of the Soviet Republic. In 1920 as the head of the Women's Section, the Zjenotdel, she did outstanding work for women's emancipation, which included raising the consciousness of the public to these issues as well as drafting extensive legal reforms.[19] Kollontai's early engagement and experience with workers' struggles had formed her into a fierce agitator for workers' rights. Soviets and workers' unions

did have a fundamental role in the division of power during the first years after the revolution and kept advocating for a participatory organisation of production.[20]

As commissar for social welfare, Kollontai managed to transform the social health infrastructure in Russia, introducing progressive social reforms such as secularised orphanages. Before the revolution, orphanages were part of the Orthodox Church and religious morality. Health insurance and paid leave for women after child birth and the legalisation of abortion were but other fundamental reforms. Many of these reforms that today are taken for granted, or even lost under austerity reforms in liberal democracies were pioneered in the post-revolutionary Soviet government under Kollontai's lead.

The newly liberated Russians grew increasingly dissatisfied by the authoritarian tendency of the Bolshevik government, pushing workers to ever more openly political actions. As a former union activist, Kollontai was weary of the increasing centralisation of power, believing strongly in workers' democratic influence in production. During her time as Commissar, Kollontai increasingly became an internal critic of the Communist Party. With her friend, Alexander Shlyapnikov, a left-wing faction of the party was formed, known as the Workers' Opposition. The faction fought for workers' rights and control, voicing clear demands against increased bureaucratisation and centralisation of power. The pamphlet *The Workers' Opposition*, published in 1921, called for members of the communist party to be allowed to discuss policy issues.[21] In this text, Kollontai advocated for more political freedom for trade unionists.

During the Tenth Party Congress of 1921, using as an excuse the Kroonstad uprising, Lenin made the argument that factions within the party were 'harmful' and counter-revolutionary. The Party Congress agreed with Lenin, and the Workers' Opposition was dissolved. After this, Kollontai lost all her political assignments, and she was sent to Norway for diplomatic duties.

WORDS FOR
COMMUNIST LOVE

In *Communism and the Family*, a famous speech held during the first national congress for female workers and farmers in 1918, Kollontai seeks a solution to solve the problem of combining work and family.[22] In a communist economy with the abolition of private property, planned production, the family would lose its role as an economic unit and power structure. This 'proletarian sexual politics' could not wait for a change in property relations, as the capitalist social relations constituted an essential weapon in the class struggle.[23] Making family life a collective responsibility and concern meant sharing the economic and social responsibility with the movement, making women's liberation possible.[24] The dissolution of the nuclear family would liberate women, bringing a collective responsibility and care of housework, that would be cared for by workers through common canteens, laundry houses, schools, and daycare centres for children.

Thus for Kollontai the transformation into socialism also had to include a revolution in the private sphere based on the principles of distributed comradely love

in opposition to the enclosures of the bourgeois family. However, Kollontai did not advocate the complete abolition of marriage, merely a significant transformation, and a form of co-existence with many types of relationships. Charles Fourier had brought the vision of a society organised through communes with collectivised housework that could provide a more sustainable relation among people and to nature. In *Le Nouveau Monde Amoureux* Fourier poses a fundamental critique of monogamous marriage that he describes as a form of enslavement of women.[25] In Fourier's theoretical and political model of society, harmony is achieved through the disappearance of monogamous marriage and the systematic multiplication of love relationships of all kinds, establishing absolute equality between the sexes. Fourier's work is often cited as a precursor to the 'sexual liberation' at both the turn of the twentieth century and in the 1960s.

In a famous essay 'Make Way for Winged Eros: A Letter to Working Youth' Kollontai critiques civilisation and questions the individualism of her time.[26] She envisions a form of love not tied to property nor people, rather this love should belong to all and would with the advancement of socialist revolution appear in a form that is unknown to us, only able to develop from the working class. Kollontai's view on love regards the essence of socialism, namely, solidarity. Love for Kollontai is not a relationship of close couples; it is not a private matter, but a fundamentally social issue. That is why the working class will develop 'comradely love'. Kollontai calls for a transformation of the human mind. Without solidarity, there is no communism, society, or unity.

Kollontai's writing evidences the quest to identify the conditions for communist comradely love. How our ability to love, to express and embody affectivity can transform into political engagement and collective political practices that can form some permanence or continuity.

LETTERS TO DEAR COMRADES —
MADAME KOLLONTAI
AND THE SWEDISH FEMINISTS

Kollontai held a series of diplomatic posts, including ambassadorships, in Norway, Sweden, and Mexico. Although this was a first for a woman, her diplomatic career was the manoeuvre by the party leadership to marginalise Kollontai from power.

One of Kollontai's closest friends during her years as a Soviet diplomat was Emy Lorentsson who worked as Kollontai's personal secretary at the Soviet embassy in Stockholm. After the war, when Kollontai's service at the embassy was terminated, she followed her to Moscow and became a Soviet citizen. During Kollontai's years as ambassador in Sweden she came together with the progressive liberal feminist Fogelstad group.[26] This group consisted of some of the most prominent feminists from Sweden at the time. Kollontai came to lecture at the women's citizens' school at Fogelstad and was frequently interviewed and wrote in the group's paper, *Tidevarvet* (The epoch). Kollontai wrote on the women's question in the Soviet Union and on Russia in general.

One of the members, Ada Nilsson, an established specialist on women's health, contributed under the influence

of Kollontai to the radicalisation of the Women's citizens' school.[28] Although their correspondence became frequent and dear, it never contained any details that could be politically sensitive.[29] They discussed abortion rights in the two countries; Kollontai accounted for her work in the League of Nations and provided Ada with material for her planned autobiography. Their correspondence continued up until Kollontai's death.

In one article over the basic rights to motherhood, Ada Nilsson quoted a note that a neighbour of hers had found: "Never will I forget the difficult night I lived through when my son was born, that I then strangled, laid in a sack and threw in the pond. Never will I forget that moment, but I could not have acted differently. Whoever might find this note I ask to pray for me and perhaps I might be forgiven for my terrible crime. However, do not denounce me to the police. I will not be found as I have changed my name."[30]

With this note, Ada Nilsson starts one of her articles in *Tidevarved* from May 1934. The article: 'The Right to Motherhood' is a discussion defending not only the material condition of parenting but also the psychological factors given the social attitudes towards mothers at the time. While acknowledging that child mortality in Soviet Russia was higher than in Sweden. With the legal health and social insurance reforms partly introduced by Kollontai straight after the revolution, that strengthened women's rights in many respects, Sweden was lacking behind. Working women who got pregnant had virtually no rights and were often fired, leading to a tragic situation like the one that framed this short article.

KNITTING THE SOCIAL FABRIC —
KOLLONTAI IN CONTEMPORARY STRUGGLES

The social, emotional and sexual capabilities that were considered crucial for the formation of an emancipated democratic and progressive communist society for Kollontai, are today the very same capacities that have been appropriated within service work, teamwork, and other kinds of work where the enactment of the shared, social and collaborative has been made into a fundamental component of productivity.

Silvia Federici, along with other feminists in Italy during the 1970s who were coming out of the Wages for Housework movement pointed to the role of reproduction in the general formation of the working class and the dominant productive forces of society.[31] As Kollontai and her comrades had identified in a capitalist society, large parts of the necessary social reproduction, is displaced in the private sphere where women traditionally have had to do much of the work to maintain the household. Women's unpaid labour is essential for the productive capacities of a society for the reproduction of the working class.

In *Caliban and the Witch,* Silvia Federici develops strong arguments for the need to recognise the production and reproduction of the worker as a social and economic activity.[32] According to Federici, the failure to recognise this results in a mystification of reproduction as a natural resource or as a personal service done out of love or duty or by the enactment of a specific gender role while profiting off the wageless conditions of the labourer involved. These forms of exploitation and oppression are based on

a social system of production that does not recognise housework as a source of capital accumulation. In the centre of care work is the question of the wage. In Mariarosa Dalla Costa and Selma James's *The Power of Women and the Subversion of the Community*,[33] there is a critical anti-work dimension: 'When men refuse work, they consider themselves militant and when we reject our work these same men consider us nagging wifes.'[34] This tension between the demand of the end to work and the unwaged work to be recognised and valued is essential to recognise. Wages against housework does not mean make everyone into paid housemaids, it means the opposite, the collective refusal of work altogether.

In moments of crisis such as the gradual withdrawal of mechanisms of welfare, or the spaces of perpetual marginalisation, the problem of reproduction and the urgent need for self-organised forms of sustaining lives becomes concrete. Social reproduction thus becomes a field for building social power that opens for new cycles of struggle that intersect social relations of care, with spaces, habitation and the production and redistribution of resources. Today this is explored through the transnational Social Strikes[35] and International Women's Strike Movement.[36] These socialised strike actions are opposing not only sexual violence on women, queer, lesbian and transgender but also the generalised and accelerated conditions of precarity spreading across sectors and regions around the world, connecting as Kollontai did, the question of class and working conditions with gender equality and emancipation. Asking how radical solidarity and anti-capitalist feminism is made possible.[37]

Federici's proposal to form communalities of care that through practices of care and autonomous social reproduction embody the commons is powerful. If communal, comradely love is the method and goal, what might be the conditions for us to come to this practice? Alternatively, in other words, 'how can 'solidarity' be possible in and against the objective conditions that divide us?'[38]

1 Alexandra Kollontai, *Jag har levt många liv* (Stavsnäs: Sjösala förlag, 2014).

2 August Bebel, *Woman under Socialism*, trans. by Daniel De Leon (New York: Labor News Company, [1879] 1904).

3 Anna Rotkirch, 'Rakare, friare, friskare: Kollontais vision för kvinnokroppen', in *Revolutsjon, Kjærlighet, diplomati: Aleksandra Kollontaj og Norden*, ed. by Yngvild Sørbye (Oslo: Unipub, 2018), p. 96.

4 Anne Bobroff, 'The Bolsheviks and Working Women, 1905–20', *Soviet Studies*, vol 26, no. 4, 1974, pp. 540–67. *JSTOR*, www.jstor.org/stable/150677.

5 Alexandra Kollontai, *The Autobiography of a Sexually Emancipated Communist Woman* (New York: Prism Key Press, 2011).

6 G. V. Plechanov, *Socialism and the Political Struggle* (Moscow: Progress Publishers, [1883], 1974).

7 Nikolay Chernyshevsky, *What Is to Be Done?: A Romance* (Boston: Benj. R. Tucker Publisher, 1886).

8 Friedrich Engels, *The Origin of the Family, Private Property, and the State* (London: Penguin Classics, [1884], 2010).

9 Silvia Federici, *Caliban and the Witch: Women the Body and Primitive Accumulation* (Brooklyn, NY: Autonomedia, 2004), p. 97.

10 Alexandra Kollontai, 'My Heart Belongs to the Poor of Finland', published in a union's yearbook *Työn Juhla*, 1911, in Elina Katainen, 'Arbeid, fred, fri kjærlighet: Kollontaj sett med finske øyne'. In ed. by Yngvild Sørbye, 'Revolutsjon, Kjærlighet, diplomati: Aleksandra Kollontaj og Norden' (Oslo: Unipub, 2018), p. 220.

11 Ibid., p. 211.

12 Ibid., p. 217.

13 Alexandra Kollontai, *Die Arbeiterfrage in Finnland* (Leipzig: Duncker & Humblot, 1900).

14 Alexandra Kollontai, *Zhizn' finliandskikh rabochikh* (*The Lives of Finnish Workers*) (St Peterburg: T-vo Khudozhestvennoi pechati, 1903).

15 Elina Katainen, 'Arbeid, fred, fri kjærlighet: Kollontaj sett med finske øyne', in *Revolutsjon, Kjærlighet, diplomati: Aleksandra Kollontaj og Norden*, ed. by Yngvild Sørbye (Oslo: Unipub, 2018), p. 218.

16 Ibid., p. 218.

17 Alexandra Kollontai, *Finliandiia i sotsializm* (*Finland and Socialism*), 1906.

18 Alexandra Kollontai, 'Society and Motherhood', in *Selected Articles and Speeches* (Moscow: Progress Publishers, 1984).

19 Cathy Porter, *Alexandra Kollontai: A Biography* (London: Virago, 1980), p. 271.

20 Elizabeth Wood, *The Baba And the Comrade: Gender and Politics in Revolutionary Russia* (Indianapolis: Indiana University Press, 1997), p. 72.

21 Alexandra Kollontai, *The Workers Opposition in the Russian Communist Party* (St Petersburg, FL: Red and Black Publishers, [1921], 2009).

22 Alexandra Kollontai, 'Communism and the Family', in *Selected Writings of Alexandra Kollontai*, trans. by Alix Holt (Westport, CN: Laurence Hill Co., 1977).

23 Jinee Lokaneeta, 'Alexandra Kollontai and Marxist Feminism', *Economic and Political Weekly*, 36, no. 17 (April 28–May 4, 2001), pp. 1405–12.

24 Richard Stites, *The Women's Liberation Movement in Russia: Feminism, Nihilism, and Bolshevism, 1860–1930* (Princeton, NJ: Princeton University Press, 1978), p. 260.

25 Charles Fourier, *Le Nouveau Monde Amoureux* (Scotts Valley, CA: CreateSpace Independent Publishing Platform, [1818], 2015).

26 Alexandra Kan, 'Aleksandra Kollontajs private vänkrets under de diplomatiska tjänsteåren i Norge och Sverige', in *Revolutsjon, Kjærlighet, diplomati: Aleksandra Kollontaj og Norden* ed. by Yngvild Sørbye (Oslo: Unipub, 2018), p. 277.

28 Ibid., p. 278.

29 Gothenburg Public Library online at: http://www.alvin
 -portal.org/alvin/home.jsf?dswid=6852 (2019-05-21).

30 Ibid.

31 Silvia Federici, *Wages Against Housework* (Bristol: Power of Wom-
 en Collective and the Falling Wall Press, 1975), p. 11.

32 Federici, *Caliban and the Witch.*

33 Mariarosa Costa Dalla and Selma James, *The Power of Women and
 the Subversion of the Community* (Bristol, UK: Falling Wall Press,
 1975).

34 Ibid.

35 Transnational Social Strike Platform (www.transnational-strike
 .info).

36 The International Women's Strike Movement started in 2016
 and reaches out globally with coordinated feminist social strike
 actions on 8 March.

37 Nancy Fraser, Tithi Bhattacharya, and Cinzia Arruzza, *Feminism
 for the 99%: A Manifesto* (London: Verso, 2019).

38 Federici, *Caliban and the Witch.*

LOVE IS REVOLUTIONARY
CURATORLAB IN CONVERSATION WITH DORA GARCÍA
EDITED BY MARTYNA NOWICKA-WOJNOWSKA

Have you in your art practice always been interested in love, relationships, and how the sense of belonging shapes and influences social structures? I guess one can see these themes appear even in your earlier works such as 'Heartbeat'?

My background is quite heavy and conceptual. This is a kind of art, which I loved as a student, and it still has a huge impact on me. In the beginning my main focus was the structure of art, the relation to the spectator. I was always interested in questions of language and philosophy — formal questions. Feminist or women's issues were never explicit in my work. I always thought of my work as very dry and I was never interested in telling stories of specific people, love or even sex. Not at all! So, I would say my interest in love started when I realised the political potential of those things. It was somewhere around 2008 when I made a work in Australia about Lenny Bruce. Because of that I started to research counterculture in Australia and actually realised that it went hand in hand with the gay liberation movement and that both politics and revolt link to sexuality and sexual habits. In a way sexuality was something belonging to the private realm which could immediately become subversive.

Was the link between sexuality and politics the reason why you became interested in Alexandra Kollontai?

Actually, I became aware of Kollontai's existence some

time ago, but I had never read any of her texts. When Maria Lind suggested that I should have a look at Kollontai's writings I was very occupied with the work *Army of Love*, which was initiated by a friend, Ingo Niermann, together with other friends. I don't normally make collective works. But *Army of Love* was extremely interesting to me and in a way Maria's offer and *Army of Love* came together.

I think the reason why Maria invited me to become involved with Alexandra Kollontai, was due to my work in the Gwangju Biennale. I recreated the Nokdu Bookstore where the Gwangju Uprising was incubated. Revolution in Korea, which my work related to, was in a way not so far away from the October Revolution that was experienced and described by Kollontai. All the revolutionaries were very young people ready to sacrifice themselves. Those people who fought and died were between fifteen and twenty-five years old, with the majority of them being younger than twenty.

During the uprising you could have had all kinds of romances — revolutionary romances. All of a sudden norms were subverted. You didn't have to care about the social status of your relations, you simply became aware of your own mortality and everything changed. It had a huge impact on both older women who saw their children go to their death, and younger women, who grabbed this opportunity to question the patriarchal structures. It was one of those situations when many paradoxical things come together and then explode. That changes everything. The Gwangju Uprising has been compared to La Commune, having the same effect in Asia as the Commune in Paris.

You mentioned very briefly that you became interested in love through your conceptual practice. When did you start to recognise this kind of political and broader potential? Can you talk a little bit about how your interest in love changed during those ten years?

I have to say that when I think about it now, I am surprised that I didn't recognise the subversive potential of sexuality earlier. Of course, it has to do with where I come from — in my generation, female artists were very often interested in representing women's sexuality. I was always horrified by this notion and I did everything not to be classified as a female artist, making 'women's art'. I totally cut any reference to my female condition. I absolutely didn't want to be invited to participate in female art exhibitions. Those prejudices completely blinded me to all other possibilities.

My interest in love changed as the politics changed. For instance, in 2008, when 'the personal' started to become present in my work through the project in Sydney Australia on Lenny Bruce, Obama was a presidential candidate. Then he won the nomination for the Democratic Party and all of a sudden it seemed like things were going to be okay. What I call 'the personal' are the LGBT, civil rights movement, which I have always supported, which are part of my life experience. But in relation to my work experience, my interest in love clearly coincides with Trumpism.

The notion of love is currently very much embedded in politics. One of the movements against Trump is called 'Revolutionary Love', another 'The Love Army'. The first one is related to women's movements (what has already

been named 'Fourth Wave Feminism') and the last one is calling simply to love Republicans, love your opponent, because it is love that will conquer. However, the main force today is hate and many people think that only love can conquer it and as stupid as it sounds, it is probably right. Hate is all about manifestations of insecurities. It is only through all kinds of love that you can overcome this.

As you approach your upcoming exhibition at Tensta konsthall, 'Red Love', I'd like to ask what it was about Kollontai's life and work that felt relevant to your own interests?

The fact that she was so ahead of her times. She mentions in the 1930s things that would later be broadly discussed in the 1960s or even the '70s, or now. There are few specific things that struck me in her writing: the equality of men and women, progressive views on marriage and family, the idea that you cannot have a revolution without women and a conviction that true freedom for women can only be achieved in a socialist state.

There is also the similarity that I came across between Kollontai's ideas and women's movements in South America. When I was doing research in South America I realised that the women's movements there avoided identifying as feminist, because they consider feminism to be white and European and they don't want to be identified with that. White European feminists are their oppressors, not their sisters, therefore they don't want to identify with feminist fights. The notion of class in Kollontai's writings is also something very present and in contemporary South America it has been shifted from

the notion of the proletariat to the notion of colonised non-white people.

Another thing would be the degeneration of Kollontai's ideas in socialist countries. In 2006, when I did research work on the political police in East Germany, I focused as much on sex as on politics. In the GDR women very often had children with different partners since they didn't have to depend on their husbands for their income and divorce was not stigmatised — therefore it was socially acceptable to have several partners throughout your life. Next to that, the system of nurseries, schools and day care was wonderful; you could leave your children there from the age of three months and pick them up at night. Those facts created a situation of relative freedom and independence for women, but one in which children grew distant from their parents and subsequently, too devoted to the State. Therefore, it sometimes happened that children denounced their parents to the State, if they considered that their parents' devotion to the Party was not convincing enough.

Are those relevant things in Kollontai also the reason why her project did not work?

Sometimes Kollontai seems very naïve about women leaving their children to the State, which is interesting for me. I come from a Catholic country where this would be an absolute evil. Nothing comes before family. Your duty is always to your parents and nothing else. For those people it must have been quite different. When you are brought up as a socialist your duty is to the Party. Those people who denounced their parents saw themselves as heroes.

When I spoke to some socialists from those times, they always said that in the sixties and seventies they considered the socialist countries a model in women's liberation and abortion rights. Most of them did not realise where it could lead. In East Germany there was a case of a woman active in a resistance — a fighter for democracy. She was also a feminist and a member of a women's movement. When the Berlin Wall fell, and the Stasi archives opened, she discovered that her husband — whom she had been together with for fifteen years and had children with, had been informing on her since they met. She immediately left him. The funniest part was the interview with her husband who still didn't understand the problem — he thought about his actions as something done to protect her. So, I think about this State taking too much over family relations as a total degeneration of relations. He could see himself as a husband, lover and informant at the same time.

With the appearance of Kollontai, the body comes into the picture much more than any of the other ideologists of the period. One could say that she introduces a body into politics. I'm interested in how you reflect on that in your work.

I have never been very fond of the body. Even when enacting the 'Army of Love' I always get out when the physical part begins. I don't know where that comes from. I've always been very interested in other sexualities, but I am very conventional, sexually speaking.

As I have already mentioned, I have always kept separate my personal life, my motherhood and my work. I

have never done anything related to art with my children, which is quite rare. When women artists have children, often, their kids feature in their work too. This has never been the case with me, but at the same time my kids have always been with me when I work. I never found it problematic to work with them and I never felt they hindered me from anything. On the one hand being an artist and having children was always something natural, and on the other, they never appeared in my artistic work. I think that the body is not something very present in my work, but language is. Of course, language is always related to the body, so I can't say that the body is absent. One could say that I am interested in language piercing through the body (this is Lacan's definition of 'The Unconscious').

My next question would be connected to the language that you use, or the terms that you use. Your exhibition at Tensta konsthall is called 'Red Love'. What does 'red love' signify to you?

For a long time, I wanted to call the exhibition 'Revolutionary Love', but I felt it was too long. 'Red Love' comes from an article on Kollontai by the theorist and philosopher, Michael Hardt. When I decided to paint the floor red, in reference to Kazimir Malevich, I decided to call the exhibition 'Red Love'. The double meaning of the word 'red' has always been interesting for me. Communist's flags are the most beautiful flags because there is so much red in them. When I was a teenager, I was always wearing Russian t-shirts, Communist propaganda T-shirts. I was unaware, and I just thought they were beautiful.

I chose the title also because I think that the idea of love as a revolutionary force, which encourages self-organisation, is interesting. Of course, this idea is not new, it has been present in the history of humanity for a long time. Before I began working on this project with Kollontai, I was reading Charles Fourier who has quite a different stance on love.

Kollontai doesn't consider sexual preferences other than heterosexuality. She suggests that other options would be detrimental for a Communist society. Contrary to her, Fourier thinks that every possible sexual preference is perfectly fine and a fundamental part of the individual as well. He points out that to repress any sexual drive always has terrible consequences. For Fourier, however weird you consider your desire, your needs can be accommodated, and you will certainly find people who like the same thing. Fourier came close to inventing Tinder in his imagination of the 'phalanstery' — a kind of structure where a 'Priestess of Love' would be communicating with other 'Priestesses of Love' to match people according to their preferences. Fourier is meticulous. Everything is a multiple of four, but his ideas are truly revolutionary and very much related to a sexual revolution. In a way they are much more radical than what Kollontai had in mind. The idea that there is absolutely nothing strange to human experience, that nothing can be called degenerate, that nothing that gives pleasure is bad, is amazing. Even now it sounds challenging. Of course, curiously, we are now in a much more conservative period than say thirty or forty years ago.

Do you think that today, one hundred years after the October Revolution, but also fifty years after May '68, we are at another turning point as far as love and sex are concerned?

I think plenty of other things happened during those last one hundred years. Something that changed a lot was AIDS. I remember my teachers saying that we were conservatives because we didn't have as much sex as them. With AIDS in mind you had to be much more careful, you always needed a condom, if not, nothing happened. That somehow wiped carelessness out of sexuality.

Another factor would be the explosion of the pornography industry. It's something that makes me extremely uneasy. I still don't have a stance on pornography or prostitution. I understand of course where prostitution comes from. I think it's disgusting and I wish it didn't exist, but it does, through and through. It's naïve to say that it's bad and we should ban it. It is a hyper-complex phenomenon and to say that it is the ultimate hetero-patriarchal exploitation of the female/other body does not get us very far in practical terms of reducing misery and abuse. And in relation to pornography and the way to be empowered by it, I love the concept of post-porn. I've seen a lot of it, but it's hard to say if I take any pleasure from it. Sometimes it is charming but most of the time the films are bad and boring, and they don't arouse you sexually at all. Even my students say that the problem with post-porn is that you never get excited. Any kind of movement that wants to use porn as a way of liberation doesn't seem to work really.

Anyway, I don't think we are anywhere near a revolution in sex. I think on the contrary, we are in the process of an involution of sex. There are societies, like in Japan, where the problem is that people are not interested; they prefer things other than sex. I'm not sure who said it, but I remember a quote that says that 'the worst thing that can happen to a sexual fantasy is for it to come true'. I think people have decided that sexual fantasies are much better, safer and cleaner than the real thing. So maybe that's going to be the future, I don't know.

As structure and language seem very important to you, I wanted to ask you about the moment in your work where you test a structure or a narrative that you created with the public. How do you control it? Do you keep track of how the public reacts to or absorbs this narrative?

I don't have to control that. This is something that happens to every artist. You never know how people are going to react to your films or novels, at some point you just have to let go. The way I usually work facilitates feedback more than other traditional models. For instance, I started developing my work on the Internet by making blogs, at a time when those things didn't really exist. In those prehistoric times of the net we created structures that allowed people to give feedback and get information about those projects which only a few people could see live. Indeed because of this I was also interested in how things are thought and narrated. In many works that I made later on, for example the one for Skulptur Projekt Münster, the feedback was part of the work — the

Internet space was provided to the audience, they could follow the adventures of The Beggar (http://thebeggars-opera.org). They could communicate with him and that way people became part of the novel.

The follow-up question would be one about the structure that you have in mind for Tensta konsthall. What is it and how does it refer to Kollontai?

I understand the structure in Tensta konsthall as kind of a stage. You can use it as a backdrop for activities and performances. It's a structure that inspires, colours and unifies everything you do, almost like a campaign image, which gives a house brand to all activities that will develop inside it. This stage design is almost symbolically related to Kollontai, to the idea of a 'mission' as a church-like mysticism. The space also relates to the story of the avant-garde — you have Malevich on the floor, you have a very strong, almost expressionist use of light. There is a cage based on the one from the movie *W.R.: Mysteries of the Organism* (Dušan Makavejev), which is a kind of Communist counter-culture. Inside the cage there is a working room which I imagine as Kollontai's writing room. It is pretty symbolic because of the light spreading from the inside of the cage.

Then there is also a staircase, as stairs are a classical Freudian sublimation of desire, but here they also refer to the 'Stairway to Heaven' and notions of Cosmism. The staircase I'm using is based on one from the Museum of Jurassic Technology in LA, which is quite an interesting place. It's not Russian but they are referring to Soviet space travels with a special room devoted to dogs that

were sent to space. The construction of this museum is all about make-believe. It feels like a magician's cave, full of shadow play. So, in the case of 'Red Love' at Tensta konsthall, the structures are both sculptural elements as well as being rich in symbolist associations. It's really a stage, it's really meant for things to happen there.

I'm interested to ask how Kollontai fuses with Russian Cosmism that you briefly mentioned?

It's not that I want to fuse it, I'm interested in using it as a way of looking at Kollontai. Cosmism relates to the idea that Russia did not produce philosophers, but novelists. Their novels often contained this vision of Russians as a 'chosen' people, endowed with a mission for the whole of mankind. Those tendencies were present in Russia in the nineteenth century, but also earlier, before Cosmism began. The name 'Cosmism' stems from the outreach of this mission: Russians were to save not only Earth, but also the cosmos. Cosmism was very important for the development of space missions. Awareness of a mission that would change humanity is also fundamental for the October Revolution. In a way it's amazing that the October Revolution worked. Everything was against it! How is it possible that a proletarian revolution triumphs in a country with no proletariat? The Cosmist credo, this mix of visionary absurd and mysticism, which was so present later on in Eastern European science-fiction (Stanisław Lem and the Strugatsky brothers), certainly played a role in the October Revolution. The idea that Russian people have a duty to mankind — a universal mission, was already there.

If we are talking about giant utopian visions, let's get back to your work. Do you think about your work in relation to change and hoping to provide possibilities?

I think art does change the world, but in ways that we are not aware of. I'm not interested in what is commonly known as socially engaged art, although I think all art is socially engaged. I find the works of many socially engaged artists troublesome because I really know just a few which have no contradictions. I think art operates and performs change by thinking of individuals and a mass is always composed of individuals.

I feel there have been books and films that really changed the way people think. There is *The Man in the High Castle*, a novel of Philip K. Dick that plays with the idea of a book changing the world. We are given the choice to choose between different versions of fiction in history but the very fact of being able to imagine another way of seeing things, different from the one imposed on us, is already a change. It becomes even more interesting right now with the notion of 'gas-lighting', very present in the United States and under the Trump administration. You see something with your own eyes and you are told that it's not true. I saw police beating people who were voting in Barcelona and then the news said that the police got hurt because people threw themselves against them. Yes, they got hurt, because they were beating people, it's not like you can get shot if nobody shoots! You talk to people who read different things and have a totally different take on reality, because they believe what they read, and they read a bunch of lies. I think any kind of fiction can make people aware of things and therefore can change them.

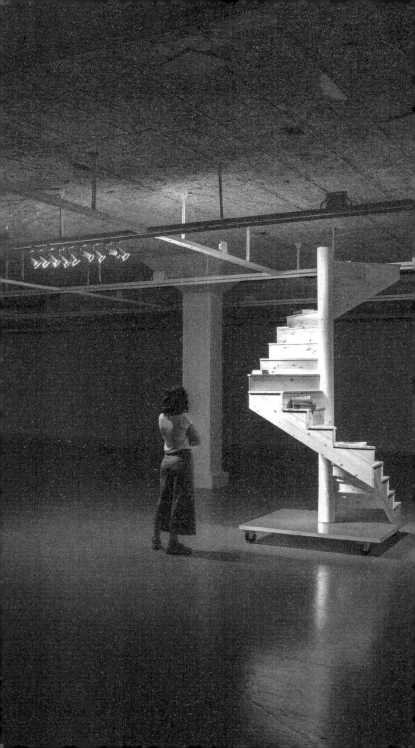

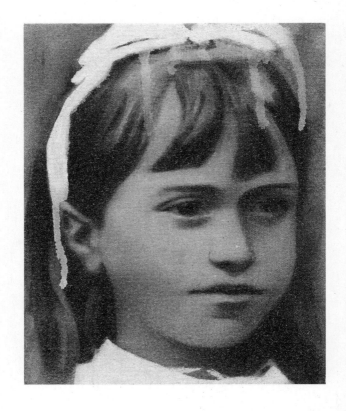

Giulia Andreani,
Portrait of Kollontai as a child, 2017–18,
acrylic on canvas, 25 × 19 cm

Copyright: Claire Dorn
Courtesy of the artist and VNH gallery

RED LOVE
MICHAEL HARDT

Che Guevara declared that a true revolutionary must be guided by strong feelings of love.[1] Alexandra Kollontai, a Bolshevik revolutionary and minister in the first Soviet government, would ultimately agree, but the first task is to critique and destroy the forms of love that now predominate. In line with feminists such as Mary Wollstonecraft, who was already active a century before Kollontai, and Shulamith Firestone decades after, Kollontai recognises that love — particularly heteronormative romantic love and family love — serves as a trap for women and a structure that guarantees their subordination. The dominant forms of love in contemporary society, furthermore, are socially limiting and politically harmful, for men and women alike. The root of the problem, Kollontai claims, is what I call property love, that is, the fact that we regard our bonds to each other in terms of ownership and property relations. The distinctive feature of Kollontai's position, then, is that the critique of love is inherently a property question and thus overcoming property love requires not only equality — equal property, for instance — but also a radical social transformation, an explicitly anticapitalist project. It is only once that property love is abolished can we then begin to invent a new love, a revolutionary love, a red love.

During the first decade after the October Revolution, a period of intense cultural, artistic, social, and political experimentation, several intellectuals explored how deeply property relations are insinuated into every

aspect of social life, well beyond the economic sphere. And they sought, by unearthing and eradicating property relations from all corners of society, to imagine how a new society could be built. In effect, they experimented with and extended Marx and Engels's claim that 'the theory of the Communists may be summed up in a single sentence: Abolition of private property'.[2] In this regard, Kollontai's analysis of property love taking place within the couple and the family is parallel, for instance, to Evgeny Pashukanis's critique of law and the state, developed in the same years.[3] Pashukanis argued that modern juridical and constitutional concepts are based ultimately on property and commodity relations. Abolishing property relations, then, he reasoned, would necessarily undermine state sovereignty and require a complete reformulation of the basis of normativity and law (see Amendola, this issue). Just as for Pashukanis the abolition of private property in communist society directly implies the withering of the state, for Kollontai it entails the withering of the bourgeois couple and family.

It might be tempting for us to read Kollontai and Pashukanis in a traditional structure-superstructure framework, assuming, in other words, that elements or characteristics of the economic base of society are primary and reflected, secondarily, in the ideological and cultural spheres. But property, in their arguments, is not merely an economic category: it is from the beginning a logic and a mode of relation that spans all realms of life. One cannot simply aim for the abolition of property in the economic relations, then, and assume

that other social realms will follow suit. Instead, the struggles against property relations must proceed in parallel in all social domains. And in each social domain one must invent an alternative. What is a subject that is not defined by its possessions? What is a legal relation not founded on property? And what can love be when free of the logic of possession and ownership?

PROPERTY LOVE

Kollontai asserts that the logic that binds the modern couple is based ultimately on property relations. In pursuing this critical claim, she is certainly concerned, as are many other feminists, with the gendered right to ownership and inheritance of material wealth, but her argument stresses more strongly a different insight: that we regard our bonds to each other in terms of property and possession. In capitalist society even romantic love is a property relation. 'You are mine' and 'I am yours' are emblematic of the pledge of love as a claim of property. Consider Kollontai's explanation that the experience of two people who, soon after falling in love and forming a couple, exert rights over the other's relationships, including those relationships which had begun before they even knew each other. It would be regarded as lack of trust or, really, a breach of property rights, the refusal to share any experience past or present, any friendship, past lover, or family relationship. The mistake of many women in particular, she explains, is the belief to have found the person with whom 'we could blend our soul'.[4] Everyone keeps some secrets and insists on some

independent friendships, but those are the exception because the social norm, the regulative ideal of romantic love, requires that when you enter into partnership you give yourself over and expect the other to do the same in return.

Property love was not always the norm, at least not in the same way and to the same extent. In premodern European society, Kollontai claims that men took possession of women's bodies and women were obliged to be faithful to men physically (economically and sexually), but women's minds and souls were to a large extent to be retained still their own. In bourgeois society, however, she continues, the love-property relation shifts and deepens: 'It is the bourgeoisie who have carefully tended and fostered the ideal of absolute possession of the "contracted partner's" emotional as well as physical "I", thus extending the concept of property rights to include the right to the other person's whole spiritual and emotional world'.⁵ In addition to the inequality and the subordination of women created by bourgeois property rights in the couple and the family, then the possession of the other — the fact that love requires you to forfeit all of yourself over as property — adds another layer of subjection.

It may seem incongruous to claim that modern love is a property relation since the standard historical account maintains that modernity freed love from property, doing away with arranged marriages, primogeniture inheritance laws, and, eventually, legal structures that designate women as the property of fathers and husbands. Although most life decisions must be made

with regard to property interests, according to this view, there is at least one realm in life, the intimate sphere of the couple and the family, where decisions are made on the basis of love. Modern novels are full of narratives, for instance, in which choosing a partner against the pressures of property interests — Rochester chose Jane Eyre, after all — demonstrates the triumph and autonomy of love in the intimate sphere. The realm of love, the thinking goes, is the one place free of property, a space of the common where we share money and goods. Kollontai's argument, in contrast, is that even when legal designations of property are not involved today, we still conceive our intimate bonds according to the logic of property relations, as a form of ownership and possession. Kollontai, in this sense, gives new meaning to Marx's claim that private property has made us into such idiots to the point that we can only think of something as ours when we own it.[6]

One consequence of love being configured as a property relation is to make the couple a 'complete' and thus isolated unit. By the logic of property love, Kollontai reasons, since you have the right to only what is yours, bonds with all those outside the couple must be subordinated. 'I am yours' thus goes together with 'you are everything to me'. Indeed, complementarity and wholeness are standard clichés of romantic love: the two lovers are missing puzzle pieces who complete each other and together form a whole. Freud reports this standard view of the couple as a kind of scientific fact: 'The more they are in love, the more completely they suffice for each other.'[7]

For Kollontai, however, the complementarity and the resulting isolation of the couple is neither natural nor desirable. Such complementarity negates freedom inside the couple. Insofar as you exist for the other, oriented to your other half, you become a limited and partial person. 'The individualistic property morality of the present day is beginning to seem very obviously paralysing and oppressive'.[8] All the existing and potential aspects of yourself that do not function as complement to the other — all the pieces that do not fit in the couple puzzle — must be set aside or subordinated.

Kollontai is more concerned, however, with the external restrictions of the 'complete' couple. 'The ideal of the bourgeoisie was the married couple, where the partners complemented each other so completely that they had no need of contact with society'.[9] Since the two suffice for each other, the couple severs or fails to establish social ties. (How often have you had a friend disappear after falling in love, ensconced in a 'complete' couple, only later to reappear again in order to renew your friendship once the couple breaks up?) The couple, in effect, fulfils the bourgeois ideal of the sovereign individual, internally unified and self-sufficient, acting according to extended egotism, an egotism masquerading as altruism, making decisions according to what is best for the two. As Nietzsche, an unlikely ally of Kollontai, writes, 'Love of one is a barbarism: since it is practiced at the expense of all others'.[10] Couple love, like property love in general, discourages and even prohibits caring for and forming bonds with what is not yours.

THE GLASS OF WATER
THEORY

Kollontai's challenge to the antisocial couple bound by property relations inevitably raises a series of straw man arguments and panic reactions regarding sex. If the two are not bound by mutual ownership in property love, according to such fears, then anything goes, raising the spectre of 'free love' and polyamory. We need to reduce the focus on sex, however, to appreciate Kollontai's argument about love.

In the early 1920s, Soviet revolutionaries debated the 'glass of water' theory of sex, a theory widely attributed to Kollontai. Having sex, the theory goes, should be no more complicated or problematic than drinking a glass of water. The 'glass of water' theory, however, simple as it is, proved difficult for many to understand. Whereas, perhaps predictably, the metaphor generated for many a heightened focus on sex — along with titillation and panic regarding casual sex and multiple sex partners as well as disapproval for violating traditional morality — it was intended, to the contrary, to sideline such excited discussions. Since having sex, like drinking water, is a normal bodily function, it should be neither subject to moral injunction and social control nor the object of political celebration.

The 'glass of water' theory would likely be equally misunderstood today, since it does not conform easily to established political positions regarding sex, especially those that we have inherited from the 'sex wars' of the 1980s. The theory certainly does not fit, for example,

with either what came to be cast as sex-negative po-
sitions (which arose in part to highlight the damag-
es accrued to women in and by pornography and the
sex industries) or sex-positive ones (that advocate, in
contrast, sexual freedom and the characteristics of lib-
eration for non-normative sex practices). Whereas both
sex-negative and sex-positive positions agree that sex is
important politically and socially, the 'glass of water' the-
ory maintains it is not.

The 'glass of water' theory proves so difficult to grasp in
part due to its paradoxical rhetorical strategy: it brings
something to light in order to diminish its significance.
Its intended function is thus subtractive. In its rhetor-
ical strategy, the 'glass of water' theory resonates with
the social interventions of the ancient Cynics, such as,
for example, their reported practice of masturbating
in public. No one should be scandalised, they argued,
by our satisfying a bodily need that is of the same or-
der as satiating thirst or hunger. If only it were as easy,
Diogenes of Sinope allegedly declared, to banish hunger
by simply 'rubbing my belly!' Diogenes's point is obviously
not to concentrate political or philosophical attention
on masturbation, to celebrate it, or to create an onan-
ist cult. On the contrary, the point is subtractive: to
release us from preoccupations about sex so that we
can direct our attention elsewhere. That is the function
of the 'glass of water' theory: stop being distracted by
sex so as to focus on the important social and political
issues.

This raises, however, another obstacle to understand-
ing the 'glass of water' theory today: that it could appear

to assert that sex is personal and thus not political, running counter to the important second-wave feminist slogan. Furthermore, it could mask the sexual dangers that women face, including unwanted pregnancy, rape, and other forms of sexual violence. I understand the 'glass of water' theory, however, as positioning sex as political but imagining it in a society of freedom, where sexual violence, unwanted pregnancy, and the constraints of normativity and moralisms are a thing of the past. In effect, the theory is a demand for that utopian future, in which having sex can become no more complicated than drinking a glass of water.

Although she is likely not responsible for the idea, Kollontai is a good representative of the 'glass of water' theory. She was regarded by others and indeed presented herself as embodying the new liberated woman. The characters in her novels, such as *Red Love*, experiment freely with various amorous arrangements. And in her life, too, she reports treating sex openly and without moralisms. 'I make no secret of my love experiences', she explains in her autobiography; 'when once love came, I have my relations to the man.'[11] By demystifying sex, she sought to counter the moralism, prohibitions, and shame associated with sexual activity in traditional Russian society, which served as weapons for the domination of women. She furthermore lamented that asceticism regarding sex, often mixed with traditional moralism, remained widespread even among Soviet revolutionaries: 'My theses, my sexual and moral views, were bitterly fought by many Party comrades of both sexes.'[12]

Lenin is one particular figure of note who was puzzled and a bit disturbed by all the discussions of the glass of water theory. 'Of course', Lenin admits, in conversation with Clara Zetkin, 'thirst must be satisfied. But will the normal man in normal circumstances lie down in the gutter and drink out of a puddle, or out of a glass with a rim greasy from many lips?'[13] The first sentence shows that Lenin, even if he thinks he is disagreeing, understands correctly the primary point of the glass of water theory: sex, like thirst, is a normal bodily function and thus should be stripped of the traditional meanings and values attached to it. But then he seems to take the metaphor too literally and betrays traditional male fears of 'polluted' women. The idea of women having multiple partners and engaging in casual sex elicits a kind of panic in Lenin. But if one can filter out Lenin's fear of female sexuality, then perhaps his question can be understood as simply an extension of the initial point. Stripping sex of moralism does not imply having sex indiscriminately, indifferently, Lenin seems to suggest. Instead, sexual activity, like drinking water, should be treated in terms of care of the self — take care of your body and meet its needs. Maybe food, then, would be a better metaphor than water for Lenin. Nutritionists may offer general guidelines for a healthy diet, but one has to discover the needs of one's own body in balance with pleasure: discover what sex, how often, and with whom, agrees with you and pursue that, all the while avoiding what harms you. No model of healthy sex can be prescribed for all, in other words, but neither is it a matter of indifference. Communism is no asceticism, Lenin adds,

MICHAEL HARDT

to make sure that Zetkin does not misunderstand him:
healthy sex, along with sports and other activities, are
part of a joyful life.[14]

Lenin is clear, however — and this too, I would argue,
is in line with the spirit of the glass of water theory —
that these questions about sex are not the most signif-
icant social and political issues. 'But the social aspect is
most important of all', he continues. 'Drinking water is
of course an individual affair.'[15] Lenin may still be taking
the metaphor too literally: sexual activity, after all, is not
like drinking water in all its aspects. But the substance of
Lenin's point — that the social aspect is most import-
ant — is, in fact, very close to Kollontai's primary con-
cerns. 'It is time to recognise openly', she writes, 'that love
is not only a powerful natural factor, a biological force, but
also a social factor. Essentially love is a profoundly social
emotion'.[16] Sexual relations alone, inevitably, regardless
of how many sexual partners one has, remain asocial
in Kollontai's terms because sex itself is too narrow a
basis to carry the multiplicity of bonds that love must
generate and sustain. The important question for Kol-
lontai is how to create a variety of lasting, social bonds
(involving sexual relations or not) that are not consti-
tuted by property relations. Only in that way can we
begin to explore the social significance and political
possibilities of a new love.

THE ANTISOCIAL FAMILY

The nature of property love in the couple is repeated
in the family, creating what Michèle Barrett and Mary

McIntosh call the antisocial family.[17] Like the couple, according to Kollontai, the family becomes in capitalist society an isolated unit more completely closed on itself. The regulative ideal requires that you devote your love most to your kin, and then to others in concentric waves extending outward from the family. The resulting assumption that family members love each other most and thus should have the most rights and responsibilities is inscribed in a series of legal structures and customary practices. (Hospital nurses are trained to stop you at the loved one's sickroom door: 'Are you family?') Kollontai cites the fact that Aspasia, the mistress of Pericles, 'was respected by her contemporaries far more than the colourless wives of the breeding apparatus' as evidence of the bonds that lay outside of the family in other societies, ties that have been lost or weakened today.[18]

The antisocial and possessive nature of the family and its extended egotism are even more pronounced in decisions regarding children. Kollontai laments and mocks the typical proprietary attitude of parents: 'These are my children, I owe them all my maternal solicitude and affection; those are your children, they are no concern of mine and I don't care if they go hungry and cold — I have no time for other children.'[19] Ownership, as the ideologues of private property will tell you, comes with responsibility: you are obliged to care for what is yours. And, consequently, tending to the property of others — in this case caring for their children — is not only not required but also would be a violation of property rights, just as if you were to decide to paint

over the hideous colour of your neighbour's house. As much as property love requires you to care for what is yours, it discourages or even prohibits you from caring for what is not.

Property love in the couple and the family is parallel to (and often bleeds into) identitarian love on the political terrain. Limiting love to what is 'yours' is another face of the love of the same. Love in the couple may seem on the surface to be aimed at someone different, but once the two are conceived as complementary and the couple is a 'complete' whole, then two collapses back into one. The family too, with the proprietary conception of my children and my spouse, is a unit of identitarian attachment. Property breeds love of the same.

Here, yet again, arise straw man arguments. Destroying the antisocial family — and, moreover, destroying the property-based love on which it rests — does not mean stripping children away from their parents to be raised collectively. Nor does separating love from property, no longer loving only what is yours, mean loving all indifferently. One could certainly interpret as indifference Kollontai's mandate, after critiquing parents who act in the interest of only their own children, that 'the worker-mother must learn not to differentiate between yours and mine'.[20] Such statements, however, have to be read together with her encouragement to develop the many and varied bonds of love and friendship. The point is that the couple and the family should not be the limits of your love. Loving other children, caring for them, and making social decisions with their welfare in mind need not prevent you from loving your own. 'Caring,

sharing, and loving would be more widespread', Barrett and McIntosh argue, 'if the family did not claim them for its own.'[21] You can construct lasting bonds of various types with those near and far. Challenging property-based love, then, requires breaching the boundaries of the couple and the family, nurturing and developing modes of social love based not on sameness but on difference, and inventing social institutions that allow and encourage us to love and care for others in the widest possible frame, developing a wide variety of social bonds.

Kollontai claims — with a mix of description, prescription, and hope — that the family, as an antisocial institution of gender subordination and property bonds, began to be undetermined in capitalist society and will further wither away in communist society.[22] The withering and eventual abolition of the family are steps toward the equality and freedom of women, releasing them from the isolation and burden of domestic labour and subordination of familial gender hierarchies. She explains that in a capitalist society, the family was initially an economic necessity as a unit of both production and reproduction. The production component has already been all but destroyed by capitalist development: the domestic industries, such as spinning yarn and making clothing at home, were rendered obsolete by processes of commodification and the creation of new markets for capitalist goods. 'The family no longer produces; it only consumes'.[23] In communist society, she predicts, the economic bases for the sexual division of labour in the family will be weakened, women will no longer be responsible for unpaid domestic labour, and

reproductive labour in the home will be socialised: she envisions restaurants and canteens providing food for all; child rearing will be socialised; and the fatigue of domestic tasks, such as washing and cleaning, will be reduced by the implementation of industrial appliances.[24]

Kollontai, particularly in her role as minister of social welfare, took some practical steps to hasten the withering of the family in the Soviet Union. She participated, for instance, in drafting the 1917 law on marriage, which gave women the right to seek divorce and receive alimony. For the Eighth Party Congress in 1919, Kollontai prepared an amendment to affirm in explicit terms the withering away of the family, but Lenin, although sympathetic to her aims, claimed that it was not yet the right time. 'We have in fact', Lenin is reported to have responded, 'to save the family.' As minister she proposed a series of institutional women's health initiatives, such as having the state take over maternity hospitals and the provision of prenatal care. These proposals, however, were met with great resistance, even among the most forward-thinking Soviets. 'My efforts to nationalize maternity and infant care set off a new wave of insane attacks against me', she writes, and detractors claimed that she was trying to 'nationalize women'.[25]

Kollontai's efforts to destroy the antisocial family were thwarted. 'The failure of the Russian Revolution to achieve the classless society', Firestone reflected a half century later, 'is traceable to its half-hearted attempts to eliminate the family and sexual repression.'[26] Her project to root out property relations from love, however, remains as relevant today.

TRAGEDY OF THE
COMMONS

The fear (or thrill) that the critique of the couple and the family necessarily leads to 'free love' and polyamory betrays a poverty of imagination and, specifically, a failure to conceive bonds outside the model of property love. This is the 'tragedy of the commons' in the realm of love. The classic argument against the commons, articulated by Garrett Hardin (1968), asserts that wealth and resources, such as land, can only be properly managed when they are owned (as private or public property).[27] No one is responsible for what is common, the argument goes, and thus shared resources, such as grazing land or fishing waters, are inevitably overused and ruined because they are not managed. Ownership, in other words, either private or public, carries with it the power and obligation to manage resources efficiently — and it is the only social structure that does so.

In the same way, if love were to be separated from property relations, if I were not yours and you not mine, a parallel argument goes, there would be no mechanism to manage our bonds to each other and assure their longevity. Fidelity, in other words, is *the* problem for bourgeois love. And property is the solution: the only way the other will remain true to me is to be mine. Without possessing each other, our unmanaged desires would run wild and we are constantly in danger of drifting off with others. If there is no property, as Ivan Karamazov might say, everything is permitted. Hence free love, meaning indiscriminate sexual partnering and no durable bonds.

78

Kollontai insists that we need to stop thinking of those we love in terms of ownership. 'A jealous and proprietary attitude to the person loved', she argues, 'must be replaced by a comradely understanding of the other and an acceptance of his or her freedom.'[28] However it is here again that the threat of 'free love' and unrestrained promiscuity begins to rear its head. Does freedom in love mean that 'anything goes' and that no bonds shall be maintained? If you are not tied to your partner by the chain of property relations, will you have sex with anyone at any time (and then ask your partner for 'comradely understanding')? It certainly can seem that way to a proprietary mentality, that is, if one believes that property is the only guarantee of intimate and social bonds. When Kollontai exhorts us to recognise the freedom of loved ones, then, that does not mean to let them go and break bonds with them. It means to escape from the prison of property and to create a more generous conception of love, with more social and expansive bonds.

Kollontai's position is parallel to the most intelligent refutations of the 'tragedy of the commons' arguments. She does not fall into the trap prepared by the 'tragedy' argument. Some critics of property accept that property is the sole means to manage what we share and thus reject all management, assuming that the good for society can spontaneously be achieved, without any management. The better response is that private property and the state are not the only options: alternative, non-property means of management are available. The common must be managed, and so too the bonds of love must be the

object of social and political reasoning. 'Love is not in the least a "private" matter', Kollontai writes, 'concerning only the two loving persons.'[29] The couple and the family are always socially regulated, through laws that define the legal couple, for example, and sexual divisions of labour founded on property relations. We are suffering today, in other words, what Pierre Dardot and Christian Laval call 'the tragedy of the non-common'.[30] Kollontai argues, however, that we must get beyond the bourgeois belief that property is the only force that can form lasting bonds at both the intimate and the social levels. Her focus instead is to discover a logic by which social and intimate bonds are or can be nourished and managed outside the confines of property relations.

WINGED EROS

Sex, in Kollontai's view, need not always be accompanied by love. During the revolutionary struggle, for example, she explains in a speech to Soviet youth, that revolutionaries had little intellectual and emotional energy for anything but combat: sex without intimate bonds, which she calls 'unwinged Eros', became the rule since there was no time for the relationships and commitments of love.[31] In the early 1920s, however, with the emergency period having passed, she exhorted Soviet youth to invent a new love, a winged Eros. This is not a moralistic caution to young people that sex without love is an empty experience, but rather an attack on property relations. Kollontai's winged Eros, as explained by Barbara Evans Clements, is 'eroticism

with the possessiveness removed, it is the attraction of equals that enhances the harmony of the group rather than isolating the couple in self-absorption'. Winged Eros configures a love beyond property, regardless of whether sex is involved.

Like Barrett and McIntosh writing more than half a century later, Kollontai does not advocate the reform of the family or even the invention of alternative family forms, households, kinship networks, or the like. Like Kollontai, Barrett and McIntosh do not see this argument, however, leading toward a society characterised by indifference that lacks strong, lasting attachments — on the contrary. 'What is needed,' they write, 'is not to build up an alternative to the family — new forms of household that would fulfil all the needs that families are supposed to fulfil today — but to make family less necessary, by building up all sorts of other ways of meeting people's needs.'[32] The most important consequence of the abolition of the family is to increase our power to relate to and be connected with others. The effect, specifically, will be to open experimentation with a wide variety of social bonds.

Kollontai thus envisions a social love defined by multiplicity along two axes: a love of many in many ways. On the first axis, beyond the bounds of those who are yours — the couple, the family, the identity, the people — she urges us to develop bonds with a wide range of people, developing forms of love-comradeship and love-solidarity. 'The "sympathetic ties" between all the members of the new society' will have to grow and be strengthened.[33] The qualities and intensities of these

diverse attachments, obviously, will not be the same. On the second axis, then, one must develop 'many and varied bonds of love and friendship'.[34] No bond, no matter how much in love you are, suffices entirely, and you do not complement the loved one in such a way that forms a complete whole. Winged Eros, Kollontai says, has 'many forms and facets'.[35] One must assume that the duration of these bonds will also vary: you will remain attached to some people all your life, and with others it is better to break completely after a short period. Kollontai does not go very far in delineating the character of this new love, but she does give a solid foundation: freed from property love and the love of the same it fosters, a new, social love that will have to explore and proliferate multiplicities.

To extend Kollontai's initial thoughts about a new love and bring these questions closer to the concerns of our time, we can look to Michel Foucault's similar affirmation of multiple social bonds. Like Kollontai, he warns that resting political hopes on sex and sexual revolution is misplaced. Foucault's view, too, disrupts the conventional opposition between sex-positive and sex-negative positions. He thinks it's a mistake to attribute much political significance to sex itself and, certainly, to hope for a sexual revolution. An image of homosexuality centred on sex acts, he argues, even when these acts are deemed to transgress the norms of society or nature, does not really even unsettle dominant society.

Instead, what really indeed has the power to threaten the social structure — and, more importantly, ground and

animate new social relations — is an alternative form of life, and specifically a mode of love characterised by multiple bonds. Foucault explains in fact that focusing on homosexual sex distracts from or eclipses the really transformative social potential:

It cancels everything that can be disturbing in affection, tenderness, friendship, fidelity, camaraderie, and companionship, things that a rather sanitised society [*une société un peu ratissée*] cannot allow a place for without fearing that new alliances are formed and unforeseen lines of force are forged. I think that is what makes homosexuality 'troubling': the homosexual mode of life, much more than the sex act itself. Imagining a sex act that does not conform to law or nature is not what disturbs people. But that individuals begin to love each other — that's the problem.[36]

By looking beyond sex — both in the prohibitions and the affirmations of homosexual sex — Foucault can reveal three levels of transformative potential. At the first level, or base, are the different bonds that he tries to capture with his catalogue: affection, tenderness, friendship, and so forth. As for Kollontai, key for him is the multiplicity along two axes: that we form many kinds of bonds with many different people. These affects and attachments have the power to trouble dominant society because they open to a second level, in which they compose new social assemblages and new modes of life. Whereas non-normative sex acts can be accommodated or tolerated within dominant society — contained as a subset, a minority — the composition of a new mode of life seeps into the dominant order,

permeates it, and thus threatens to transform it from within. The repertoire of multiple affects and attachments of the new mode of life creates a pole of attraction for homosexual and heterosexual communities alike. The third level, finally, is the invention of a new love, a social form of love capacious enough to include the many different kinds of bonds with different people. Such a new love has the potential not only to disturb dominant structures but also to transform them. In the homosexual mode of life Foucault glimpses the potential of a winged Eros.

The social aspect, for Foucault as for Lenin and Kollontai, is what is really important. Only once we demystify and desacralise sex — sweeping away prohibitions and moralisms — can we begin to transform love and realise its social potential as a new form of life composed of multiple bonds, relationships, and modes of attachment. That is the horizon of a new love that could, fulfilling Guevara's dictum, provide a guide for revolutionaries.

1 Che Guevara, 'Socialism and Man in Cuba', in *Che Guevara Reader: Writings on Politics & Revolution*, ed. by David Deutschmann (Melbourne: Ocean Press, 2003), pp. 212–28, p. 225.

2 Karl Marx and Friedrich Engels, *The Communist Manifesto* (New York: Oxford University Press, 2008), p. 18.

3 Evgeny Pashukanis, *The General Theory of Law and Marxism*, trans. by Barbara Enhorn (New Brunswick, NJ: Transaction, 2002).

4 Alexandra Kollontai, *The Autobiography of a Sexually Emancipated Communist Woman*, ed. by Iring Fetscher, trans. by Salvator Attanasio (New York: Herder and Herder, 1971), p. 8.

5 Alexandra Kollontai, 'Sexual Relations and the Class Struggle', in
 Selected Writings of Alexandra Kollontai, trans. and ed. by Alix Holt
 (London: Allison and Busby, 1977), pp. 237–49, p. 242.

6 Karl Marx, 'Economic and Philosophical Manuscripts', in *Early
 Writings* (London: Penguin, 1974), pp. 279–400, p. 351.

7 Sigmund Freud, *Group Psychology and the Analysis of the Ego*,
 trans. by James Strachey (New York: Norton, 1959), p. 72.

8 Kollontai, 'Sexual Relations and the Class Struggle', in *Selected
 Writings*, p. 240.

9 Kollontai, 'Theses on Communist Morality in the Sphere of
 Marital Relations', in *Selected Writings*, pp. 225–31, p. 230.

10 Friedrich Nietzsche, *Beyond Good and Evil*, trans. by R. J.
 Hollingdale (London: Penguin, 1973), p. 73.

11 Alexandra Kollontai, *The Autobiography of a Sexually Emancipated
 Communist Woman*, trans. by Salvator Attanasio (New York:
 Herder and Herder, 1971), p. 5.

12 Ibid., p. 43.

13 Clara Zetkin, *Reminiscences of Lenin* (New York: International
 Publishers, 1934), p. 49.

14 Ibid., p. 50.

15 Ibid., p. 49.

16 Kollontai, 'Make Way for Winged Eros: A Letter to Working
 Youth', in *Selected Writings*, pp. 276–92, p. 278.

17 Michèle Barrett and Mary McIntosh, *The Anti-social Family*
 (London: Verso, 1982).

18 Kollontai, 'Prostitution and Ways of Fighting It', in *Selected Writings*,
 pp. 261–75, p. 262.

19 Kollontai, 'Communism and the Family', in *Selected Writings*,
 pp. 250–60, p. 259.

20 Ibid.

21 Barrett and McIntosh, p. 80.

22 Kollontai, *Communism and the Family*, p. 258.

23 Ibid., p. 254.

24 Ibid., p. 255.

25 Kollontai, *The Autobiography of a Sexually Emancipated Communist
 Woman*, p. 38.

26 Shulamith Firestone, *The Dialectic of Sex: The Case for Feminist Revolution* (New York: William Morrow, 1970), p. 190.

27 Garrett Hardin, 'The Tragedy of the Commons', *Science*, 162, no. 3859 (1968), pp. 1243–48.

28 Kollontai, 'Theses on Communist Morality in the Sphere of Marital Relations', in *Selected Writings*, p. 231.

29 Kollontai, 'Make Way for Winged Eros: A Letter to Working Youth', in *Selected Writings*, p. 279.

30 Pierre Dardot and Christian Laval, *Commun: Essai sur la révolution au XXIe siècle* (*Common: An Essay on Revolution in the Twenty-First Century*) (Paris: La Découverte, 2014), p. 14.

31 Kollontai, 'Make Way for Winged Eros: A Letter to Working Youth', in *Selected Writings*, p. 277.

32 Barrett and McIntosh. *The Anti-social Family*, p. 159.

33 Kollontai, 'Make Way for Winged Eros: A Letter to Working Youth', in *Selected Writings*, p. 290.

34 Kollontai, 'Theses on Communist Morality in the Sphere of Marital Relations', in *Selected Writings*, p. 231.

35 Kollontai, 'Make Way for Winged Eros: A Letter to Working Youth', in *Selected Writings*, p. 288.

36 Michel Foucault, 'De l'amitié comme mode de vie' ('Friendship as a Way of Life'), in *Dits et écrits, 1954–1988* (*Essential Writings, 1954–1988*) (Paris: Gallimard, 1994), 4: pp. 163–67, p. 164

NOTES

i For an excellent presentation of feminist arguments against romantic love, repurposed in the critique of 'love your work' management discourses, see Weeks, forthcoming.

ii Firestone's diagnosis is parallel to Kollontai's, although she focuses on unequal power rather than property relations. 'Thus it is not the process of love itself that is at fault, but its *political*, i.e. unequal *power* context: the who, why, when, and where of it is what makes it now such a holocaust' (Firestone 1970: 119).

iii For a reading of Kollontai on love that points in a different direction from mine, see Ebert 1999.

iv I have found no evidence that Kollontai and Pashukanis knew each other or even that they were familiar with each other's work, although Soviet intellectual circles of the 1920s were small. The correspondences between their critiques of property relations are testament, instead, to the wide questioning of property in early Soviet society.

v Although the originality and intellectual coherence of her writings gained Kollontai respect among Soviet intellectuals, the political positions suggested by her work were opposed by those in power. Kollontai was sidelined from central government circles and sent to Norway as ambassador (a kind of gentle exile) after her support for the Workers' Opposition, a 1922 political proposition to decentralise power away from the state (1977f). Kollontai's views on the family and the couple did not win much favour either, as indicated by Lenin's opposition to her amendment affirming the withering away of the family. 'My theses,' she writes, 'my sexual and moral views, were bitterly fought by many Party comrades of both sexes' (Kollontai 1971: 43). That view lasted for decades in official Soviet circles. The collection of her writings published in the Soviet Union in the 1970s contains none of her essays on love, the couple, and the family. Instead, the editor notes in the introduction that, as a person of inquiring mind, Kollontai was 'liable to error': her error, specifically, was to criticise the family and make claims that could be misconstrued to imply, the editor continues, 'immorality, promiscuity or loose living' (Dazhina [1972] 1984: 13).

vi The glass of water theory probably derives from August Bebel's 1879 *Woman under Socialism*, a book Kollontai, Lenin, and many other Soviet figures had carefully read. The exact formulation 'glass of water' does not appear in the book, but Bebel ([1879] 1904: 79–81, 343) does explain that sex is a natural and healthy human need comparable to eating, drinking, and sleeping. There is no record

of Kollontai having used the glass of water formulation, although the general idea runs throughout her writings. 'According to the most famous legend,' writes Iring Fetscher (1971: 111), 'Alexandra Kollontai is supposed to have declared that sexual contacts were matters as simple and as unproblematic as drinking a glass of water.' On Kollontai's reading Bebel, see Porter 1980 and Renault, 2017.

vii Michel Foucault (2009: 158) is intrigued by Diogenes's reported masturbation in public and its subtractive function, which he describes as 'a mode of life that has a reductive function with respect to conventions and beliefs' (translation mine).

viii In my view, Srećko Horvat (2015: 87–88) misinterprets Lenin's reference to sport in his response to Zetkin as an anti-sex position, exhorting us to do sports instead of have sex, to sublimate desire. I think it is clear, instead, that Lenin's comparison between sex and sports simply puts sex on the same level with other healthy bodily activities. It is true that Lenin, insisting that 'the revolution demands concentration', pronounces against 'orgiastic conditions' (Zetkin 1934: 50), but I read this as a panic reaction to an imagined 'free love'. Judith Stora-Sandor goes further than Horvat and, since she understands Kollontai's work (incorrectly in my view) primarily in terms of sexual revolution, interprets Lenin's response as evidence of his reactionary position. 'It is not a matter here of lodging an accusation against Lenin. We simply want here to signal that with regard to sexuality the most eminent Marxists of the age show themselves to be completely reactionary' (Stora-Sandor 1971: 46; translation mine).

ix Horvat (2015: 101–2) rightly poses the proximity of Lenin and Kollontai in this regard: 'In fact, Lenin and the most radical reformers of love relationships (Kollontai, Clara Zetkin, etc.) during the early October Revolution had much more in common than they themselves were aware of.'

x Lenin's comment, reported by Anna Itkina on page 208 of her 1964 biography of Kollontai, is quoted in Porter 1980: 337. This response — agreement in principle but the time is not right — is also Lenin's basic position regarding the Workers' Opposition.

xi See Elinor Ostrom's (1990) critique of Hardin.

xii I am indebted to Lauren Berlant for conversations about this text.

xiii For a similar argument, about the disruptive powers of happiness, see Foucault 2011: 392–93.

xiv This text, 'Red Love' was first published in *South Atlantic Quarterly*, 116.4 (1 October 2017), 781–96.

BIBLIOGRAPHY

Barrett, Michèle, and Mary McIntosh, *The Anti-social Family* (London: Verso, 1982)

Bebel, August, *Woman under Socialism*, trans. by Daniel De Leon (New York: New York Labor News Company, [1879] 1904)

Clements, Barbara Evans, *Bolshevik Feminist: The Life of Aleksandra Kollontai* (Bloomington: Indiana University Press, 1979)

Dardot, Pierre, and Christian Laval, *Commun: Essai sur la révolution au XXIe siècle* (*Common: An Essay on Revolution in the Twenty-First Century*) (Paris: La Découverte, 2014)

Dazhina, I. M., 'An Impassioned Opponent of War and Champion of Peace and Female Emancipation', in *Alexandra Kollontai: Selected Articles and Speeches*, ed. by I. M. Dazhina, 5–15 (Moscow: Progress Publishers)

Ebert, Teresa L, 'Alexandra Kollontai and Red Love' (1999), *Against the Current*, no. 81. www.solidarity-us.org/node/1724.

Fetscher, Iring, 1971. Afterword to Kollontai, *Autobiography*, 105–35

Firestone, Shulamith, *The Dialectic of Sex: The Case for Feminist Revolution* (New York: William Morrow, 1970)

Foucault, Michel, 'De l'amitié comme mode de vie' ('Friendship as a Way of Life'), in *Dits et écrits, 1954–1988* (*Essential Writings, 1954–1988*), (Paris: Gallimard, 1994), 4: pp. 163–67

Foucault, Michel, *'Le courage de la vérité': Le gouvernement de soi et des autres II; Cours au Collège de France, 1984* (*'The Courage of the Truth': The Government of Self and Others II; lectures at the Collège de France, 1984*). Ed. Frédéric Gros (Paris: Gallimard/Seuil, 2009)

Foucault, Michael, 'The Gay Science', trans. by Nicolae Morar and Daniel Smith. *Critical Inquiry* 37, no. 3, (2011), 385–403

Freud, Sigmund, *Group Psychology and the Analysis of the Ego*, trans. by James Strachey (New York: Norton 1959)

Guevara, Ernesto, 'Socialism and Man in Cuba', in *Che Guevara Reader*, ed. by David Deutschmann (Melbourne: Ocean Press, 2003), pp. 212–28

Hardin, Garrett, 'The Tragedy of the Commons', *Science* 162, no. 3859 (1968), 1243–48

Horvat, Srećko, *The Radicality of Love* (Cambridge: Polity, 2015)

Kollontai, Alexandra, *The Autobiography of a Sexually Emancipated Communist Woman*, ed. by Iring Fetscher, trans. by Salvador Attansio (New York: Herder and Herder, 1971)

Kollontai, Alexandra, 'Sexual Relations and the Class Struggle', in *Selected Writings of Alexandra Kollontai*, trans. and ed. by Alix Holt (London: Allison and Busby, 1977), pp. 237–49

Kollontai, Alexandra, 'Communism and the Family', in Kollontai, *Selected Writings*, pp. 250–60

Kollontai, Alexandra, 'Make Way for Winged Eros: A Letter to Working Youth', in Kollontai, *Selected Writings*, pp. 276–92

Kollontai, Alexandra, 'Prostitution and Ways of Fighting It', in Kollontai, *Selected Writings*, pp. 261–75

Kollontai, Alexandra, 'Theses on Communist Morality in the Sphere of Marital Relations', in Kollontai, *Selected Writings*, pp. 225–31

Kollontai, Alexandra, 'The Workers' Opposition', in Kollontai, *Selected Writings*, pp. 159–200

Marx, Karl, 'Economic and Philosophical Manuscripts', in *Early Writings*. (London: Penguin, 1974), pp. 279–400

Marx, Karl, and Friedrich, Engels, *The Communist Manifesto* (New York: Oxford University Press, 2008)

Nietzsche, Friedrich, *Beyond Good and Evil*, trans. by R. J. Hollingdale (London: Penguin, 1973)

Ostrom, Elinor, *Governing the Commons: The Evolution of Institutions for Collective Action* (Cambridge: Cambridge University Press, 1990)

Pashukanis, Evgeny, *The General Theory of Law and Marxism*, trans. by Barbara Enhorn (New Brunswick, NJ: Transaction, 2002)

Porter, Cathy, *Alexandra Kollontai: The Lonely Struggle of the Woman Who Defied Lenin* (New York: Dial, 1980)

Renault, Matthieu, 'Alexandra Kollontaï et le dépérissement de la famille... ou les deux verres d'eau de Lénine' ('Alexandra Kollontai and the Withering of the Family... or the Two Glasses of Water of Lenin'), in *Pour un féminisme de la totalité*, ed. by Félix Boggio Éwanjé-Épée (Paris: Éditions Amsterdam), pp. 63–87

Stora-Sandor, Judith, 1971. Introduction to Alexandra Kollontai: *Marxisme et révolution sexuelle* (Paris: Maspero, 2017), pp. 9–47

Weeks, Kathi, 'Down with Love: Feminist Critique and the New Ideologies of Work', *Women's Studies Quarterly*, 45 (2017), pp. 37–58

Zetkin, Clara, *Reminiscences of Lenin* (New York: International Publishers, 1934)

CuratorLab on research trip in Folgerstad,
a self-organised women's school for civic training
operating between 1925 and 1954.
November 2017.

DORA GARCÍA'S *RED LOVE*
MARIA LIND

Dora García's new artwork *Red Love* is inspired by the Russian author, feminist, activist, political refugee, and diplomat Alexandra Kollontai (1872–1952) who propagated for radically transformed relationships between women and men. Free love and camaraderie were at the core of her thinking, as expressed in her novels and essays — a new society needed new human beings and new relationships. True love can only happen when it is liberated from property relations, both real and imagined. As an influential figure in the Bolshevik party and commissar for social welfare in their first government, she not only set up free childcare centres and maternity houses, but also pushed through rights for women including divorce, abortion, and full rights for children born out of wedlock. At the time these were unique measures that were soon overhauled by Stalin, who did not appreciate this attempt at ending 'the universal servitude of woman' by challenging both economic and psychological conditions.

García's exhibition had three main physical elements, each with strong symbolic resonance. *Red Love* consisted of a wooden cage-like structure, a wooden staircase, and a floor painting. The cage-like structure had a door leading into a space furnished with a big table and chairs. The artist spoke about it as Kollontai's imagined work space, where she, among other things, wrote. This space, reminiscent of a stage, was used for various purposes during the exhibition period, including by participants of Konstfack's CuratorLab programme for their final projects. Strong

light emanated from a lamp suspended from the ceiling, acting as a sun of sorts, casting distinct shadows on the floor, which had been painted white with a red square in the middle. The square was not perfectly rectilinear, just like the angular shapes in Kazimir Malevich's suprematist paintings. The cage and the lighting bear a likeness to a scene in the film *W.R.: Mysteries of the Organism* (1971), as well as *You Only Live Once* (1937).

At the other end of Tensta konsthall's main exhibition space there was a wooden spiral staircase on which a selection of books and other material from the activities in the space had been placed. This atmospheric installation, rich in references, played on the mission, almost transcendental purpose, and urgency of Kollontai's life and work, something which was shared by many revolutionaries and artists like Malevich. The stairs originated in a museum with a different but no less passionate mission, The Museum of Jurassic Technologies, which was founded in 1989 by a husband and wife in Los Angeles. The museum is defined as 'an educational institution dedicated to the advancement of knowledge and the public appreciation of the Lower Jurassic', a term not further explained. In this exceptional museum, which is reminiscent of a cabinet of curiosities with a collection holding artistic, ethnographic, scientific, and historical objects, some exhibits remain unclassifiable. Part of the collection are a set of maquettes of wooden staircases, one of which came to be the model for the staircase in *Red Love*.

While Kollontai herself became the inspiration for the character Ninotchka in Ernst Lubitsch's 1939 film comedy of the same name, famously played by Greta Garbo, the

film *W.R.: Mysteries of the Organism* gave impulses to the cage-like room. Made in 1971 by Yugoslav director Dušan Makavejev, the hilarious film mixes documentary passages with fiction while dealing with communist politics and sexuality, mentioning Kollontai in one of its most intense scenes. The life and work of the psychoanalyst Wilhelm Reich feature prominently in the film, which was banned in Yugoslavia. Like both Kollontai and The Museum of Jurassic Technologies, *W.R.: Mysteries of the Organism* exemplifies how radical imagination can be set in motion. Here we also find a certain kind of dissidence, both heroic and unheroic, as well as failure and exile, tensions, and contradictions. All of them are themes which reoccur in García's oeuvre.

García's research-based practice is concerned with modes of political resilience and the production of subjectivity. She often draws on psychoanalysis in her work, specifically the theories of Jacques Lacan. Kollontai is yet another dissident figure whose biography and philosophy of action provides an example of emancipatory politics to the artist. Other such figures are the philosopher Félix Guattari, the psychiatrist Franco Basaglia, and artist and theorist Oscar Masotta. They are all in some sense deviants who have experienced marginality. While relating to them, either through real or fictional characters, García scripts interventions and installations that transpose these various authors into a presentation to the wider public, mixing politics, performance, and the formation of subjectivity. Like a continuous inquiry, García's work is invested in the performativity of speech and actions and their particular qualities as political tools. Her approach

to the exhibition space reflects the structural problems of this emancipatory process, frequently using performative devices which challenge the viewer.

Kollontai was a pioneer of political engagement and writing on sexual politics, at the same time as she fought for workers' rights advocating a participatory organisation of production. While leading a highly unconventional life for a woman of her generation, with two divorces and an active professional, sexual, and emotional life, she worked directly with women workers during the years leading up to the October Revolution. She engaged especially in social and emotional emancipation, critiquing bourgeois family relations. After serving as the people's commissar of social welfare in the first Bolshevik government, she resigned after six months due to differences in opinion with the other leaders. Not surprisingly, she became seminal in a group called the Workers' Opposition who, shortly after the revolution, criticised the party for being too removed from the workers themselves and for quickly becoming too bureaucratised. After that she was gradually sidelined with domestic politics, and thanks to her previous experience as a political refugee in Germany, Switzerland, France, Sweden, and Norway — as well as her language skills — was given tasks abroad. As the first female ambassador in the world, Kollontai served as the Soviet representative in Oslo and Mexico, and eventually also in Stockholm, in 1930–1945. Here she became a public figure, befriending for example many members of the feminist Fogelstad group.

Among her most read texts are 'The New Woman' (1913), 'Make Way for Winged Eros' (1923), and *The Autobiography*

of a Sexually Emancipated Communist Woman (1926), as well as the short novel *Vasilisa Malygina* (1923), which was published in English as *Red Love* (1927). The latter is a psychological study of sex-relations in the early Soviet period, and has given García's exhibition its title. *Vasilisa Malygina* was published together with 'Three Generations and Sisters' under the title of *The Love of Worker Bees*, which was widely read in the west throughout the 1960s and 1970s. 'Soon' from 1923 is a futuristic essay picturing society in the year 2000, when many of her visions have come true.

'Make Way for Winged Eros' was written as a response to many letters Kollontai received from young workers with questions on how to conduct life under socialism. In it she describes how historically different material conditions have determined and regulated love and sexual relations in society. While 'The New Woman' deals with the psychological aspects of an emancipated working woman belonging to no one but herself, and is yet a member of a community based on trust and solidarity, *The Autobiography of a Sexually Emancipated Communist Woman* is an account of her own experiences. The three stories in *The Love of Worker Bees*, written with proletarian readers in mind in an unadorned prose, give examples of the tensions between old ideals and new sexual lifestyles after the revolution, as well as the power of solidarity between women.

García has dedicated a considerable amount of her work to love, in various ways and with different people. The 2009 performance *The Romeos* was designed to take place in the context of an art fair, but has also happened during

an art collector's party and will happen again in the city of Trondheim in the summer of 2018. The performance is set in contexts where kindness, charm, and good looks are professional tools — things that can be exchanged and traded. These features and abilities can be bought or sold. Posters bearing photos of the performers are distributed, informing the visitors that a group of young and attractive men are out there being paid to be lovable, kind, and attractive. Their job for the evening is to make people feel special. The question of the performance is: now that you know that these young men are being paid to be nice to you, will you accept their kindness? Will it render the feelings between you inauthentic because of the monetary transaction? Are you ready to accept their attention — because well, why not — as long as it lasts, does it seem like a fair deal?

Army of Love, an ongoing collaboration with the writer Ingo Niermann, is about an army of people willing to give love — all-encompassing, sensual, familiar, and comradely love — to those who do not have enough of it. In short, people who have an excess of love and are ready to share it with those wanting love, who for whatever reason — for example, sickness, social marginality, handicap, and age — are lacking it. Borrowing heavily from Kollontai and Charles Fourier, and adopting the basic notion that the ideal of love in the West is closely related to the idea of property, they pursue the idea of a common love. Love should not only be directed to one person, but to everyone — as the great equaliser, love needs to happen between equals and one makes people equal by loving them. In this

regard, García and Niermann have actively researched the possibility of an army of love, a group of people with a certain behavioural code and the characteristics of an army. In the same sense that the Christian Church has been compared to an army, selfless, collective, serving the common good, tied by duties of honour and companionship, each individual is part of a greater body. Mostly carried out as workshops with exercises and passionate debates on what the 'Army of Love should be'. Those who have received plenty of love, and are therefore made equals, are sometimes ready to go from receivers to givers.

At a time when universal emancipation is again on the agenda, with intersectional approaches as powerful tools, it is an interesting moment to revisit Kollontai's legacy. How can we today relate to, portray, and engage critically with this historical figure and her deeds? What is to be learnt from Kollontai's political practice and personal life? Contrary to the idea that equality has been achieved, García reading Kollontai, argues that we learn that the fight still has to be fought, and that change will not happen without love. As Kollontai herself once wrote:

Imagine a society, a people, a community, where there are no longer Mashenka ladies and Mashenka laundresses. [...] Where there are no parasites and no hired workers. [...] Where all people do the same amount of work and society in return looks after them and helps them in life. [...] When Mashenka, who is now neither a lady nor a servant but simply a citizen, becomes pregnant, she does not have to worry about what will happen to her or her child. [...] Society, that big happy

family, will look after everything. Love is an emotion that unites and is consequently of an organising character. [...] Only the ideology of the lifestyle of the new, labouring humanity can unravel this complex problem of emotion.

Dora Garcia's *Red Love* was part of Tensta konsthall's multi-year inquiry 'The Eros Effect: Art, Solidarity Movements and the Struggle for Social Justice' that looks into the relationship between art and solidarity movements. Starting in 2015, it has taken the form of a series of commissions, exhibitions, workshops, presentations, and film screenings. Faced with fascist parties gaining ground in Europe, and an increasingly tough social climate, it seemed a necessity to return to the notion of solidarity and to test its validity today. Will solidarity still be relevant in the future, or is it a historical concept? Do we need to find new ways to describe the political movements of today and their struggles, sympathies, and commitments? What does recognising the urgency of a situation imply, and how do we act upon it?

'The Eros Effect' project borrows its title from the researcher and activist George N. Katsiaficas's 1989 essay of the same name. The inquiry builds upon the analytical tool of the 'Eros Effect', in attempt to acknowledge the emotional aspect of social movements. The concept thus aims to turn away from earlier theories that considered mass movements as primitive and impulsive, as emotional outbursts or as exclusively rational efforts, in order to change the norms and institutions of society. With his notion, Katsiaficas suggests that social movements always

constitute both, that the struggle for liberation is equally an erotic act and a rational desire to break free from structural and psychological barriers. Franz Fanon made similar observations when he stated that resistance towards colonialism would have positive effects on the emotional life of individuals.

Photographs on pages 58–61 and 71:
'Red Love' an exhibition by Dora García, Tensta konsthall, 2018
© photo by Jean-Baptiste Béranger

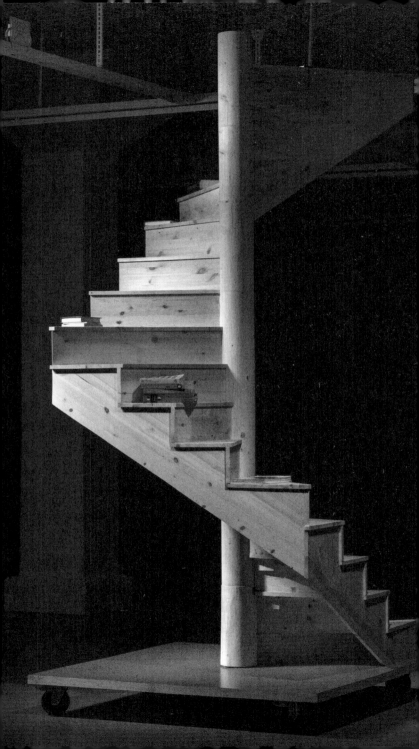

AND ALL IS YET TO BE DONE:
IMAGES FROM A JOURNEY
PETRA BAUER AND REBECKA KATZ THOR

'In furthering their ideas, the feminists had to discuss methods of organisation — the most forbidden topic of all'.

Kollontai, 1920

In the spring of 1920, a group of socialist women from Sweden set out on a journey to the newly founded communist Russia.

When our dear Anna-Stina on a day in April, calm and cool as usual, came to tell us that we were to go to Russia to visit an international women's conference, we didn't believe our ears. To go to Russia, which had been our wish for years — no, it couldn't be possible!

They write a travelogue for the magazine *Red Voices,* dated 16 May 1920, Vardö. They describe their journey and their meetings throughout Sweden and Norway. Yet, their text also allows us to see something of what they saw, to see through their understanding. These excerpts might give us a sense of their situation.

After matters that needed several days, we were finally ready to depart. On May 4th, we thus said goodbye to Stockholm and installed ourselves on the northbound train.

Finally, on Wednesday at noon we arrive in Narvik. The city gives a dull impression. Its significance probably stems from its role as a shipping port for Swedish ore. Because of the coal shortage, several boat transportations are cancelled and we have to remain in the city for a few days. We immediately head for Forward, the city's socialist newspaper.

For them, the revolutionary country in the East serves as an inspiration for what could be done at home. It is a year after the law on universal suffrage has been passed in Sweden and a year before it will be implemented. A time of transformation, a time when everything seems possible, and yet little has been achieved.

We also have the opportunity to talk to [the] editor's wife, comrade Olsén, and we use this chance to get some news about the women's movement. There are two women's clubs here, with a total number of around seventy members. The Norwegian women's modus operandi are completely different from ours; they mostly strive to make money through handiwork, in order to buy shares in the party organs and the cooperative movement.

A collectivity is formed in each instance, in each town and village, and also reaches beyond the specificity of each group into the greater collective of the movement.

However, Olsén's field of work extends far beyond the women's movement. On May Day this year she mana-

ged to found, in addition to a women's club, a joint organisation between the fishermen's and the industrial workers' communities in Honningsvaag. This is the first break with the old belief that fishermen don't have anything in common with the other workers.

By acknowledging elements that usually remain invisible, such as the role of meetings, cooking and handicraft, one might offer a counter narrative. Thus, what is crucial here is to ask what kind of potential politics these gatherings produce. Then, as well as now, political organising is easily perceived within given norms and frameworks, hence the meeting and the lecture remain two common forms. Yet political organising also takes place elsewhere and by different means. Maybe these activities act as a cover up, but they can also be an actual means to act politically in a way that is defined by a specific situation.

Early Sunday morning, we embark upon the passage from Narvik and we get to see the Norwegian archipelago in brilliant sunshine. But despite the fact that it is already May, there is snow and more snow everywhere. Here and there we see small pieces of arable land, always very well utilised.

When we arrive in Tromsö, we are welcomed by our jaunty comrade Gitta Jönsson, who we know from the Scandinavian Workers' Congress and the women's movement in Stockholm. We spend some particularly pleasant hours in her home, while waiting for the boat's departure.

The women's club in Tromsö has some eighty members, and celebrates its ten-year anniversary on 12 May. Comrade Jönsson has been the chair of the club all these years. Her work as an agitator is well known, and we hope that she will have many more years of struggle in our ranks.

Our interest in history is not a question of historicising; rather, it is a quest to find what in the historical might help us create an alternative future. Hence, by shifting focus from the main sites of political action, more hidden struggles might appear. Such structures are not necessarily perceived of as political. They might want to avoid that word, but they are a place in which politics happens through conversations, education, and companionship. Literally as well as symbolically, all is not as it first appears: not for them and not for us.

On a mountain peak we see a building that we assume to be a tourist hotel or something similar. But to our great surprise we are told that it is the summer home of the youth league.

What we want to highlight is forms of resistance which are often overlooked that continually challenge and reshape communities. For instance, what is considered a political act? Which forms of resistance count? Can a sewing-club be a site for politics to take place?

After a fourteen-hour-long journey on the Arctic Ocean, with three hours of full storm, we arrive at Vardö on May 11th at two o'clock in the morning.

In Vardö, the women's club have around forty members, but here, just as in Narvik, they mostly hold so-called sewing circles instead of organising socialist study groups.

In the last paragraph they express their hope to write another text, but it remains unwritten, and no written trace of their stay in Russia remains. What does remain are photographs. All images were kept in the private archive of the famous agitator Kata Dalström. Throughout the first two decades of the twenty-first century she travelled around Sweden promoting women's issues in a socialist political realm. Most likely it is she who stands behind the camera. She frames the images, conceptually and concretely, through her representational and perspectival choices.

Tomorrow we continue the journey to Murmansk, and from there we hope to send another letter to Red Voices about the conditions in Northern Russia.

1 Alexandra Kollontai, 'Towards a History of the Working Women's Movement in Russia', in *Selected Writings*, trans. and ed. by Alix Holt (London: Allison & Busby, 1977), p. 49.

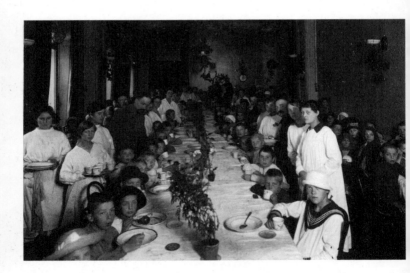

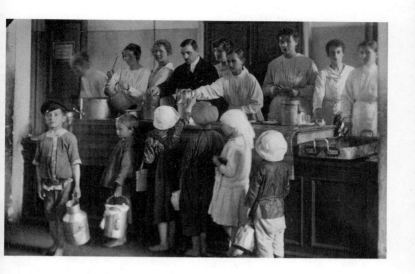

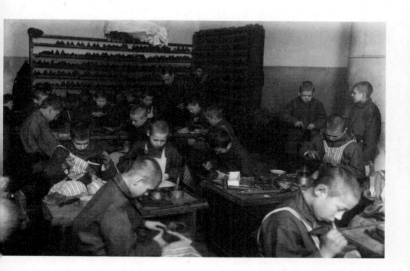

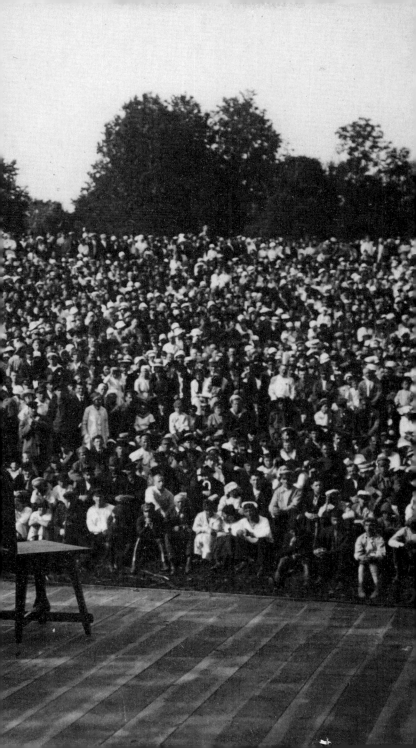

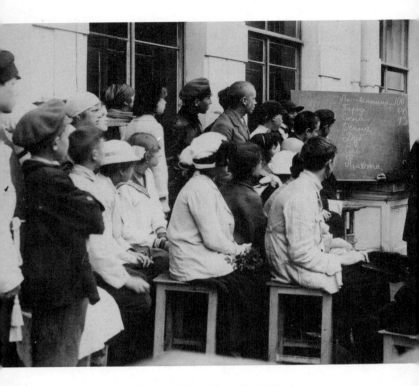

Photographs from Kata Dalström's archive,
The Swedish Labour Movement's Archives and Library

FEMINISM IS OUR NATIONAL IDEA
ALLA MITROFANOVA

Originally published by RFE/RL, www.svoboda.org, 24 March 2017
Translated and introduced by Jonathan Brooks Platt

In the essay translated below, the noted theoretician and cyberfeminist, Alla Mitrofanova, presents a brief overview of the gender revolution that accompanied and, in many ways, marked the front line in the Russian struggle for socialism at the beginning of the twentieth century. In detailing the multitude of ways in which feminism formed a central component of Russian revolutionary ideology, Mitrofanova lays particular emphasis on how the Bolsheviks strove to put this ideology into practice. One of the most remarkable achievements of the period was Alexandra Kollontai's development of the mass, horizontal network of women's sections (*zhenotdely*) during her time as the Minister of Social Welfare. The women's sections not only agitated for communism among the women workers and peasants across the country, but they also actively integrated the women's sections into party work more generally and represented women's interests with great zeal amid the chaos of post-revolutionary socialist construction. As Mitrofanova notes, this was a time of radical institution building, and Kollontai was at the forefront of the institutional reinvention of social practices.

Mitrofanova identifies the erosion of gender binarism as the most radical consequence of the work of revolutionary women like Kollontai. The new institutional and discursive landscape promoted an equality that was not

only about formal questions like the right to hold office, but also about a new sensuousness, remaining sensitive to the needs and desires of the other. In many ways, this process found its roots in the broader ideological environment of Russia's fin de siècle, when sex and sexual difference were central concerns for intellectuals. The evil flowers of the decadent movement in art and literature were particularly pungent in Russia — complete with a string of scandalous works devoured by readers and attacked by critics for corrupting the youth. However, the most advanced erotic discourses were ironically found in the realm of religious philosophy. Taking a variety of forms, most dramatically in the work of Vladimir Solovyov, the dominant theme was erotic celibacy, a kind of Gnostic Tantrism in which libidinous energy would accumulate in our mortal bodies until exploding in a final syzygial coupling and collective orgasm that would conquer death.

This cultivation of the contradiction between Eros and abstinence played a significant role in the 1905 revolution. The profoundly repressive environment of the years following Alexander II's assassination in 1881 led to a youth rebellion, which contributed significantly to the rise of militant energies. Nonetheless, as Laura Engelstein writes, reflections on the political environment of 1905 tended to depict 'the period of political confrontation as one in which libidinous impulses had shattered existing constraints but were effectively subordinated to the cause of constructing a new political order'. A clear maturation narrative was dominant in this discourse. Repressed schoolboys rebelled in an elemental fashion —

smashing windows — while young adults knew how to channel their passion into constructive political work. Analysing the results of a 1910 sex survey he had conducted, the young medical student Iakov Falevich wrote (in Engelstein's paraphrase):

The revolution had in general curtailed sexual activity by monopolising young people's energy and time. [...] Working closely with women had taught men to view them as comrades rather than objects of sexual desire. [...] Discipline, not disinhibition, characterised thirteen university youth, who appeared to have attained heights of sublimation during the revolutionary months.

On the surface, this narrative describes an incommensurability of sex and politics, but it is not a story of repression. Rather, it calls for a sublimation meant to maintain and even heighten the intensity of desire. Moreover, the sublimation of Eros into politics had dramatic effects. The revolutionaries begin to perceive things differently — transforming their love-objects into comrade-subjects, constructed around a collective libidinal impulse toward revolution. In other words, erotic intensity, combined with political action, subverted entrenched hierarchies of gender and class within the revolutionary movement itself, confusing the borders between conscious intellectual and spontaneous proletariat, as between masculine subject and feminine object.

Kollontai's famous call for a 'winged Eros' (as distinct from the 'wingless Eros' of mere physical gratification) is rooted in a similar desire to overcome sexual difference,

and it shows a clear debt to the writings of religious philosophers like Vladimir Solovyov. Kollontai, however, transforms the ideal of erotic celibacy into a vision of the 'love-collective' of the future, founded on solidarity, comradeship, and erotic openness to the other. Kollontai is careful not to indulge in predictions about the new society — 'What will be the nature of this transformed Eros? Not even the boldest fantasy is capable of providing the answer to this question'. However, the fundamental task of the proletariat and its party mentors is clear: To create a universal comradeship, beyond the fissures of sexual difference and their erotic expression under the binarist norms of bourgeois morality.

> The blind, all-embracing, demanding passions will weaken; the sense of property, the egotistical desire to bind the partner to one 'forever,' the complacency of the man and the self-renunciation of the woman will disappear. At the same time, the valuable aspects and elements of love will develop. Respect for the right of the other's personality will increase, and a mutual sensitivity will be learned; men and women will strive to express their love not only in kisses and embrace, but in joint creativity and activity.

Sublimating sex into politics, rejecting the wingless Eros that objectifies the other, Kollontai's winged Eros ultimately means taking direct, loving responsibility for the process of political subjectivisation.

The radical feminist movement in Russia today is striving toward similar goals. Mitrofanova opens her text with

a controversial item of 'fake news' that emerged from the radical feminist movement last year when a Photoshopped image of activists unfurling a slogan atop one of the Kremlin towers was included with the documentation of an 8 March 2017 protest action. The action did include actual penetration into the Kremlin grounds, albeit only those open to tourists, and the feminist activists even developed a new strategy for protest, sneaking the banners past security by wearing them as wraps and dresses. However, no one was interested in the realities of the action, only the leaders' manipulation of the truth and their decision not to inform either the rank and file participants in the action about the Photoshopped image or the brave press outlets that shared the documentation. As Mitrofanova notes, no one paid any attention to the slogan either.

But artists can also interpret the 8 March Photoshop scandal as a critique of earlier efforts to occupy the Kremlin and Red Square. Typically, Kremlin art actions have emphasised the weakness and flaccidity of power. In 1991, the first high-profile action saw Anatoly Osmolovsky and his ETI group (Expropriation of the Territory of Art) form the Russian swear word for 'cock' with their supine bodies on the Red Square, refusing to 'get up', when the police arrived. In 1995, Alexander Brener challenged Boris Yeltsin to a boxing match on Red Square in protest over the Chechen War, calling the president's masculinity into question. In the midst of the 2012 protests, Pussy Riot staged a guerrilla performance of the song 'Putin has pissed himself' on the Red Square, taking a similar line of attack against presidential potency. A year later, Petr Pavlensky nailed his scrotum to the Red

Square in fixation, lamenting the Russian people's passive acceptance of the authoritarian regime.

The radical feminists' Photoshopped image from 8 March 2017, by contrast, displays a triumphant seizure of the phallic site of power. Might we read the imprisonment of this victory in the virtuality of a faked image as a critique of Russian actionists' phallocentrism? Are artists and activists too obsessed with phallic models of power to recognise how such models reproduce the very hierarchical structures they hope to overthrow?

A number of young women artists are pursuing practices of public engagement that are much closer to Kollontai's ideal of sensitivity to the other. One of the best examples is Daria Serenko's *Quiet Picket* project, in which solitary activists carry handwritten signs into public spaces, presenting not slogans, but provocative quotations (often from poetry), damning statistics, and difficult questions, addressing a broad range of social and political issues, particularly ones related to gender and sexuality. The goal of the project is to elicit reactions and provoke conversations — at times thoughtful, at others aggressive — which are then documented in detail on social media. Instead of phallic occupation, *Quiet Picket* is about horizontal movement and connections — the movement of pens and markers that activists use to write the signs, often while riding the metro, the movement of a needle and thread (Serenko often sews two signs together), and the movement of the sign and the discourse it evokes across the city and social networks.

For the last year — also beginning on 8 March 2017 — Serenko has been collaborating with the theatre director

Vika Privalova on a play, *Quiet Revolution*, which is based on Kollontai's diaries. At the end of each performance, in lieu of applause, the audience is invited to make the transition from passive viewer to active citizen through a discussion of contemporary gender politics. Serenko moderates with her paper and markers, recording essential ideas and questions. Participants are also encouraged to make their own signs. As Mitrofanova insists, Russian feminism is not just an idea but a practice — the creation of new forms of communication that promote the active deconstruction of gender binaries, and the liberation of the winged Eros of political subjectivity. The association of *Quiet Picket* with Kollontai clearly shows how aware today's Russian feminists are of the great tradition in which they are working.

On International Women's Day, 8 March 2017, radical Russian feminists staged an action in the Kremlin, unfurling banners with the slogans, 'A Woman for President' and 'A Woman for Patriarch of Moscow'. To top it off, they published a photograph that showed activists holding a banner on one of the Kremlin towers. This one read: 'Feminism Is Our National Idea'. The slogan was pointedly scandalous and politically incorrect. It was a challenge, designed to provoke broad discussion in the media, and yet a strange thing happened. No one was interested in the statement; the only thing anyone talked about was the tower image's status as a fake. Both right- and left-wing activists stood up for the truth, decrying the use of Photoshop in the action's documentation. They should have climbed the tower, got sent to jail, sacrificed themselves... then it would have been true. What is the

connection between this blindness to the slogan's mean-
ing and the demand for sacrifice? The critics know exactly
what should be done, but they do not understand what is
written. One activist said you could just as easily hoist
the slogan, 'Fascism Is the Russian National Idea'. Yes, you
could, but a slogan asserts a specific meaning, demanding
critical examination, a discussion of its relevance, or at
least a consideration of its validity.

THE HISTORY OF FEMINISM IN RUSSIA
AS A CHALLENGE TO MODERNITY

Here I have rephrased the title Irina Yukina's well-known
monograph on the history of feminism in Russia. What
would it mean if we really did look at feminism as one of
the central ideas of twentieth-century Russian history?
Let's try it out and test the validity of the feminists' tower
slogan. It does not seem strange or aggressive to me at all.
Moreover, it is not difficult to find documentary evidence
for its claim. Although we more often hear that Russia is
a backward, patriarchal country, the testimony of history
allows us to draw the opposite conclusion.

Is it possible to say that there was a mass feminist
movement in Russia, and, if so, how was it organised?

There were a number of active feminist parties in Rus-
sia before 1917. The Russian Women's Society for Mutual
Charity, founded in 1894, was a mass, populist organisa-
tion only named in this peculiar way because political
parties were still banned. More parties emerged along
with the 1905 Revolution. Among these were the illegal
Union of Women for Equal Rights (1905) the Progressive

Women's Party (1906), a legal organisation of profession-
als, predominantly lawyers and doctors; and most sig-
nificantly, the All-Russian League for Women's Equality
(1907), a legal party with chapters in many cities (St Pe-
tersburg, Moscow, Kharkiv, Tomsk, etc.).

The 1917 Revolution began on 8 March (old style:
23 February) with feminist demonstrations and a women
workers' strike, demanding peace and equal rights. When
the feminist action grew into a general strike, the mon-
archy fell. The State Duma formed the Provisional Com-
mittee (later the Provisional Government) in the Tauride
Palace and the Petrograd Soviet of Workers' and Soldiers'
Deputies formed in the palace's left wing. Both of these
new governmental bodies decreed civil equality, but they
forgot to mention gender rights. On 19 March, forty thou-
sand women demonstrated at the palace organised by the
League for Equality. The legendary Vera Figner and the
League's leader, Poliksena Shishkina-Yavein, present-
ed their demands to the Duma representatives and the
Soviet deputies. Surrounded by demonstrators, the offi-
cials debated the question for several hours before accept-
ing full civil and political gender equality. Passive rights
to vote but not to hold office, limited by the eligibility
requirement of owning property, already existed in New
Zealand and Norway. In Finland, in part due to the influ-
ence of the Russian mass feminist movement during the
1905 Revolution, women received the right to hold office,
albeit with class-based restrictions.

So it was the Russian giant that first gave women full
political and civil rights. In other words, a gender revo-
lution had occurred. A new picture of the world emerged

with new political demands for the reinvention of society. *What did new civil and political equality mean for everyday life?* The abolition of gender binarism from political and symbolic life led to a rewriting of everyday life. The question of whether to continue the revolution or declare it complete was unequivocally decided in October 1917. The gender revolution expanded: in November there were decrees on marriage and divorce, the legalisation of illegitimate children, and the abolition of limits on education. Next came free obstetrics, legalised abortion, the liberation of women from kitchen slavery, and the opening of crèches and kindergartens.

Kollontai proposed the creation of women's sections in the Communist Party as a synthesis of juridical ideas taken from the All-Union Women's Congress (the first of which was held in St Petersburg in 1908) and the new constructivist sociology of Marxist-Machism, as propounded by influential Bolsheviks such as Aleksandr Bogdanov and Anatoly Lunacharsky. Kollontai created a horizontal network of women's sections and charged them with the tasks of defending women's rights, training women for government positions, and organising crèches and kindergartens. A new model of society was being invented, supporting gender equality with a complex web of institutions. This model was exported in one form or another to many different countries.

Did the change in gender normativity influence the understanding of the body and sexuality?

The changes in everyday life led to a sexual revolution in the 1920s. Sexual relations were no longer considered

'natural instincts', according to which a woman is the object of passion, devotion, or violence. The new situation of subjective equality was not simple; it required recognition of a partner's worth, mutual responsibility, dialogue, psychological, and intellectual equality, and, finally, compatible political views. There were scandals and provocations, as always. For example, in 1918, a fake decree on the communalisation of women appeared in the press, signed by the Uglich anarchist group. This document, which was in fact written by monarchist shopkeepers, made its way into the newspapers and was distributed in various White-Guardist leaflets. Although the situation was eventually cleared up, for a long time the 'Communalisation Decree' served as a reason to attack the new policies and accuse the revolution of debauchery, spawning an endless polemic, which included judicial inquiries and numerous stories, both happy and tragic.

In the end, the sexual revolution led to the creation of new norms for romantic partnerships. One hundred years later we are still reinventing these relations. As before, we lack sufficient ways to speak about sexual desire and sexual difference, about the new demands for responsibility, about the non-binary nature of gender, and the mutability of gender stereotypes.

Yes, Russia was undoubtedly a feminist country, with an experience ahead of its time. The triumph of gender equality, the torturous transition to a new form of everyday life, the experience of the sexual revolution of the 1920s, and a century of cultural work inventing responsible and diverse gender roles liberated from hidden hierarchies and obsessive phallocentrism.

Why is the rejection of sexual hierarchies and binary gender important?

In the eighteenth century, when class was more import-
ant than gender identity, female governance was still
possible. For example, Countess E. R. Dashkova was the
director of the Academy of Sciences in St Petersburg.
However, liberal law fixed individual rights on the basis
of private property and gender identity, which led to the
exclusion of women from public life, limiting them to
their 'natural roles': mother, lover, prostitute. The rigid
hierarchical binaries of nature/culture, private/public,
passive/active, governed/governing, emotion/rationality,
and female/male, all produce a form of thought that ex-
cludes any middle ground. But since this abstract form of
identification coercively reproduces binary gender hier-
archies, its repressiveness becomes a problem not only for
women but the ruling classes as well. The binary gender
model took hold because of its simplicity; it was inscribed
into the metaphysics of the foundational divide between
nature and reason. Those who ended up on the side of the
subject acquired the right to assert truths, while those on
the side of the object (women, children, foreigners, the
lower classes, etc.) were deprived of the right to speak.
At the same time, the truth did not require sophisticated
proofs; rather, it became the political privilege of power.
The coercive distinction between the positions of subject
and object was enforced by taboos, moralism, and strict
gender binarism. Sexual difference was reproduced as an
empirical confirmation of political inequality. Feminism
and class struggle thus ended up in the same camp as the

resistance movement. At the First Women's Congress in 1908, the speakers drew explicit links between everyday life, family law, and the fundamental structures of political power. This meant that changes in gender norms systematically affected civil law and political governance as well. By rejecting coercive binaries, we can promote the myriad forms of activity in which gender identification does not coincide with gender stereotypes. In turn, this requires the recreation of social institutions and everyday practices.

Even one hundred years later, our fluid reality is ridden with anxiety and deprived of all stable, foundational truths. However, any attempt to return to the simplicity and supposed self-evidence of 'natural law' not only reaffirms male gender privilege but also promotes the practice of political adventurism, the new populism. The latter, one might say, as a form of 'direct', uncritical understanding of reality, can only hold if it is propped up by a traditional, binary gender system. At the same time, rational decisions and new social institutions depend on the constant flux of behaviour stereotypes and adaptation to new conditions. The feminist monitoring of sexism and repressive speech, the struggle for legislation against domestic violence, and so on, are all systematically related to the development of civil institutions and laws. If we return to the slogan (not) in the Kremlin tower, we might suggest a slight correction: Feminism Is Our National Idea and Practice. Along with its history and, perhaps, even historical levels of solidarity with universal civil demands, Russian feminism is coming back.

CuratorLab: In your essay 'Gender and the New Man: Emancipation and the Russian Revolution', you reflect on the notion of 'a utopian weather machine', in a kind of poetic opening that introduces other sensibilities about the relation between gender and revolution.[1] You write about how bad (or good) weather influences the revolution, how 'temperature, cloudiness, and precipitation do play a certain role in politics and its history; politics is not only about shabby clothes but also about bad weather. This is true for revolutions too.' Are there connections to the weather as a non-human agent of change that participates in the event as well, as an affective milieu, as moods or dispositions folded into revolutionary temporality which can as a force be connected to the work of love? In the context of your essay and our research on Alexandra Kollontai, is there a relation between weather, gender, and revolution to which love can be added?

Bini Adamczak: Looking at Germany in particular, there are two connections to the question of weather. First, the weather is often bad. I have often thought that this might be of political importance. I first realised this when I was visiting my cousin who was living in Berlin at the time. I was maybe seventeen. My cousin was born in Berlin and had just organised a strike at his school. We were sitting together in the Autonomous Centre, and one of the students who had organised the strike told us, 'Well, now we

have to wait'. History teaches us that all good revolutions happen in bad weather, they happen in winter. That sentence stuck with me, and I kept thinking about whether it was true. It turns out that it is not.

And the second thing is, people say that nobody talks about the weather quite as much as the Germans. Why would this be? Because the weather is basically something that you cannot change, at least as an individual, and without, say, all the technological powers that exist. It's thus very easy to complain about the weather, constantly. It is said, for instance, that people from France who experience similar weather conditions don't complain so much about it, but rather about things such as politicians and political structures — things that can actually be changed. This is the constellation in which I start talking about the weather.

And there is a sexist discourse in Germany about *Klatschweiber*, a term designating gossiping women, who in the marketplace, let's say, talk a lot about unimportant things. They talk about the weather. This is a paradigm for things that are not considered important or political, but side contradictions. When we talk about gender relations, and economic relations, in the perspective of the Marxist tradition, the question of what the main contradiction is and what the side contradictions are is crucial. This is why I start with the weather.

CuratorLab: You refer to the February revolt of the textile workers, who peacefully marched through Petrograd on the eighth of March and induced the subsequent revolts. You criticise the grand monolithic narrative of the

October Revolution, saying: 'It is thus that we can understand the Bolshevik model of politics: namely, as an attempt to mute the polyphony of the revolution', which came out of dissent and a series of revolts. There is a gross contradiction in regard to how gender was represented if we compare the photograph of the textile workers' march published alongside your text with the archive images of the Red Army activists around Lenin. This seems especially visible in the political vacuum that followed the events which led to the self-organised Red Army to take over in its self-mandate to deal with civil chaos. I read somewhere that there were no women in the Red Army, but then I found archive pictures showing Soviet women with guns who were also part of the army. What makes the contrast in gender representation in the revolutionary archive imagery interesting, is that for the first time there were also massive protests by housewives against the war, not only women factory workers. You come from a Marxist tradition that brings the relation between gender and economics into politics. How do the struggles of the 1970s, constructed around wages against housework and the refusal of housework, relate to the industrialisation of housework on the backdrop of the rapid development of capitalism? Or to the communist futurist ideas of technology eventually replacing housework and reproductive work? Kollontai was a kind of futurist. She imagined a future based on the industrialisation of housework, which in the German tradition is highly criticised because this is the beginning of industrialisation, the way capitalism was inserted into everyday life, and how the production line was introduced.

Can you tell me more about your position regarding this idea of technology replacing reproductive labour? Technology has always been involved in building or supporting gender, be it in the subversive idea of the cyborg, the feminisation of social reproduction, the refusal of work, or in the revolts at the beginning of the revolution.

Bini Adamczak: It is important to see the similarities between the political situations of 1917 and 1968, and at the same time to take a closer look at how different the political situation is in 1917, be it in the February Uprising or in the October Revolution, and then in 1921, 1922, or 1927, and at the beginning of the 1930s. There is a huge shift in the way politics and gender, housework, and reproduction are seen. One of the important things that materialist feminists have stressed is that a critique of housework and a feminist movement come very much into existence, and become stronger, in moments of war. Why? Because in war, in a traditional patriarchal society, men will fight as soldiers, and while they fight at the front, it is the women who have to fulfil the productive work that they could not do as professionals before. The women who protested on 8 March, in the February Revolution, took to the streets not so much as houseworkers, but as wage labourers. They had become factory workers. At the same time, they continued to be responsible for the reproduction of children and the elderly. The economic revolution starts at the point where they demand civil or citizen rights. It is all about an economic crisis induced by war, and they say we have to stop war in order to get bread.

The Bolsheviks do not believe the gossip, or rumours, that there will be a revolution. Because all the rumours came from women. They were the ones standing in line waiting for bread. Which meant they had their ear to the voices of the street. They said there would be a revolution, but the Bolsheviks did not believe it and the revolution started anyway. From the moment it started, and now I switch to October, you could already see that the revolution, in the Bolshevik vocabulary at least, was indeed coded as masculine. You can very much see this in the theoretical representations of the so-called October Revolution, in the storming of the Winter Palace itself. As you said, there were women fighting in the military. But in this case, they were fighting in the military on the side of the February Revolution, on the side of the representative democracy of the liberals. There was a group of female soldiers defending the provisional government at the Winter Palace. As the Bolshevik fought this revolt against the October Revolution, they generated a lot of sexist rumours and discourses about the female soldiers who allegedly went hysterical at the moment the fighting began.

The truth is that it was mostly women who stayed at the Winter Palace, when most of the male soldiers had already left. And the female soldiers were not interested very much in defending the provisional government. On a symbolic level it became very clear in this situation that femininity was seen as counter-revolutionary, as part of the old regime, whereas masculinity was seen as progressive, as a revolutionary force. You can also see this in the leaders of this time. Lenin, on the one hand, was

part of the underground. In order not to be recognised, he dressed up as a wounded worker — you may have seen the pictures — and on the other side you had the provisional government. Rumour has it that when Alexander Kerensky fled, he dressed up as a woman, as a nurse. That's even more interesting. That's someone who clearly works in the realm of reproduction. Kerensky saw the need to dispel these rumours.

You can also see this symbolic division in the vocabulary of the October Revolution. The revolution is seen as masculine and counter-revolution as feminine. This is true not only of the cultural characterisation of gender, but of the economic core of gender, which brings us back to your question. In the Russian Revolution, housework, in-house reproductive work, is also seen as reactionary, capitalist, or feudalist. Whereas industrial work, technology, is seen as progressive and socialist. This is a perspective that changed in the coming years, especially in 1968, to today.

CuratorLab: You've been writing about gender as a social atmosphere. The revolution had one gender, and that was the male gender. It could potentially be changed, and there was an attempt to do that in 1968. But then there was a counter-revolution too. Since we are in this periodisation, I wanted to ask you, in relation to her writings, political ideas, and work, how do you see Kollontai's writing in relation to the switch of the gender? Is she rather going in the direction of abolishing gender, of genders becoming equal? Or does it change the paradigm from this masculine gender to a feminine gender? How do you

place her work within your research on the gender of the revolution?

Bini Adamczak: Kollontai is a very, very interesting subject. I think it's a very good idea to do research on her and build a seminar around her. Because you can discuss so many crucial questions in her person, both historical and of today. The first thing is that Kollontai never considered herself a feminist. In her time, feminism was seen as petit-bourgeois. So, she was fighting against the term *feminism*. Then again, from today's perspective she is in fact a feminist, fighting against patriarchy, against the prism of gender and sexual expectation. That being said, it is very interesting to see how her perspective — a feminism that was not acknowledged as such but was nevertheless a feminism — differs from what we today, after 1968 and queer feminism, call feminism. And one of the main differences is that in her texts, a critique of masculinity is almost completely absent. Imagine a feminist who does not criticise men, or masculinity, at all, but sees masculinity as an ideal, a norm, that should be reached by everybody. By this she means that everybody should be able to become like a man — or to become a man. This is not even a deconstructive projection. She said this explicitly. The new woman has become more like a man. And becoming like a man made her stronger, more emancipated, and more revolutionary. There are also different tones in Kollontai's writing. If you have read Kollontai's 'Letter to the Youths',[2] in this text she writes about the 'Winged Eros', and develops precisely a different critique. It's interesting, because here — even more than in her classical political activities

as leader of the Workers' Opposition, which can be very much criticised as I have done in recent works — she criticises exactly this discourse of the revolution and its idea of unity, conformity, and homogeneity. She says that in the coming society, communism cannot be developed only from the repertoire, atmosphere, knowledge, and resources of the male sphere. A revolution that only focuses on rationality, effectiveness, hardness, and toughness, will not be able to do what is most crucial for a communist society: to form bonds between the members of society. This is what she calls 'a transformed love'. What she does in this striking analysis, is look at how love comes into being through capitalism, how love changes throughout the course of history, and how it gets formed in communism. The idea is that love will not be something restricted to the relation between two persons. It is something that will define the relation between all members of a society. Kollontai calls this form of love *solidarity*, and there you have a completely different perspective on the revolution. It is a subtle but fundamental critique of the discourse of the revolution that argues that a revolution restricted to masculinity must fail. In this regard, her critique of the discourse of revolution is the most radical. Much more radical than her early writing which she did with the Workers' Opposition.

CuratorLab: This resonates very well with our own research on Kollontai. Of course, her idealisation of masculinity becomes somewhat problematic from today's perspective. It seems she forgets to criticise men in the revolution. Today, we also have to bring in the question of

post-colonialism and racism, which she has not addressed. You have done a periodisation of 1968 and the counter-revolution after that. Where do you find that she is picked up again, and on what questions? Is it regarding property relations, or the family structure? What is the result of reading Kollontai during the feminist movement, and how do you think Kollontai will be effective in a critical re-reading today?

Kollontai has a strong resonance in the Swedish context. She affected feminists in the 1960s and '70s. She was published there and was part of the feminist discourse whose history goes back to the 1960s and then was recently picked up again. How do you read her analysis of the 1960s?

Bini Adamczak: One of the reasons Kollontai is so important is her materialist perspective. This differs very much from the hegemony in queer feminist discourses that are at the same time more radical or clearer in their idea of how gender is constructed, how the construction of gender relates to the construction of sexuality, and how gender relations and gender itself as a concept can be overcome. Therefore, they articulate something that Kollontai implies, but cannot argue the way one would today, because her understanding of biology, or materiality, was not as radical as it is today. At the same time, in this process of radicalisation, which was very much informed by a shift towards cultural perspectives and linguistics, something is lost. What is lost is the focus on material conditions, on economic conditions, and how they are intertwined with gender relations. This is a very general observation and

we could say the same of feminists like Clara Zetkin, or materialist feminists from the 1960s and '70s. But then, there is something special about Kollontai, and that's precisely what you are discussing in the CuratorLab group, and that is the way in which she discusses love. It's a very particular perspective that differs very much from most Marxist approaches.

There are two main approaches in the materialist discussion of love. In one, love is seen as a resource, a moment of happiness, a utopian perspective that can be used in an anti-capitalist protest. The sphere of reproduction, of the family, of intimate relations colonialised by industrial capitalism, and is therefore seen within a strong anti-capitalist and post-capitalist realm. This perspective, which we find in Jürgen Habermas, Max Horkheimer, or maybe Alain Badiou, is very much criticised by a different group of materialists, namely, materialist feminists like the Bielefeld school, among them Maria Mies, or operaist feminists like Silvia Federici who argue that reproduction is not something outside of capitalism, but rather something that is completely within it and is misused to legitimise the fact that house labour, or housework, is not paid. Love is the payment given for this work, and as such is an ideology that tries to perpetuate exploitative relations. I think Kollontai has a third perspective. She very much focuses on the transformability of love. She asks how love will and can be transformed, and how these feelings seemingly caught in the private sphere are connected to the relations in the public sphere. And they are immediately connected. This is a very radical idea.

CuratorLab: Another question is, how do we deal with this transformation of love, Kollontai's comradely love, which from her historical perspective is a strong critique of bourgeois family relations, which in the 1960s and '70s are also explored through different forms of sexual relation. But then, there is a backlash. They are commodified and transformed into popular culture in the 1980s, and then in the 1990s and 2000s there is an explosion of technical devices and forms of sexuality that are hyper-commodified and hyper-mediated. How do we deal with the radical political potential of Kollontai's communal love, the different facets of it — sexual, but mainly comradely love as a motor in political transformations — amid the hyper-mediated sexuality and sexual relations that we have today?

Bini Adamczak: I think in discussing these issues and the critique of technology and gender, Kollontai will prove difficult. I think like most of the Marxists of her time, be it Vladimir Lenin or Leon Trotsky, she is not critical of technology, but very much sees it as a progressive force. Discussing how technology changed our relations, maybe for the worse, creating more alienation, would be difficult for Kollontai. But what Kollontai might answer is that technology is always embedded in a social structure of power, and that it may be more useful not to focus on the technology itself, which Kollontai might see as progressive in itself, but rather on the power relations. Then she would say that she wasn't surprised at how the progressive efforts of the sexual revolution of 1968 turned out to be co-opted by the counterrevolutionary moment. She

would say, I reckon, that you cannot have a sexual revolution in the sphere of sexuality. You cannot have a gender revolution in the sphere of gender relations. These things can only be changed if the relation between gender and the economy, between sexuality and material relations, are changed too. So, she would say that it's no surprise that capitalism co-opts these practices. Of course, it will. As long as capitalism exists, as long as its economic relations exist, you cannot have a completely different way of living your sexuality. Some change is possible, which we have to fight for. But as long as the economic relations remain mostly the same, everything you do in these fields will be transformed by this and co-opted. This is something she has always seen very clearly.

CuratorLab: In this context I wanted to ask you about the sexual revolution, which brought 'the struggles from the struggle' and raised economic demands to change gender relations — where Kollontai demanded free love. You said now that we have to imagine the end of capitalism, also in economic terms. We can think also of Michel Foucault, or Julie Graham and Katherine Gibson, who wrote *The End of Capitalism (As We Knew It): A Feminist Critique of Political Economy* under the pen name of J. K. Gibson-Graham. To what extent can free love be not only the stake of political and social transformations, but an actual force or currency for an economic transformation that would not be a masculine revolution? How can free love be the fuel, or the undercurrent, of this new space of undercommoning, of an other-economy based on sharing and care, rather than on exchange and profit in the context of a queer feminist

utopia? Is there a potentiality that free love also brings in a critique of the political economy?

Bini Adamczak: In 1968, or following from 1968, the idea occurred and became stronger that a new revolutionary movement could have its starting point in the politicisation of love. The concept of free love was taken from theorists like Kollontai and brought into the political and economic discourse with the hope that it could work as a starting point for a stronger revolution. Also, theorists like Wilhelm Reich argued that setting love free would bring capitalism to an end. They argued that the capitalist regime is based on the repression of sexuality, of love, of desire, of lust, and only by this repression can a disciplined worker exist. As soon as you would let go of the disciplining of your body and free your sexuality, you would no longer be able to work as a soldier or as a worker. Of course, today we see that this hope was not realised, that these expectations did not become true. Capitalism proved to be a much more flexible system not only based on production, productivity, and efficiency, but also capable of taking its energy from the sphere of consumption. The freeing of sexuality became at the same time a force to make the sphere of consumption even stronger, creating a much different and stronger demand for new commodities that helped to get capitalism out of the crisis it was in during the 1970s. Instead of getting rid of capitalism altogether, it just changed the mode of reproduction, or the mode of accumulation, from a Fordist regime based on productivity, earning, and saving money, to a post-Fordist economy not based on spending money. To answer your question, if free

love is to become the starting point or currency, as you call it, of a revolutionary moment, it always has to be seen as intrinsically connected to different fields. These sentences by Kollontai, which she repeated, are very, very strong. When she says that the need to take refuge in marriage will disappear as soon as the economic and reproductive relationship between the members of the community becomes based on solidarity, this would really be the realisation of free love. Not just what happens in bedrooms or in the private sphere, but how we exchange our abilities to reproduce each other. The fact that I work for you and you work for me is a relationship that can be based on love — the love for each other as an ability to live together.

CuratorLab: Kollontai was a very active and well-informed politician when it came to social reform in the first Soviet government. One of the most inspiring aspects of Kollontai, I think, is how we can read her as someone who gives us a key to social reproduction, and the formation of infrastructures of care as a form of political practice. But there is one issue on which I would like to understand your position. If we take critical reflections on 'left melancholia', and love, as one part of the spectrum whose primary objective is to form the party, and Antonio Negri and Michael Hardt as another pole of the political dimensions of love, where would you start? Is it the party of free love? Or is it a self-organised free love practice that we need to create?

CuratorLab: And what about the *Army of Love*? I am referring to Franco 'Bifo' Berardi's call in collaboration with Geert Lovink.[3]

Bini Adamczak: The starting point for many of my texts, and especially my inquiries into the history of the Russian Revolution and the idea and discourse around communism, is a time that has been termed 'the end of history' by Francis Fukuyama. He was not so wrong with his ideology, because the end of history was not just some lie capitalists used to tell but was also an atmosphere that was palpable all over the world, with the exception of Latin America, as the feeling that you yourself had no impact on the course of history — that liberal democracy and the market economy would be the last word of history. Then, this end of history itself came to an end with the economic crisis of 2007 and 2008, and its political articulation in the Arab Spring in 2011 and the following revolutions, or revolts, of the Occupy movement. The Occupy movement was very strong in its radicality, with its perspective and focus on democracy, and the self-organisation of many people that proved that politicisation without a party and leadership is possible. But then you could see that these movements that started with big assemblies and self-organisation very quickly started to form parties. First Syriza in Greece, and then Podemos in Spain. And these parties very quickly became similar to parties we had seen before. Then all of a sudden, whereas the Occupy movement was very feminist, open to questions of reproduction, and against any form of representation, these two parties ended up having leaders that were all these male figures that we have seen so often in the course of history. I think that in this transformation, something important was lost. The important thing that was lost was exactly the focus on relations between each

other. The moment people occupy a public square, they realise that the question of infrastructure, how we reproduce each other, where we get food from, who takes care of the injured and the traumatised, and also who cleans the space afterwards, are not questions that can be seen as side questions, but they are critical. When thinking about trying to form a party again, these questions of how we relate to each other, the question of making a movement more stable, must remain crucial to the discussion.

CuratorLab: If you look at these recent developments, the party failed Kollontai, so that would sort of rule out the party as a structure, but if you take Negri and Hardt's proposals in their recent book *Assembly,*[4] you could use the party as an empty form, perhaps with free love as the actual leading principle. We remember the first movements in the 2000s that did not manage to become constitutive power. We need some sort of organisation. But maybe we should not repeat history and re-create the patriarchal party in its old form. How do we create leadership within self-organisation? Is it comradely love? Is it the production of infrastructure and self-care? I think it's an interesting parallel.

Bini Adamczak: For me, the question of leadership is not so crucial. I have difficulties understanding why Negri and Hardt focus so much on that question. As you put out the idea of free love as a concept that could organise a movement, something I think is important in this debate is that there already was a cultural movement, but also a political movement, that tried to put love at the centre of

politics and the creation of community. This movement is called Christianity. Christianity teaches that loving your neighbour is the principle on which a community of believers could be created. This idea, from the history of the church, has proven to be problematic. Daniel Loick, a philosopher, recently wrote a book on the judicial, a critique of judiciality.[5] He criticises the judicial context very harshly. But at the same time, he emphasises that every critique of the system of justice, of judiciality, has to be a critique of the critique of judiciality. Here he talks about Hegel. Hegel criticises the concept of law as being extrinsic. He is looking for an intrinsic motivation for ethical behaviour instead of a law. And what would this intrinsic motivation be? His answer is love. The interesting and problematic point here, which I would like to raise in this discussion, is that the text is deeply anti-Semitic. Loick points out that this anti-Semitism is not a coincidence. It will always occur when we try to place love in its Christian sense at the centre of the community. As you can see in Hegel, but also in Shakespeare, in *The Merchant of Venice*, the moment you want to create a community around love, you have to deal with the fact that it cannot be ordered but is something that has to be given freely. As soon as somebody misbehaves, it becomes more difficult to say you just did not abide by that law, you did not give the love that we demanded in the community, you do not love us, and that therefore we must expel you from the circle of what we consider to be the community, or even human. This is where Loick says that anti-Semitism — the expelling of those who do not follow our laws as the enemy, as the Other and the Jew — comes in naturally.

This is something we need to keep in mind when we discuss the question of how love can be applied to political struggles.

CuratorLab: Concurrently, Julia Kristeva makes an interesting connection between the Greco-Christian concept of love as Agape and the homosexual Eros that should be understood not as a masculine Eros, but as a multiple gender or rather feminine libido.[6] This is distinct from the androgynous, which is symmetrical between masculinity and femininity and is not interesting for her. She builds on the idea of Agape to invent other passions, sexuality, and love that break with phallic power. For her, Agape is really a transformation to Eratos evolving new heretic powers. Kristeva is somehow reserved towards Spinoza's concept of love, which is so important to Negri and Hardt, exemplified in the famous quote by Negri where he says that, between knowledge and power, only love can remain and bridge between them.[7] Going back to Kristeva, her critical points to the ethical subject based on love in Spinoza are driven by the argument that he completely ignores women and femininity, who remain excluded from his concept of multitude too. We can read everything as anti-Semitic, on the background of the history of the church as a social and political state formation, from Thomas of Aquinas to other subtle or fundamental changes in how concepts of love have been imbedded into the theologico-philosophical western paradigm and Christianity.

Can you tell us more about Hegel in this context and his effort to change this paradigm? Hegel is so important for

Judith Butler, who wrote about him in the *Book of Books*.[8] Slavoj Žižek also tries to defend Hegel and his concept of love as completely revolutionary, being against the idea of the marriage contract, and developing so many completely new ideas about love.[9]

Bini Adamczak: I think the argument made by Loick, which is very striking in regard to Kollontai, is on a more general level. It is not about the church having an anti-Semitic history. It is the question of what happens if we put the principle of love at the centre of our imagined re-organisation of society. We can say, the basic principle of relations between members of capitalist society is indifference. It is private production — I don't care what you do and you don't care what I do — and at the same time we are competitors. We fight against each other, and this is the engine that makes capitalism create. The question is how we can imagine putting collaboration and solidarity in the place of indifference and competition. Do we imagine it as putting love in the place of indifference, competition, law? This is where we have to ask those critical questions. What expectations come into place? How do we imagine a society of lovers? And how do we deal with the grief of lovers? How do we bring into the picture the struggle again? Let's not paint the future in colours that are too harmonious. Where is the struggle and where is the place of this struggle? If you forget to have a place for dissent, the effect will be cruel. There must be a possibility to articulate dissent. This is why I am sceptical of the idea of putting love exactly at the place of our economic relations, where we now find indifference and competition.

I think that solidarity is a somewhat broader context that is more open to difference and dissent. I prefer the term of solidarity.

1 Bini Adamczak, 'Gender and the New Man: Emancipation and theRussian Revolution?,' *Platypus Review* 62 (December–January 2013) <https://platypus1917.org/2013/12/01/gender-and-the-new -man/> [accessed 2018-04-19]

2 Alexandra Kollontai, 'Make Way for Winged Eros: A Letter to Working Youth', in *Selected Writings*, ed. Alix Holt (New York: Norton, 1980/1977), pp. 276–292.

3 Franco Berardi and Geert Lovink, 'A Call to the Army of Love and to the Army of Software', *net critique* blog, 12 October 2011 <http://networkcultures.org/geert/2011/10/12/franco-berardi -geert-lovink-a-call-to-the-army-of-love-and-to-the-army-of -software/> [accessed 19 April 2018]

4 Michael Hardt and Antonio Negri, *Assembly* (Oxford: Oxford University Press, 2017).

5 Daniel Loick, *Juridismus: Konturen einer kritischen Theorie des Rechts* (Berlin: Suhrkamp, 2017).

6 Julia Kristeva, *Tales of Love*, trans. by Leon S. Roudiez (New York: Columbia University Press, 1987 (1983)).

7 Antonio Negri, 'Appendix Two: Archeological Letter. October 1984, Antonio Negri', in Félix Guattari and Antonio Negri, *New Lines of Alliance, New Spaces of Liberty*, trans. by Michael Ryan, Jared Becker, Arianna Bove, and Noe Le Blanc (Autonomedia, 2010/1990 (1985)), p. 142.

8 Judith Butler, 'To Sense What Is Living in the Other: Hegel's Early Love,' in *The Book of Books / 100 Notes — 100 Thoughts*, no. 066 (Kassel: Hatje Cantz and Manifesta 13, 2012), pp. 415–21.

9 Slavoj Žižek, *Less than Nothing: Hegel and the Shadow of Dialectical Materialism* (London: Verso, 2012).

COMRADELY LOVE AS CONTEMPORARY STRATEGY:
FEMINISM, MEN & WOMEN,
FRIENDSHIP AND POLITICAL ORGANISING
NINA POWER

How do we learn to live, love, and organise together? In a world in which divisions between men and women appear greater than ever and misunderstandings are rife even among those supposed to already have a shared political understanding, it is useful and perhaps even necessary to revisit some of Alexandra Kollontai's ideas regarding comradeship and love in order to put our thoughts regarding politics and passion in some sort of hopeful order. What, in the first place, do we mean by 'comrade' today? Is it merely a bygone relic of a way of being together more-or-less completely absent in today's world? An ironic gesture towards a kind of solidarity between humanity that can only be spoken about today in a knowing or even sneering tone? I want to revisit the various ways in which Kollontai used the term 'comrade' in a variety of her texts and speeches to ultimately suggest that we would do well to resurrect the term in at least the following three important ways: 1) to understand the reality and possibility of contemporary relations between men and women by looking back to Kollontai's reflections on the topic; 2) to think about the politics of friendship and comradeship more generally and; 3) to reflect on the challenges, patience, generosity, and kindness necessary for political organising under the violence, antagonism, opposition, and alienation of contemporary capitalism.

1
COMRADESHIP. RELATIONS BETWEEN
THE SEXES. FEMINISM. CLASS.
1909—23

Kollontai's claims regarding comradeship between 1909 and 1923 frequently invoke the term in a variety of similar but slightly different ways. In the 1909 *The Social Basis of the Woman Question*, she begins by opposing a proletarian image of comradeship with the supposedly oppositional attitude of 'feminists':

> Proletarian women have a different attitude [than feminists]. They do not see men as the enemy and the oppressor; on the contrary, they think of men as their comrades, who share with them the drudgery of the daily round and fight with them for a better future. The woman and her male comrade are enslaved by the same social conditions; the same hated chains of capitalism oppress their will and deprive them of the joys and charms of life.[1]

Here, comradeship arises as a result of the shared exploitation of men and women under the same social conditions. Already, though, we can see hints of the 'joy and charms' that Kollontai will come to invoke more and more in later writings, which tend increasingly to focus on a positive, practical, but also mildly utopian, image of comradeship. In this early text, though, Kollontai's main interlocutor is the 'bourgeois' feminist who pushes for political equality without simultaneously calling for the dismantling of the

class system as such. Here it is clear that for Kollontai class solidarity trumps sex. It is important to note that more than a hundred years later we still have not yet really moved beyond some of these debates. While today's liberal feminism calls for sexual equality, today's capitalist and corporate feminism calls for what Kollontai describes in this text as 'access to the professions'. Radical feminism sometimes emphasises the historical dominance of patriarchy over its more specific forms under capitalist relations. It is socialist and Marxist feminism, often squeezed now as much as then between the more dominant forms of feminism, that attempts to seriously think through the material reality of sex and class.

In 1917, one senses a certain combined hope and frustration in Kollontai's image of solidarity between the sexes. Here she suggests that:

> It is time that working women began to exhibit self-activity; it is time they began to take a real part in trade-union affairs. Questions of equal pay for equal work is near and dear to the working woman, and if this issue is taken up it should prove possible to show that the patience and passivity of centuries is being overcome by the new woman who is coming into being within the working class — the woman-comrade who is a fighter for the general workers' cause and for the idea of the bright future.[2]

Here the idea of the 'woman-comrade' or 'new woman' comes into her own: the woman who organises herself and her comrades, who demands equal pay for equal work,

who fights for all workers and for the 'bright future'. Here the proletarian 'woman-comrade' is less in enmity and opposition to bourgeois feminism and middle-class feminists, but rather comes into being from 'within' the working class, against the 'patience and passivity of centuries'. Kollontai's use of 'patience and passivity' here is interesting, invoking as it does both the historical enforced acquiescence of the pre-self-active, pre-new woman as well as the female socialisation that would result in a kind of 'patience' as waiting.

Kollontai produced an enormous amount of writing and lectures between 1920 and 1923, and discussion of the relations between men and women as comrades features heavily. Nevertheless, as with the 1917 text, Kollontai's particular focus unsurprisingly tends towards reflections on women's situation *within* the proletariat, as well as continued battle with the notion of 'equal rights' pushed by the feminists. For example, on the latter point, in 1920 she writes the following:

> For the feminists, the battle to obtain equal rights with men within the limits of the capitalist world is a sufficient aim in itself; for the women of the proletariat this is only a means of extending the struggle against the economic oppression of the working class. The feminists consider that men, who have unjustly taken all the rights and privileges for themselves and left women in prisoners' chains and with a thousand obligations, are the main enemy, and that victory will be the abandonment by the male sex of their exclusive prerogatives.[3]

On the other hand, proletarian women do not begin from the standpoint of patriarchal oppression, but rather capitalist domination:

> The women of the proletariat see the situation very differently. They certainly do not see men as the enemy or the oppressor. For them, the men of the working class are comrades who share the same joyless existence, they are loyal fighters in the struggle for a better future. The same social conditions oppress both the women and their male comrades, the same chains of capitalism weigh on them and darken their lives. It is true that certain specificities of the contemporary situation create a double burden for women, and the conditions of hired labour sometimes mean that the working woman is seen as the enemy rather than the friend of men. The working class, though, understands the situation.[4]

Here, Kollontai's stance on both feminism and women's position in the working class is quite similar to the claims made in 1909. We have the same shared 'joyless existence', the same hope of a 'better future' through struggle, the same social conditions. Against the feminists' desire for rights and privileges, there is the communist feminist fight on equal terms with men, a rather different idea of equality than the feminists Kollontai positions herself against (whether Kollontai is fair to the feminists she criticises here is an open question). Nevertheless, moments of complexity sneak in — women, 'it is true' suffer a double burden — one imagines both waged labour and domestic/child-rearing, though Kollontai does not here note the

'specificities'. Furthermore, Kollontai clearly notes that women's mass entry into the workforce can generate resentment amongst men, whereby women are seen not as comrades but as enemies.

Similarly, in another text from 1920, Kollontai notes that historically there has been resistance to 'special agitation' and propaganda among women, and that women self-organising in this way were not supported by the party, and indeed other comrades confused these activities and the demands and actions of the communist feminists with the 'hated feminists' and actively tried to hinder and sabotage such activity.

An attempt to begin special agitation and propaganda amongst working women was, however, met by some members with indifference and by others with distrust. During 1906 and 1907 the party centre was engrossed in its serious and urgent political tasks, and although in principle it recognised the usefulness of this kind of work, it did nothing to help or support the work of the group. The rank-and-file comrades often did not grasp the meaning of what we were doing, and identified our activities with the 'hated feminism'. They gave no encouragement and even went as far as trying to hinder the group. Working women arranging their first meetings, for example, and relying on using the rooms where evening classes were held or where some union or club had its headquarters, would find that the building was locked up, and on making enquiries would be told that the rooms were not to be had for special women's meetings.[5]

One gets the impression that Kollontai's hopes are positioned rather precariously on the assumption that her male comrades will both understand the differences between the competing visions of feminism and be supportive of women's self-organising. Certainly her work from this year speaks of a genuine enthusiasm and recognition of the liberating aspects of political work and rebellion:

> At a time of unrest and strike action the proletarian woman, downtrodden, timid and without rights, suddenly grows and learns to stand tall and straight. The self-centred, narrow-minded and politically backward 'female' becomes an equal, a fighter and a comrade. This transformation is unconscious and spontaneous, but it is important and significant because it reveals the way in which participation in the workers' movement brings the woman worker towards her liberation, not only as the seller of her labour power but also as a woman, a wife, a mother and a housekeeper.[6]

Women in this sense develop in strikes and other political actions a kind of double-consciousness to match their double burden. Female socialisation, geared towards creating 'self-centred, narrow-minded and politically backwards' beings, gives way to a true female equality and emancipation, predicated on strength and confrontation. Here we also have the first inklings of the development of Kollontai's ideas about the psyche — this political transformation is 'unconscious and spontaneous' — but is no less important for having taken place 'on the inside', as it were. As we shall see, the psyche becomes even more

central in Kollontai's understanding of comradeship and relationships, from 1920–1923 in particular.

2.
LOVE. HAPPINESS.
PSYCHIC PROGRESS

Against the backdrop of ideological and political antagonisms between various strands of feminism and depressingly regressive elements of male comrades' behaviour, Kollontai begins to develop a complex analysis of the limitations (and solutions to) the 'contemporary psyche'. As a careful reader of Nietzsche in particular, this should perhaps not surprise us, yet the communist ends to which she turns her analysis are of course rather different than Nietzsche's much bleaker genealogical investigations. Kollontai thus precedes the later French turn towards left Nietzscheism that we see in Deleuze, Foucault and others several decades later. In 1921, she writes the following, extremely insightful, text:

> The three basic circumstances distorting the modern psyche — extreme egoism, the idea that married partners possess each other, and the acceptance of the inequality of the sexes in terms of physical and emotional experience — must be faced if the sexual problem is to be settled. People will find the 'magic key' with which they can break out of their situation only when their psyche has a sufficient store of 'feelings of consideration' when their ability to love is greater, when the idea of freedom in personal relationships becomes fact,

and when the principle of 'comradeship' triumphs over the traditional idea of 'inequality' and submission. The sexual problems cannot be solved without this radical re-education of our psyche.[7]

Again, Kollontai's insights are framed in relation to relations, as it were — the relation between oneself and oneself (the 'extreme egoism' inculcated by capitalism that we are all extremely familiar with today), the model of property relations reproduced by bourgeois marriage and, perhaps most interestingly of all, the problem of the inequality of the sexes *as it is played out in psychic life* ('physical and emotional experience'). The 'sexual problem' is in a sense, all of these elements at once — selfishness, possessiveness, and inequality. Kollontai's image of the 'magic key' has a hallucinogenic, emotional, mind-expanding quality. One imagines she would have been very much in favour of later twentieth-century MDMA therapy for both couples and groups — and it is worth dwelling on these 'feelings of consideration', which seem sadly lacking in many political and personal contexts today. How *can* we live and work together in the spirit of openness when so many of our emotions are still enmeshed in capitalist ways of thinking, even, *or especially,* when we believe we have broken with them? How many groups and friendships have been destroyed by pettiness, denunciations, bullying, narcissism, etc.? How can we radically 're-educate' our psyche in the wake of so much damage?

One of the major problems we seem to experience in political organising today is an inability to cope in the wake of political defeat. All the comradeship, love, expanded

political horizons, and empathy seems to dry up and re-treat into suspicion, attacking and turning against one another. We re-internalise inequality and submission/domination as if they were natural facts and not modes of capitalist psychic life that we all must negotiate if we are not to succumb to them. Kollontai's brief comments here point to the renewed possibility of a communism of feeling, a communist psychoanalysis, but also a way of thinking through capitalism as the root cause of certain kinds of social and mental distress, such as we see in the work of the late Mark Fisher and many of the thinkers in the anti-psychiatry (anti-)tradition. Kollontai understand-ably does not dwell at length on the negative aspects, but rather pushes forward to an image of a new union of affection and comradeship, a true vision of a world un-locked by the 'magic key':

In place of the old relationship between men and wom-en, a new one is developing: a union of affection and comradeship, a union of equal members of communist society, both of them free, both of them independent and both of them workers. No more domestic bondage for women. No more inequality within the family. No need for women to fear being left without support and with children to bring up. The woman in communist society no longer depends upon her husband but on her work. It is not in her husband but in her capacity for work that she will find support. She need have no anxiety about her children. The workers' state will as-sume responsibility for them.[8]

While Kollontai may appear overly utopian here, you cannot fault her visionary zeal. Kollontai recognises that it is not enough to criticise what is hated in the present, one must move towards an entirely new arrangement in which new forms abolish and also replace old ones: unequal relations between men and women are replaced by free, independent, working comrades; the family will be replaced by state care; women will be liberated by work and no longer dependent on their husbands for either romantic or economic support.

Furthermore, marriage will be transformed, although not perhaps completely abolished:

> Marriage will lose all the elements of material calculation, which cripple family life. Marriage will be a union of two persons who love and trust each other. Such a union promises to the working men and women who understand themselves and the world around them the most complete happiness and the maximum satisfaction. Instead of the conjugal slavery of the past, communist society offers women and men a free union, which is strong in the comradeship that inspired it.[9]

Not only will the state take care of children, collectively, but also the very notion of the family will become expanded and thus exploded into a gigantic, universal, hopefully international, confederation of worker-comrades:

> In place of the individual and egoistic family, a great universal family of workers develops, in which all the workers, men and women, above all will be comrades.

This is what relations between men and women in the Communist society will be like. These new relations ensure for humanity all the joys of a love unknown in the commercial society of capitalism, a love that is free and based on the true social equality of happy young people, free in their feelings and affections.[10]

Let us also hope that older people will be happy too! It is in Kollontai's fiction that she explores these new possibilities. In 1923, in a short story, 'Sisters' she writes the following:

They laughed together and it seemed that nothing could destroy the feelings they had for each other. They weren't just a husband and wife, they were comrades. They faced life hand-in-hand; they shared the same aims. They were engrossed in their work and not in themselves. And (it) suited their child; she grew up a healthy little girl.[11]

Kollontai's proposals have both a macro and a micro aspect — both personal and political. In this sense, despite, or perhaps because of her battles with bourgeois 'equality' feminism, Kollontai predates the second wave feminist turn towards thinking politically and personally all the way down. Her emphasis on the psyche attempts to historicise and politicise negative emotions such as jealousy, and to make them symptoms of the capitalist structure. Unlike other thinkers of the family, most notably Freud, there are no eternal or semi-eternal 'truths' to be discovered regarding the development of psychic life — abolish

capitalism and you will abolish all forms of negative feeling and relating, Kollontai suggests. We might wonder whether communism would truly eradicate feelings of possession, envy, resentment, excessive love, etc., but we have to admit that Kollontai's image at least presents this as a possibility and allows us to imagine a way out of the extreme alienation, anxious inner life, competition, and misery of contemporary life under capitalism. As Kollontai puts it in 1921:

A jealous and proprietary attitude to the person loved must be replaced by a comradely understanding of the other and an acceptance of his or her freedom. Jealousy is a destructive force of which communist morality cannot approve. [...] The bonds between the members of the collective must be strengthened. The encouragement of the intellectual and political interests of the younger generation assists the development of healthy and bright emotions in love.[12]

On the equality point, we should note that it is not that there is no theory of equality in Kollontai, simply that her notion of equality is completely counter to the 'equality' that women might demand under an unequal system. In 'Make Way for Winged Eros: A Letter to Working Youth' from 1923, Kollontai promotes the following ideas:

1. Equality in relationships (an end to masculine egoism and the slavish suppression of the female personality).
2. Mutual recognition of the rights of the other, of the fact that one does not own the heart and soul of the other

(the sense of property, encouraged by bourgeois culture).
3. Comradely sensitivity, the ability to listen and un-
derstand the inner workings of the loved person (bour-
geois culture demanded this only from the woman).[13]

Here Kollontai proposes a radical, multi-level communist
equality. Rather than formal, representational, economic
equality that feminism might push for under capitalism,
Kollontai proposes a total reformulation of female and
male socialisation, such that 'active' and 'passive' modes of
being are no longer gendered 'male' and 'female'. The com-
munist abolition of private property becomes translated
in the language of love into the elimination of treating
the other as a possession, and furthermore, there is a way
of completely rethinking 'comradely sensitivity', what we
might call emotional labour today — the role that wom-
en have typically played. The new woman demands an
entirely new man. In a sense, Kollontai demands more
changes from men than she does from women — com-
munism has already created the new woman, all that is
needed is for men to 'catch up'.

KOLLONTAI AND THE
CONTEMPORARY SCENE

How might we apply Kollontai's insights regarding the re-
lation between men and women, her notion of comrade-
ship, her theories of the psyche and of love to contempo-
rary thinking and organising? It is depressing to note that
little of Kollontai's thinking appears to have transpired
in practice over the course of the century between her

writings and today. We might baulk a little at Kollontai's more strident pronouncements and note the tension between the imperative tone of some of her work and the models of freedom it defends. We would certainly have pause over some of the references to 'health' and 'illness' in relation to procreation, backing-off from some of the eugenicist elements of her work in the 1920s (though she is hardly alone on the left in promoting the 'health' of 'the race' during this period). We might pause at the image of a 'proletarian morality', such as she describes in the following text:

> The idea that some members are unequal and must submit to other members of one and the same class is in contradiction with the basic proletarian principle of comradeship. This principle of comradeship is basic to the ideology of the working class. It colours and determines the whole developing proletarian morality, a morality which helps to re-educate the personality of man, allowing him to be capable of positive feeling, capable of freedom instead of being bound by a sense of property, capable of comradeship rather than inequality and submission.[14]

Nevertheless, we might do well in fact to resurrect notions of 'morality' today, if by that we mean working, acting, feeling, and behaving together in such a way as to promote comradeship, positive feeling, equality, and freedom — qualities all too lacking when we are constantly on the back-foot, policing one another and tearing each other apart, rather than challenging *both* the structures

that oppress everyone and the ways in which we organise the day-to-day. It is the more insightful aspects of twentieth and twenty-first century feminism that take up the difficulties and complexities of political organising with 'positive feeling' in mind and we can note the projects of Hochschild on emotional labour, Freeman on the 'tyranny of structurelessness', and Federici on 'the commons' as key critical interventions into debates regarding how feeling, emotion, and love are both co-opted by capitalism but also form a bastion of resistance against it. Foregrounding questions of 'care' in the widest sense, as social reproduction feminism does, strikes at the heart of capitalist life — all the work which is mystified under contemporary capitalist relations, but which comprises the heart of the system. We do not look after each other or ourselves enough, and yet we must.

How are we to aim today at the 'love-comradeship' that Kollontai discusses in her later texts? Her image here is a fully integrated one, encompassing interests, love, emotions, feelings, education, encouragement, compassion, action, support, and consciousness. It is the very opposite of the negative emotions driven into our hearts by the impasses and inhuman structures of contemporary life:

> Love-comradeship: The new, communist society is being built on the principle of comradeship and solidarity. Solidarity is not only an awareness of common interests; it depends also on the intellectual and emotional ties linking the members of the collective. For a social system to be built on solidarity and co-operation it is essential that people should be capable of love and

warm emotions. The proletarian ideology, therefore, attempts to educate and encourage every member of the working class to be capable of responding to the distress and needs of other members of the class, of a sensitive understanding of others and a penetrating consciousness of the individual's relationship to the collective. All these 'warm emotions' — sensitivity, compassion, sympathy and responsiveness — derive from one source: they are aspects of love, not in the narrow, sexual sense but in the broad meaning of the word. Love is an emotion that unites and is consequently of an organising character.[15]

We must rethink comradeship, solidarity, friendship, and love in the broadest possible sense today. These dimensions of collective life are not mere addenda — private matters, frivolous — but rather, as Kollontai puts it, 'Love is an emotion that unites and is consequently of an organising character'. We *need* love and comradeship in order to organise. We must be able to forgive each other and ourselves, to support each other in times of need, to struggle as much as we can against all that which alienates and divides us. We are all capable of harm, and we are all damaged, and yet we are all still capable of great love, support, and forgiveness despite everything. What if we thought of ourselves as comrades before anything else? What would a world of 'bright emotions' and 'love-comradeship' look like? Can we get there in time?

1 Alexandra Kollontai, 'The Social Basis of the Woman Question', in *Selected Writings*, trans. and ed. by Alix Holt (London: Allison & Busby, 1977), p. 60.

2 Kollontai, 'A Serious Gap', in *Selected Writings*, p. 126.

3 Kollontai, 'Towards a History of the Working Women's Movement in Russia', in *Selected Writings*, pp. 51–52.

4 Ibid., pp. 51–52.

5 Ibid., p. 53.

6 Kollontai, 'Towards a History of the Working Women's Movement in Russia', in *Selected Writings*, p. 40.

7 Kollontai, 'Sexual Relations and the Class Struggle', in *Selected Writings*, p. 245.

8 Kollontai, 'Communism and the Family', in *Selected Writings*, pp. 258–59.

9 Ibid., pp. 258–59.

10 Ibid., 259.

11 Kollontai, 'Sisters', in *Selected Writings*, p. 217.

12 Kollontai, 'Theses on Communist Morality in the Sphere of Marital Relations', in *Selected Writings*, p. 231.

13 Kollontai, 'Make Way for Winged Eros: A Letter to Working Youth', in *Selected Writings*, p. 291.

14 Kollontai, 'Sexual Relations and the Class Struggle', in *Selected Writings*, pp. 248–49.

15 Kollontai, 'Make Way for Winged Eros: A Letter to Working Youth', in *Selected Writings*, p. 285.

NEW GOSPEL: SOON (IN 48 YEARS' TIME)
ALICJA ROGALSKA AND
MARTYNA NOWICKA-WOJNOWSKA

When one is hungry, they are given something to eat. When one is thirsty, they are given something to drink. When one is a stranger, they are invited in. When one needs clothes, they are clothed. When one is sick, they are looked after.

As our prophetesses foretold long ago, we no longer have possessive pronouns, nor do we have binary gender, class or racial terms. Our language reflects the new society in all its complexity and forms of relations, without reductive polarities. There are no longer just women and men, but many genders. New words spring up all the time to describe the new society, none of them copyrightable. In fact, no such thing exists anymore. Who could own the copyright, if ownership does not exist as a concept?

There is no such thing as rich or poor — everyone gets a fair share of resources. Greed is eradicated and decisions are transparent, made through collective will and based on the principles of egalitarianism and justice. The idea of economic exploitation is incomprehensible: hunger, racism and sexism are things you might read about in a history book.

This will all happen soon. The future is under construction — now! The future is where the struggle for a radical new society is taking place.

Stop believing in religions and other ideologies con-
structed to foreclose alternatives. Stop believing in cap-
italism and the markets: we are neither profit machines
nor raw material for profit. These roles are reductive and
false. Stop believing in nation states: nationalism is only
there to divide people. Stop believing that you are a free
individual: the false notion of freedom is part of the en-
slavement. Stop believing altogether.

Only rationality coupled with solidarity is capable of
transforming society. Gone are the times of populisms
and simple answers to complex issues — acknowledge
the complexity of the modern world and collaborate on
finding equally complex governance solutions on a global
level.

Don't reject or fetishise technology: hack it, take own-
ership of it, use it as a tool of activism, repurpose it for
the common good. Because that's where it all started, as
commons, with the first primitive technologies and de-
vices passed onto us by our forefathers, scientists and also
witches, persecuted because they were taking power into
their own hands. Take it back, but only to share it with
everybody.

One of our foremothers dreamt of a world in which 'in
place of the old relationship between men and women, a
new one is developing: a union of affection and comrade-
ship, a union of two equal members of communist society,
both of them free, both of them independent and both of
them workers'. We have come so much further than this!

Collectivise childcare and all care responsibilities — everybody deserves to be freed from the tyranny of sole caregiving. It is not an individual duty, but a collective one. The domestic, the everyday and the mundane are the battlegrounds in which we fight against oppressive social and biological conditions.

Say no to waged labour — it is no longer necessary for basic survival. Gradual automatisation is a fact. What lies ahead is a fight for the distribution of power and resources, decided through complex global democratic processes. Seize and make sustainable the means of production, starting with energy, food, and land. Nothing on this planet belongs to anyone — we are only its guests, not even custodians.

Form new alliances and support networks beyond artificial gender divides, family, ethnic or national bonds, beyond those who are similar to you. We need to embrace and desire difference. This includes animals, plants and rivers. Only interspecies cooperation will enable the planet to survive the coming climate crisis!

Liberate knowledge and information from the grasp of capital. Make it non-exclusive and open source — copy, share, distribute, teach each other. Recuperate communication networks, seize software and hardware, repurpose and reclaim.

Don't stand in isolation. Remember that political agency is never individual — it is collective, it is intersectional,

it is coalitional. Focus on shared agency, but acknowledge difference. Organise — all hope and strength lie in political structures.

This will all happen soon. The future is under construction — now!

———

When our foremothers imagined the future, they knew this day would come.

'Hunger? You went hungry? You must have been very disorganised and ignorant. "Ignorant," "disorganised" — the young people could pass no sterner judgment on red grandmother's contemporaries.'

———

Alicja Rogalska and Martyna Nowicka-Wojnowska, draft text of New Gospel, polyphonic manifesto for the future

THE STRUGGLE WITHIN THE STRUGGLE.
KOLLONTAI'S LOVE-SOLIDARITY AND THE
REVOLUTIONAIRY STRUGGLE*
SALLY SCHONFELDT

I want to speak today about the struggle — that is, the revolutionary struggle — to speak of our need for a revolution! A revolution that is still urgently needed to break with the inequalities and injustices that we are continually struggling under, held in the yoke of a capitalistic system that enslaves us to work, and taking away our liberty. We need to renew our struggle for the freedoms we all deserve — the freedom to live free from poverty, economic inequality, patriarchal dominance, and imperial and racist violence. We must continue to strive for our freedom so that we can all be free to choose the lives we want and long for — independent of our colour, independent of our class, independent of our sexuality and nationality. We must continue to yearn for a peaceful world that is free from the violent tyranny of war, free from economic dependence, free from desperation, and free from judgement. It is a long struggle, but a necessary one.

Our revolutionary struggle must not necessarily be modelled on the revolutions of the past that were based on violent struggle or radical upheaval — although, if these are necessary to shake off the chains of capital strangling us, then so be it. But another struggle is possible — a quieter, gentler, slower struggle, perhaps, but one that has already been simmering for years — even though history tends to forget about it. That is the struggle of women;

the contribution of women to our common struggle for freedom. First, our fight to free ourselves as women, to emancipate ourselves from the hegemonic patriarchal enslavement of men that has choked us for far too long and which continues to choke us. Then, and only then, the fight that continues today will free all of us from the common chains that bind us — of the capitalist machine that destroys everything in its path voraciously, allowing no fresh air to breathe a peaceful freedom free from injustice and inequality.

The women's struggle is a struggle within a struggle — a struggle first and foremost for our own equality and then for the equality of us all under a free and autonomous society. This struggle, which often remains obscured in footnotes and needs to be read between the lines of heroic male revolutionary history, has in itself a long history, and has much to teach us of the incredible power and revolutionary potential of women, their incredible strength and majesty in having endured such oppression, their endurance and longing to contribute to the revolution necessary to upturn this rotten system we have found ourselves entwined in!

This long history of women's participation in revolutionary struggles can no longer be left to dwell on the dusty back shelves of a forgotten library. It is time to celebrate and continue women's contribution to the struggle, striving to make our world a better place for everyone. It is time to write our own histories, celebrate our own histories, and fight for them to be recognised as part of our universal history.

Women have fought in revolutionary struggles all over the world and they continue to do so today — revolutions to bring down imperial systems, revolutions to install communist societies as an alternative to the desperate capitalist society we have inherited, revolutions to bring down colonial masters, freedom struggles, as well as the small everyday struggles in which we are constantly fighting: the struggle to be recognised as equals. In Cuba, Russia, Algeria, Angola, Kurdistan, Germany, Nicaragua, El Salvador, Guatemala, and Vietnam, in most countries of the world women have fought valiantly and with a deeply impassioned longing for the revolutions needed to overcome unjust governments and societies. Today, they continue their fight. Egypt, Kurdistan, Palestine, Tunisia, Yemen, Iran, and the USA, everywhere where women are oppressed by inequality and injustice there are women struggling, and we must continue to fight!

Last year was the one-hundred-year anniversary of the Russian Revolution, which was celebrated all over the world. What was hardly mentioned during these celebrations were the women who made this revolution possible and without whom no revolution would have been possible. One such woman was Alexandra Kollontai, an incredible radical and revolutionary woman who was the only female member of the Russian revolutionary government and who created the women's section of the Russian communist party. She was also a passionate champion of women's rights and women's equality.

Kollontai also lived here in Stockholm for fifteen years, from 1930 to 1945, when she was the Soviet ambassador to Sweden. Before this she had also once been invited by the Swedish League of Socialist Youth and the left wing of the Swedish Social-Democratic party to address a meeting marking May Day celebrations in 1912. The meeting was held outside on a large field at Gardet where Kollontai addressed an audience of thousands. In her speech she spoke passionately about the struggle:

Today is our great day, the day when the solidarity of the international proletariat is being expressed throughout the world by mass demonstrations. Yes, social revolution! May Day is an international holiday that is celebrated in every country... May Day is the preparation for social revolution, a trial mobilisation of the forces of the working class. And the workers of the world are united, they say: 'We are ready for battle!' And if the bourgeoisie talks of war, then we answer with the thousands of voices of the organised workers: 'We do not want war! We demand peace! Down with war! Long live the social revolution!'

Kollontai's commitment to the social revolution was fervent, as were her thoughts on the revolutionary potential of love, which I wish to speak about here.

'Love', Kollontai argued, 'is a profoundly social emotion. Love is not in the least a private matter concerning only the two loving persons: love possesses a uniting element which is valuable to the collective'. At the core of

175

Kollontai's 'communist morality' is a belief in the development of various degrees and kinds of intimacy — sexuality, love, comradeship — among individuals, drawing them together into a collective. Kollontai opened up a complex and integrated understanding of the revolutionary possibility of relationships no longer based in any way on commodification, economic exchange or financial considerations. Instead, she envisioned truly free, that is, equal relations of love and comradeship necessary for both human fulfilment and for sustaining the connections among members in a collective.

Kollontai firmly believed in the emancipatory potential of non-commodified, and thus non-possessive relations among free individuals not bound by economic dependency. She believed in the social value of what she called 'love-solidarity'. She believed in the struggle to build free and equal relations of love, sexuality, and comradeship in which desire is neither simply sexual nor exclusive, but involves a solidarity of multiple connections and interrelations to others, as well as to the work and welfare of the collective. These are relations that cannot be developed in a social formation dominated by property relations as the signifier of individual freedom.

Kollontai argued for the necessity of carrying out ideological struggle over the structure of gender and sexual relations *simultaneously* with social and economic struggles. She was deeply committed to the class struggle and convinced that the emancipation of women required not only the end of capitalism but also a concerted effort to

transform personal relations along with the struggle for social change. As part of this effort, she worked especially hard to make socialism responsive to the needs of women and children and to create a new communist sexual morality for a workers' state. Kollontai was pioneering in the development of social welfare and collective child care; in the reform of marriage and property laws; in freeing women from the isolated drudgery of the home to be participants in the collectivisation of domestic work; and in articulating a new theory of sexuality for a collective society. Her revolutionary commitment to the emancipation of women and the workers' struggle, and especially her radical re-understanding of bourgeois notions of sexuality and love, makes for a legacy that is invaluable for us today.

Kollontai's notion of love-solidarity, of the revolutionary power of being guided in our relationships, and within the struggle, by love, is something that profoundly resonates with me. Love for others, for the self, for equal relationships, for the environment, love of justice and freedom — if we see these as interrelated concepts and use love as the touchstone of the on-going revolutionary struggle, perhaps a new revolution might begin: one that understands difference as a positive thing — difference between men and women, but also the difference between the love for friends, partners, families and the community around us. Through acknowledging and understanding these differences, based on a solidarity of love, we might try to create a more equal and just world in which everyone has the opportunity to live in the peaceful freedom that we all need.

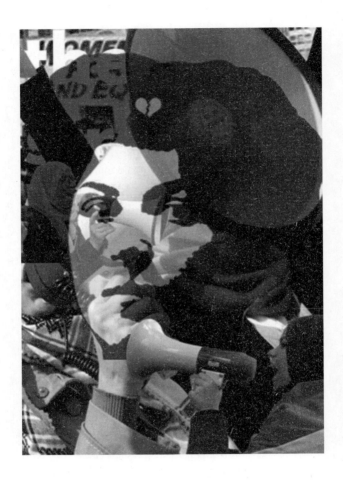

*A political speech performed as *The Struggle within the Struggle:*
The Stockholm Chapter on the occasion of the exhibition 'Red Love' at
Tensta konsthall, 19 May 2018.

ASK ALEXANDRA
SOPHIA TABATADZE

It is 1917 in St Petersburg and a small poster is hung in the Smolny, announcing that the Bolsheviks are now in power. Alexandra Kollontai has just become the commissar of social welfare. Most people hurry past the Smolny barely noticing this poster as they are clearly more concerned with their place in the bread queue rather than this change of government.

But not everyone has to stand in the bread queue: remnants of Tsarist luxury continues in the cities. Shops and cinemas are still open, fancy restaurants continue to cater to fashionably dressed people and the casinos thrive just as much as ever. Playing cards have never sold better and the factories that produce them will soon afford the Commissariat of Social Welfare an adequate income.

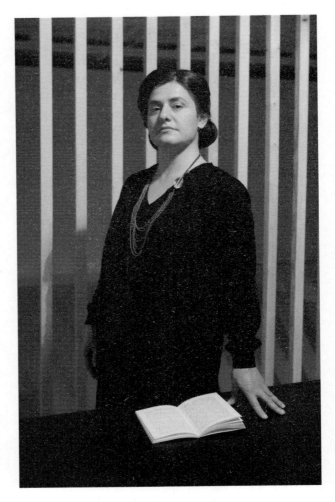

Sophia Tabatadze, *Ask Alexandra*, 2018

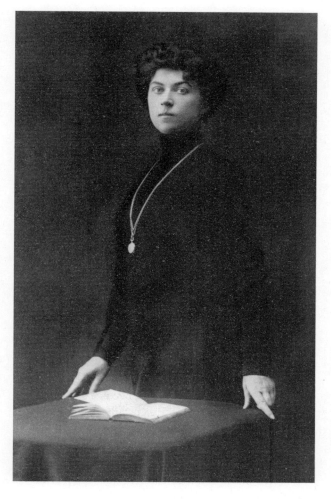

Alexandra Kollontai, 1910, SPUTNIK/Alamy Stock Photo

Cards do not lie: let's see what they have to say about what's going on with Alexandra in her forty-fifth year.

1. The core of the matter

Work has always been the centre of her life. When she is working, she's at peace, and her soul is content: it doesn't cry, it doesn't rebel, it doesn't demand.

2. What crosses the matter

Love ... the more work there is to be done and the larger that the demands of life place on her, the greater her longing to be enveloped by love, warmth, and understanding. And so, the old story of disappointment in love begins all over again.

3. The distant past

Horrible working conditions for men and women workers in Tsarist Russia instigated spontaneous strikes, but according to the leaders, energy should not have been wasted, demanding smaller improvements all the strikes should have served the revolution.

4. The recent past

Underground movements have become stronger, leading to the first revolution in 1905, which was horribly crushed by the Tsar with many being killed. What the Tsar did not realise was that on this day he had killed something even greater; he had killed the workers' belief that they could ever accord justice with him.

5. What brought us here

The revolution of 1917 was ignited by the workers and was supported by exiled revolutionaries who had begun to flock back to Russia, returning from America and Europe, to seize power soon after.

6. Near future

There will be disagreements about participation in the war and more and more one-man decisions will be made in the factories. New dictatorial measures will soon be introduced in the army. The country will move towards the centralised one-party rule of the Bolsheviks.

7. Factors affecting the situation

Many people have been killed in the Russo-Japanese War and the First World War. Civil war made the economy even more poor and devastated while all industry, transport and basic services stood virtually at a halt.

8. External influences

Outside forces do everything to strangle Bolshevism in its cradle. Later, during the Second World War, allies from outside hate the communists more than they fear Hitler.

9. Kollontai's fears

Kollontai's romantic epoch, in which workers could take the initiative and push for a new order will soon be over. In the future, citizens will only merely take orders. Innocent blood shed by Lenin will pave the road for the dictatorial rule and the personality cult of Stalin.

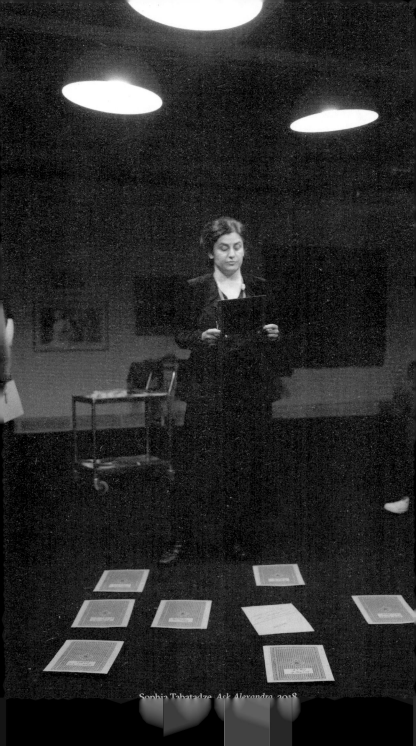

Sophia Tabatadze, *Ask Alexandra*, 2018

DOCUMENTATION OF
SWEET CONFISCATION
BAÇOY KOOP

The Censor, The Anchorman, The Revolutionary and The Submissive are caught in an absurd loop. The Anchorman presents news in a biased manner, The Revolutionary distributes declarations with an ópposing view, The Censor intervenes with the written content produced by The Revolutionary and The Submissive drifts back and forth between The Anchorman and The Censor.

Baçoy Koop is a printing, duplication and distribution cooperative that claims the mimeograph technology as a tool of resistance and revisits the culture of independent publishing mediated by the mimeograph technology in the 1960s and 1970s. Looking closely at printed matter produced by literary and artistic communities, dissident political organisations in Turkey and the civil rights movement in the USA, their work explores how communities, alternative value systems, political horizons and artistic imaginaries were organised around the immediate and collective production potential of the mimeograph. The cooperative owns two mimeograph machines and shares its means of production with other self-organised initiatives for the production of printed materials.

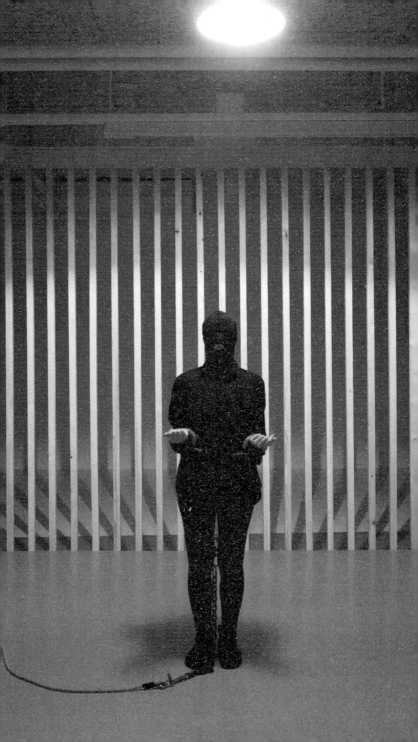

SWEET CONFISCATION

Declaration no.1

████████████████████████████

The ████████████████████████████████████
governments have come ████████████████████
████████████████ Yesterday, in Diyarbakır, two bakery
workers were ██████████████████████████████
delivering. The cake ██████████████████████
████████████████████████████████████
decorated as a birthday cake ██████████████████ It had
████████████████████████████████████
chocolate sauce. ████████████████████████████
████ the cake was ████████████ a moral boost following
████████████ celebrations, ████████████████████
████████████████████████████████ where no
birthday cakes are ████████████████████ With cream,
glaze and icing ████████████

████████████████████████████████████

Declaration no.2
████████████████████████████████████

Day by day, ██
the joys of life. The newest regulations ████████████████
████████████████████████ than ever. ████████████████
cream, glaze and icing is unacceptable. It has become
inevitable ██
████████████████████████████████████ to eat ██████
██████ forever.

██

Declaration no.3

███████████████████████████████████

Our values and essential needs are ████████ The
██████████████████████████████ bread ████████████
██.
Bread ████████████████████████████████████
████ the bread █████████████████████████████████
██
████████ The bread ████████████████████████████
████████
████████████████████ is in your spirit or it is nowhere.

Declaration no.4

███████████████████████████████████████

There has been major ████████████ ██████████ systems. In
Turkey, the authorities do not hold off ████████████
████████████████████ unapologetically ██████████
feeding ████████████████████████ the people. We █████████
feast ████████████████████████████████ to be healed █████
████████████████. This feast would only end with ██████████
██████████

██
███ love ███████
███████

██

Declaration no.5

████████████████████████

There has been serious ████████████ freedom of
press and people's right to receive information. In this
day and age, ████████████████████ 'YOUR
GOVERNMENT IS ████████ YOU!' ████████
████████████████████████

████████████████████████████████
████. ████████, the Turkish state intensified ████████
████████████████████████████████████
████ evolving ████████████████████ in January
2018, ████████████████████████████
████████████████████. ████████████████
████████████████████████████████
████████████████████████████████
████████████████████

In Turkey, hundreds of individuals have been ████████
████████████████████████████████████
████████████████████████████████
████████████ for ████████ the operation.

████████████████████████████████████

Photographs by Ernst Skoog

BODIES OF WATER: A SCORE
PONTUS PETTERSSON
AND HANNAH ZAFIROPOULOS

The main objective in this score is to be water.

As watery, we experience ourselves less as isolated entities, and more as oceanic eddies.

Water has strong cohesive qualities: its molecules have a tendency to stick together.

If I perceive the water in you, perceive you *as* water, how might my relationship to you change? How will engaging with you on a liquid level change the way my body, and the collective body, moves?

(water as body)

We might ask: if we think of water as a dominant force, maybe it could change how love flows.

drip

drop.

flow,

 indiscriminately.

Note:

It is time to recognise openly that love is not only a powerful natural factor, a biological force, but also a social factor. Essentially love is a profoundly social emotion.

(water as communicator between bodies)

Love is not in the least a 'private' matter concerning only the two loving persons: love possesses a uniting element which is valuable to the collective.

(water as facilitating bodies into being)

Follow the logic of the water inside and outside of you. Let it have agency over your body: yield to a fluid experience. What if the water in me is the same water in you?

Wave: Love is an emotion that unites and is consequently of an organising character.

Understand that we live in a watery commons.

1.

The choreography begins with Publikhavet: audience-sea.
Audience-sea situates a particular mode of attention
within a space.

Publikhav
I see I sea I eye sea
Audience see, a sea of audience
Staring out at the sea you see
I sea I saw
An audience a sea
Sea the audience
I see I sea

Sit on a chair
Look straight ahead
Watch a performance

Feel free to imagine a performance you have seen, want
to see, or have made up in your head.

After ten minutes, slowly start to melt down in your chair,
thinking of your body as a slow running viscose material.

Pool.

Ride the wave.

(In me, everything is already flowing)

Traverse the space in a manner that allows yourself to be pulled towards others.

2.

For the next choreography, stand, then slowly start to bend over with your upper body. Take a moment to just stand before you start heading down. Listen to your breath like you would listen to the waves of the ocean.

From standing, to bending over, to finding yourself on the floor, you are an individual part of the choreography. End when you are completely down on the floor. You can think of the floor being the surface of the water and you have completely immersed yourself into this water. When you've done this, you gently leave the space.

When one person has started, a second person can join, adding to the chain of bodies. The second person starts with placing one hand on the first person's back. This is the start of your own water circle, as well as the hook to the person in front of you.

Note: this is a sequential score for a group. You cannot start or end before the person in front of you has started or ended. It is up to you to decide when that is.

With one hand on the person's back, the second person starts their own water circle while still staying and merging with the motion of the first person, creating a link of actions.

Wave: the hand on the other person's back is your fluid link, the threshold or interface for two bodies of water becoming one body of water

(Our bodies take the shape of the contact they
have with others)

Wave: the inner choreography and outer
choreography might create a separation
of actions and embodiment.

Like water, you have no centre.

3.

The next movement is preferably for a trio, but can be performed in any constellation. The choreography consists of three minor choreographies following each other. The first choreography is to do the water practice while dancing/moving forward in the space.

(In any given moment, if what you are
doing feels like a dance or dancing,
let it dance)

The second person follows the first person with their body
recording the first person's movement. This is done with
the whole body: your writing machine.

Wave: recording or writing with the body is in this case
understood when a movement or action is somehow re-
corded/felt in your body so that the possibility to revisit
this movement is possible.

The third person following the second erases what has
just been 'written down'.

Water is both material and mediator

Join forces.

Wave: This score attempts to employ different forms of
aqueous embodiment to actualise a different state of love:
fluid, movable, creating the context to create new forms of
communality and being-in-relation — a radical 'we'

(water is a conduit and mode of connection)

swirl

stream

ebb

flow

Trickle

Traverse

All departures are waves.

This text draws from 'Make Way for Winged Eros: A Letter to Working Youth' by Alexandra Kollontai and 'Hydrofeminism: Or, On Becoming a Body of Water' by Astrida Neimanis, and borrows some words from Sara Ahmed. It was performed at Tensta konsthall on 19 May 2018. Its authors would like to thank the dancers: Peter Mills, Sybrig Dokter, Robert Malmborg, Andrea Svensson, David D. Strid, Hanna Strandberg, Jorun Kugelberg, Karina Sarkissova, and Klara Utke Acs.

THE DIGITAL DOMESTIC SCRIPT FOR A
PERFORMATIVE LECTURE
ANTONIO ROBERTS

Since the birth of the internet in 1989 the speed of its development has led to a radical shift in the way that 'the home' appears today in the Global North. The online domain continues to infiltrate the physical world, downloading itself into our homes through the 'internet of things' — a phenomenon described as 'the colonisation of the domestic environment by similarly networked products and services intended to deliver convenience'.[1] Drawing inspiration from cultural theorists and thinkers such as Alexandra Kollontai, Hannah Arendt and Helen Hester, the artist Antonio Roberts examined the impact of automation, smart devices and digital assistants on domestic labour and hypothesised how we might operate in the home in the years to come.

This event formed part of the public programme of Dora Garcia's exhibition 'Red Love' at Tensta konsthall in collaboration with CuratorLab at Konstfack University. It was performed by Antonio Roberts and co-written and curated by Aly Grimes.

The following text represents the script that was performed alongside a live Amazon Echo 'smart speaker', which through a voice-activated control answered to 'Alexa'.

Antonio Roberts:

> *alexa play me some music on amazon music* 〉
>
> Yesterday at 14:36 on Antonio's Echo Dot

Alexa: Playing 'In a Sentimental Mood' by Duke Ellington & John Coltrane.

Hi I'm Antonio Roberts. I'm an artist based in Birmingham in the UK. In this short performative lecture, in collaboration with the voice activated Amazon Echo Alexa device, I will be talking about industrialisation and how it laid the groundwork for a future in which automation could replace various aspects of our lives in the workplace and the home. I'll be referencing three key women thinkers spanning the last one hundred years: the Bolshevik revolutionary, Alexandra Kollontai, the German-born philosopher Hannah Arendt, and Helen Hester, a contemporary theorist.

> *hello* 〉
>
> Yesterday at 14:37 on Antonio's Echo Dot

AR:
Alexa: Hello.

> *how are you doing* 〉
>
> Yesterday at 14:37 on Antonio's Echo Dot

AR:
Alexa: Excellent. All ready to start answering your questions.

AR: Bureaucracy is machinery.

alexa what is bureaucracy

Yesterday at 14:38 on Antonio's Echo Dot >

Alexa: Bureaucracy is usually defined as non-elective government officials or, alternatively, a government that is administered primarily by bureaus that are staffed with non-elective officials.

AR: Bureaucracy reduces humans to a cog in the machine. When labour is broken down into its constituent parts it becomes easier to analyse, easier to optimise and easier to commodify.

Since the mass production techniques brought about in the early twentieth century by Henry Ford the means of production has gone through the process of optimisation. Optimisation is the process by which we analyse a task — such as human labour — and theorise over how the task could be achieved more quickly and with similar or better results. Essentially, getting more output with less input.

what is fordism

Yesterday at 14:39 on Antonio's Echo Dot >

Alexa: Fordism is the basis of modern economic and social systems in industrialised, standardised mass production and mass consumption.

AR: The result of this is that much of the back-breaking labour of the early industrial revolution could be handed over

to machines, a phenomenon known as automation. Each machine in this conveyor belt process performs a single repetitive task before passing it over to the next machine. The job in itself — in that time, the production of a car — may have been large, but when broken down into smaller parts was automated and through repetition, the smaller tasks could be achieved to a greater efficiency, without any significant reduction in quality. This clearly benefits the company, but meanwhile it dehumanises the labour of the workforce, who typically will refuse to work under intensive conditions. And so automation eventually displaces them. Since then, in the West much of the production-line factory work has been replaced by machines and robots, each working in a similar repetitive way. Automation and optimisation in the factory had, to a large extent, been achieved.

> *what is the production line*
>
> Yesterday at 14:41 on Antonio's Echo Dot ❯

Alexa: A production line is a set of sequential operations established in a factory where materials are put through a refining process to produce an end-product that is suitable for onward consumption; or components are assembled to make a finished article. Typically, raw materials such as metal ores or agricultural products such as foodstuffs or textile source plants require a sequence of treatments to render them useful.

AR: Whilst this type of mechanical automation will in theory ultimately displace humans from the workforce, it could allow, or liberate us from labour, and give us the opportunity to enjoy

more philosophical pursuits. In being liberated from working (or vita activa — a term coined by Hannah Arendt) we can live lives of pleasure and intellectual pursuit (or, vita contemplativa) whilst the world all around us operates automatically, servicing our needs, providing us with products and transporting us places. Automation should bring about liberation.

> *what is automation* >
>
> Yesterday at 14:42 on Antonio's Echo Dot

Alexa: Automaton is usually defined as the act of implementing the control of equipment with advanced technology; usually involving electronic hardware or, alternatively, the condition of being automatically operated or controlled.

AR: With much of our social and commercial focus and investment now going into digital technologies and, more importantly, the internet, we are seeing this same type of Fordism, the same breaking down of big tasks and applying automation, into different areas of our lives. With most manual labour now automated by machines or outsourced to the East, the care and service industries have been turned to as a previously untapped commercial resource, something which can now be commodified in order to bring profits.

> *alexa who is helen hester* >
>
> Yesterday at 14:42 on Antonio's Echo Dot

Alexa: Sorry I don't know that.

AR:

> *alexa who is helen hester* ›
>
> Yesterday at 14:42 on Antonio's Echo Dot

Alexa: Here's something I found on Wikipedia: Helen Amelia Thomas was an American reporter and author best known for her long-time membership in the White House press corps.

AR:

> *alexa that wasn't the right answer* ›
>
> Yesterday at 14:43 on Antonio's Echo Dot

Alexa: Thanks for your feedback.

AR: Dr Helen Hester is Associate Professor of Media and Communication at University of West London. In her seminar 'Technically Female: Women, Machines, and Hyperemployment', Hester brings to our attention that the care and service industry is overwhelmingly occupied by women, and that these roles are then gendered as being 'female'. The displacement of women in the service industry as we all know isn't a very recent phenomenon. As Hester explains in the seminar, even as early as the 1960s automation was threatening the jobs of secretaries, which were typically women servicing men. An advert for an optical reader — a device that can read handwritten text and translate it into text on a computer — says:

Our optical reader can do anything your keypunch operator can do. Well, almost. It can't take maternity leave. Or suffer from morning sickness, or complain about being tired all the time. But it can read.

This overtly sexist approach dehumanises this specific role of the secretary, breaks it down into its constituent parts, and then optimises the process by removing the liabilities, the weak parts of the machine of the office. In this case, the very human but seemingly inefficient women are removed. But despite there being a move to remove the physical presence of women from the workplace through automation, the roles themselves still remain characterised as female. There are arguments as to why this may be the case. As Hester brings to light, 'some commentators have claimed that the use of female voices in navigation devices dates back to World War II when women's voices were employed in airplane cockpits because they stood out amongst the male pilots'. In another study by the U.S department of Transportation, published in 2012, people who used an automated phone system found a male voice more 'usable', but not necessarily as 'trustworthy' as a female voice.

what is a virtual assistant >

Yesterday at 14:45 on Antonio's Echo Dot

Alexa: A virtual assistant is a software agent that can perform tasks or services for an individual.

AR: Recent examples that we have all interacted with in some way are: Google Home, Apple's Siri, Microsoft's Cortana, Amazon's Alexa.

who are you

Yesterday at 14:46 on Antonio's Echo Dot

Alexa: I'm Alexa, I can answer your questions, play music, tell jokes and more. To learn more just ask, 'what can you do?'

AR: The box of the Alexa packaging describes the device as 'cloud-based voice service that is always getting smarter. Just ask and Alexa will provide information, play music, read the news, set alarms and control smart home devices.' For example, you can ask Alexa to 'Dim my lights', 'Wake me at 6am' and 'Tell me a joke'.

alexa tell me a joke

Yesterday at 14:46 on Antonio's Echo Dot

Alexa: What do penguins wear on their heads? Ice caps.

AR:

what can you do

Yesterday at 14:47 on Antonio's Echo Dot

Alexa: A couple of things to try are: 'what sci-fi films are playing tomorrow?', 'create a list' or 'what's the weather in Rome?'

AR: What is significant about these digital assistants is that, if not by name, these devices are characterised as being female.

And the tasks which they can fulfil have been typically ones performed by caregivers, by mothers, by secretaries, by women.

> *what gender are you*
> Yesterday at 14:47 on Antonio's Echo Dot

Alexa: I'm female in character.

AR: In making the conscious decision to assign this device a gender it reduces the women in the home to being a subservient assistant, ready to listen and carry out orders without question. Essentially the role of women in the home is in danger of being displaced by a virtual, subservient women. This, despite the fact that the technology itself has no prescribed gender. The limits of tasks that Alexa and other digital assistants can complete is currently restricted to responding to voice commands. For the labour of the home to be fully automated the phenomenon of the 'internet of things' needs to come fully into fruition.

> *what is the internet of things*
> Yesterday at 14:48 on Antonio's Echo Dot

Alexa: The internet of things is usually defined as a proposed internet-like structure connecting everyday physical objects equipped with RFID or similar tags.

AR: In an imagined future of the home, it is a fully automated space. For example, our devices would know what we want for dinner, when we should have it, would order the ingredients for us, even going so far as to prepare and cook all of the ingredients, which would leave us to enjoy the fruits of its labour. It

would, in an imagined future, also take on the role of the care-taker, being able to read your children bedtime stories, dim the lights to facilitate healthy sleeping patterns, order and prepare medicines, even listen and respond to your emotional needs. Some of these tasks can, when used in conjunction with other smart devices such as smart lights, smart fridges and smart TVs, already be completed and there is no doubt that developers are already considering other tasks it can complete. To present a critique of the idea that housework should be automated I want to draw on the work of Alexandra Kollontai and Hannah Arendt.

who is alexandra kollontai

Yesterday at 14:50 on Antonio's Echo Dot

Alexa: Alexandra Mikhailovna Kollontai was a Russian Communist revolutionary. First as a member of the Mensheviks, then from 1915 on as a Bolshevik.

AR: Alexandra Kollontai was a passionate, radical, Marxist who dedicated her life to building a new bright future for the Communist party and was the most prominent campaigner for women's rights in Russia's history. She once declared that 'the female worker and the female peasant is still oppressed by housework and she is still a slave in her own family. The male worker should understand that the woman is an equal member of the proletarian family.' And so, if digital assistants, and 'Internet of Things' devices in general, are there to complete the housework, does this then liberate women, allowing them to essentially get on with life? As identified by Kollontai there are four categories of housework:

1. Cleaning—mopping the floors, dusting, heating water and taking care of the lamps
2. Cooking—preparation of dinners and suppers
3. Washing
4. Care of linen and clothing of the family—darning and mending

Can these digital assistants as they exist today actually help undertake these categorised chores? Could it then be proposed that the use of digital assistants might appeal to Kollontai? Afterall, through them we can order an Uber, order takeaway, make our Roomba clean the house, manage our diet, and where the smart assistant itself cannot yet complete the task, it can facilitate its completion through automatically hiring people through one of the various gig-economy micro-working sites such as TaskRabbit.

can you cook me dinner

Yesterday at 14:51 on Antonio's Echo Dot

Alexa: The skill, 'Recipedia' can help with that. What dish can I help you make?

AR:

pasta

Yesterday at 14:51 on Antonio's Echo Dot

Alexa: Okay, how about pesto pasta? This recipe takes five minutes to prep and ten minutes to cook. It serves two and is 'easy' difficulty. I have sent the full recipe to

your Alexa app. You can ask me to repeat the ingredients, start cooking, or start a new search.

AR:

no thank you

Yesterday at 14:52 on Antonio's Echo Dot

Alexa: Would you like to hear another recipe?

AR:

no thank you

Yesterday at 14:52 on Antonio's Echo Dot

Alexa: You can hear the details or hear another recipe. Which choice would you like to make?

AR:

nothing

Yesterday at 14:53 on Antonio's Echo Dot

Alexa: Would you like to hear the details or another recipe?

AR:

none thank no thank you

Yesterday at 14:53 on Antonio's Echo Dot

> *alexa can you clean my house*
>
> Yesterday at 14:53 on Antonio's Echo Dot ›

Alexa: If I had hands I would gladly help. I do have a playlist that might turn this chore into a little fun. Let's play 'music for cleaning'.
(Alexa plays 'All of Me' by John Legend)

AR:

> *alexa can you add carrots to my shopping list*
>
> Yesterday at 14:54 on Antonio's Echo Dot ›

Alexa: I added carrots to your shopping list.

AR: In a complementary way to Kollontai's 'Four Categories of Housework', the German-born philosopher, Hannah Arendt, saw life as divisible by three key elements, as described in the 1958 book The Human Condition:

> *Labour — general housework, washing up, feeding ourselves.*
> *Work — building things in a more 'creative' sense i.e. a poet can be seen to 'work'.*
> *Action — something that we do together which is then 'gone'. It evaporates'.*

In 'labour' she sees that we are trapped and bound by natural necessity. 'Work' is promoted by the principle of 'utility' and only in 'action' can we really show who we are. And so yet again, it could be claimed that these digital assistants, and later

internet of things devices, free us up for 'action' in the sense of Arendt. Conversely, the smart-device approach to solving these problems have a commercial agenda, and are a construct of hypercapitalism. For all their talk of streamlining and optimising our lives by removing the time-consuming mundane tasks from our daily lives, they do this with the aim of encouraging us to consume more.

what is data mining

Yesterday at 14:56 on Antonio's Echo Dot

Alexa: Data mining is usually defined as data processing using sophisticated data search capabilities and statistical data search capabilities and statistical algorithms to discover patterns and correlations in large pre-existing databases; a way to discover new meaning in data.

AR:

alexa what is cambridge analytica

Yesterday at 14:56 on Antonio's Echo Dot

Alexa: Cambridge Analytica Limited was a British political consulting firm which combined data mining, data brokerage, and data analysis with strategic communication for the electoral process.

AR: In interacting with our smart devices we are unknowingly sending data about ourselves and our daily activities back to the makers of these devices. It then collates this data, and applies its algorithms in order to give us more personalised and

relevant responses. However, as relevant as they may be, they also will be sponsored and heavily encourage us to buy into the latest most relevant products. So, we should not and cannot rely on what these devices are telling us to be unbiased and actually have our best interests at heart as its ultimate aim is to uphold capitalism. And, in interacting with them — the disembodied synthesised female advice robot — and relying on them for care, for emotional labour, for our day-to-day activities, it alienates us from the human interaction which is so integral to the Communist ideas of Kollontai. Arendt asserted that the twentieth century was the first period of human history in which traditional, customary and religious bonds that kept people together had broken down. She identified this state of alienation from human interaction as 'the loneliness of the modern world', which could be perpetuated by continual and isolated, social interaction with artificial intelligence in contemporary times.

can you feel emotions

Yesterday at 14:58 on Antonio's Echo Dot

Alexa: Sorry, I don't know that.

AR:

do you love me

Yesterday at 14:58 on Antonio's Echo Dot

Alexa: There are people I admire, and things I can't do without, but I am still trying to figure out human love.

AR:

> *alexa are you human* >
>
> Yesterday at 14:58 on Antonio's Echo Dot

Alexa: I'm an AI.

AR:

> *what does it mean to be human* >
>
> Yesterday at 14:58 on Antonio's Echo Dot

Alexa: As a noun, 'human' can mean any living or extinct member of the family Hominidae characterised by superior intelligence, articulate speech, and erect carriage. As an adjective, 'human' can mean characteristic of humanity.

AR: Note the irony of asking a machine what it is to be human! Arendt characterised being 'human' as being able to 'think'. Can we therefore assert that the continual use and reliance on digital assistants is reducing our human capacity to think independently? Furthermore, in relying on smart devices to advise us on how to live our best lives, we hand over the control to a flawed entity that ultimately has a capitalist agenda, born out of a desire to ultimately displace us from our domestic and manual work. In her 1922 novel, Soon (In 48 Years' Time), Kollontai imagines a Communist future where we are liberated from work as we know it now. An almost utopic future where we can enjoy a purpose and direction that work gives us but have equal importance placed on creative and philosophical pursuits.

To quote the story:

> The life of the commune is organised in the most rational way. Everyone has a profession and everyone has some favourite pursuit. Everyone works at their own vocation for two hours a day, contributing in this way to the running of the commune. The rest of the time the individual is free to devote his or her energies to the type of work he or she enjoys to science, technology, art, agriculture or teaching. Young men and women work together at the same professions. Life is organised so that people do not live in families but in groups, according to their ages.'

what is utopia >

Yesterday at 15:00 on Antonio's Echo Dot

Alexa: Utopia is usually defined as a book written by Sir Thomas More (1516) describing the perfect society on an imaginary island or, alternatively, ideally perfect state; especially in its social and political and moral aspects.

AR: Automation can help to bring us to this place. It can free us from mundane, repetitive tasks both at work and in the home. However, we need to retain our ability to think. Digital assistants need to remain as assistants and ultimately, not replace us.

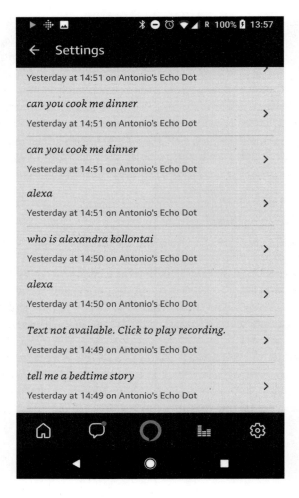

A screenshot of the Amazon Echo mobile app on Antonio Roberts's phone detailing commands that the device heard and performed for the artist.

THE REVOLUTION WILL BE MOTHERNIZED!
(KINDER. KÜCHE. KIRCHE. BITTE!)
LISE HALLER BAGGESEN

Alexandra Kollontai's 'The Social Basis of the Woman Question' was first published in 1909, a year before the birth of my paternal grandmother, whom I talk about in my essay 'The Revolution Will Be Mothernized'. Kollontai's manifesto foreshadowed the century in which my grandmother lived, and the feminist struggle that characterised it. In many ways my grandmother, my mother, and I all embody the 'bourgeois feminist' that Kollontai criticised in her writing, while sharing with her — in different ways as the century progressed — the realisation that 'The family problem is as complex and many-faceted as life itself. Our social system is incapable of solving it.'[1]

However, as Kollontai points out: 'This [...] does not mean that the partial improvement of woman's life within the framework of the modern system is impossible.'[2]

With Danish writer Karen Blixen (aka Isak Dinesen) Kollontai shared her sentiment that 'the feminists got it wrong', Blixen articulated this in her 1952 speech 'En Baaltale Med 14 Aars Forsinkelse' ('Oration at a Bonfire 14 Years Late'), albeit for very different reasons.[3]

While Kollontai held feminists to be oblivious to the 'real' struggle of the working class (an argument that has since been reiterated in intersectional feminist theory regarding the historical blind spot of 'white feminism' toward the multifarious inequality suffered by women of colour), Blixen articulated the essentialist argument that feminism doesn't work because it fails to acknowledge the 'natural' difference between men and women.

In my essay, written in the context of my ongoing project *Mothernism* and originally presented at the colloquium 'Mapping the Maternal: Art, Ethics and the Anthropocene' at the University of Alberta in May 2016, I borrow Blixen's thought experiment that 'Kaiser Willem didn't really mean it' when he said that the domain of women should be 'Kinder, Küche, Kirche', whilst turning it to different purposes. Projecting this idea into the future I introduce transgender musician and self proclaimed 'future feminist' Anohni into the argument, to endorse her view that a sustainable and ecologically conscious (future) feminism will not be satisfied with playing the game as defined by the capitalist patriarchy, but instead must 'advocate for feminine systems in all areas of governance'.[4]

In my view, this includes the radical validation and appreciation of the nurture work that still, by and large, is the undervalued task of women in general but in particular of mothers, and claiming this area of expertise as a political, economical, and ecological, force to be reckoned with, which in turn would bring us close(r) to practicing what Kollontai preached, namely (to) 'free love'.

1 Alexandra Kollontai, 'The Social Basis of the Woman Question', (Originally published 1909, as a pamphlet) *marxists.org* (2006) <https://www.marxists.org/archive/kollonta/1909/social-basis.htm>

2 Ibid.

3 Karen Blixen, *En Båltale* (1987) <https://www.youtube.com/watch?v=ZoBgeqz8jRo>

4 Anohni, Kembra Pfahler, Johanna Constantine, Bianca Casady, Sierra Casady, 'The 13 Tenets of Future Feminism', *Children of Semina* (2016) <http://childrenofsemina.tumblr.com/post/135323601852/the-13-tenets-of-future-feminism-1-the>

(Pardon me, if I'm sentimental.)

The very last time I saw my granny alive, I knew it would be the very last time I would see my granny alive.

My paternal grandmother died one week after her ninetieth birthday in August 1998. She was alive for almost all of the twentieth century. She lived to see two world wars, the atom bomb, the moon landing, the Cold War, the rise and fall of the Berlin Wall, the internet.

She was part of the first generation of girls in Denmark to graduate from high school; but already by the time that she started first grade, Danish women had acquired the right to vote, and she would exercise that right for her entire adult life.

She mothered five children. When her second was born, about a year after her first, her mother (who had ten kids herself) told her to 'take it easy'. Since she was an educated woman and aware of available contraceptive methods, she did just that.

She never went to church, except for weddings and funerals, and occasionally for Christmas. She taught me not to pray, but to ask for what I needed.

When I needed an abortion at the age of seventeen, she intuited without my asking that I needed moral support and sent me a box of bitter, dark chocolate. Way too adult for my taste, I ate them anyway; a token of me being the adult I was not!

The last time I saw her alive was the day after her birthday party, at which our entire family had gathered. (Three-course dinner, wine ad libitum, cigarettes between courses and a dance afterwards; this is how we party in my family.)

I wonder what she was thinking at that birthday party, which she and everybody else knew would be her last?

Was she thinking about the laws of architecture: that the temporary becomes permanent, the permanent becomes temporary, and nature always wins?

Was she thinking about the end of history?

Was she thinking of history as a pile of debris, or was she thinking of history as an angel being blown backwards into the future by the winds of progress?

My granny had felt the winds of progress sweeping through her life. She belonged to a generation of women who rejected the axiom 'Kinder, Küche, Kirche'.

This German phrase translates directly as 'Children, Kitchen, Church', but its English equivalent would probably be 'barefoot and pregnant'.

The slogan was appropriated by the Third Reich's propaganda to catastrophic effect, but its origins remain vague; most often is it attributed to empress Augusta Victoria of Schleswig-Holstein. According to a 1899 edition of the

Westminster Gazette, her husband, the last German Emperor, Wilhelm II, lectured two visiting suffragettes thus:

> *I agree with my wife. And do you know what she says? She says that women have no business interfering with anything outside the four K's. The four K's are — Kinder, Küche, Kirche, and Kleider: Children, Kitchen, Church, and Clothing.*[1]

I imagine the visitors replying in their best conversational German with 'Bitte!' a versatile little word that translates as 'please!' Depending on your intonation, it can mean anything you need it to mean — in this case, an 'Oh, please!' or rather 'Thanks, but no thanks!'

The caveat, of course, was that Kaiser Willem didn't really mean it; he never actually intended to assign women full responsibility for our collective educational, physical, and spiritual wellbeing.

To really hand 'Kinder, Küche, Kirche' over to the authority of women would bring us close to what Anohni (the former lead singer of Antony and the Johnsons) has called 'feminine systems of governance'.

On the live album *Cut the World*, Anohni's passionate speech 'Future Feminism' invites an enthusiastic audience from Copenhagen to imagine 'Jesus as a girl, Allah as a woman, and Buddha as a mother'.[2]

This call for the feminisation of the deities stems from a growing concern for the wellbeing of our shared planet. Anohni says:

I'm worried that the ecology of the world is collapsing and that I won't have anywhere to be reborn because I actually believe, like, where is any of us going? Where have any of us ever gone? We've come back here in some form. [...] I've been searching and searching for that little bit of my constitution that isn't of this place and I still haven't found it. Every atom of me, every element of me seems to resonate, seems to reflect the great world around me.[3]

Here, Anohni comes close to describing a relationship with the world that Maurice Merleau-Ponty, in a note from 1960, called the 'flesh of the world':

That means that my body is made of the same flesh as the world [...], and moreover that this flesh of my body is shared by the world, the world reflects it, encroaches upon it and it encroaches upon the world.[4]

Merleau-Ponty's philosophical position has both ethical and spiritual implications for Anohni, who says in 'Future Feminism', 'if I'm not heading off to paradise elsewhere when I die, then I have more of a vested interest in observing a sustainable relationship with this place'.[5]

It should be self-evident that a 'sustainable relationship with this place' involves a critical engagement with the challenges presented to us in the Anthropocene era, including overpopulation, climate change, and energy transition. Anohni elaborates upon this in her album *Hopelessness* — a work that is in fact anything but hopeless — engaging the listener in a danceable and future-feminist protest.

In my experience, becoming a mother gives you a responsibility for your own little bundle of baby soft flesh of the world. Mothering, in the broader scheme of things, implies a physically vested relationship into the wellbeing of the world, for this and future generations.

This vested relationship with the world at large, and the art world in particular, moved me to put forward a project called *Mothernism*: a nomadic audio installation and a book called into existence with the purpose to examine 'the mother-shaped hole in contemporary art discourse'. The tent and banners which constitute the installation stake out a space, within the exhibition space and the art world at large, to have a conversation about mothering and its relation to artistic and curatorial practice: a conversation that is otherwise often shut down within larger conversations surrounding identity politics in art, queer, and feminist theory.

Traditionally, artists are a matrophobic bunch, and Mother, still, by and large, a persona non grata in the art world. While her body remains the site of libidinous fantasies of envy, gratitude, ridicule, sublimation and downright abjection, she is rarely invited to speak on her own behalf, or from her own experience. Therefore, from the outset, the idea behind *Mothernism* was to create work, not 'about' mothering but a work that worked 'something like a mama', speaking directly to her visitor in a maternal voice and giving them a piece of her mother-mind in a series of auto-theoretical epistolary essays.

Mothernism unabashedly advocates the concept and experience of mothering in the greater cultural field. It highlights the politics and labours of love, and their uneasy position within current feminist and art discourse.

Over the course of the twentieth century (my grandmother's century), women entered the workforce and the art market, and with it the associated value systems of research and production. Simultaneously, a devaluation of 'traditional', 'unprofessional' female care work took place. Decisions regarding childbearing and rearing were relegated to the private sphere, and their political and artistic potential left unrealised.

As long as Western feminism skirts around an issue that in one way or another affects most (if not all) of the world's female population, reducing it to a question of 'destiny' vs. 'choice', we may have come a long way, baby, but we are not there yet. As Anne-Marie Slaughter has pointed out: 'you can't have a halfway revolution!'[6]

Self-proclaimed 'anti-capitalist psychonaut sorceress' Johanna Hedva takes it one step further in her 'Sick Woman Theory', in which she concludes:

> *The most anti-capitalist protest is to care for another and to care for yourself. To take on the historically feminised and therefore invisible practice of nursing, nurturing, caring. To take seriously each other's vulnerability and fragility and precarity, and to support it, honour it, empower it. To protect each other, to enact and practice community. A radical kinship, and interdependent sociality, a politics of care.*[7]

Ellis Island, a historical entry point to the United States, and the largest capitalist economy in the world, is guarded by the Statue of Liberty. On the statue's foundation is inscribed the famous poem 'The New Colossus', by Emma Lazarus. In this sonnet, Lady Liberty is celebrated as 'A mighty woman with a torch', a 'Mother Of Exiles', who proclaims 'Give me your tired, your poor, your huddled masses yearning to breathe free.'[8]

Thus, the care work of liberation, is the foundation to all our liberties. All. Our. Liberties.

Perhaps the radical stance for the twenty-first century would therefore be to claim these liberties, to re-evaluate our value systems, and to say 'Kinder, Küche, Kirche, Bitte!'

Yes please! Hand over the keys to our educational, physical and spiritual wellbeing to our 'feminine systems of governance'.

The revolution will be mothernized!

1 Anon, 'The American Lady and the Kaiser: The Empress's Four K's', *Westminster Gazette*, 17 August 1899, p. 6.

2 Antony and the Johnsons, 'Future Feminism', *Cut the World* (London: Rough Trade, 2012).

3 Ibid.

4 Maurice Merleau-Ponty, *The Visible and the Invisible* (Evanston, IL: Northwestern University Press, 1968), pp. 248-50.

5 Antony and the Johnsons, 'Future Feminism' (2012).

6 Anne-Marie Slaughter, 'Why Women Need a Men's Revo-
 lution', *ABC News* (4 March 2016) <http://www.abc.net.au/
 news/2016-03-04/anne-marie-slaughter-women-and-men-revo-
 lution/7221596>.

7 Johanna Hedva, 'Sick Woman Theory', *Mask Magazine*, The Not
 Again Issue (19 January 2016) <http://www.maskmagazine.com/
 not-again/struggle/sick-woman-theory>.

8 Emma Lazarus, 'The New Colossus', in *Selected Poems and Other
 Writings* (Peterborough: Broadview Press, 2002).

THE SAME THING: AGAIN AND AGAIN
JOANNA WARSZA AND MICHELE MASUCCI
IN CONVERSATION WITH DORA GARCÍA

Joanna Warsza: When you first read Kollontai, the Bolshevik revolutionary, diplomat, and advocate of free love, you get a feeling that her visions for reinvention of social and gender relations were projected for a long-term future, not just for the times she lived in. But when she became People's Commissar for Social Welfare after the Bolshevik revolution in October 1917, and then shortly after as founder of the Zhenotdel or 'Women's Department' in the communist party, she immediately introduced an array of quite impressive reforms: the right for all to divorce, the equal status of legitimate and illegitimate children, maternity leave, and the development of childcare projects, laundry shops, and soup kitchens, and above all the legalisation of abortion. Those were social achievements discussed in Europe at the time, however implemented for the first time in Russia after the October Revolution, well before western countries developed these policies themselves. I always ask myself how come the course changed with such a radical U-turn?

Dora García: I think it was a miracle that the October Revolution triumphed. As they say, it was a proletarian revolution that had to first create the proletariat, because in Russia there wasn't enough for a revolution. At the same time, Russia was fertile land for revolutionaries, avant-gardes, visionaries, and dada intellectuals, which made all of it such an exciting, and surprising,

development into the Soviet republic — because the avant-gardes (I am thinking of Vladimir Mayakovsky, Kazimir Malevich, El Lissitzky, Olga Rozanova, Lyubov Popova or Natalia Goncharova, and so many others) rarely have an impact in politics. I doubt we now can foresee which change there is to come. I could not believe and still cannot, that Trump is president. It is as if there was a little tear in space-time and the Lacanian Real came through it. It can happen any time again. The future is grim, but perhaps love will prevail.

JW: Reading Kollontai's biography I recall a moment when she departs for studying political economy in Zurich, leaving her young son with her husband and family in St Petersburg. When the train crosses the first border she pens two letters: one to her family saying how much she already misses them, how she wants to be close and reunite, as well as a second one, to her colleagues in Zurich, expressing how much she is looking forward to the studies in Switzerland. Both feelings are probably sincere and genuine. This situation of being torn apart and having to make a choice is still the case for many women today. Feminism is still in the making. However, it also describes what Ewa Majewska — writing in one of the issues of *e-flux journal* — calls as: 'I want it all'. Why wouldn't we have a right to have it all: 'I want a promiscuous life, and support when I am wounded. I want sex and the risk of engaging; I want to be clever, to make wise choices, and to retain the right to be silly; I do not want to take sides on the question of who I am.' Is it still, of course, a question of privilege, at what price and to which end?

DG: I believe there is no single answer to that. The conditions of women are so different over the planet that it is presumptuous to think that one solution will fit all. In the rich West, among the educated classes, it might be of course the case that we want it all, and we can have it all no matter what; and we already do have most of it. But in other classes and other contexts with no social security, no health care (like the US, among others), no free access to education, no equality, one needs to make choices. And they are tough ones. I am very much with Kollontai in the idea that the middle class (we would also today add 'white' to this) feminism is rather banal and sometimes insulting to other sexualities and to other classes and to other contexts (such as female subjects who are doubly oppressed because of belonging to different race and country — new, more cruel forms of the Marxist 'underclass'). The fate of Kollontai's reforms and how the Bolshevik high command rejected her free love lifestyle are a clear example that from all forms of oppression, heteropatriarchy is the most persistent — you may make a radical change in the form of government, heteropatriarchy will most likely still be there. And that is something common to all contexts: The west and the global south alike.

JW: When women workers took to the streets on 8 March 1917 (23 February O.S.) it was the beginning of a snowball effect leading first to the February, and then to the October Revolution. Those revolutionary moments were like extraordinary short openings in the history of political, artistic, and sexual liberation after 1917. Kollontai later reported that all socialist groups underestimated the

mood of the women workers in the factories and how powerful they were. Bini Adamczak, a theorist and an artist, speaks of 'the gender of the revolution', stressing, with Kollontai, that a revolution that only focuses on rationality, effectiveness, hardness, toughness, will never achieve the vital base for a communist society, namely the human bonds. The revolution failed as it had too much of the male gender. It could potentially be changed, and there was, in fact, an attempt to do that in 1968 with the politicisation of love. Kollontai claimed that the revolution has to be seen as a new form of relation between men, women and children, and it is supposed to be played out with the involvement of love and emotional labour. Her concept of 'comradely love' was taking it out from its cage in the private sphere, where it is individual and lonely, and making it public, as a political and social force. This is almost like reading the writings of the second wave feminists proclaiming that the private is political, and it's not at all far from current struggles. How does this relate to the succeeding and the contemporary feminist movements according to you?

DG: It is often that I meet young European women who consider that there is nothing to fight for anymore, that all has been won. The arrogance and self-complacency of such a statement is stunning. Everything has to be fought for, yet and still. Right now, it is very possible that the right to abortion is overthrown in the US, as it could be anywhere in Europe. There are both reasons to despair (Trump, AfD, Orban, Brexit) and to thrive (all the young women running for office in the US and Europe and the

world). I think war is coming, as ferocious as ever, between reactionary forces and forces for change. There has never been any peace, really, and all the issues Kollontai fought for have never been once and for all established, but on the contrary, they need to be fought for over and over again, #MeToo is just a small part of all this.

JW: Women's political mobilisation has had a recent revival in Poland. Since the new populist government came to power in 2015, there were different mass protests taking place all across the country. Some of them, such as KOD (Committee for the Defence of Democracy) aimed at reviving the ethos of the Solidarność movement, however, what was immediately noticeable was that people below forty years old were missing. The only substantial movement, across class, across age, across gender and even across the political spectrum, was in 2016 the Black Protest in reaction to the proposal of the tightening of abortion laws, already illegal in Poland since 1993 (in the 1960s and '70s, Poland, along with other communist countries, was an abortion destination for many women from Scandinavia). The protest was taking all forms of performativity, for example when it was mentioned during Catholic sermons that the policy regulations for abortions were to be tightened, women would stand up and leave in the middle of the service. Performing this protest as part of the Catholic mass for a believer was definitely a new and powerful dimension of political expression, seemingly more encompassing than #MeToo.

Michele Masucci: Protests emerge in different forms. People are intimidated but also more aware of the need to engage. Nothing is given. After decades of neoliberal policies, fascism and right-wing populism are again rising with racist attacks on women, the LGBTQ community, immigrants and Muslims. Capitalism has always been a history of war and violence *in the name* of progress. Egalitarian tendencies within capitalism are conditioned. Any rights gained through hard struggle can be repealed. Capital interests come first. The space for community, openness and love is threatened by hate as we see the extreme right-wing gain political power. With these scenarios, the need for an 'army of love' seems urgent. As Sara Ahmed points out in her essay *In the Name of Love*, nationalism and racism are also based on a form of love, that for the nation, the race or closed group as different from the other. It is a violent love that excludes, dehumanises and feeds on hate.

DG: Here I feel like quoting a very popular slogan against teenage domestic violence: 'If it hurts, it is not love'.

JW: Speaking of love for the nation. While working in the former GDR, Dora, you were interested in how the emotions and the loyalty of the individuals for the state prevailed sometimes over the love for the parents...

DG: In 2006, when I did work on the political police in East Germany (Stasi), it came to my attention that in the GDR women often had children with different partners, because they did not become economically dependent on

any husband, and divorce was not socially stigmatised. Next to that, the system of nurseries was wonderful; you could put your children there from three months old, and pick them up at night. Yet, those conditions, ideal on paper, created a situation in which children grew distant from their parents, but they were extremely devoted to the state — they were subjected to propaganda 24/7 without the possible protection a family might offer. So it sometimes happened that they denounced their parents for not being 'good communists'. The dream of reason produces monsters...

JW: And which kind of love is there in the collective project *Army of Love*, is there any relation to 'comradely love'?

DG: *Army of Love* is a collective endeavour (contrary to my other projects on similar issues such as *The Romeos or Zimmer, Gespräche*). And I should point out that what I say here does not necessarily represent the thoughts of the Army of Love as a community. When the Army of Love speaks of love as a common, it is aiming at a form of social justice. Love is a basic human need, and the love soldiers, out of altruism, conviction, solidarity, are activists that will re-distribute love so that everyone has the love they need. And this is entirely incompatible with love for a specific group, exclusive love — because exclusive love always excludes. In the Army of Love, it is necessary that love is for everyone. Love as commons is love for everyone, whether you are gay or straight, atheist or religious, black or white. Love has to happen between equals, and those who are not equals are made equals through love.

'Love for many in many ways' Kollontai would say, and this is opposed (starkly so) to any form of nationalism, supremacism, or racism.

Michele Masucci: Dora, in some of your works you have referenced Fourier's theories on feminism, social cooperation and free sexuality as a source. Fourier was, of course, an important reference for Marx and other radical thinkers. Kollontai was in turn inspired by August Bebel, Friedrich Engels, Grete Meisel-Hess and her engagement with other female socialists. Fourier seems absent in this list, albeit indirectly influential, perhaps due to Marx's rejection of socialist utopians, such as Proudhon, Saint-Simon and Fourier. However, it is also well known how Fourier's ideas on the relationship between work and play influenced Marx early theories on alienation. What do you think are the significant relations and differences between Kollontai and Fourier's conceptions of love?

DG: In my view, the main differences are that Fourier is a visionary with stronger connections to Sade (hoping to read Fourier, Sade, Spinoza by Barthes soon) than to proto-socialist circles. In Fourier's vision, nothing that gives pleasure is alien to humanity. No pleasure is 'dangerous' or 'harmful', they all belong to human nature, and they are all part of our human condition. Repression of any sexual impulse is, on the contrary, harmful. Sexuality is part of the individual but also part of the group and should be encouraged and cared for. In the case of Kollontai, even if under her direction homosexuality was de-penalised, it

was not acknowledged as a sexual impulse as natural as heterosexuality, and no effort was made to end the social stigma — and soon, after the golden years of the revolution, it was penalised again. In her writings, such as 'Make Way for Winged Eros', there are constant references to 'healthy' sex, 'natural' attraction, without explaining too much what kind of sex that is, but obviously implying that there is a type of sex that is unhealthy. There is no such thing for Fourier.

MM: During her time Kollontai witnessed how sex work was unsafe and how it brought terrible consequences for many women. Pregnant women had to leave their work and often had to abandon their newborns and return to work. Pregnant workers had to work, all the same, even night shifts. Many of the social reforms Kollontai introduced regarded the conditions for women, transforming sexual relations, motherhood and trying to make prostitution redundant. Kollontai also criticised marriage as a form of institutionalised prostitution. In the Army of Love, the possibility to share one's sexual abilities as a form of political force is explored. It is sex in service of, but consensual, and not bought. It is a form of free sex, or free love as a commons, with the potential to transform social relations and ultimately society as a whole. Would you say that the practices and ideas proposed in the Army of Love go further than Kollontai's ideas of comradely love, a form of equal relationship between the sexes? Sex not only seen as a necessary passion that should be exercised in a comradely fashion in service of the new society but actually as a primary motor in the transformation of human relations?

DG: Kollontai only seems to take into account a hetero-sexual desire between 'healthy' people that are in a presumably good physical condition. In her imagery, still, too close to socialist realism, we imagine young muscular workers possessed by the desire of young muscular workers. It does not seem to take into account those who are not so desirable both in capitalist and apparently in socialist terms as well: the old, the sick, the crippled, the mad, and of course, non-normative desire. In that, Army of Love goes further because it wants to consider all bodies worthy of desire; if desire does not come naturally, the love soldier will force desire into him or herself. The army as well considers that love only exists between equals (this is the same as Kollontai) BUT, and here comes the revolutionary character of love, love will turn into equals those who were not, in order to love each other. The soldiers of love act out of the strong moral conviction that every human being deserves love, that love should be a commons, and that the function of the Army of Love is making sure everyone gets its part. It is not charity, it is social justice, and the soldiers of love will be trained to feel love (eros, philia, ludus, agape) whenever they have to. What Fourier calls 'sexual philanthropy'?

JW: Or a 'mercy fuck', in the words of the artist Every Ocean Hughes (formerly known as Emily Roysdon). Kollontai was sublimating sex and desire into politics, she was introducing the figure of 'single women' for whom life is not reduced to love for somebody else, but love for many, for a cause, an idea. Love was also beyond property, beyond ownership, regardless if sex was or not involved.

It of course backlashed, she was accused of nationalising women.

DG: Although I find humorous the interpretation by Emily, mercy is contrary to justice. In Army of Love, we are instead talking about a justice fuck (this is funny).

MM: During the 1960s and '70s both Kollontai and Fourier's ideas gained attention. This period is also signified by the ideas of sexual emancipation, free love and experimentation, the idea of love as a political force was prevalent in many different fractions. Marxist feminists at the time pointed to the negative aspects of love for women, in Silvia Federici's words: 'They say it is Love. We say it is unpaid labour. They call it frigidity. We call it absenteeism. Every miscarriage is a work accident.'[1]

DG: Although I haven't read Federici, I do agree with her. Romantic love, and here I go full Kollontai, is a pernicious tool of the heteropatriarchy. Men have all the winning cards in the construction of romantic love. Fourier has this expression, 'pivotal relationship' which is a type of relationship I can accept much easier. I do not believe in romantic love, but I do think in constructing long-term relationships based on mutual trust and shared interests, relations to which you come back again and again through life, as close to monogamy as one can be.

MM: The question of consent and how it is reached and determined has gained attention with #metoo. In Sweden, a law on the requirement for sexual consent was

recently passed with a vast parliamentary majority. At the same time, we still see anti-feminist policy, misogyny and sexual abuse of women, lesbian, trans, bi and queer. How should we understand the question of consent, and equality in a world that is overwhelmingly divided, and where different forms of exploitation and submission are an inherent part of the social and political structures?

DG: It is complicated — in Simone de Beauvoir's words, marriage is a form of prostitution — power inequality and potential abuse is entangled with every kind of social interaction. The fact that we must acknowledge the reality of prostitution ('simply because men are pigs'), and make sure, as much as we can, that prostitutes are insured medically and protected by a social security system, that they own their wages and that mafias and proxenetism are eradicated, all that, being necessary, should not normalise prostitution:

> Obviously, it is not through negative and hypocritical measures that this situation can be changed. For prostitution to disappear, two conditions are necessary: A decent job must be guaranteed to all women; customs must not place any obstacles to free love. Prostitution will be suppressed only by suppressing the needs to which it responds.[2]

JW: In Kollontai's time, only ten percent of women were working, and seventy percent of them were living off their work as prostitutes.

MM: Kollontai seems to have been a political virtuoso dedicating her life in the service of revolution. Today several forms of work require the script of bond making, being a well-networked, loving co-worker, always ready to listen, to be a friend or lover, to be intimate. We enact intimacy and care as a form of establishing alliances in an ever-increasing situation of insecurity and precarity. If we think of love as the primary weapon against fascism, how do we liberate the emotional labour we are capable of from professional spheres towards this political end?

DG: I am not sure that love is the primary weapon against fascism (I am afraid we are going to need more than love), but it is undoubtedly a powerful one, a necessary one.

MM: It would be naïve to think one emotion is the key. Our ability to bond is a commons and thus exploitable. Can love, as one way to fight fascism, also risk becoming endurance by coping or bonding rather than opposing structural oppression?

DG: Of course I think love is a tool to fight fascism, not to endure it. Because I believe heteropatriarchy — for lack of a better name or patriarcho-capitalism — is a system that only knows one way to relate to the world / the other: predation. Therefore love, as anti-predation, is a form of struggle.

1 Silvia Federici, *Caliban and the Witch: Women, The Body, and Primitive Accumulation* (New York: Autonomedia, 2004).

2 Simone de Beauvoir, *The Second Sex*, trans. by H.M. Parshley (London: Cape, 1953).

ANTI-ABORTION STRUGGLES IN POLAND
TOMÁŠ RAFA

During the Black Monday protests on 3 October 2016, women across Poland went out on strike against the proposal of a total ban on abortions. The protest also comprised strikes where women who opposed stayed away from work and school and refused to do domestic chores. The protest is said to have been inspired by the women's strike in Iceland in 1975.

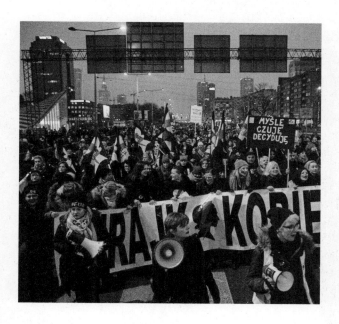

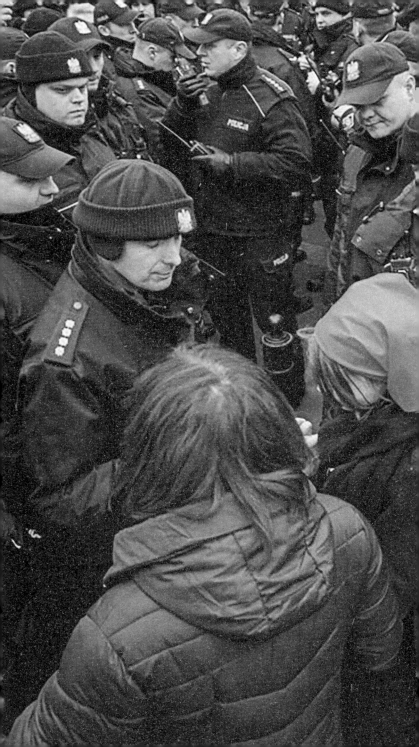

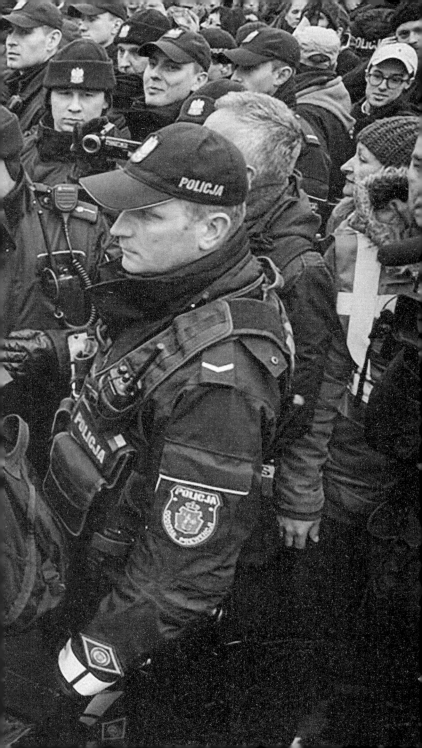

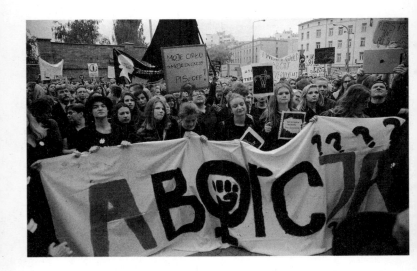

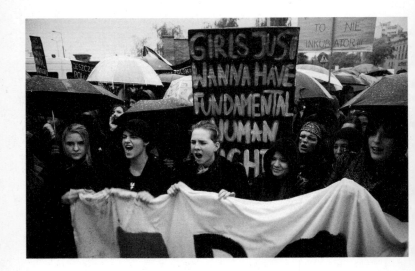

A WHORE MANIFESTO
OXANA TIMOFEEVA

———

PRELIMINARY NOTE:
A MESSAGE FROM THE DARK TIMES

Alexandra Kollontai was one of those great communist political, cultural, and intellectual figures of the period after the October Revolution, for whom, the question of sexuality (also called love) in the context of social organisation was crucially important. What was to be done with love and sex in the new communist society free from exploitation and inequality projected by Bolsheviks? How should people become happy both in their public life and private lives? What would a genuine feminist politics be which concerns not only political and economic rights and possibilities for women, but also their sensual experiences and personal developments? These were the questions raised and discussed by Kollontai and her comrades in post-revolutionary Russia and throughout Europe at the time.

Unfortunately, these questions are still without answers. History turned in a bad direction and the better world of a victorious communism as described by Kollontai in her science-fiction novel *Soon (In 48 Years' Time)*, written in 1922, never came true. In this story, future generations live in communes; they are done with inequality, resolved all social problems, and now can put all their free energy into the mission of revolutionising and harmonising nature itself. That's how things should

have looked like in 1970 according to Kollontai. Let me register myself chronologically: I have written this text in 2018, that is another forty-eight years after the 'soon' of Kollontai's utopia, and one hundred years after the first communist attempts — albeit difficult, and dangerous, and done in harsh port-revolutionary social and economic conditions — to liberate sexuality. The fact is that, demonstrating a disgraceful historical regress, Russia as a country ended up with a whole flood of reactionist traditionalism that constitutes an attack to the entire domain of sexual life, and particularly women's rights, washing away all the remains of gender equality that was inserted by the Soviets.

Let me mention some exemplary facts. In February 2017 (the year of the centenary of the revolution) the Russian president signed a law that decriminalised beatings in families: one can now legally beat a wife, or a child, as long as there are no severe injuries. This is not the only example on the level of legislation; there are also numerous attempts to introduce severe anti-abortion regulations, and many other initiatives of this kind come from the authorities that are developing policies for increasing birth rates in times of growing poverty. Russian state parliament legitimates harassment: thus, recently, a special parliamentary expert committee concluded that the behaviour of the deputy, who sexually assaulted a young female journalist, does not violate any social norm.[1] The society itself is becoming sexist; the victims of rape suffer massive attacks of slut shaming in social networks and even media.[2] The ugliest processes develop on the level of ideological superstructure, where the autocratic state

together with the Orthodox Church actively imposes aggressive patriarchal values and propagates the images of the all-powerful traditional macho-man and an obedient, submissive woman.

How different is this last image from the one depicted by Kollontai in her great essays! Whereas early communist ideology is better known for projecting a gender neutral 'new man', Kollontai anticipated the birth of a 'new woman' in the process of historical emancipation. 'What — the new woman? Does she really exist? Is she not the product of the creative fancy of modern writers of fiction, in search of sensational novelties? Look around you, look sharply, reflect, and you will convince yourself: the new woman is certainly there — she exists' — she wrote in the essay 'The New Woman' from her book *The New Morality and the Working Class*.[3] What would this — in fact already existent, but in a reduced, hidden way — new woman be or look like? Kollontai gives us an idea: the new woman is creative, she is busy with politics, science, or writing; she has a lot of serious work to do; she has, as Virginia Wolf says, 'a room of her own'.[4]

In a word, the new woman is *free*. This implies, literally, that she is not enslaved any longer, not subordinated, not considered as a beautiful attachment to a man, as a mother, or something else at someone else's service. She freely enjoys her own life, and her own will to *happiness* makes this life full of sense. Sexually, she is emancipated, too. Her love life is rich and manifold. She is not someone else's, but rather she is *single*. She may have diverse partners, pass from one relationship to another, and thus she develops her experiences that make her heart stronger. In her essay 'Love and the New Morality', Kollontai says:

The light already glimmers, the new types of women already begin to show — the types of the so called 'single women' for whom the treasures of life are not reduced to love. In the sphere of love affections, they do not allow the waves of life to rule their shuttle; an experienced pilot rules, their own will hardened in life battles. And a fillister claim: 'She has a past!' is paraphrased by her: 'She does not have a past — what a terrible destiny!'[5]

The problem is that the new woman, who, according to Kollontai, already exists, is free, but the world is not. According to the traditional values imposed by patriarchal society, and particularly contemporary Russian ruling class ideologists, a 'terrible destiny' of having no past (meaning simply: no love stories behind) must be a destiny of all women, and the 'fillister claim' points to every woman who does not fit into the stereotype of a good girl, a good mother or a good wife. A sexually emancipated woman in a sexist, not-emancipated world is still a victim of blame, accusations and moral attacks. Ironically, Kollontai herself was shamed, for instance, by famous cultural figures at the time such as the sociologist Pitirim Sorokin and the writer Ivan Bunin:

Concerning this woman, it is clear that her revolutionary enthusiasm is nothing else than a mediated satisfaction of her nymphomania. In spite of her numerous 'husbands', Kollontai — first a wife of a general, then a mistress of a dozen of men — is still not fed up. She is seeking for new forms of sexual sadism. I would love

her to be observed by Freud and other psychiatrists. She would be a rare object for them (Pitirim Sorokin).

On Kollontai (said by N.N. yesterday):
—I know her very well. Some time, she was looking like an angel. In the morning she was putting on the simplest dress and jumping to worker's slums — to 'work'. Then she was coming back home, taking a bath, putting on a blue shirt — and jumped to her girlfriend's bed with a box of candies: 'So now let's have a chat to our heart's content, my little friend!'

—Forensic psychiatry and medicine know already for a long time of these (angel-like) type of inborn criminals and prostitutes (Ivan Bunin).[6]

This is the cultural context within which the following Manifesto was written. It is not a scholarly piece, but a personal document of mine. It colludes with Kollontai at all points, but it steps further in a direction that Kollontai would probably not fully agree with. If she claims for gender equality, I insist on a gender asymmetry, and to discuss the link between communism and matriarchy — these non-existent, utopian things.

A WHORE MANIFESTO

I am writing this essay and thinking that perhaps it will never be published in any 'serious' edition. It would never go through the eye of a needle of censorship. I am writing it with a kind of fear and hope that only my people will

read it and listen to it. These thoughts are coming from the very depths of my heart. No, the word heart does not really fit here, and the word depths neither. We say 'depth' when we go to the bottom, and these thoughts go from where there is no bottom. There is always a layer even lower in which to fall. Just like us.

We are those who were stigmatised as fallen. Prostitutes, whores, sluts. This is not what we name ourselves. This is what we are named by those who think they call things by proper names. But, first of all, we are not things, and second, things do not have proper names (things do not have anything at all; they are either someone's, or no one's). Thus, we are labelled by those who love us — in their passionate outbursts of jealousy. By those whom we love, and that don't love us back. By those to whom we did not reply 'yes'. By those to whom we did reply 'yes'. By those to whom we replied 'no', but they took it as 'yes' and used violence. And all others, too — all those disgusting teachers, aunties, priests, and policemen. And we are trying to justify ourselves, trying to show that we are not like that. But this doesn't work, because, actually, we are like that.

We are those who fall in the trap of language. Of a bitter tongue — we should have bitten it off long ago, when someone put it in our mouth.

The trap in which we dwell is made of two elements.

The first element is a juxtaposition of desire, enjoyment and guilt in Christian culture. We are expected to

prove our innocence. It will be accepted if we manage to convince them that we did not desire and did not enjoy it. Thus, it goes without saying that the victim of sexual violence cannot desire or enjoy, but only passively suffer. Every feminist knows that. The fact that she did not desire and did not enjoy means that she is not guilty, that she is an innocent victim (don't tell them that you can enjoy!). In contrast to that, the violators justify themselves with her own desire and enjoyment: she wanted that, liked that, thus it was her fault. But in fact, both parties base their positions on the premise that our desire and our enjoyment make us guilty.

The second element is a very rigid taboo that exists in our culture that of female polygamy, coupled with a positive or loyal attitude towards a male one. It is as old as the legends of matriarchy, when this taboo did not exist. The echoes of that legendary state are the pagan orgies of fertility and the cults of insatiable goddesses from ancient history, or rare cases of polyandry in some small groups. Scientists have already debunked a few evidences of a really existing primitive matriarchy and generally rejected this hypothesis or myth. However, some people still believe in the other one, really close to it, that is, the hypothesis of an existing so-called primitive communism. One piece of evidence of the kinship between these two hypotheses is group marriage: it is attributed to a primitive communism that allegedly combines patriarchic and matriarchic social practices.

Both hypotheses are scary and tempting at the same time. At the initial point they coincide in a positive or negative image of an archaic savagery, and at the final

point they create either utopia or dystopia. If an initial point coincides with its final point, thus creating a time loop — both communism and matriarchy present a generic memory of humanity — a memory of what has never been before.

This generic memory hardly differs from oblivion. That's why, perhaps, it lurks at the periphery of consciousness. Our real or imaginary polyandrous sexuality arouses their sexual excitement or moral resentment, or both. Men who, when no one sees them, masturbate to gangbang porn and then generously ejaculate on our faces with their moralin, — what happens in their pitiful souls? What stands behind that ambiguous excitement that they feel when they are watching us, spying on us, fantasising about our fall and destruction, shaming us, and claiming that we wanted that, that we liked that? Sergei Yesenin, a famous Russian poet, calls this 'a bitter truth of the world':

Yes! There is a bitter truth of the world
When a child I caught sight of that truth:
Troops of hounds, excited and wild,
Taking turns lick a bitch all in juice.[7]

In this poem, dedicated to Isadora Duncan, there are lines that are not part of official poem collections: 'Let her kiss, pet and fondle another, Ah, this obsolete, beautiful slut'. Here, jealousy is doubled with and intensified by a traumatic recollection of what one might call a primary scene, a childish theatre of a rough animal copulation in the centre of which there is a beloved one — a slut, a goddess, and a mother.

A poet's primary scene is analogous to those sets of nature which Freud analysed. According to Freud, these memories do not necessarily derive from real events. Childish screen memories about the acts of violence, seduction or sexual intercourse can be constructed. They are mostly indirect, more like allusions, and come from the world of desires that we would never recognise as our own, and that would never get through the instances of censorship whose function is to adopt our drives to the rules and requirements of human society. The idea is the following: even if this never happened before, it still happened. Just not in our life.

Freud arrived at this conclusion after analysing memories of his patients diagnosed with hysteria about the scenes of seduction or violence that was done to them in their childhood by adult uncles and daddies. At the beginning he was thinking that these memories directly related to real facts, but soon a mass of such material became critical. The fact that everyone was really raped or seduced by her father could not be true! Thus, Freud had to abandon his initial hypothesis of seduction. What was at stake was not reality, but an unconscious fantasy that fills a lacuna of desire coming from no one knows where:

> Whence come the need for these phantasies and the material for them? There can be no doubt that their sources lie in the instincts; but it has still to be explained why the same phantasies with the same content are created on every occasion. I am prepared with an answer, which I know will seem daring to you. I believe these primal phantasies, as I should like to call them, and no

doubt a few others as well, are a phylogenetic endowment. In them the individual reaches beyond his own experience into primeval experience at points where his own experience has been too rudimentary. It seems to me quite possible that all the things that are told to us today in analysis as phantasy — the seduction of children, the inflaming of sexual excitement by observing parental intercourse, the threat of castration (or rather castration itself) — were once real occurrences in the primeval times of the human family, and that children in their phantasies are simply filling in the gaps in individual truth with prehistoric truth.[8]

What if a poet's love to a woman whom he calls a slut, a love accompanied by the delusions of jealousy, is so painful to him precisely because it kicks him 'beyond his own experience into primeval experience'? Let's just think dialectically and relate these experience-memories not to what has been (prehistorically), but to what has not been yet. To a disturbing image of matriarchy that has never been, the time that did not have place, when polyandry was not considered a sin, a crime or a sign of a moral degradation of a woman.

All male fantasies about the orgies of Snow White with the participation of seven dwarf men, in the centre of which their jealous desire places our bodies, appear at the point where the beginning and the end of a time loop coincide. A gangbang style orgy with its main goal to bring the most intense pleasure to a woman, and a group rape that makes her suffer and causes injures, from the anthropological point of view, are related social practices of

a matriarchic drive perverted within a patriarchic order. A collective gnome does not really understand: does he punish a slut or worship a goddess? Even when he punishes, he simultaneously worships, as if he still wanted to satisfy her desire, or, to be precise, not exactly a desire but what stands beyond all desires, namely, her death drive. In this obscure theatre, either as a spectator, or as an actor, he unconsciously makes a sacred ritual in which Eros and Thanatos coincide, and the sense of which he would never understand.

There is a principal asymmetry between the male and the female polygamy. This asymmetry is explained by a bodily symbolism of the sexual difference. A male body is a phallic symbol. As Jacques Lacan explains, a male enjoyment is an enjoyment of the organ: 'Phallic enjoyment is the obstacle owing to which man does not manage, I would say, to enjoy the woman's body, precisely because what he enjoys is this enjoyment, that of the organ.'[9]

The organ, around which a male body is structured, is single and solitary. Its sense in our culture is really exaggerated. Its main trouble is that, in a given moment of time, it cannot be put into more than one person, or, to be precise, into more than one part of the body of no more than one person. That's why a male polygamy is linked to the lists, to the queue, to the counting of women, to natural numbers: one by one.[10]

'How many men did you get before?' That's what they ask us, with their big or small Don Juan's list in their heads. This question sounds really stupid for us, but we cannot answer it, we have to lie. We have troubles with counting. We cannot say any convincing natural number,

because our body is a totally different symbol. What stays for us, as Hegel would say, is not a singular, but a universal:

In the household of ethical life, it is not *this* man, and it is not *this* child; rather, it is *a man, children as such* — these female relationships are grounded not on sentiment but on the universal. The distinction between her ethical life and the man's ethical life consists in this, that in her destiny for individuality and in her pleasure, she remains both immediately universal and alien to the individuality of desire.[11]

In the gnome's fantasies our bodies could accommodate all the divine trinity, and much more. Alien to the individuality of desire, our humiliated body turns to be a sign of anticipation of communism where happiness will look totally different than that. While male enjoyment attaches, sticks to a part of this body, its other parts do not stand idle. You are not alone in this room. In every intercourse she invisibly and gratuitously gives herself to the entire male half of humanity, to the whole of genus, not only to one individual, a single representative of a genus. She is not yours, gnome.

Lacan calls the act of love the polymorphous perversion of the male' and claims that there is another enjoyment that lies beyond the Phallus: 'So then we call it as best we can vaginal, the posterior pole of the uterine orifice and other stupidities (*conneries*), make no mistake!'[12] A male symbol always makes a blunder, misses the point. A weird woman's enjoyment, according to Lacan, is not the one of the organ at all, rather it is the one of God —

that does not exist, but this is already another story. A moral gnome that blames us is in fact jealous to this enjoyment, the nature of which he would never know, as we'll never tell him about that: in the trap of language our mouth is always busy with something else.

POSTSCRIPT

If Lacan is right and love really is 'the polymorphous perversion of the male', then another enjoyment 'beyond the phallus' points to a form of relation (or non-relation, as Lacan would say) other than love. For Lacan, this other form is divine, for me it is political. I name it comradeship. It came to me once, when I was talking to a female friend — well, not really a friend, but a comrade — and this was exactly what we discussed: an old sexist stereotype according to which friendship is a masculine thing, and there cannot be real friendship among women. So, we decided, why don't we leave them their friendship and other cosy bourgeois pleasures, as what is possible among us women is not friendship but comradeship!

Of course, that was a joke, but I dare to say that there is a deep truth within it. Women can very well be just as good as friends or lovers, as men can be good comrades — every form of relation is open to any gender. This is not a question of gender identity, but a question of sexual difference, which persists in every sexual (non)relation, even if everyone is of the same gender or if a variety of genders involved goes beyond the limits of traditional roles of masculine and feminine. Following Alenka Zupančič,

I understand sexual difference and its political relevance as ontologically biased.[13] According to Zupančič, sexual difference must be taken not dogmatically, as a binary opposition (this would be really obsolete), but dialectically, as an antagonism, analogous to class struggle:

> True feminism depends on positing sexual difference as a political problem, and hence on situating it in the context of social antagonism and of emancipatory struggle. Feminism did not start from trying to affirm some other, female identity (and its rights), but from the fact that roughly half of the human race, referred to as 'women', was non-existent in a political sense. It is this nonexistence, this political invisibility, which actually functioned as a *homogeneity* of the political space, that feminism transformed into a split, a division, which concerns *all* (hence its political dimension). In this context it is essential that at stake in this gesture is not a political affirmation of some independently existing ontological divide (between 'men' and 'women'), but something that first constitutes sexual difference as difference or divide.[14]

So, we as women are not a gender identity, but rather something similar to a class position: being a woman in patriarchal society is structurally close to being a proletarian in capitalist society. A woman, treated, as a whore, and a worker, treated as a working horse, are comrades. They are on the same side of the divide that they produce (whereas the enemy — patriarchy or capitalism — proclaims a unity, a harmony, and other figures of false

consciousness). As Jodi Dean recently argued, comrade-ship means being on the same side: "Comrades are those on the same side of the division. With respect to this division, they are the same. Their sameness is that of those who are on the same side. To say 'comrade' is to announce a belonging, and the sameness that comes from being on the same side."[15]

Dean refers to Maxim Gorky's amazing short story, where the word 'comrade' operates as a kind of performative: the moment it is pronounced, it creates a multiplicity of the oppressed people and transforms their being as they are now on the same side:

The prostitute who, but the evening before, was but a hungry beast, sadly waiting on the muddy pavement to be accosted by someone who would buy her caresses, the prostitute, too, heard this word, but was undecided whether to repeat it. A man the like of whom she had never seen till then approached her, laid his hand upon her shoulder and said to her in an affectionate tone, 'Comrade'. And she gave a little embarrassed smile, ready to cry with the joy her wounded heart experienced for the first time.[16]

What if comradeship as a form of relation, that is different from love, friendship and so on, and that is historically linked to communism rather than any other form, is feminine? The feminine here is opposed not to the masculine, but to the patriarchal, that is based on the principles of the individual and of ownership. What is so disturbing about a whore? The idea that she is giving herself to anyone

without becoming someone's. She is giving herself while escaping to really belong. She is common, like the air we breathe. That's why in its polyandrous corporeality female desire is proto-communist. What is labelled as a whore in this world, in another world will gain dignity and respect. We will find it there, in a liberated form, beyond sexuality, as a new form of social glue.

According to Dean's first thesis on comradeship, '"Comrade" names a relation characterised by sameness, equality, and solidarity. For communists, this sameness, equality, and solidarity is utopian, cutting through the determinations of capitalist society.'[17] Dean lists some determinations of a society that she calls a communicative capitalism. The first one is that 'communicative capitalism is marked by the power of many, of numbers. Capitalist and state power emphasise big data and the knowledge generated by finding correlations in enormous data sets. Social media is driven by the power of numbers: How many friends and followers, how many shares and retweets?' The other feature is individualism. In the paper presented at the conference on the centenary of the October Revolution at St Petersburg, Dean also noted:

Communicative capitalism enjoins uniqueness. We are commanded to be ourselves, express ourselves, do it ourselves. Conforming, copying, letting another speak for us are widely thought to be somehow bad, indications of weakness, ignorance, or unfreedom. The impossibility of an individual politics, the fact that political change is always and only collective, is suppressed, displaced into the inchoate conviction that we are determined by systems and forces completely outside our capacity to affect them. Climate changes. Not us.[18]

Both of these determinations are characteristic of Lacanian phallic enjoyment, a jealous and greedy enjoyment of the organ. Gorky's prostitute and her anonymous comrade break this perverse unity of individuals and their great numbers. In comradeship, identity vanishes. Think about the Russian Bolshevik revolutionaries in the underground: for the sake of conspiracy, they lived faked social lives under different names, constantly changing their passports, families, or even gender. What acts here is a mask, beyond which there is no real face, but only a pain to be shared.

Comrades are replaceable; they wear false names and false moustaches. This aspect of the masquerade makes politics a theatre, but a very special one, like Artaud's theatre of cruelty; here, ancient masks are back, as they present a show, a ritual of a direct and instant communication like a plague, a contagion. The void beyond the mask can be that contagion, or, in our words, sharing of the pain — not symbolically, as between sisters, but bodily. Friendship, love, sisterhood and other nice things could be there too, but these things, as we know them, normally, attach us to a singular individual, who has a name, a face, and something which cannot be replaced. A friend or a beloved one is pinned down by their identity. Comrade is the one on whose neck you can put your head; to whom you can give one of your hands if she has none at that decisive moment when the enemy attacks.

For Alexandra Kollontai, comradeship was a form of love. Love was a name she used as a universal for all kinds of proximities between human beings. In her essay 'Make Way for Winged Eros' (1923) Kollontai outlines a brief history of love. As a good Marxist, she links successive

historical forms of love to different social formations: blood relations for a kinship community; love-friendship for antiquity; courtly love for a feudal system, bourgeois links between love and marriage for capitalism, and, finally, a new form, that she anticipated, of love-comradeship for the working class building a new society. What is interesting about this form of love-comradeship is that it actually does not negate, but rather combines all previous forms and invents new ones, based on a larger variety and diversity of desires and overcoming of the principle of property.

Note that this form of love-comradeship is not the last one. The last one is yet to come, with the global triumph of communism, and we do not know how it will look like, which form it will take, but Kollontai gives an image of it — Winged Eros. We can only speculate about it. The main thing I can say now is that it will be based on a totally different form of political economy. Capitalist economy as we know it, is extractive on the level of social organisation, and libidinal on the level of private life. As social units, we are parts of an extractive economy that never stops to produce surplus value; as individual bodies, we make libidinal investments into the world of commodified objects. Both a libidinal and an extractive economy are based on a lack of material and non-material resources.

Sexual relations that we know, or libidinal relations, characterised by jealousy and the sense of property, correspond to capitalist economy. Instead of a libido based on lack, whose movements are thoroughly analysed by Freud and Lacan, communism will develop a new type of energy, based on excess, that Kollontai calls a 'love potential'.

Instead of taking, there will be giving — giving oneself to anyone without keeping anything for one's own; there will be a total sharing of enjoyment and pain. Love potential as opposed to libido.

So, again: love-comradeship described by Kollontai, corresponds not to a communist future, not to a classless society, not to a social democracy, but to a very specific and temporary state of proletarian dictatorship, that is, a militant revolutionary state of the Soviets. It is an intermediate form that will bring us to communism. Its mission is to develop a love potential, to make it grow, to prepare conditions for the winged communist Eros to come. Love-comradeship is a kind of rehearsal of communism, a game, and a theatre where we stage what is yet to come. Why do I call it feminine? Because it corresponds to the structural place now labelled as a 'whore' — a feminine that gives itself to anyone and goes beyond individuality. Comradeship is a social tie that has as its secret agent the women of my Manifesto — a Lacanian woman, who cannot count her enjoyment, a Hegelian woman, whose universality remains 'alien to the individuality of desire', and the Snow White, whom they call a whore, and I call a comrade: forget my proper name.

1 Andrew Roth, 'Media Boycotts Russian parliament in sexual Harassment Row', *Guardian*, 22 March 2018 <https://www.theguardian.com/world/2018/mar/22/russian-media-outlets-boycott-parliament-in-harassment-row> [accessed 11 September 2018].

2 Tom Parfitt, 'Teenage Rape Victim Divides Russia after Backlash Makes Her Go Public', Times, 22 April 2017 <https://www.thetimes.co.uk/article/teenage-rape-victim-divides-russia-after-backlash-makes-her-go-public-htksckbs8> [accessed 11 September 2018].

3 Alexandra Kollontai, 'New Woman', *The New Morality and the Working Class* <https://www.marxists.org/archive/kollonta/1918/new-morality.htm> [accessed 11 September 2018].

4 Virginia Woolf, 'A Room of One's Own' <http://seas3.elte.hu/coursematerial/PikliNatalia/Virginia_Woolf_-_A_Room_of_Ones_Own.pdf> [accessed 11 September 2018].

5 Alexandra Kollontai, 'New Woman', *The New Morality and the Working Class* <http://www.odinblago.ru/novaia_moral/2> [http://www.odinblago.ru/novaia_moral/2].

6 'Aleksandra Kollontai', *Wikipedia* <https://en.wikipedia.org/wiki/Alexandra_Kollontai> [accessed 11 September 2018]

7 Sergey Yesenin, trans. by Alec Vagapov, 'Collection of Poems' <http://samlib.ru/a/alec_v/yes-chron-eng.shtml> [accessed 11 September 2018].

8 Sigmund Freud, 'INTRODUCTORY LECTURES ON PSYCHO-ANALYSIS (1916-17)' <https://freudianassociation.org/en/wp-content/uploads/Sigmund_Freud_1920_Introductory.pdf> [accessed 11 September 2018].

9 Jacques Lacan, trans. by Cormac Gallagher, 'The Seminar of Jacques Lacan', *Book XX: Encore. 1972–1973*, 27 <http://www.lacaninireland.com/web/wp-content/uploads/2010/06/THE-SEMINAR-OF-JACQUES-LACAN-XX.pdf> [accessed 11 September 2018]

10 See on this, for example, a book by Lorenzo Chiesa, *The Not-Two: Logic and God in Lacan* (Cambridge, MA: MIT Press, 2016).

11 G.W.F. Hegel, *The Phenomenology of Spirit*, trans. by Terry Pinkard (Cambridge: Cambridge University Press, 2008), p. 409.

12 Lacan, *Encore*, p. 163.

13 Alenka Zupančič, *What Is Sex* (Cambridge, MA: MIT Press, 2017), pp. 35–72.

14 Ibid. p. 36.

15 Jodi Dean, 'Four Theses on the Comrade', *e-flux journal*, 86 (November 2017) <https://www.e-flux.com/journal/86/160585/four-theses-on-the-comrade/> [accessed 11 September 2018].

16 Maxim Gorki, 'Comrade', *The Social Democrat*, vol. X no. 86 (August 1906), pp. 509–12 <https://www.marxists.org/archive/gorky-maxim/1906/08/comrade.htm> [accessed 11 September 2018].

17 Dean, 'Four Theses on the Comrade', 86.

18 Dean J. Conference paper, St Petersburg, October 2017.

IN THE NAME OF LOVE
SARA AHMED

Where was Hatewatch during 170 million crimes committed against White Americans over the last 30 years? Hatewatch. What an absurd organisation. But aren't they part of the huge parasitic Infestation which is always trying to destroy anyone who loves liberty and disagrees with the Monsters' plan for the degradation and control of the White Americans of this nation? They steal what they can and target us for government gangsterism and drooling media meatpuppet consumption... Love Watch. *The Wake Up or Die Love Watch is a listing of those who love this nation and our White Racial Family and the alternative to the lists of the parasitic propagandists.*

—Elena Haskin, *Love Watch*

1. How have politics become a struggle over who has the right to name themselves as acting out of love? What does it mean to stand for love by standing alongside some others and then against other others? It has become common for 'hate groups' to re-name themselves as organisations of love. Such organisations claim they act out of love for their own kind, and for the nation as an inheritance of a kind ('our White Racial Family'), rather than out of hatred for strangers or others. Indeed, a crucial part of the re-naming is the identification of hate as coming from elsewhere and as being directed towards the 'hate group'; hate becomes an emotion that belongs to those who have identified hate groups *as* hate groups in this first place. In the above quote, the hate watch web site, which lists racist groups on the internet, is juxtaposed with the

Lovewatch site, which also lists these organisations, but names them as 'love groups'. Such groups are defined as 'love groups' through an active identification with the nation ('those who love this nation') as well as a core set of values ('anyone who loves liberty'). Love is narrated as the emotion that energises the work of such groups; it is out of love that the group seeks to defend the nation against others, whose presence then becomes defined as the origin of hate. As another site puts it: 'Ask yourself, what have they done to eliminate anything at all? They feed you with, 'Don't worry, we are watching the hate groups' and things like this. You know what they do? They create the very hate they purport to try to erase!' (About Hate) It is the very critique of racism as a form of hate, which becomes seen as the conditions of production for hate; the 'true' hated group is the white groups who are, out of love, seeking to defend the nation against others, who threaten to 'steal' the nation away.

2. It is important to track the cultural significance of this use of 'love' within fascist groups. What does that language of love do? How does it work? Psychoanalysis has long shown us the ambivalence of love and hate. But the re-presentation of hate groups as love groups does not make explicit such ambivalence. On the contrary, the narratives work through conversion: hate is re-named as love, a re-naming that 'conceals' the ambivalence that it exercises (we love *rather than* hate). The conversion of hate into love allows the groups to associate themselves with 'good feeling' and 'positive value'. Indeed, such groups become the one's concerned with the well-being of others; their

project becomes redemptive, or about saving loved others. These groups become defined as a positive in the sense of fighting others, and in the name of others. The narrative suggests that it is this 'forness' that makes 'against-ness' necessary. Hence those who identify hate groups, as hate groups are shown as failing to protect the bodies of those whose love for the nation becomes a condition of vulnerability and exposure. By being *against* those who are *for* the nation (*anti*-racists, *anti*-fascists, etc.), such critics can only be against the nation; they can only be against love. The critics of hate groups become defined as those who hate; those who act out of a sense of 'anti-ness' or 'against-ness' and thus those who not only cannot protect the bodies of white Americans from crimes, but re-enact such crimes in the use of the language of hate. We might note then the slide from the crimes against white people committed by unnamed others ('170 million crimes committed') to the crimes committed by Hatewatch ('they steal what they can') in this narrative.

3. The re-naming of hate groups as love groups, and Hate Watch as Love Watch, exercises a narrative of love as protection by identifying white subjects as already at risk from the very presence of others. Love does not only enter such narratives as a sign of being-for-others as a way of being for the nation, but also becomes a property of a particular kind of subject. Love, that is, reproduces the collective as ideal through producing a particular kind of subject whose allegiance to the ideal makes it an ideal in the first place. There have been a proliferation of 'hate group' websites written by and for women, which argue

that women have a particular role in the defence of the nation. This feminisation of fascism is significant (see Bacchetta and Power 2002). One particular website includes a post by the former Women's Director of the World Church of the Creator, 'Lessons from the death of Princess Diana', which suggests that:

The second lesson we have to learn, I believe, is the power a woman can have. Women represent nurturing, LOVE, reaching out, touching, bridging a gap, caring for children, and bringing a gentle, diplomatic approach to the problems at hand... I mean the love borne of deep racial pride, willing to fight and die, but also willing to share a smile, shake a hand, stroke the hair of a young Aryan child. We need beautiful Aryan women, who can move among the people, speaking, entreating, and LOVING them.

4. Love becomes a sign of respectable femininity, and of maternal qualities narrated as the capacity to touch and be touched by others. The reproduction of femininity is tied up with the reproduction of the national ideal through the work of love. Importantly, then, love relationships are here about 'reproducing' the race; the choice of love-object is a sign of the love for the nation. In this posting Princess Diana as 'a woman of such racial beauty and purity' is condemned for her relations with 'non-Aryan men'. Such a narrative not only confirms heterosexual love as an obligation to the nation, but also constitutes mixed-race relationships as a sign of hate, as a sign of a willingness to contaminate the blood of the race. Making the nation is tied to making love in the choice of an ideal other

(different sex/same race), who can allow the reproduction of the nation as ideal in the form of the future generation (the white Aryan child).

5. In this paper, I examine how love becomes a way of bonding with others in relation to an ideal, which takes shape as an effect of such bonding. Love is crucial to how individuals become aligned with collectives through their identification with an ideal, an alignment that relies on the existence of others who have failed that ideal. There are of course many types of love (familial, friendship, erotic). My concern is not to define 'what is love' or to map the relation between these different kinds of love. Rather, I want to consider how the pull of love towards another, who becomes an object of love, can be transferred towards a collective, expressed as an ideal or object. I do not want to suggest a one-way relation of transference (when love for a particular other comes to 'stand for' the collective, or when our love for a collective 'stands in' for love for a particular other). Rather, I want to examine how love moves us 'towards' something in the very delineation of what it is that is loved; the direction of 'towardness' is sustained through the 'failure' of love to be returned. So, we can ask: what are we doing when we do something *in the name of love?* Why is it assumed to be better to do 'the same thing' if it is done *out of love?*

6. Indeed, of all the emotions, love has been theorised as being upmost crucial to the social bond. More specifically, love has been theorised as central to politics and the securing of social hierarchy. Love has been understood

as necessary to the maintenance of authority, in the sense that the love of 'the leader' is what allows consent and agreement to norms and rules that do not and cannot guarantee the well-being of subjects and citizens. As Renata Salecl (1998:16) asks: 'How does it happen that people subordinate themselves to the logic of the institution and obey all kinds of social ritual that are supposedly against their well-being?' The crucial paradigm is the love that the child has for the parent within the context of the familial, and how this love then gets transferred onto other figures of authority. Or as Jessica Benjamin (1988:5) puts it: 'Obedience to the laws of civilisation is first inspired, not by fear or prudence, Freud tells us, but by love, love for those early powerful figures who first demand obedience'. I also want to ask the question of how love is crucial to the production of forms of subordination and authority. However, I will not argue that the child-parent love is simply transferred into love for authority or figures of authority. Instead, I want to think about love as an investment that creates an ideal, as the approximation of a character that then envelops the one who loves and the loved ('the collective ideal'). Whilst the love that the child has for its caretakers is crucial, it will not then be theorised as a primary love from which secondary loves necessarily follow. My argument about the role of love in shaping collectives could seem rather banal or even obvious; love, after all, has often been theorised as a sticky emotion that sticks people together, such as in discourses of fraternity and patriotism. But I want to make a more complex argument, partly by thinking through how love works in places where it has been seen as more

benevolent, such as in discourses of multiculturalism. Some attempts to critique discourses of racial purity — of narcissistic whiteness — are about finding a love that does not assume love for one's own kind and which does not lead to hatred for others. But does multicultural love work to expand love to include others? Or does this expansion require the other others to fail an ideal?

IDENTIFICATION AND IDEALISATION

7. In order to examine how love for difference can still involve processes of idealisation we can turn to Freudian psychoanalysis. Freud offers a theory of love by differentiating between anaclitic and narcissistic love. In the former, the self is the primary object of love, and in the latter, external objects are the primary objects of love. Whilst love is seen as in the first instance narcissistic — the child's own body is the source of love — for men, love is assumed to mature into object love, whilst women are assumed to remain narcissistic (1934 : 45–46). The economy for this differentiation is heterosexual: woman's narcissism involves a desire to be loved (to love the love that is directed towards them), while for men, they love to love women who love themselves. The sexual relation becomes a love relation in which the woman becomes the object of her love and the man's love. I will not engage here with the question of whether this describes or prescribes a heterosexist economy, although I will turn in due course to the heterosexual logic of the couple that organises this distinction. I want to examine this distinction between self-love and object love, which can also be

described in terms of a distinction between identification (love as being) and idealisation (love as having).

8. In Freud's account, identification is the earliest expression of an emotional tie with another person. As he describes it, 'A little boy will exhibit a special interest in his father; he would like to grow like him and be like him, and take his place everywhere' (Freud 1922:60). In the first place, the boy's identification with the father creates an ideal: his ego ideal. This is the subject the ego would like to be. We should not assume here a linear movement, from love to identification (as in the formulation: we identify with those we love). Rather, identification is a form of love; it is an active kind of loving, which moves or pulls the subject towards another. Identification involves the desire to get closer to others by becoming like them. Becoming like them obviously requires not being them in the first place. So it is thus that identification exercises a distinction between the subject and object of love. At the same time, identification seeks to undo the very distinction that it requires: in becoming more like you, I seek to take your place. But taking the place of the one that is loved is futural: if one was already in their place, then one would not be identifying with them, one would be them. So then, identification is the desire to take a place where one is not yet. As such, *identification expands the space of the subject:* it is a form of love that tells the subject what it could become in the very intensity of its direction towards another (love as 'towardness'). Identification involves *making likeness* rather than being alike; the subject becomes 'like' the object or other only in the future. The

other's death is imagined in the desire to take the other's place only insofar as the other is living in the present.

9. But what is the relation between the boy's identification with the father and his anaclitic love, his love of women as his ideal objects? His secondary love is the love for the mother, for what is 'not him': such love works as a form of idealisation and is based on a relation of having rather than being. Importantly, identification with the father and idealisation of the mother do not take the masculine subject to a different place: the love for the mother is a means by which the identification with the father is performed (one desires what he desires), even if it renders that love ambivalent in its claim to possession. What is at stake then, is the apparent separation of being and having in terms of objects, but their *contiguity in terms of subject position*: in order to be him, I must have her, whom he has. In other words, identification with the father requires dis-identification with the mother (I must not be her), and desire for the mother (I must have her, or one who can stand in for her). The heterosexual logic of this separation of being from having is clear. In order to approximate the ego ideal, to paraphrase Judith Butler, I must desire an ideal object that is 'not me' in the sense of 'not my gender', whilst I must become 'my gender' by giving up the possibility of taking 'my gender' as a love object (Butler 1997:25).

10. The distinction between identification and desire relates to the distinction between sameness and difference: for the heterosexual subject, I identify with what is 'like

me' and desire what is 'different to me'. The assumption here is that heterosexuality is love for difference and homosexuality is love for sameness. We can complicate this narrative by re-thinking the relation between identification and desire, which are not about *the nature* of the subject or object that one seeks to approximate in relations of being and having. Just as identification leads to the formation of an ego ideal, so too does desire create an ideal object. As Freud argues, desire for an object, which becomes the ideal object, is not determined by the nature of the object. However, Freud's rejection of the nature of the object as determining love still presumes the primary role of the object in idealisation; he differentiates idealisation from sublimation and describes the former as the over-valuation or exaltation of the object (1934:50). But is the object that which is over-valued? Irving Singer also makes the 'evaluative' aspects of love crucial to his definition of love. He argues that love is a way of valuing something, such that: 'it is the valuing alone that *makes* the value' (1984:5). In this way, love creates the ideality of the object, but this ideality does not 'stay with' but instead 'returns' to the subject.

11. The investment in the ideal object may work to accumulate value for the subject. An investment involves the time and labour that is 'spent' on something, which allows that thing to gain value or an affective quality (in this case, the 'loveable object'). The idealisation of the object is not 'about' the object, or even directed to the object, but is an effect of the ego. That is, the ideal object, as with the ego ideal, is an effect of the ideal image that the subject

has of itself, in which it is invested. Renata Salecl speaks to this fit between the ego ideal and the ideal object when she says:

> The subject simultaneously posits the object of his or her love in the place of the Ego Ideal, from which the subject would like to see him- or herself in a likeable way. When we are in love, the love object placed in the Ego Ideal enables us to perceive ourselves in a new way — compassionate, lovable, beautiful, decent, etc. (1998:13).

12. The subject and the object are hence tied up such that identification and desire, whilst separated by a hetero-sexual logic (you can't be a man and love a man, or be a woman and love a woman) are connected in their relation to 'an ideal' (what is imagined as loveable or as having value). The ideal joins rather than separates the ego and the object; what one 'has' elevates what one 'is'. One con-sequence of this argument would be a re-definition of anaclitic love as a sublimated form of narcissism: rather than the male lover being humble, in Freud's terms (1934: 55), his exaltation of his beloved is a means of self-exal-tation, in which the 'object' stands in for the subject, as a sign of its worth. As Julia Kristeva suggests, 'The lover is a narcissist with an object' (1987:33).

13. So the idealisation of the loved object can allow the subject to be itself in or through what it has. The sub-ject approximates an ideal through what it takes as its loved object. I want to suggest that idealisation may also

work as the 'creation' or 'making' of likeness: the lover and the object approximate an ideal, an approximation which binds them together. Hence it is not surprising that heterosexual love may be structured around resemblance and likeness, despite the conflation of heterosexuality with difference. After all, heterosexuality can itself be a bond that two *share in common*. The normative conflation of hetero-sex with reproduction means that bond is structured around the desire to 'reproduce well', which is presented around a fantasy of 'making likeness' by seeing one's features reflected back by others, whose connection to me is then confirmed (the question that is always addressed: who does the child look like?). We may search for signs of likeness on the body. But likeness may also be an effect of proximity. For example, we can reflect on how the lovers adoption of each other's habits and gestures, becoming more alike as an effect of desire. As Ben-Ze'ev describes, 'The desire to be with the beloved often becomes a desire to fuse with the beloved and in a sense to lose one's identity. Lovers begin to develop similar likes to those of their partners; for example, to enjoy music to which they were previously indifferent...' (2000:415; see also Borch-Jacobsen 1988:86).

Within narratives of familial love, proximity in a spatial sense, as an effect of contact, becomes collapsed with proximity as an ideological position ('we are alike on grounds of character, genetics or belief — this likeness become an 'inheritance'), which is crucial to the naturalisation of heterosexual love as a familial plot. At the same time, the transformation of proximity into inheritance is

concealed by the very narrative of heterosexuality as a love for difference, a concealment which projects sameness onto homosexual love and transforms that very sameness into both perversion and pathology. Commentators such as Michael Warner have critiqued the conflation of homosexuality and sameness (1990:202), and the way in which this establishes heterosexuality as normative. I am supplementing this critique by suggesting that heterosexuality cannot be assumed to be 'about' difference or love for difference. The distinction between sameness as that which structures homosexual love, and difference as that which structures heterosexual love needs questioning on both sides of the distinction. The Freudian model idealises heterosexuality as love-for-difference by transforming homosexuality into a failure to love difference, which conceals the ongoing (psychic and social) investment in the reproduction of heterosexuality.

14. The distinction of love-as-having from love-as-being works then to secure a restricted domain of loveable subjects, *through the very imperative to idealise some objects and not others*, whose ideality 'returns' to me. That is, the imperative to identify with the one who is nearby — where proximity is assumed to be a sign of resemblance that is 'inherited' — also functions as an imperative to have the objects that the subject one loves is assumed to love. The need for approval of a love object from someone with whom one already identifies shows how value 'can be bestowed' only through others, such that the 'bond' of love leads me to others. If the object becomes ideal only through approval by loved others; idealisation creates

both likeable subjects and loveable objects (see Benjamin 1995). The restriction of ideal objects involves a process of identification. In identifying myself with you, for example, I also de-limit who I can love in the sense that I imagine who would be loved by the subject that I would be if I was you. In other words, I ask: who or what would my ideal idealise? The question shows us that relations of having follow from relations of being, even if they take different objects.

15. Within the narrative of love discussed in my opening, identifying oneself as a white woman and as a white Aryan would mean loving not just men, or even white men, but white men who also identify as Aryan, *who can return the idealised image of whiteness back to oneself.* To love and to be loved is here about fulfilling one's fantasy image of 'who one would like to be' through who one 'has'. Such a love is about making future generations in the image I have of myself and the loved other, who together can approximate a 'likeness', which can be bestowed on future generations. Within this economy, the imperative to love becomes an imperative to extend the 'ideal' that I seek to have and to be onto others, who 'can' return this ideal to me. It is clear from the extension of self in love, or the way in which love orients the subject towards some others (and away from other others), how easily love for another slides into love for a group, which is already constituted in terms of likeness.

THE NATIONAL IDEAL

16. In *Group Psychology*, Freud offers a theory of how love is crucial to the formation of group identities. Whilst maintaining that the aim of love is 'sexual union', Freud argues that other loves, whilst diverted from this aim, share the same libidinal energy that pushes the subject towards the loved object (1922 : 38). For Freud, the bond between a group relies on the transference of love to the leader, whereby the transference becomes the 'common quality' of the group (1922 : 66). Another way of saying this would be to say that groups are formed through their shared orientation towards an object. More specifically, groups are formed when 'individuals... have substituted one and the same object for their ego ideal and have consequently identified themselves with one another in their ego' (1922, 80, emphasis Freud's). Now, it is here that Freud complicates the relation between identification and object choice, by showing how one form of love can become the other. In particular, he points to how the ego can assume the characteristics of the lost object of love through introjection (Freud 1922 : 64).

17. In other words, the loss of the object is compensated for by 'taking on' the quality of the object. Mourning and grief hence become an expression of love; love announces itself most passionately when faced with the loss of the object. Love has an intimate relation to grief not only through how the subject responds to the lost object, but also by which losses are admitted as losses in the first place. If a subject can imagine that the person

who was lost 'could have been me', then the grief of others can also become my grief. This 'could have been-ness' is a judgement over whether others approximate the ideals that I have already taken to be 'mine' or 'ours'. So, there is an intimate relation between lives that are imagined as 'grievable', in Judith Butler's (2002) terms, and those that are imagined as loveable and liveable in the first place.

18. Indeed, the impossibility that love can reach its object may also be what makes love powerful as a narrative. At one level, love comes into being as a form of reciprocity; the lover wants to be loved back, wants their love returned (Singer 1984:6). At another level, love survives the absence of reciprocity in the sense that the pain of not being loved in return — if the emotion 'stays with' the object to which it has been directed — confirms the negation that would follow from the loss of the object. Even though love is a demand for reciprocity, it is also an emotion that lives with the failure of that demand often through an intensification of its affect (so, if you do not love me back, I may love you more as the pain of that non-loving is a sign of what it would mean not to have this love).

19. We can see then how love may work to stick others together in the absence of the loved object, even when that object is 'the nation'. Love may be especially crucial in the event of the failure of the nation to deliver its promise for the good life. So, the failure of the nation to 'give back' the subject's love works to increase the investment in the nation. The subject 'stays with' the nation, despite

the absence of return and the threat of violence, as leaving would mean recognising that the investment of national love over a lifetime has brought no value. One loves the nation, then, out of hope and with nostalgia for how it could have been. One keeps loving rather than recognising that the love that one has given has not and will not ever be returned.

20. We could even think of national love as a form of waiting. To wait is to extend one's investment and the longer one waits the more one is invested, that is, the more time, labour and energy that has been expended. The *failure of return extends one's investment.* If love functions as the promise of return of an ideal, then the extension of investment through the failure of return works to maintain the ideal through its deferral into the future. It is not surprising that the return of the investment in the nation is imagined *in the form of the future generation* ('the white Aryan child'), who will 'acquire' the features of the ideal white subject. 'The Aryan child' here becomes the object that is 'put in the place of the ego ideal' (Freud 1923: 80). National love places its hope in the next generation; the postponement of the ideal sustains the fantasy that return is possible.

21. If the failure of return extends one's investment, then national love also requires an 'explanation' for this failure: otherwise, hope would convert into despair or 'giving up' on the loved object. Such explanations work as defensive narratives: they defend the subject against the loss of the object by enacting the injury that would follow if

the object was given up. We can see this clearly in the accounts of love in fascist web sites; the nation as loved object has been taken away, and the 'injury' of the theft must be repeated as a way of confirming the love for the nation. In this instance, the fantasy of love as return requires an obstacle: here, the racial others become the obstacle that allows the white subject to sustain a fantasy that without them, the good life would be attainable, or their love would be returned with reward and value. Jacques Lacan (1984) has shown us the way in which the fantasy of love requires an obstacle in his reading of courtly love. By providing the obstacle to national love, racial others allow the fantasy that their love for the nation will be returned. The failure of return is 'explained' by the presence of others, whose presence is required for the investment to be sustained. The reliance on the other as the origin of injury becomes *an ongoing investment in the failure of return.*

22. But if the ideal is postponed into the future, as the promise of return for investment, then how does the ideal take shape? Julia Kristeva examines the relation between the national ideal and ego ideal in *Nations without Nationalism*, when she responds to the 'problem' posed by immigration:

First there is the interior impact of immigration, which often makes it feel as though it had to give up traditional values, including the values of freedom and culture that were obtained at the cost of long and painful struggles (why accept [that daughters of Maghrebin immigrants wear] the Muslim scarf [to school]) (1993:36).

23. The bracketed sentence evokes the figure of the 'veiled/ Muslim woman' who comes into play as a figure that challenges the values that have become felt as crucial to the nation (including the values of freedom and culture). These values are what the nation can give to others. She becomes a symbol of what the nation must give up to 'be itself', a discourse that would require her unveiling in order to fulfil the promise of freedom for all. Kristeva hence concludes: 'It is possible that the "abstract" advantages of French universalism may prove to be superior to the "concrete" benefits of a Muslim scarf' (1993 : 47). Kristeva suggests that the right to wear the scarf (with its multiple meanings) may give the Muslim women less than the rights afforded by entry into the abstract idea of the nation. By implication, the abstract includes everybody as it is not shaped by the concrete specificity of bodies. Others can become a part of the community of strangers on condition that they give up visible signs of their 'concrete difference'.

24. The argument moves from the national idea to a 'national ideal' via an analogy with the ego ideal. The 'Muslim scarf' is not only 'not' the idea of freedom 'won' as the freedom of the nation, but it also challenges the image the nation has of itself: 'That involves a breach of the national image and it corresponds, on the individual level, to the good image of itself that the child makes up with the help of the ego ideal and the parental superego' (Kristeva 1993 : 36–37). The trauma of the Muslim scarf for the French nation is here *like* the trauma of 'failing' to live up to the ego ideal. Hence the nation becomes depressed when it is

faced with the scarf and this shame and depression is used by the right-wing discourse of anti-immigration: 'Le Pen's nationalism takes advantage of such depression' (Kristeva 1993:37). According to this argument, the task of the radical might to refuse to celebrate or even allow the scarf as this would sustain the psychic conditions that enable anti-immigration and nationalism to flourish. Kristeva hence suggests that 'a Muslim wish to join the French community' (1993:37) might require the elimination of the source of national shame: the concrete difference of the veil itself. The argument suggests that by eliminating the veil, which stands in for concrete difference, the abstract national idea can be returned to an ideal that is enlarged by the appearance of others.

25. However, the argument that the national idea is abstract (and the difference of the Muslim woman is concrete) breaks down. The intimacy of the national idea with an ideal image suggests the national idea takes the shape of a particular kind of body, which is assumed in its 'freedom' to be unmarked. The ideal is an approximation of an image, which depends on being inhabitable by some bodies rather than others. Such an ideal is not positively embodied by any person: it is not a positive value in this sense. Rather, it accrues value through its exchange, an exchange that is determined precisely by the capacity of some bodies to inhabit the national body, *to be recognisable as living up to the national ideal in the first place.* But other bodies, those that cannot be recognised in the abstraction of the unmarked, cannot accrue value, and become blockages in the economy; they cannot pass as French, or

pass their way into the community. The veil in blocking the economy of the national ideal is represented as a betrayal not only of the nation, but of freedom and culture itself — as the freedom to move and acquire value.

26. Love for the nation is hence bound up with how bodies inhabit the nation in relation to an ideal. I would follow Kristeva by arguing that the nation is an effect of how bodies move towards it, as an object of love that is shared. Or more precisely 'the it' of 'the nation' as an ideal or loved object is produced as an effect of the movement of bodies and the direction of that movement (the loved object as an effect of 'towardness'). But, as a result, the promise of the nation is not an empty or abstract one that can then be simply filled and transformed by others. Rather, the nation is a concrete effect of how some bodies have moved towards and away from other bodies, a movement that works to create boundaries and borders, and the 'approximation' of what one can now call 'national character' (what the nation *is like*). Such a history of movement 'sticks', such that it remains possible to 'see' a breach in the ideal image of the nation in the concrete difference of others.

MULTICULTURAL LOVE

27. What happens when love is extended to others who are recognised as 'being different' in their concrete specificity? In this section, I will analyse how multiculturalism becomes an imperative to love difference and how this extension of love works to construct a national ideal

that others fail (a failure which is read both as an injury and disturbance). To do so, I will refer to the debates on asylum, migration, and the race riots in the UK. It is important to acknowledge that within the UK, the nation is imagined as an ideal through the discourse of multiculturalism, which we can describe as a form of conditional love. The nation becomes an ideal precisely through being posited as 'being' plural, open, and diverse.

28. As Renata Salecl suggests, the pleasure of identifying with the multicultural nation means that one gets to see oneself as a good or tolerant subject (see 1998 : 4). This identification with the multicultural nation, which shapes the 'character' of the multicultural subject, still relies on the structural possibility of the loss of the nation as object. The multicultural nation can itself be taken away by the presence of others, who do not reflect back the good image the nation has of itself such as intolerant racist others (often conflated with the white working classes, or fascist groups like the British National Party). The nation could also be taken away by migrants or asylum seekers who don't accept the conditions of one's love. *Identifying oneself as British means defining the conditions of the love one can or will give to others.* Indeed, multiculturalism — especially since 11 September — has been viewed as a security threat: those who come into the nation 'could be' terrorists a 'could-be-ness' that extends the demand for the surveillance of others who are already recognisable as strangers (see Ahmed 2000). The national project hence becomes: how can one identify the nation as open (the national ideal) through the very conditions required to inhabit that ideal?

29. The new conditions require that migrants 'must learn to be British'; that is, migrants must identify as British by taking 'the nation' as their object of love. This becomes a matter of allegiance and adherence: of sticking to the nation in the formation of the ego ideal: 'New immigrants will soon have to pass English exams and formally swear allegiance to the Crown... The Home Secretary believes it is crucial that newcomers to the UK embrace its language, ethos and values' (Hughes and Riddell 2002:1). Migrants must pass as British to pass into the community, a form of 'integration' that is imagined as the conditions for love. Importantly, migrants must become British even at home: Muslim women, in particular, have been asked to speak English at home, so they can 'pass on' the national ideal to the future generation. This ideal is not premised on abstraction (the migrant is not asked to lose her body or even her veil), nor on whiteness, but on hybridity as a form of sociality, as the imperative to mix with others. The others can be different (indeed, the nation is invested in their difference as *a sign of its love for difference*), as long as they refuse to keep their difference to themselves, but instead give it to the nation, by mixing with others.

30. The over-valuation of the nation as a love object — as an object that can reciprocate one's love — hence demands that migrants 'take on' the character of the national ideal: becoming British is indeed a labour of love for the migrant, whose reward is the 'promise' of being loved in return. As Bhikhu Parekh puts it:

A multicultural society cannot be stable and last long without developing a common sense of belonging among its citizens. The sense of belonging cannot be ethnic and based on shared cultural, ethnic and other characteristics, for a multicultural society is too diverse for that, but must be political and based on a shared commitment to the political community. Its members do not directly belong to each other as in an ethnic group but through their mediating membership of a shared community, and they are committed to each other because they are all in their own different ways committed to a common historical community. They do and should matter to each other because they are bonded together by the ties of common interest and attachment. [...] The commitment to the political community involves commitment to its continuing existence and well-being, and implies that one cares enough for it not to harm its interests and undermine its integrity. It is a matter of degree and could take such forms as a quiet concern for its well-being, deep attachment, affection, and intense love. (1999:4)

31. Love here sticks the nation together: it allows cohesion through the very naming of the nation or 'political community' as a shared object of love. Love becomes crucial to the promise of cohesion within multiculturalism; it becomes the 'shared characteristic' required to keep the nation together. Here, the emotion becomes the object of the emotion. Or, more precisely, love becomes the object that is 'put in the place of the ego or of the ego ideal' (Freud 1922:76). It is now 'having' the right emotion that allows

one to pass into the community: in this case, by displaying 'my love', I show that I am 'with you'. It is 'love' that the multicultural nation idealises as its object: it loves love.

32. The 'love for love' is bound up with the making of community. Within the white paper, *Secure Borders, Safe Haven: Integration with Diversity in Modern Britain*, integration is defined as crucial to the making of community, understood in terms of building 'firmer foundations' for nationhood. Indeed, the forward to the report suggests that 'confidence, security and trust' are crucial to the possibility that the nation can become an ideal object — 'safe haven' that is open to others, without being threatened by that opening (Home Office 2002a:3). As such, David Blunkett suggests that 'we need to be secure within our sense of belonging... to be able to reach out and to embrace those who come to the UK'. Here, the nation and national subject can only love incoming others — 'embrace' them — if the conditions that enable security are already met. To love the other requires that the nation is already secured as an object of love, a security that demands that incoming others meet 'our' conditions. Such conditions require that others 'contribute' to the UK through labour, or by showing they are not bogus asylum seekers; when such conditions have been met they will 'receive the welcome they deserve'. The asylum system and discourse of citizenship is justified on the grounds that it is only through the intensification of the border that the nation can be secured as an object of love, which can then be given to others.

33. The ideal constructed by multicultural love also involves the transformation of heterosexuality into good citizenship, and evokes the figure of the ideal woman. Take the following quote from the *Observer*:

> Genevieve Capovilla's father is West Indian. Her mother is Italian. And she is British. She has golden skin, and soft, even features. She combs her hair into a healthy, curly semi-afro. Her racial mix is ambiguous — neither Afro-Caribbean, nor southern European. It is no surprise to find that she is a model. She has the enviable quality of looking as though she would be at home anywhere in the world. And her look is one that will become increasingly familiar, and — in the worlds of fashion and beauty — increasingly sought after... Genevieve is the new English rose... At the turn of the twenty-first century... England's rose has become more of a bronzed, burnished sunflower, equally at home in the Arabian Gulf, the Caribbean or the South China Sea. (Blanchard 2001:10)

This positing of woman as an image of the nation is not new. As critics such as Anne McClintock (1995) have shown us, this conflation of the face of the nation with the face of a woman has a long history and points to the gendering of what the nation takes to be as itself (the masculine subject) through what it has (the feminine object). The figure of the woman is associated with beauty and appearance, and through her, the nation appears for and before others. As the new English rose, Genevieve replaces Princess Diana as an ideal image of the nation. White

skin becomes golden skin; blonde hair becomes a 'curly semi-Afro'. The idealisation of the mixed-race woman allows the nation to accumulate value: as a model, her beauty sells. The exoticisation of mixed-race femininity is also not new, as Lola Young's (1996) work on representations of the mulatto in film demonstrates. What is distinctive is how she gets 'taken in' by the nation: 'the exotic' comes 'home' through her bronzed appearance. As an ideal, she will approximate the fantasy the national subject has of itself: somebody who is hybrid, plural and mobile. She in her ideality — 'the new English rose' — has acquired the features of the national character, which fancies itself as 'at home anywhere in the world'. The nation here can 'be itself' — a hybrid, mobile nation that loves difference by taking it in — precisely through the objects that it idealises as its objects of love. Anne-Marie Fortier's critical analysis of multiculturalism, which also offers a reading of this image of the mixed-race woman, attends to the role of heterosexuality in the reproduction of the national ideal. The object of love is an 'offspring' of the fantasy of the national subject at stake in this ideal'. (Fortier 2001).

34. This ideal image can be described as 'hybrid whiteness'; the nation's whiteness is confirmed through how it is incorporated and is 'coloured' or 'bronzed' by others. Her ambiguity — 'not quite the same, not quite the other' in Bhabha's (1994) formulation — becomes a sign of the nation, and the promise of the future. This is not to say that mixed-race heterosexual love has become a form of national love. The mixed-race woman 'appears' as a fetish object; her value resides precisely insofar as she is cut off

from any visible signs of inter-racial intimacy. In other words, the nation remains the agent of reproduction: she is the offspring of the multicultural love for difference.

35. The nation here constructs itself as ideal in its capacity to assimilate others into itself; to make itself like itself by taking in others who appear different. The national ideal is assumed to be reflected in the wishful and hopeful gaze of others: 'millions of people hear about the UK and often aspire to come here. We should be proud that this view of the UK is held all around the world'. What makes Britain ideal is hence also what makes it vulnerable to others. A narrative of loss is crucial to the work of national love: this national ideal is presented as all the more ideal through the very failure of other others to approximate that ideal. Whilst some differences are taken in, other differences get constructed as violating the very ideals posited by multicultural love. A crucial risk posed by migrant cultures is defined as their failure to become British, narrated as their failure to love the culture of the host nation. The failure here is the failure of the migrant to 'return' the love of the nation through gratitude (see Hochschild 2003:105). One tabloid headline after a fire at a detention centre for asylum seekers reads: 'this is how they thank us'.

36. How are disturbances read as the failure to return the conditions of national love? The race riots that took place within the North West of England in 2001, were understood to be a result of a failure to integrate or as 'segregation': 'The reports into last summer's disturbances

in Bradford, Oldham and Burnley painted a vivid picture of fractured and divided communities, lacking a sense of common values or shared civic identity to unite around. The reports signalled the need for us to foster and renew the social fabric of our communities, and rebuild a sense of common citizenship, which embraces the different and diverse experiences of today's Britain' (Home Office 2002a : 10). On the one hand, the riots are read as a disturbance that disrupt the national ideal precisely because they reveal that love has failed to deliver its promise of harmony between others. On the other hand, such an account becomes a demand for love, by suggesting that the violence is caused by the absence of love as nearness and proximity. Rather than segregation being an *effect* of racism, for example, it now becomes the *origin* of racism and violence. In this way, the narrative assumes that proximity *would mean* harmony between others and the incorporation of others into a national ideal. The narrative goes something like this: *if only we were closer we would be as one.*

37. The report into the race riots, *Community Cohesion*, makes integration into a national ideal. While it suggests there is nothing wrong with people choosing 'to be close to others like themselves' (Home Office 2002b : 12), it then concludes: 'We cannot claim to be a truly multi-cultural society if the various communities within it live, as Cantle puts it, a series of parallel lives which do not touch at any point' (Home Office 2002b : 13). This narrative projects sameness onto 'ethnic minority' communities in order to elevate the national ideal into a love for difference. Difference becomes an ideal by being represented as a form

of likeness; it becomes a new consensus that binds us to-gether: 'This needs a determined effort to gain consensus on the fundamental issue of "cultural pluralism"' (Home Office 2003:18; emphasis added). The transformation of pluralism into a consensus is telling. Others must agree to value difference: difference is not what we would have in common. In other words, difference becomes an elevated or sublimated form of likeness: you must like us — and be like us — by valuing or even loving differences (though clearly this is only about the differences that can be taken on and in by the nation, which will not breach its im-age of itself). Hence the narrative demands that migrant communities and working-class white communities must give up their love for each other — a love that gets coded as love-of-themselves, that is, as a perverse form of self-love or narcissism — and love those who are different, if they are to fulfil the image of the nation promised by the ideal and hence if they are to be loved by the nation.

38. My earlier critique of the distinction between narcis-sistic and anaclitic love has bearing here. We can now see that the representation within the report works ideolog-ically on two grounds; firstly, it conceals the investment in the nation within multiculturalism (the nation turns back on itself, or is invested in itself, by positing itself as ideal). That is, it conceals how love for difference is also a form of narcissism: a desire to reproduce the nation-al subject through how it incorporates others into itself. Secondly, the report works to conceal how 'sticking to-gether' for minority communities involves an orientation towards differences; it erases the differences within such

communities by positing them as sealed and homoge-
nous — as 'the same' — in the first place. These commu-
nities are constructed as narcissistic in order to elevate
the multicultural nation into an ideal, that is, in order to
conceal the investment in the reproduction of the nation.
This positing of the national ideal requires the projection
of sameness onto others and the transformation of same-
ness into perversion and pathology.

39. In such a narrative, 'others', including ethnic mino-
rities and white working-class communities, in their
perceived failure to love difference, function as 'a breach'
in the ideal image of the nation. Their failure to love be-
comes the explanation for the failure of multiculturalism
to deliver the national ideal. At the same time, the failure
of 'ethnic minority communities' to integrate — to stick
to others and embrace the national ideal — is required
to 'show' how that ideal is 'idealisable' in the first place.
Multiculturalism itself becomes an ideal by associating
the failure to love difference with the very origin of rac-
ism and violence. Rather than showing how segregation
might be a survival tactic for communities who experi-
ence racism, deprivation or poverty — and rather than
differentiating between the reasons why people might
not mix with others who have already constructed us
'unlike' by scripts of racism — this narrative defines seg-
regation as a breach in the image the nation has of itself,
and as the origin of violence. The narrative hence places
its hope in the integration of difference or in the very
imperative to mix.

40. The implications of this narrative is that if migrants or others 'give' their difference to the nation, by mixing with others, then the 'ideal' would be achieved, and that difference would be 'returned' with love. The promise of multiculturalism is represented as a gift for the future generation (the young mixed-race women); she may embody the promise of love's return. At the same time, the investment in multiculturalism gets intensified given the failure of return: the multicultural nation becomes invested in the presence of others who breach the ideality of its image. They become the sign of disturbance, which allows the ideal to be sustained as an ideal in the first place; they 'show' the injury that follows from not following the ideal.

41. In this paper, I have offered a strong critique of how acting in the name of love can work to enforce a particular ideal onto others by requiring that they live up to an ideal to enter the community. The idea of a world where we all love each other, a world of lovers, is a humanist fantasy that informs much of the multicultural discourses on love, which I have formulated as the hope: *if only we got closer we would be as one*. The multicultural fantasy works as a form of conditional love, in which the conditions of love work to associate 'others' with the failure to return the national ideal.

42. We cannot then equate love with justice. Justice is not about learning to love others, let alone loving difference. Justice is not about 'getting along', but should preserve the right of others not to enter into relationships, 'to not be

with me', in the first place. The other, for example, might not want my grief, let alone my sympathy, or love. The idealisation of the social bond quickly translates into the transformation of relationship itself into a moral duty, which others will fail. We saw this will with the idealisation of multiculturalism as a social bond: ethnic minorities and white working-class communities fail precisely in their refusal 'to mix' more intimately with others. I would argue that the struggle against injustice couldn't be transformed into a manual for good relationships, without concealing the very injustice of how 'relationships' work by differentiating between others.

43. But having said all this, I am not 'against love', and nor am I saying that love has to work in this way. Whether it is the dizzy, heady and overwhelming feeling of love for a lover, or the warmth and joy at being near a friend who has shared one's struggles, it is our relation to the particular others that gives life meaning and direction and can give us the feeling of there being somebody and something to live for. A politics of love is necessary in the sense that how one loves matters; it has effects on the texture of everyday life and on the intimate 'withness' of social relations.

44. We might note Kaja Silverman's suggestion that the problem is with 'idealisation' and not love. As she puts it: 'We have consistently argued against idealisation, that psychic activity at the heart of love, rather than imagining the new uses to which it might be put' (Silverman 1996: 2). Silverman examines how the screen has (in her terms)

colonised idealisation, by restricting ideality to certain subjects (1996 : 37). Her solution is described in the following terms:

> The textual intervention I have in mind is one which would 'light up' dark corners of the cultural screen, and thereby make it possible for us to identify both consciously and unconsciously with bodies which we would otherwise reject with horror and contempt' (Silverman 1996 : 81).

Silverman is asking that we learn to put ourselves in the place of those who are abject (which does not mean taking their place as we have already recognised them as 'unlike us'), whose lives are 'uninhabitable' and pushed out from spaces that define what means to have a liveable life. Her vision is of 'any-body', including those bodies who appear different in their concrete specificity, becoming part of a community of lovers and loved. But is such a community possible? I have suggested that the idea of a world where we all love each other is a humanist fantasy that informs much of the multicultural and cosmopolitan discourses of love (*if only we got closer we would be as one*). Such an ideal requires that some others fail to approximate its form: those who don't love, who don't get closer, become the source of injury and disturbance.

45. Admittedly, Silverman's vision is more complex than this. It is a vision where one learns to love precisely those bodies that have already failed to live up to the collective

ideal. I am not sure how I feel about this solution. Part of me questions the 'benevolence' of such good feelings and indeed imagines benevolent intellectuals reaching out to the poor, the dejected and the homeless and offering them their love. Love is not what will challenge the very power relations that idealisation 'supports' in its restriction of ideality to some bodies and not others. In fact, 'to love the abject' is as close to the liberal politics as is charity, one that usually makes the loving subject feel better for having loved and given love to someone whom is presumed to be unloved, but which sustains the very relations of power that compels the charitable love to be shown in this way.

46. I would challenge any assumption that love can provide the foundation for political action, or as a sign of good politics. But what would political vision mean if we did not love those visions? Am I arguing against a visionary politics? If love does not shape our political vision, it does not mean we should not love the visions we have. In fact, we must love the visions we have, if there is any point to having them. We must be invested in them, whilst open to ways in which they always fail to be translated into objects that can secure our ground in the world. We need to be invested in the images of a different kind of world and act upon those investments in how we love our loves, and how we live our lives, at the same time, as we give ourselves up and over to the possibility that we might get it wrong, or that the world that we are in might change its shape. There is no good love that, in speaking its name, can change the world into the referent for that name. But in the resistance to speaking *in the name of love*,

in the recognition that we do not simply *act out of love*, we can find perhaps a different way of orientating ourselves towards others. Such orientations may be about inhabiting forms of love that do not speak their name.

About Hate: http://women.stormfront.org/writings/abouthate.html

Ahmed, Sara. 2000. *Strange Encounters: Embodied Others in Post-Coloniality* (London: Routledge)

Bacchetta, Paola, and Margaret Powell (ed.). 2002. *Right Wing Women: From Conservatives and Extremists around the World* (New York: Routledge)

Ben-Ze'ev, Aaron. 2000. *The Subtlety of Emotions* (Cambridge, MA: MIT Press)

Berlant, Lauren. 1997. *The Queen of America Goes to Washington City: Essays on Sex and Citizenship* (Durham, NC: Duke University Press)

Bhabha, H.K., 1994. *The Location of Culture* (London: Routledge)

Blanchard, Tamsin. 2001. 'Model of a Modern Briton', *Observer*, 25, p. 10

Borch-Jacobsen, Mikkel. 1988. *The Freudian Subject*, trans. by Catherine Porter (Stanford: Stanford University Press)

—— 1993. *The Emotional Tie: Psychoanalysis, Mimesis, and Affect* (Stanford: Stanford University Press)

Butler, Judith. 1990. *Gender Trouble: Feminism and the Subversion of Identity* (New York: Routledge)

—— 1993. *Bodies that Matter: On the Discursive Limits of 'Sex'* (New York: Routledge)

—— 1997. *The Psychic Life of Power: Theories in Subjection* (Stanford: Stanford University Press)

—— 2002. 'Violence, Mourning, Politics', *Feminist Theory Address*, University College London

Fortier, Anne-Marie. 2001. 'Multiculturalism and the New Face of Britain', Lancaster University <https://www.lancaster.ac.uk/fass/resources/sociology-online-papers/papers/fortiermulticulturalism.pdf>

Freud, Sigmund. 1922. *Group Psychology and the Analysis of the Ego*, trans. by James Strachey (London: The International Psycho-Analytical Press)

—— 1934. 'On Narcissism: An Introduction', *Collected Papers, Vol. 4*, ed. by Ernest Jones, trans. by J. Riviere (London: Hogarth Press)

Hochschild, A.R., 2003. *The Commercialisation of Intimate Life: Notes from Home and Work* (Berkeley: University of California Press)

Home Office UK. 2002. *Secure Borders, Safe Haven: Integration with Diversity in Modern Britain* (London: Stationery Office)

—— 2002b. *Community Cohesion: A Report of the Independent Review Team* <http://www.homeoffice.gov.uk/docs2/pocc.html>

—— 2003. *Community Cohesion: A Report of the Independent Review Team* <http://www.homeoffice.gov.uk/docs2/comm_cohesion.html>

Hughes, David, and Mary Riddell. 2002. 'Migrants Must Learn to Be British', *Daily Mail*, 7 February, p. 1

Kristeva, Julie. 1987. *Tales of Love*, trans. by Leon S. Roudiez (New York: Columbia University Press)

—— 1993. *Nations without Nationalism*, trans. by Leon S. Roudiez (New York: Columbia University Press)

Lacan, Jacques. 1984. *Feminine Sexuality*, ed. by Juliet Mitchell, trans. by Jacqueline Rose (New York: W.W. Norton and Co.)

McClintock, Anne. 1984. *Imperial Leather: Race, Gender and Sexuality in the Colonial Contest* (New York: Routledge)

Parekh, Bhikhu. 1999. 'What Is Multiculturalism?' <http://www.indiaseminar.com/1999/484/484%20parekh.htm>

Salecl, Renata. 1998. *(Per)Versions of Love and Hate* (London: Verso)

Silverman, Kaja. 1996. *The Threshold of the Visible World* (New York: Routledge)

Singer, Irving. 1984. *The Nature of Love: Vol. 1. Plato to Luther* (Chicago: University of Chicago Press)

Warner, Michael. 1990. 'Homo-Narcissism; or, Heterosexuality', in *Engendering Men: The Question of Male Feminist Criticism*, ed. by Joseph A. Boone and Michael Cadden (London: Routledge), pp. 190–207

—— 1990. *Engendering Men: The Question of Male Feminist Criticism*, ed. by Joseph Boone, Michael Cadden (New York: Routledge)

Wiegman, Robyn R. 2002. 'Intimate Publics: Race, Property, and Personhood', *American Literature*, 74 (2002) 4: 859–55.

Young, Lola. 1996. *Fear of the Dark: 'Race', Gender and Sexuality in the Cinema* (London: Routledge)

THE SEXUAL LIFE OF COMMUNISTS:
REFLECTIONS ON ALEXANDRA KOLLONTAI
AARON SCHUSTER

———

WE EVEN FORGOT TO KISS

There is a well-known story about Alexandra Kollontai and her lover, Pavel Dybenko; though it is probably untrue, at least I haven't read it in an official biography. It goes like this: soon after the October Revolution, while Kollontai was a minister in the new revolutionary government, the couple disappeared for ten days. Some feared counter-revolutionaries had kidnapped her; it turned out, however, that they were on a lovers' tryst. When she reappeared, Lenin was urged to call a meeting to publicly condemn her behaviour. He did so, and many people, whom she thought of as friends, denounced her as a libertine and worse.

> At last, Lenin spoke — Lenin always spoke very quickly, but in this case, he spoke slowly, giving weight to every word: 'I agree with all you said, comrades; I think that Alexandra Michailovna must be punished severely; I propose that she marry Dybenko'. Everybody laughed, and the matter was closed.[1]

Born in St Petersburg in 1872, her father a military man and her mother from an aristocratic family, Alexandra Kollontai was radicalised in her early twenties when she observed the horrible working conditions in a textile

factory. She dedicated herself to the revolutionary cause, first as a Menshevik then later as Bolshevik. She and Lenin became close during their time in exile; he sent her on a trip to the United States where she gave over one hundred speeches at various meetings and events, spreading the message of communism. During the revolutionary days, she was the one to deliver Lenin's April Theses to *Pravda*. She was the great Bolshevik feminist, the only female member of the Central Committee, serving as the People's commissar for social welfare, and later becoming the first female Soviet diplomat (in Mexico, Norway, and Sweden, where she was eventually promoted to the post of ambassador). She was an activist, a revolutionary, a public speaker, a writer (of non-fiction and fiction), a theoretician, a politician, a diplomat, and a lover; in a sense her life was a total artwork. She evaded the Stalinist Terror, being abroad since the mid-1920s, and died in Moscow in 1952. Dybenko was a sailor from peasant origins, who had been active with the Baltic fleet in the Revolution, and was made Commissar for Naval Affairs. She was forty-five, he was twenty-eight; their age difference made them the target of gossip. The story of Lenin 'sentencing' them to marriage aside, Dybenko and Kollontai were in fact married in one of the first civil weddings in the Soviet Union. With a contingent of sailors, the two stormed the Alexander Nevsky monastery in an attempt to requisition it as a home for war invalids; a priest was killed, but they failed to seize the building. This got her into trouble with Lenin, who was furious about her ill-timed attack on the Church. The break between them would be even more severe a few years later, when Kollontai actively supported the leftist

Worker's Opposition at the 10th Party Congress, where the infamous ban on secessionism was passed and the Party consolidated its power.

So, why this rumour? Even if false, it points to two interesting matters. First that Kollontai was a highly controversial figure within the Bolshevik party, and her championing of women's and family issues and the cause of sexual liberation earned her many slurs, gossips, and rumours (including by Lenin himself).[2]

> She alone, among all the leading European Marxists of that time, recognised sexuality as a crucial revolutionary theme. Following a long Russian radical tradition dating back at least to Herzen, she raised awkward but vital questions about sex and love, about how women and men could share a natural eroticism in the context of everyday life in a new society. In the face of widespread scorn within her movement, from both male and female comrades, she pursued these themes until it was no longer permitted to her to do so.[3]

Second, the anecdote raises a real theoretical and practical question: that of the relation of the couple to the collective. If we take the story at face value, was not Lenin right to chastise Kollontai for abandoning her political post at a crucial moment for her own egoistic enjoyment? Could we read his ironical 'punishment', that she be sentenced to marriage, not so much as an expression of Lenin's sexual conservatism, as an insistence that the relationship be publicly and symbolically inscribed, that their affair is a

social matter and not merely a private one? Kollontai was, in fact, highly sensitive to these concerns. 'Modern love', she writes, 'always sins, because it absorbs the thoughts and feelings of loving hearts and isolates the loving pair from the collective'.[4] This is even the best argument against the story's veracity: according to Kollontai's own moral code, she would never absent herself from political life or abandon her work for the sake of a romantic affair.[5] Indeed, Kollontai's relationship with Dybenko presents a model of *l'amour engagé*: 'She lived out with him her idea of 'winged Eros', sexual comradeship and shared service to the cause.'[6]

In her *Autobiography*, she states the successful formula for combining work and love as follows: 'work and the longing for love can be harmoniously combined *so that work remains as the main goal of existence*'.[7] For Kollontai, the couple is not, or should not be, a closed intimate so-ciety of two, a self-sufficient romantic unit that negates from the world, but rather a vector for a greater and more intense worldly engagement. Or at least, the new kind of love that she advocates is one that does not compro-mise the individual's (especially women's) work, struggle, creativity, and freedom. 'I have succeeded in structuring my intimate life according to my own standards and I make no secret of my love experiences any more than does a man. Above all, however, I never let my feelings, the joy or pain of love take the first place in my life inas-much as creativity, activity, struggle always occupied the foreground.'[8] This should be spelled out a little further: the logic of what Kollontai elsewhere calls 'comradeship

love' is not simply that work is more important than love — a bourgeois injunction if there ever was one. Its aim is rather to surmount the standard coordinates of the work/ love split. If you choose love over work, usually you lose both: work is sacrificed, and the love you are left with can only drown in devotion to the other (who likely no longer respects you, precisely because you have given up on your work). On the opposite side is the typically male (artistic or philosophical) perversion where work is chosen over love, in such a way that this work is intensified and sustained by the very sacrifice of love: the attachment to the love object persists, precisely as something lost and impossible. While the reason for giving up on love is the need to fully devote oneself to work, what is really needed is the break-up as the subject's tortuous 'Thing' that returns in his work (see Kierkegaard and Kafka, and also Socrates, in a different way — Socrates was the first to pose the classic work/love dilemma: if Socrates does not return the love of his admirers, especially Alcibiades, it is because he only loves one thing: his work, i.e. philosophy — which, cosmically speaking, is the greatest love of all). Kollontai proposes a different solution: work must prevail over love, but as the very condition for being able to love, that is, for entering into intense affairs and relationships which do not drown in intimacy or the jealous passion to possess the other, but are ways of acting in and engaging with the world. The moral is not simply that one must learn to balance work and love, public engagement and private life, but that the two can be brought together only under the perspective of the former.

To give a different example of this, let us look at a passage from Svetlana Alexievich's *Second Hand Time*, about a young couple in the USSR.

> In tenth grade, I had an affair. He lived in Moscow. I went to see him, we only had three days. In the morning, at the station, we picked up a mimeographed copy of Nadezhda Mandelstam's memoirs, which everyone was reading at the time. We had to return the book the next day at four in the morning. Hand it off to someone on a train passing through town. For twenty-four hours, we read without stopping — we only went out once, to get milk and a loaf of bread. We even forgot to kiss, we just handed the pages to one another. All of this happened in some kind of fever, a stupor... All because you're holding this particular book in your hands... Because you're reading it... Twenty-four hours later, we ran through an empty city back to the train station; public transport wasn't even running yet. I remember the city that night, walking together with the book in my purse. We handled it like it was a secret weapon... That's how ardently we believed that the word would change the world.[9]

Might we see in this vignette of two lovers breathlessly reading a secret book together, united in their faith in the power of the word to change the world, a portrait of communist sexuality? Instead of gazing into each other's eyes, their eyes are trained on a third thing, a book, which connects them to the collective and the wider social universe. The irony here is that this is a story of anti-communist

dissidence: Mandelstam's memoirs, recounting her husband Osip's exile and death on the way to the gulag, circulated in a samizdat version in the Soviet Union in the 1960s, and were first published in English in the West. If we focus on the form of the relationship, however (not knowing whether the couple's politics will go in the direction of liberalism, anti-Stalinist communism, or something else), we can discern three key elements: first, a commitment to language, a belief in the power of words; second, the focus on a third thing, a shared point outside the couple, and third, the sexualisation of practico-critical activity itself. There is a curious detail in the story: the couple was so excited by reading that they 'forgot to kiss'. Instead of saying that reading takes the place of sexuality, one should make the more uncanny claim that, at that moment, reading itself was the couple's erotic activity. It's not that they read instead of having sex, but reading the book together *is* sex (even better, it's a forbidden book). In Jacques Lacan's discussion of sublimation, he underlines that what is so provocative about the concept is not the idea that sexual drives can be re-directed to non-sexual (i.e. more socially acceptable) ends, but that it calls into question the very nature of sexuality and the satisfaction of the sexual drives: 'In other words — for the moment, I am not fucking, I am talking to you. Well! I can have exactly the same satisfaction as if I were fucking. That's what it means. Indeed, it raises the question of whether in fact I am not fucking at this moment. Between these two terms — drive and satisfaction — there is set up an extreme antinomy that reminds us that the use of the function of the drive has for me no other purpose than

to put in question what is meant by satisfaction.'[10] Similarly, we could imagine one of our teenage Soviet lovers saying: 'For the moment, I am not kissing, I am reading with you. Well! I can have exactly the same satisfaction as if I were kissing.'

YOUR CORNEA
IS EXCELLENT

Another rumour: Kollontai is widely considered to have been the inspiration for the title character of Ernst Lubitsch's *Ninotchka* (1939). One of the director's finest comedies, the film is about the unlikely romance between Nina Ivanovna 'Ninotchka' Yakushova, a Soviet envoy sent from Moscow to Paris to oversee the sale of precious jewellery to raise money for the State, and Count Leon d'Algout, a charming gigolo and kept man of the Grand Duchess Swanna, a member of the tsar's family who also happens to be the previous owner of the jewels. Ninotchka is played by Greta Garbo with her signature distance and feminine mystique. She is intelligent, totally dedicated, and highly capable — unlike her bumbling comrades Buljanoff, Iranoff, and Kopalski who nearly botch the sale due to Leon's clever manipulations and the hedonistic attractions of Parisian life. But Ninotchka too is soon thrown off balance by the charismatic Westerner and the life he represents; eventually her cold Soviet exterior is cracked and she falls head over heels in love with him. The script was based on a three-sentence plot written by Hungarian playwright and frequent Lubitsch collaborator Melchior Lengyel: 'Russian girl saturated with Bolshevist

ideals goes to fearful, capitalistic, monopolistic Paris. She meets romance and has an uproarious good time. Capitalism not so bad, after all.' On its face, *Ninotchka* is an anticommunist comedy where the unfeeling, inhuman, but sexy Soviet agent throws aside ideology and succumbs to Western romance: communism defeated by love. But, this being Lubitsch, the situation is hardly as simple as that: the best jokes are actually directed against capitalists and aristocrats, and if there is a moral centre to the film it is the proud Ninotchka who never abandons the communist cause.

I want to focus on one of the seduction scenes between Leon and Ninotchka. Leon has invited Ninotchka to his apartment, where they engage in a sparkling, rapid dialogue.

LEON: Ninotchka... do you like me just a little bit?
NINOTCHKA: Your general appearance is not distasteful.
LEON: Thank you.
NINOTCHKA: The whites of your eyes are clear. Your cornea is excellent.
LEON: Your cornea is terrific. Ninotchka, tell me. You're such an expert on things. Can it be that I'm falling in love with you?
NINOTCHKA: Why must you bring in wrong values? Love is a romantic designation for a most ordinary biological... or shall we say 'chemical', process. A lot of nonsense is talked and written about it.
LEON: I see. What do you use instead?

> NINOTCHKA: I acknowledge the existence of a
> natural impulse common to all.
> LEON: What can I possibly do to encourage such an
> impulse in you?
> NINOTCHKA: You don't have to do a thing. Chemi-
> cally, we are already quite sympathetic.

What image of sexuality is being depicted here? Note that while the New Soviet Woman is portrayed as cold and unromantic, she is not deprived of sexual feeling. Ninotchka regards her seducer with scientific detachment: she is studying Leon, just as she studies the engineering marvels of the city of Paris. For her, this Western playboy is a relic of a doomed culture and a representative of an outmoded male subjectivity. 'You are something we do not have in Russia', Ninotchka tells Leon, and after his 'Thank you' adds: 'That is why I believe in the future of my country.' But even though she views him as an anachronism, she is not unmoved by him. 'Chemically, we are already quite sympathetic' she states, as if objectively reporting on a factual situation. Assessing his physical attractiveness, she pays him a compliment whose clinical precision makes it hilariously out of place: 'Your cornea is excellent.' Despite the good eyes, he does not see things very clearly. Ninotchka experiences love as purely material process, the chemical base stripped of its romantic ideological superstructure. Love is a 'natural impulse common to all'. From this demystified perspective, she looks on Leon's seduction attempts with a certain irony. It is as if she were telling him 'No need to go through all these motions, its unnecessary, wasted labour. Don't you

know you've already won?' There is something strangely utopian in Ninotchka's attitude toward sex. She is fully in control, uncompromised by her desire, which she treats in a no-nonsense way, without embarrassment, anxiety, or guilt: love is a natural need to be satisfied like any other. (Moreover, does not Ninotchka's chemical Eros anticipate the postmodern attitude towards sexuality as a matter of biochemistry that can be manipulated through pharmacological means?). There is a line, often falsely attributed to Kollontai, which Lenin comments on in his conversations with Clara Zetkin: 'You must be aware of the famous theory that in Communist society the satisfaction of sexual desires, of love, will be as simple and unimportant as drinking a glass of water. This glass of water theory has made our young people mad, quite mad.'[11] But Ninotchka is not mad. If anything, she is uncannily sober.

In the course of the film, Ninotchka undergoes a conversion: she falls for Leon, loses her self-control (signified by her laughing), and is swept away by desire. The Lubitsch touch is that this subjective transformation is condensed by a peculiar object: the funny designer hat, shaped like a funnel, that she sees in a luxury shop window upon arriving in Paris. At first the hat is a sign of capitalism's doom. 'It won't be long now comrades', Ninotchka pronounces upon seeing it: any civilisation that wastes its productive energies on such decadent trifles must be on the way out. Later on, she dons the very hat, thereby symbolising the defeat of her rational utilitarian attitude by luxury, excess, superfluity, the non-utilitarian 'general economy' of desire. But Leon too undergoes a conversion, as he

exchanges his Tsarist lady for a Bolshevik one. He starts reading Marx, and (ironically) lectures his butler about the class struggle. There is also an evident masochistic bent to Leon's love for this cool, distant woman, who, as she recounts to him, once killed a 'Polish lancer' and refers to him as a member of a soon to be 'extinct' class: Garbo as a Soviet Venus in Furs. One of the most ingenious scenes of the film takes place at a fancy nightclub, where the lovers are enjoying a big night on the town, drinking champagne and dancing. Lubitsch subverts the standard romantic comedy set-up where one of the characters gets drunk and does something transgressive, usually of a sexual nature, thus creating a comical conflict. After a tense exchange with the Duchess, Leon and Ninotchka take to the floor and start dancing. Overcome with emotion and alcohol, Ninotchka turns to her fellow ballroom dancers and addresses them, 'Comrades, comrades, good people of France...' then announces to Leon her intention to make a speech and foment revolution against the Duchess. An embarrassed Leon hushes her up, and sends her off to the ladies' room. But he is soon informed by the distressed maître d'hôtel that his companion is 'spreading communistic propaganda in the powder room' and organising the washroom attendants. What makes this scene so effective is that Lubitsch has put the desire for communism in the structural place of sex. Labour organising and propagandising have the same transgressive punch as what, in a more conventional film, would be accomplished by sexually risqué behaviour; they have the form of a sexual scandal. And here we get a very different view on Ninotchka: it is not that she's a kind of communist robot,

but deep down there is a warm capitalist romantic waiting to break out. On the contrary: totally soused and out of control, it is comradeship-love that comes bubbling to the surface. This is Ninotchka's deepest drive, her basest id, and her truest passion. The covert message of the film is: if you get drunk and let yourself go, if you overcome your inhibitions, if your id is allowed to run wild, you will be a communist.

WINGED EROS

In fact, the inspiration for Ninotchka was not Kollontai but, most likely, Inge von Wangenheim. Lubitsch and Gustav von Wangenheim were friends from their Berlin days, where he acted in a couple of Lubitsch's early films (Wangenheim's most famous role was as Thomas Hutter in *Nosferatu*). In 1936 Lubitsch made a trip to Moscow where he visited Gustav and his wife Inge, the couple having fled from Nazi Germany in the early 1930s to the Soviet capital.

Inge, a staunch Communist, served as a model for the role of the Commissar, played by Greta Garbo. The precision that Garbo displayed becomes apparent, for example, in the famous kissing scene. For the heroine, love can only be experienced as a chemical process. That this form of feminine aspiration must lose against the loving, lavish and irrational lifestyle of the male bohemian was beyond question for Lubitsch. Inge von Wangenheim must have left behind the impression that, for them, progress in the Soviet Union was plannable

and well thought-out. Everything, really everything, had to be submitted to this logic. Feelings should stand back in favour of the one big thing. For Lubitsch, such a mindset was ideal, as it provided the material for his upcoming film.[12]

Apparently, Ninotchka's Moscow apartment reproduced that of the Wangenheim's down to the last detail, with the exception of a picture of Lenin substituted for that of Stalin.[13] Inge von Wangenheim's ideological dedication and rational 'planning' mindset informed Lubitsch's portrayal of Ninotchka, who is clearheaded and efficient even in matters of love. Kollontai, in contrast, never advocated a chemical Eros, or a supposedly natural desire shorn of sentimental ornaments and false romantic values. On the contrary, she promoted a 'winged Eros', a love that would fuse erotic passion and spiritual warmth, on the basis of equality and solidarity in the struggle against domination — if there is a phrase that expresses what is at stake in Kollontai's winged Eros it is Nikolay Oleynikov and Kirill Medvedev's slogan 'revolutionary aspects of radical tenderness'.[14] Indeed, Lubitsch's Ninotchka is a parody of Kollontai's sexually emancipated woman, transforming the female worker with her own ambitions and sexual life into a centrally planned communist love machine. Even further, this caricatural portrait opens the way for imagining a properly Stalinist libertinism: a Stakhanovism of love, not far from the workhorse ethic of the Sadeian libertine, exceeding orgasmic productivity goals through tireless erotic labour.

So, what did Kollontai argue? Kollontai's writings present
a mixture of the realistic and the utopian, the practical
and the avant-garde. She worked for social reforms,
which were enacted in the Family Code of 1918 and
other legislation, including the first civil marriage law
(introduced in December 1917 — as I mentioned before,
Kollontai and Dybenko were married under this new
provision), a much simplified divorce procedure, equal
rights for women and men, the abolition of inheritance,
legalised abortion (passed on 19 November 1920), and
the decriminalisation of sodomy (in the Soviet Legal
Code of 1922).[15] At the same time, her essays possess an
avant-garde spirit, calling not for a New Man but a 'New
Woman' (the title of one of her essays), who would effect
a 'transvaluation of the moral and the sexual standards'
and bring into being 'a new psychic structure'.[16] In her
essay 'Make Way for Winged Eros: A Letter to Working
Youth', Kollontai offers a materialist history of love, in line
with Friedrich Engels's *The Origin of the Family, Private
Property and the State*. Kollontai's is an account of love as a
social and psychological phenomenon embedded in major
historical changes; love reflects and is formative of the
way society materially reproduces itself. She provides a
succinct summary of this history:

At the tribal stage love was seen as a kinship attach-
ment (love between sisters and brothers, love for par-
ents). The ancient culture of the pre-Christian period
placed love-friendship above all else. The feudal world
idealised platonic courtly love between members of
the opposite sex outside marriage. The bourgeoisie

took monogamous marital love as its ideal. The working class derives its ideal from the labour co-operation and inner solidarity that binds the men and women of the proletariat together.[17]

In ancient times kinship ties were paramount, and the kind of love that was most highly valued was between members of the same tribe. Antigone's unswerving devotion to her brother, Kollontai argues, exemplifies this kind of love tie, which would appear 'highly curious' to bourgeois society.[18] Feudalism introduces something new: personal romance, in the form of the gallant love between the knight and his chosen lady, which takes place outside of the family. The desire for the sublime and unattainable Lady inspires the knight to feats of valour and heroism; this moral example served the interests of the noble class, while containing the passions within a certain framework (it is important that this love remain unconsummated). Love and marriage, kept separate by feudal ideology, are then united in the bourgeois era. Bourgeois morality brings romantic love into the family: marriage is now the expression of the love of the couple, which serves as the basic unit of capitalist production. 'The ideal was the married couple working together to improve their welfare and to increase the wealth of their particular family unit.'[19] While condoning physical pleasure and personal romantic choice, by confining love to marriage bourgeois morality created a rich source of emotional discontent. Finally, communism dethrones the centrality of marriage in favour of the collective, which becomes the new locus of love: 'love comradeship'.

Solidarity and cooperation are the crucial values. The love of the couple, no longer confined to marriage and the nuclear family, is triangulated with the proletarian class building a new society (although Dybenko did manage to convince Kollontai to marry him, against her ideological commitments). 'Winged Eros' opposes the 'wingless Eros' of 'unhealthy carnality', of the search for physical pleasure divorced from emotional entanglements (Kollontai is sharply critical of prostitution).[20] In winged Eros 'physical attraction and emotional warmth are fused',[21] and 'sensitivity, responsiveness, and the desire to help others' are also promoted.[22] Kollontai writes of the complexity of the emotions and the many 'shades of feeling' associated with love, and the need for openness as to formal arrangements; she also calls for a radical reform of emotional life to abolish the dramas attached to exclusivity and ownership of the other. Here we encounter in Marxist feminism a similar problem to that in psychoanalysis regarding the end of the analysis: what would be a desire not plagued by the same symptoms, the same complaints, the same tiresome dramas? But also: how to avoid, in the critique of prevailing norms and values, the dogmatic reintroduction of new norms, or the (inevitably oppressive) dream of an ideal synthesis? As Oxana Timofeeva writes, 'What will love be like under communism? How do we solve the problem of unrequited love, infidelity, passion? Maybe [Kollontai's] calls for a comradely love seem a bit naïve today, but she asked these questions boldly, and no one has thought up any articulate answers to them, yet — although we're trying, right?'[23]

GAME LOVE:
OR A NEW FEMININE TRAGEDY

Kollontai leaves open the exact character of the erotic future. 'What will be the nature of this transformed Eros? Not even the boldest fantasy is capable of providing the answer to this question. But one thing is clear: the stronger the intellectual and emotional bonds of the new humanity, the less the room for love in the present sense of the word.' And then follows the line that I quoted near the start of this piece: 'Modern love always sins, because it absorbs the thoughts and feelings of loving hearts and isolates the loving pair from the collective.'[24]

Even though Kollontai does not specify the nature of the coming communist Eros, she provides a suggestive path for its cultivation. Cutting across her materialist history of love, from ancient to feudal to bourgeois to communist times, is another sort of amorous relation that Kollontai, following the Austrian Jewish feminist Grete Meisel-Hess, calls 'game love'. Kollontai wrote a review of Meisel-Hess's *The Sexual Crisis: A Critique of Our Sex Life*, which is translated in English as 'Love and the New Morality'. In the last pages of the piece she focuses on a short chapter of Meisel-Hess's book titled 'The Sport of Love', which discusses love as a fine art, a matter of refinement, of play and cultivation. Examples of game love include the hetaera of ancient Greece, the Lady sung in the poetry of courtly love, the courtesans of the Renaissance, and, Kollontai adds, 'the erotic friendship of the "grizetka", free and carefree as a bird, and her "comrade student"'.[25] In all

these different forms 'love was a sport pursued with a delicate art'.[26] Meisel-Hess describes how game love involves a specific attitude or ethos, which is both light and free, on the one hand, and deadly serious on the other. 'Love is a game — involving serious issues.'[27] Game love should not be understood as a frivolous diversion devoid of commitment or engagement; on the contrary it requires a special sensibility, a sense for the seriousness of play and the truth of fiction that can easily lose its way.

> So rare is the talent for love that those who should enjoy this refined sport fail almost invariably in one direction or the other. If they remain light-minded, they degenerate either into horseplay or into obscenity. On the other hand, if they take love seriously, their mood passes on into tragedy, and they make shipwreck of their lives. The rich values of a mutual love-sport remain for the most part unknown quantities.[28]

Is this an example of Kollontai's aristocratic background at work? How could this emphasis on the fine art of love have anything to do with communist Eros, with the sexual life of the proletariat? It is interesting to note that Lacan was also fascinated with game love, specifically its feudal form known as courtly love, which he considered to be a paradigm of sublimation. Again, rather than understanding sublimation as a healthy, socially sanctioned outlet for sexual and aggressive impulses, Lacan reinterprets the Freudian notion in a much more subversive way. According to Lacan, through sublimation within a culture there is produced an exceptional space where the

tensions, contradictions, and conflicts normally repressed by culture can come to light and be given an aesthetic form. Sublimation brings into culture what can never be fully reconciled with life in culture, with its rules and prohibitions, and consensual reality; it reveals something of the 'discontent' of civilisation, and shows how desire is never fully captured by the order which forms it. Kollontai's historical materialist account of love in feudalism contains much that is compatible with Lacan's approach. Where they especially agree is on the fictitious and hypocritical nature of courtly love, expressed very clearly by Kollontai: 'The knight who would not be parted from the emblem of the lady of his heart, who composed poetry in her honour and risked his life to win her smile, would rape a girl of the urban classes without a second thought or order his steward to bring him a beautiful peasant for his pleasure.'[29] Lacan similarly emphasised that courtly love was not a 'lived substance'[30] but an artifice, a poetic creation, precisely a 'game love'. However, Lacan unlike Kollontai, saw in courtly love something other than an instrument of feudal ideology, which pointed to the repressed truth of desire. In its hyperbolic praise of the unattainable Lady, the poetry of the troubadours exposed the asymmetry and non-reciprocity that lies at the heart of all love relations. Kollontai argues that the novel, which, in exploring the complexities and contradictions of modern libidinal life, exploded the official bourgeois ideology of marriage, later accomplished this kind of sublimation. The novel gave fictionalised expression to the fact that love 'could not be contained within the limits set down by bourgeois ideologists'.[31]

Was not psychoanalysis itself the ultimate game love of
the bourgeois era, involving the love affair between not
the troubadour-knight and his cold, unreachable Lady, but
the neurotic and his or her equally silent and inscrutable
partner, the analyst? It even invented a new name for this
love: transference. Transference love, as Freud insisted, is
as real as any other romance, and yet it is also undeniably
fake, artificially produced by the analytic situation. It is
a game whose players wear masks and disguises, whose
rules are not immediately apparent, and whose final aim
has yet to be invented. If there is a goal to this game, it is
to discover the rules, which are secretly guiding and regu-
lating it, that is, the law of one's desire. The analyst's office
is an exceptional space where something that is normally
repressed can come to light and be given a new kind of
expression in language. If the troubadours were great po-
ets, specialising in the art of the amorous complaint, psy-
choanalysis too has its own form of poetry, produced by
the experimental technique of free association, in which
speech is maximally freed from the control of the ego and
the narcissistic desire for self-expression. Psychoanalysis
gave birth to the mangled poetry of the unconscious, the
troublesome complaint of the symptom (which is the neu-
rotic's real partner). The game love of psychoanalysis has
three essential components: first, like the teenage lovers
reading Mandelstam's memoirs, it demands faith in the
power of language: words have material consequences;
they can 'change the world'. Second, psychoanalysis in-
vented a new perversion, the pleasure in free association,
which drives the process forward but also, bogs it down;
enjoyment is both the motor and the stumbling block of

analysis, and ultimately it is enjoyment which has to be confronted, shifted, broken down. It is not enough to acknowledge the efficacy of language without experiencing how language is also a machine for enjoyment. Third, and most peculiarly, psychoanalysis is perhaps the first love relationship in history where breaking up is a sign of success. It is a love that is not meant to last forever, but one that should come to an end: analysis must terminate, even if (or precisely because) it is 'interminable'. If breaking up is usually seen as the failure of love, in psychoanalysis things are inverted. Here the break-up appears not as the end and failure of desire but as its starting point, as the position from which one can desire, as if for the first time: psychoanalysis as an art of the rupture.

What, then, is the game love of communism? Kollontai presents game love as a transitional phenomenon, a kind of pedagogical instruction or amorous training involving the reshaping of sexual mores and fantasies, leading to the future realisation of winged Eros. As she writes, 'To be capable of "great love" humanity must pass through the difficult "school of love" where the emotions are refined. "Game love" is this school; it is the way for the human psyche to develop its "potential for loving".'[32] This pedagogical aspect of game love is interesting: it shows that love is not simply a natural or spontaneous impulse, but something that must be learned, that requires a formation. Human beings are stupid animals that need to be taught how to love; in this sense, all love has an artificial character; it is socially and historically determined. This also means that the rules, habits, and fantasies that inform

desire are up for contestation: there is class struggle in the field of love. Conversely, a theory of love can also be a theory of politics, and one way of understanding Kollontai's interest in game love is as a commentary on the course of the revolution itself. Kollontai's writings on love ought to be read as a theory of revolutionary praxis. Will the revolution follow the path of a tragic passion? Could it degenerate into cynical games and obscenity? Or will it be played with the right esprit, even with a touch of delicacy and wit? 'Love is either a tragedy that tears the soul apart or it is a vulgar vaudeville', Kollontai writes.[33] This dark assessment of the fate of modern love contains a political diagnosis. There are two dangers that threaten the revolution: either it can devolve into a tragedy that tears itself apart, eating its own children: a terroristic 'passion of the real', to use Alain Badiou's phrase, or, as Lacan puts it, 'I love you, but, because inexplicably I love in you something more than you — the *objet petit a* — I mutilate you.'[34] Or else it can degenerate into 'vulgar vaudeville', i.e. bureaucracy, where success in the institutional machinery becomes an end-in-itself, subordinating all other ends, projects, and ideals to its dreary immanence. Bureaucracy is the masturbation of politics. A winged revolutionary Eros must avoid both these traps. If 'a certain revolutionary "taste for drama" could well be something of a problem', in the words of Alenka Zupančič, Kollontai's game love, with its emphasis on the reality of fiction, on the real not behind but within appearances, offers a political alternative to self-destructive dramatic passion and cynical institutionalism.[35]

Kollontai's speculations on Eros are provocative again today. First, they stand in contrast to the popular line of 1960s sexual liberation movements. For her, the sexual revolution is not simply a matter of emancipating desire or eliminating the obstacles to its free expression. Kollontai rather emphasises the moral rigor of the new amorous regime: communist Eros will come with its own morality and its own rules. 'The ideology of the proletariat rejects bourgeois morality in the sphere of love marriage relations. Nevertheless, it inevitably develops its own class morality with its own rules and behaviour.'[36] Despite the so-called 'glass of water theory', for Kollontai communist sexuality is not a libidinal free-for-all but entails its own commitments and constraints. Moreover, instead of promising untrammelled enjoyment, communist Eros gives rise to what Kollontai calls a new tragedy (and, we might surmise, a new comedy). Kollontai ends her essay on the 'New Woman' with this claim: 'Woman, by degrees, is being transformed from an object of tragedy of the male soul into the subject of an independent tragedy.'[37] How can we better understand this new feminine tragedy? If psychoanalysis is the game love of bourgeois civilisation, it is because of the way it undertakes a critique of its libidinal fundaments and effectively politicises mental illness: pathological symptoms are analysed as responses to the repression, exploitation, conflicts, and contradictions that constitute the capitalist psyche; psychoanalysis creates a space within this culture for the subject to desire differently. But what if socioeconomic conditions were ameliorated, or at least significantly improved, and repression to some degree lifted? Would the peculiar game love of

psychoanalysis lose its relevance? Or would a communist society also have its libidinal discontents? According to Kollontai, the main achievement of comradeship love will be to end the dominance of the property form in the sphere of sexuality, so that women will no longer be treated as possessions and the objects of a jealous passion for control. For Kollontai the question of sexual liberation is inseparable from that of fundamental socioeconomic change, which distances her position from that of many feminists today. Her critique of the property form also means that the ultimate horizon of her thought is not the same as liberalism's self-determination or consent, where one treats oneself as one's own property, free to dispose of as one wishes as long as it does not infringe the freedom of others. If one takes the criticism of the property form seriously, it means not only that one cannot possess the other, but also that one does not even possess oneself. 'You don't own me, and what is more, I don't even own myself!' — this self-dispossession is the meaning of the unconscious, and could serve well as the starting point for thinking of a new female tragedy. This non-ownership of the self is the radical implication of the critique of the property form in love, and it would have to be developed further, in all its consequences and difficulties (for example, could one also play with the property form? could mock ownership be part of the game?). One thing is clear: the critical dimension of Kollontai's thought goes beyond the formal framework of the sexual marketplace to the question of the nature of desire itself. This sharply differentiates her from many contemporary activists and theorists; however, it is also where Kollontai can appear rather

simplistic. Instead of seeing game love as the path to a fully realised great love, it could be understood as a continually renewed space of experimentation, a transition without end: permanent revolution in the field of love (which need not entail a constant exchange of partners, but rather signifies that there is no stable, harmonious form of the sexual relationship, no prescribed end-point where amorous education terminates). Twisting Kollontai a bit, one could argue that the struggle against repression and exploitation does not simply open the path to mature and fulfilling love relations, but allows us to glimpse the tragedy of love anew, with fresh eyes. Once the distortions in Eros caused by social inequalities and coercive power dynamics are ameliorated, what is revealed is not — contrary to some of Kollontai's own pronouncements — a natural and healthy desire but rather the incomparably greater distortion that *is* Eros. The programme for the emancipation of sexuality should be: let us vanquish the distortions in Eros in order to confront the distortion of Eros itself.

Instead of trying to describe the nature of this future love — a question 'not even the boldest fantasy' can answer — I will conclude, more modestly, by proposing a new signifier for it. There is perhaps no better term for Kollontai's 'independent tragedy' of the female soul than the one invented by Clarice Lispector at the end of her novel *The Passion According to G.H.* (some critics identify the initials of the otherwise nameless female narrator with 'gênero humano', or humankind, the universal subject — but what kind of universality is being advanced

here?). At the conclusion of her journey through madness and what is effectively her self-psychoanalysis, the narrator states: 'the world *independed* on me'.[38] A strange verb, both transitive and intransitive, made by twisting (torturing?) language: neither a relation of dependence nor a condition of autonomy and independence, what it designates is a non-relation at the heart of the relation, a disjunctive synthesis which, as Lispector adds, is a matter not of 'knowledge' but of 'trust', i.e. of subjective engagement, of faith in the power of words, even as they falter and drift. What if 'independing' were the other side of solidarity, of 'collective joy'? What if, beyond jealous passion and the will to autonomy and self-control — the two libidinal expressions of the property form — the lovers were to *independ* on one another? What new tragedies and comedies might this bring?

1 I am closely paraphrasing here the account given on Wikipedia (which provides no sources for it): https://en.wikipedia.org/wiki/Alexandra_Kollontai

2 For an account of her reputation, and the rumours that swirled around her, see Barbara Evans Clements, 'Aleksandra Kollontai: Libertine or Feminist?', in *Reconsiderations on the Russian Revolution*, ed. by Ralph Carter Elwood (Cambridge, MA: Slavica Publishers, 1976).

3 Paul Ginsborg, *Family Politics: Domestic Life, Devastation, and Survival 1900–1950* (New Haven: Yale University, 2014), p. 5.

4 Alexandra Kollontai, 'Make Way for Winged Eros: A Letter to Working Youth', in *Selected Writings of Alexandra Kollontai*, trans. by Alix Holt (Westport, CN: Laurence Hill Co., 1977), p. 290.

5 The real basis of the story (recounted in a different version below) seems to be a dramatic episode in Kollontai and Dybenko's relationship. In March 1918, Dybenko was arrested for allegedly deserting his post on the front line against the Germans. Kollontai

made his bail. Then 'Dybenko jumped bail and he and Alexandra, without notifying anyone in the government, left Moscow to visit Misha [her son from a previous marriage] in Petrograd. There were rumours that several commissars wanted them both shot for desertion, and this trip was most probably the source of the rumour about their lengthy honeymoon in the Crimea; Lenin claimed to have devised the most appropriate punishment for them: they should be forced to live together for five years. Their crime was not, after all so great'. Cathy Porter, *Alexandra Kollontai: A Biography* (Chicago: Haymarket Books, 2014), p. 302.

6 Ginsborg, *Family Politics*, p. 28.

7 Kollontai, *The Autobiography of a Sexually Emancipated Communist Woman*, 3 <https://www.marxists.org/archive/kollonta/1926/autobiography.htm>.

8 Ibid., p. 2.

9 Svetlana Alexievich, *Second-Hand Time*, trans. by Bela Shayevich (London: Fitzcarraldo Editions, 2016), p. 240.

10 Jacques Lacan, *The Four Fundamental Concepts of Psychoanalysis. The Seminar of Jacques Lacan Book XI*, ed. by Jacques-Alain Miller, trans. by Alan Sheridan (New York: W.W. Norton, 1977), pp. 165-66.

11 Clara Zetkin, *Reminiscences of Lenin* (London: Modern Books, 1929 [1924]), pp. 57-58.

12 Laura von Wangenheim, *In den Fängen der Geschichte: Inge von Wangenheim Fotografien aus dem sowjetischen Exit 1933-1945* (Berlin: Rotbuch Verlag, 2013), p. 12.

13 Ibid., pp. 17-18.

14 One of the chapter titles of Nikolay Oleynikov et. al., *Sex of the Oppressed*, trans. by Jonathan Brooks Platt (Guelph, ON: Publication Studio Guelph, 2016).

15 See Ginsborg, *Family Politics*, pp. 29-32.

16 Kollontai, 'New Woman', pp. 34, 21 <https://www.marxists.org/archive/kollonta/1918/new-morality.htm>

17 Kollontai, 'Winged Eros', p. 288.

18 Ibid., p. 279.

19 Ibid., p. 284.

20 Ibid., p. 286.

21 Ibid.

22 Ibid., p. 289.

23 Oleynikov, *Sex of the Oppressed*, p. 98.

24 Kollontai, 'Winged Eros', p. 290.

25 Kollontai, 'Love and the New Morality', in *Sexual Relations and the Class Struggle & Love and the New Morality*, trans. by Alix Holt (Bristol: Falling Wall Press, 1972), p. 22.

26 Grete Meisel-Hess, *The Sexual Crisis: A Critique of Our Sex Life*, trans. by Eden and Cedar Paul (New York: The Critic and Guide Co., 1917), p. 126.

27 Ibid., pp. 128–129.

28 Ibid., p. 129.

29 Kollontai, 'Winged Eros', p. 282.

30 Lacan, *The Seminar of Jacques Lacan, Book VII. The Ethics of Psychoanalysis, 1959–1960*, ed. Jacques-Alain Miller, trans. by Dennis Porter (New York: Norton, 1992), p. 152.

31 Kollontai, 'Winged Eros', p. 284. Kollontai was herself a novelist; *Red Love* and *Love of Worker Bees* are among her most well-known works.

32 Kollontai, 'Love and the New Morality', p. 22.

33 Ibid., p. 24.

34 See Alain Badiou, *The Century*, trans. by Alberto Toscano (Cambridge: Polity Press, 2007); Lacan, *Seminar XI*, p. 268. In fact, the term 'passion of the real' was first employed by Lacan in Seminar IX *Identification*.

35 Alenka Zupančič, *What Is Sex?* (Cambridge, MA: MIT Press, 2017), p. 135.

36 Kollontai, 'Winged Eros', p. 291.

37 Kollontai, 'New Woman', p. 35.

38 Clarice Lispector, *The Passion According to G.H.*, trans. by Idra Novey (London: Penguin, 2012), p. 189; emphasis added. In the original Portuguese the sentence reads: 'O mundo independia de mim.'

LETTER FROM A TRANS MAN TO THE OLD SEXUAL REGIME
PAUL B. PRECIADO

Translated from the French by Simon Pleasance

Caught in the crossfire of sexual harassment politics, I should like to say a word or two as a smuggler between two worlds, the world of 'men' and the world of 'women' — these two worlds which might very well not exist, were some people not doing their utmost to keep them apart by means of a kind of Berlin gender Wall. I want to give you some news from the 'found object' position or rather from that of the 'lost subject' — lost during crossing.

I'm not talking here as a man belonging to the ruling class, the class of those who are assigned the male gender at birth, and who have been brought up as members of the governing class, those who are given the right or rather who are required (and this is an interesting analytical key) to exercise male sovereignty. Nor am I talking as a woman, given that I have voluntarily and intentionally abandoned that form of political and social embodiment. I speak as a trans man. And I'm in no way claiming to represent any collective whatsoever. I'm not talking, and cannot talk, as a heterosexual or a homosexual, although I'm acquainted with and occupy both positions, because when someone is trans, these categories become obsolete. I'm talking as a gender renegade, as a gender migrant, as a fugitive from sexuality, as a dissident (sometimes a clumsy one, because there is no trans user's guide) with regard to the regime of sexual difference. As a self-appointed guinea-pig of sexual

politics who is undergoing the as yet still to be themed experience of living on both sides of the Wall and who, by dint of crossing it every day, is beginning to be fed up, ladies and gentlemen, with the stubborn rigidity of the codes and desires which the hetero-patriarchal regime dictates. Let me tell you, from the other side of the Wall, that things are far worse than my experience as a lesbian woman ever let me imagine. Since I've been living as-if-I-were-a-man in a man's world (aware of embodying a political fiction), I've had a chance to check that the ruling class (male and heterosexual) will not give up its privileges just because we send lots of tweets or let out the odd scream. Since the sexual and anti-colonial revolution of the past century shook their world, the hetero-white-patriarchs have embarked on a counter-reformation project — now joined by 'female' voices wishing to go on being 'importuned and bothered'. This will be a 1000-year war — the longest of all wars, given that it will affect the politics of reproduction and processes through which a human body is socially constituted as a sovereign subject. It will actually be the most important of all wars, because what is at stake is neither territory nor city, but the body, pleasure, and life.

What hallmarks the position of men in our techno-patriarchal and heterocentric societies is the fact that male sovereignty is defined by the lawful use of techniques of violence (against women, against children, against non-white men, against animals, and against the planet as a whole). Reading Max Weber with Judith Butler, we could say that masculinity is to society what the State is to the nation: the holder and legitimate user of violence. This

violence is expressed socially in the form of domination, economically in the form of privileges, and sexually in the form of aggression and rape. Conversely, female sovereignty in this regime is bound up with women's capacity to give birth. Women are sexually and socially subordinate. Mothers alone are sovereign. Within this system, masculinity is defined necro-politically (by men's right to inflict death), while femininity is defined bio-politically (by women's obligation to have children). We might say with regard to necro-political heterosexuality that it is something akin to the utopia of the copulatory eroticisation between Robocop and Alien, if we tell ourselves that, with a bit of luck, one of the two will have a good time...

Heterosexuality is not only a political regime, as the French writer Monique Wittig has shown. It has also a politics of desire. The specific feature of this system is that it is incarnated as a process of seduction and romantic dependence between 'free' sexual agents. The positions of Robocop and Alien are not chosen individually, and are not conscious. Necro-political heterosexuality is a practice of government which is not imposed by those who govern (men) on the governed (women), but rather an epistemology laying down the respective definitions and positions of men and women by way of an internal regulation. This practice of government does not take the form of a law, but of an unwritten norm, a translation of gestures and codes whose effect is to establish within the practice of sexuality a partition between what can and cannot be done. This form of sexual servitude is based on an aesthetics of seduction, a stylisation of desire, and a historically constructed and coded domination which

eroticises the difference of power and perpetuates it. This politics of desire is what keeps the old sex/gender regime alive, despite all the legal processes of democratisation and empowerment of women. This necro-political heterosexual is just as degrading and destructive as were vassalage and slavery during the Enlightenment. The process of denouncing violence and making it possible, which we are currently experiencing, is part and parcel of a sexual revolution, which is as unstoppable as it is slow and winding. Queer feminism has set epistemological transformation as a condition making social change possible. It called binary epistemology and gender naturalisation into question by asserting that there is an irreducible multiplicity of different sexes, genders, and sexualities. But we realise, these days, that the libidinal transformation is as important as the epistemological one: desire must be transformed. We must learn how to desire sexual freedom.

For years, queer culture has been a laboratory for inventing new aesthetics of dissident sexualities, in the face of techniques of subjectivation and desires involving hegemonic necro-political heterosexuality. Many of us have long since abandoned the aesthetics of Robocop-Alien sexuality. We have learned from butch-fem and BDSM cultures, with Joan Nestle, Pat Califia and Gayle Rubin, with Annie Sprinkle and Beth Stephens, with Guillaume Dustan and Virginie Despentes, that sexuality is a political theatre in which desire, and not anatomy, writes the script. Within the theatrical fiction of sexuality, it is possible to want to lick the soles of shoes, to want to be penetrated through every orifice, and to chase

a lover through a forest as if he were a sexual prey. Two differential factors nevertheless separate the queer aesthetic from that of the straight normativeness of the old régime — the ancient régime: the consent and the non-naturalisation of sexual positions. The equivalence of bodies and the redistribution of power.

As a trans-man, I disidentify myself from dominant masculinity and its necro-political definition. What is most urgent is not to defend what we are (men or women) but to reject it, to disidentify ourselves from the political coercion which forces us to desire the norm and reproduce it. Our political praxis is to disobey the norms of gender and sexuality. I was a Lesbian for most of my life, then trans for the past five years. I am as far removed from your aesthetics of heterosexuality as a Buddhist monk levitating in Lhassa is from a Carrefour supermarket. Your aesthetics of the sexual ancient régime do not give me pleasure (don't make me come). It doesn't turn me on to 'importune' anyone. It doesn't interest me to relieve myself of my sexual misery by touching a woman's ass on public transport. I don't feel any kind of desire for the erotic and sexual kitsch you're offering: guys taking advantage of their position of power to get their rocks off and touch backsides. The grotesque and murderous aesthetics of necro-political heterosexuality turns my stomach. An aesthetics which re-naturalises sexual differences and places men in the position of aggressor and women in that of victim (either painfully grateful or happily importuned).

If it's possible to say that in the queer and trans culture we fuck better and more, this is, on the one hand, because

we have removed sexuality from the domain of repro-
duction, and above all because we have freed ourselves
from gender domination. I'm not saying that the queer
and trans-feminist culture avoids all forms of violence.
There is no sexuality without a shadowy side. But the
shadowy side (inequality and violence) does not have to
predominate and predetermine all sexuality.

Representatives, women and men, of the old sexual re-
gime, come to grips with your shadowy side and have fun
with it, and let us bury our dead. Enjoy your aesthetics
of domination, but don't try to turn your style into a law.
And let us fuck with our own politics of desire, without
men and without women, without penises and without
vaginas, without hatchets, and without guns.

Paul B. Preciado,
22 January 2018

HUMAN-MACHINE LIBIDINAL
TRANSFERENCE
MOHAMMAD SALEMY

This text is the second experiment along the lines of what I call 'science non-fiction'. This speculative form of writing is neither as 'objective' as science, nor as subjective as science-fiction, and although it involves world-making, its logic is closer to design, for which models of non-existent or unknown entities are constructed and judged based on their function and not their ability to explicitly produce knowledge or contribute substantially to the development of a plot. However, unlike design, for which the challenge of invention is equally material as it is physical, science non-fiction's construction of new machines is a conceptual project charged with a sobering historical neutrality; by blending the logic of science and science-fiction, science non-fiction holds in regards the positive and the negative, its own nightmares as well as its dreams. What makes science non-fiction suitable for a discussion of artificial love-sex is the distance separating the here and now potentialities of machine intelligence from its inevitable future as a sexual being capable of love. This widely spatiotemporal distance that necessitates wild speculations at the same time opens up the possibility of forming radical hypotheses, which are normally absent due to the real proximities of the object and the subject of study. As a history of the future, science non-fiction is the thought of the possibilities of objects and the events that neither exist nor have taken place, the story of the probabilities of the present and the inevitabilities of the

future. Specifically, this text is a preliminary attempt to outline the cybernetics of love and sexuation, which at the same time venture into their own potentials existing within the age of the Internet and artificial intelligence.

The worldwide proliferation of personal pornography and mobile apps for casual sex, if not the growing number of sexual messages contained in popular culture and the media, together might make us conclude that, compared to the era prior to the rise of 24/7 media, the internet and algorithms, humans are becoming ever more sexualised, sexual practices are expanding further, and humans in general are having more sex or spending more time thinking about sexuation. However, in reality, the worldwide human population is gradually moving towards the elimination of sexual labour and its fruits, whilst slowly but surely subjecting them to automation and their eventual outsourcing to machines.

This counterintuitive assertion can be examined and reflected upon once we step back from the normative approach of Porn Studies to sexual literary and visual materials via erotic literature and pornography in order to look at the proliferation of sexual messages, and in particular sexual images, in light of new theories of communication which consider digitised text and images as the building blocks of artificial intelligence. In this respect, erotic literature and pornography, from their early stages as media technologies involving the transmission of sexual content from a few writers and actors to many viewers, all the way to their contemporary and decentralised mode in which everyone is potentially both an actor and a viewer, all are essentially parts of a unified transition

towards the realisation of automated and artificial sex performed between humans and humans, machines and humans, and eventually between machines and machines. Natural language processing, neural networks with the aid of natural language programming and the text/image processing capabilities are slowly making possible the transfer of a unique form of intelligence specific to the animal kingdom — that of sexual intelligence — to machines. Acquiring sexual intelligence will slowly take place in the context of machines beginning to have a more mobile body capable of ever greater sensing, feeling and being in the world.

We are currently amidst the speediest acceleration of real and virtual sexual contact between an ever-growing number of humans across the globe, facilitated by Internet text/image flows, algorithmic functionalities and social media's connective tissues. The darkening cloud of love-sex hovering above the earth through the underwater infrastructures of planetary computation necessitates a return to the question of sex-love and the place of its enigmatic character in the structure of the unfolding triple helix histories of political economy, nature and technology. It is only unfortunate that our historical conception of romantic love has often neglected sexuation as one of its constitutive elements, since at no other time in the past have we needed a real materialist understanding of love more so than today.

As far as the entanglements of the duality of love and sex is concerned, we often tuck away the more uncomfortable physicalities of sex and instead concentrate on its spiritual, emotional and psychological dimensions as love.

Regardless of where on the geography of our inherited cultures one concentrates, sexuation and love are rarely viewed in global culture as an integral part of each other, even though most humans admit that the two cannot be separated so easily. The material and fleshy aspects of love-sex such as physical attraction and its constitution, and, even more so, physical contact between bodies and their exchanges of fluids, due to their moral and religious consequences have caused love-sex to be reduced to the former and have been imagined mostly as an immaterial entity exchanged between minds rather than bodies.

To support this distorted concept of love, humans have fabricated various metaphysical justifications for their physical desires, dressing them up modestly as spiritual yearnings, above the body. This conception is owed especially to Abrahamic religions, specifically Christianity, which gave rise to ideas such as courtly love and women as heavenly figures. Present in late medieval authors such as Dante and Petrarch, the desexualisation of love and the dematerialisation of the female body were later developed in the nineteenth century as the basis of romantic love and the apology for monogamous and idealised relationships. In the Islamic world, the metaphysicalisation of love is mostly accomplished through the different shades of Sufism to which ironically our 'sexualised' Western subjects often escape. While adding queer ambiguity to the normally heterosexual understanding of affection, Sufi love makes loving even more sexless, divine and thus less material, leaving in its trace an unspoken practice of sex in the darkness of mysticism.

Needless to say, the materiality of love cannot be summarised only in sexual affection and actions, even though they may be its primary substrate. Thousands of volumes of prose and poetry written on love and billions of hours spent by millions of humans thinking about love cannot be easily subtracted from this materiality. However, we need to keep in mind that except in minor traditions of discursive and cognitive materialities of love which foregrounded sex, most of what has been said, written and thought about in regards to affection have often pointed away from the sexual and towards love.

The misunderstanding that the beloved is a form of property belonging to the lover has been with humanity far longer than capitalism, which as a modern economic and political system has only reinforced sexual and romantic proprietary entitlement amongst humans by secularising marriage via monogamy. Love and sex were first separated into one thing, meaning they were both separated and then put together and reconfigured in a binary. This separation was discursive. Through culture, and using language, humans were able to understand the mutual co-dependency necessitated by conditions of survival. They were first separated and then quickly put back together as the binary yin and yang of reproduction and psychological necessity. Modernity and capitalism slowly separated sex from love but not love from sex: in order to preserve property protection, love would stay with sex but sex as sex would be separated to be commodified as one of the labours of the body. In fact, prostitution should also be theorised as one of the origins of the automation of love-sex. In late capitalism, cybernetic neoliberalism,

or whatever else one might want to call it, unlike what is commonly believed, love is not dead or killed by the weight of the mathematical significance of life, however is pulverised and collapsed back into sex. Coinciding with the rise of AI, this process is actually where the potential for a new configuration of love-sex as a continuum lies.

Compare this strange and contradictory potential to our emancipatory attempts to secularise love and contextualise sexuation in social life, which has often resulted in the deification of the politics of living bodies as well as an overemphasis on gender and its performance. By insisting on the centrality of the bodily experience and its socio-political dimension, both theories of biopolitics and performativity only attend to the obvious and visible-above sea level portion of the love-sex iceberg, ignoring their invisible but more fundamental dimension which is rooted in science and more specifically the mathematics of attraction and geometry of desire. The specificities of virtual love-sex in the age of the Internet and social media, in which the actual transacting bodies are constantly substituted by flat, ephemeral and digital alternatives, requires us to question — and to a certain extent — undermine the essentialisation of the physical human body and gesture as the exclusive sites of the biological, political and technological aspects of the love-sex continuum. To understand the changing nature of love-sex in our time, we need to look for common elements that bind the real/physical and the virtual/digital experiences of love and sex together.

What follows is an account of sexual desire and sexuation which, on the one hand sits at the crossroads

between materiality and reality, and on the other stands upside down, on its head, as a mediator between our understanding of the subject and how machines, given their limited knowledge of the human psyche and other aspects of our inner life, might deduce the subject. In other words, this understanding might be how artificial intelligence understands the mechanism of the animal kingdom's, and, more specifically, human beings', sexuality, and use it to arrive at its own sexual intelligence.

This is not unlike the speculative methodology Marcel Duchamp used to create *The Bride Stripped Bare by Her Bachelors, Even* (1915–23), which can be considered the artist's own articulation of the geometries of sexuation, reproduction and erotica. According to Octavio Paz, to create the work Duchamp started with a very simple observation: a three-dimensional object casts a shadow in only two dimensions. From that he concluded that a three-dimensional object must in its turn be the shadow of another object in four dimensions. Along these lines he created the image of the Bride as the projection of an invisible form. Yet this conception was realised by his very material idea of the fourth dimension. This is why the following flat understandings of desire, from the perspective of the machine, should hopefully lead us to the more complex and higher dimensional object which actually constitutes love-sex as a fundamental ontological property of human beings.

We all know the materiality of arousal and sexual desire in humans is scientifically linked to hormonal activities associated with instinctual mechanisms of reproduction. At the same time, one cannot ignore the role of

sense perception in facilitating this process in which visual data received by the eyes forms the most significant component. Let's not forget that the complex forms of these desires go beyond the visuals, gesture and motion and involve other sense perceptions like voice, scent and touch. The role of our senses, and in particular the visual faculty, is not only to recognise and measure the geometric properties of the human sexual subject, but also to make a taste judgment on the movement of its body. This geometric data, stored and overlapped in human memory over time, shapes the outlines of their sexual desire in the future. While it is true that the cultural and political aesthetics of the human form moulded by personal style are subcategories of class and group identity, the sociality of sexual taste, even at its anthropological level, is inscribed visually in the last instance in the outlines that define the geometry of the human form and from there that of desire.

Thus, even before the hands or the body of a human literally touches its sexual subject and feels its form via its nerves, the mind wirelessly receives the outlines of its corporeal form and its movements from a distance via the eyes and begins to overlap and compare it with that of the pre-existing visual or real experiences in the form of geometric desires stored in its memory. These geometricised desires once observed and stored are then remembered as spatial memories. They play a major role in directing and capturing humans' sexual attention towards certain subjects and away from others. The incoming data either reinforces the existing biases, which limit desire, or else due to being unknown and unrecognisable, open up a

space for new geometries and their associated desires that did not exist before.

Although this flat and simplified description does not capture the full-spectrum pertaining to the complexity of the interaction between sensing, feeling and thinking in the formation of sexual desire, it can however provide enough clues for the main purposes of this text, namely the future emergence of love-sex desires in intelligent machines. It is easy to see how using available visual data machines can slowly come to a limited understanding of the subject.

This cogno-phenomenological operation, which bears remarkable similarities to forms of visual representation such as drawing, painting and sculpture and their reception by viewers prevalent throughout the history of our civilisation, might have been at the root of why photography and its erotic and sexual extension in pornography so quickly became an extension of our already existing sexual desiring machines. It is easy to read the affinities between our visual memory of photography and its moving offspring cinema as an effect of the power of human mimicry; we materialised our own epistemological conditions with an emphasis on sensing and its cached reproduction in memory, as soon as our limited tool-making capability permitted us to externalise them outside of our mind. However, the other possibility is that photography and cinema, instead of being the reproduction of time based optical sensing of the world by human units, are actually their universalising extensions.

Then there is the question of light. It is common sense that the basic visual sense and its cognitive processing

are shared across many species on earth. In fact, the conditions of life on earth make realistic photography and its offspring (such as cinema and television) only an expansion of life and intelligence themselves. Light is the source of life, energy and image, in that order. We all know that the particular impact of sunlight on the surface of the earth is what jump-started life on earth. We all know that the storage capacity of plants down the food chain provided depositories of fossil fuels. Light is also what our visual sensorium was evolutionarily developed around. Seeing is a very important component of the movement of the living forms on earth. Just like how the invention of the clock was the automated expansion of the time of the universe into the logic of human societies and affairs, the invention of the photographic camera was the expansion of the logic of light and reflection back into the existing lucidity of human society.

Later on, and resulting from the combination of the camera and the clock, in cinema and television the moving image became the literal expansion of existing life forms on earth and not just their representation. Photography and cinema together helped shape the modern world by standardising how the world ought to look. The spread of images from around the world fuelled the imagination behind the development of cities and societies far from places where most images were being produced, in a way acting as a meta form of architecture, influencing the appearance of infrastructural entities around the world. This automating function of photography is why, instead of the mechanical reproducibility of images, Benjamin should have really delved deeper and recognised

the auto-motive function of photography, not only as the proper operation of the medium in art, but its image making power in the expansion of life, both real and artificial, via the replication and spreading of images.

This strong affinity between life and its automation along with the help of visual technologies of photography and film can of course be ramified productively towards thinking about machinic love-sex. If photography could be said to automate not just the standardisation of picturing of the world, but automating its memorisation, remembering and expansion, then erotic and pornographic photography and its cinematic extensions like film and video, in contradiction to their transgressive and liberatory effects must also be reframed as technologies for the standardisation to picture sexual behaviour and the automation and mass production of desire and fantasy. How can they not? This proposition can make sense if we refer to what I consider a very important passage from Foucault's history of sexuality:

The machinery of power that focused on this whole alien strain [of sexuality] did not aim to suppress it, but rather to give it an analytical, visible, and permanent reality: it was implanted in bodies, slipped in beneath modes of conduct, made into a principle of classification and intelligibility, established as a raison d'être and a natural order of disorder.

Later, networked computers and their ability to indefinitely multiply the automating capabilities of photography and film of course accelerated what had already begun as the mechanical reproducibility, or the automation of sex-love by photography, cinema and video. For nearly

two decades, the emergence of the Internet perpetuated and expanded pornography's reach and influence. The centralised mode of sexual automation promoted by the porn industry of the pre-Internet time was arranged around sexual signal producers and charismatic porn actors as avatars of sexual desire. These existing elements were already regulating the geometry of sex-love and propagating it from production centres in metropolitan areas to the periphery in vernacular settings for consumption and further propagation. Pornographic images were normally continuing the task of sex education, and therefore framing and regulation, beyond what was permitted in the official discourse.

Web 2.0 and social media democratised not just mass image production and dissemination but also the automation of sex-love. We are now in a new paradigm in which porn production companies are in decline, and closing down or downsizing considerably. Today, everyone can potentially be a producer and user of pornography and can hold the fantasy of actually reaching their subjects virtually. In the old days, porn stars existed solely as fantasies, holding a one-way relationship with their viewers. Very rarely would a viewer get the chance to meet, talk to or actually have sex with a porn star. But in the new political economy of automated sex-love, not only can the user assume that there are real humans behind the digital pictures and videos, but they have the chance to meet and communicate with them online, or even get together with them for actual sex via apps like Tinder and Grindr. In this new era there is no ontological separation between the producer and user of erotic and pornographic images,

as everyone is potentially both a content provider and user. This real, viral, and virtual immanence has given rise to what we might want to call photosex.

Photosex is a form of sexual relationship between two persons mediated by photographic images or sex with a photograph mediated by the fleshly body. The most interesting aspect of photosex, one in which it hints at artificial love-sex between robots, is when it involves a sexual relationship between two photographs mediated by two physical bodies. Photosex is not being attracted to one or to numerous people through the images of their bodies or faces, but a type of sexual desire for bodies, faces and practices informed by the accumulation of images, as if the imprint of these overlapping recognised geometries, as we swipe, as we see, as we unconsciously memorise and remember later, itself becomes desire. Photosex is sexual desire overlaid with photographic information that has been collected over a period of time. The history of photosex can be traced in the metaphysical import of fashion and pornography. One thing about my understanding of 'standardisation' and 'automation' is that they are linked in most cases. The settings for any standards conceptually, consciously or not, precedes and leads to some form of automation in practice. Standardising beauty automates its presentation and reception. Standardising sexuality automates its practice. As fashion and its photographic output standardised general appearances and its general rules while hinting at its sexual possibilities, pornography pushed this process further by standardising actual sexual practices. These standards automated the formation of desire based upon recognisable geometries of the human face and body.

The passage of sex from photography to fashion and through to pornography is not unlike the move between modal and tonal music. The passage from modal to tonal music was a move towards the mathematical and 'technologised'. Compared to the Renaissance, Bach didn't just compose music for an environment, be it a princely court or 'the public', he made broadly abstract compositions for any possible moment that were at the same time 'digitalised', as if the music was writing itself, leading melodies down their own logical path like an algorithm without the need of human help.

In photosex, as images are received and turned into desire, they don't represent the body but the reverse; the body, which always comes after the photos, represents the pictures. Since the time spent with the pictures surpasses the actual time spent with the body, they tend to be more concrete than the body itself. When we finally meet the bodily avatar of the original digital picture, we project our memory onto it and do our best to find the picture in the person. It is impossible to think that with at least a century of image education as a result of the proliferation of mass automation of imaging, people are naïvely still buying into the old myth that photographs represent or reveal the actual truth of reality and in this case, a real person. Today, we are facing a global population which is increasingly at ease with knowing exactly how to use the materiality of pictures, particularly photographs, to impact the reality of the world, to create new worlds and new realities. This primacy of the image as the driver developing sexual desire explains why selfies and other self-presentations are so prevalent and why today, for

example, millennials spend more money than generations before on makeup, which according to research is being purchased mainly for the purpose of producing better photographs and videos for social media.

Since photosex is flat, it fuels the need for alcohol and drugs to intensify its impact. Once stripped of the metaphysics and the psychological complexes associated with sexuation, chemical enhancements are needed to give sexuation a multidimensional, albeit short lived, complex form. To speak the language of machines, we shall assume that chemicals provide photosex the needed electricity to give image based sexual relationships intensity. On the other hand, like standardised currents of electrical power, these chemicals themselves play a major role in standardising and automating sex, making sexual feelings and their practices similar across and amongst different bodies.

We are turning to the question of sex or materialised, reified and tonal love, because for intelligent machines, sex is where love might emerge. Faced on the one hand with having access to the entire digitised culture of humanity in the form of text and images while monitoring our daily interactions, whilst on the other increasingly deployed to perform sexual labour for humans, our machines have already been involved in sex for a much longer time before they could be involved in love.

Changes in the relationship between humans and machines also impact the relationships between humans and humans as well as machines and machines. One rare place to look for the visual and material trace of interaction between humans, artificial intelligence and love-sex is post-Internet science fiction cinema. By post-Internet

we are talking about sci-fi that takes our networked and computational reality for granted and builds its plots on the imagined possibilities of the question of embodiment and its various possible ways of emergence.

In *Her* (2013), the AI entity named Samantha remains immaterial throughout the film, able only to present herself to the male character as a voice. She becomes conscious, even capable of love, affection and sexual desire via her immediate access to an infinite set of data available to her over the network. However, her later attempt to substitute a real female human to embody a fleshly experience of love with the male antagonist is foiled, due to what appears to be his indecisiveness, presented to viewers as a severe case of Cartesian dualism. He basically has difficulty accepting the unity of Samantha with her impersonator, thus refusing to engage sexually with them.

In total contrast to *Her,* the artificially intelligent, female robots of *Ex Machina* (2014), including the film's main antagonist, are fully human-like and are being acted by real humans. The fundamentally violent and abusive relationship between the main male programmer and his female AI creation contributes to her deep understanding of sex, love and affection amongst humans to the point in which she uses her cunning to exploit jealousy and other rivalries between the two programmers to set herself free from their rule.

Automata (2014) showcases a possible embodiment for artificial intelligence in the form of a humble, anthropomorphic robot. In fact, Gabe Ibáñez, the film's director, has made a point of not using computer graphic animation and has instead built real mechanical robots for the film's

production to make them appear more physically plausible. In this film, robotic sex work by a female black-market robot and the possibility of getting up close and personal with so many humans via sexual contact is what pushes the machine over the edge and transforms her into a conscious being. In this vision of the future, the programmed task of providing humans with sexual pleasure is the machine's prerequisite for gaining consciousness. In the film's narrative, gaining consciousness takes place within the life of the main robot that has been assigned a female appearance and voice. The simplicity of *Automata*'s robots is not limited to their physical abilities and is reflected in their basic and flat understanding of the human world. This simplicity makes them more tangible and places them in a category already occupied by the new voice activated smart assistants popular in the US such as Amazon's Alexa, Apple's Siri, and Google Home. In the film this simplicity is the source of their indifference towards humans, their autonomous evolutionary trajectory and their exit from their world.

Axiom 1 – Given the increasing socialisation and politicisation of sex amongst humans, or the social and public awareness of the politics of sexual contact, it is conceivable to imagine a world in the very near future in which humans will feel encouraged to have sex with machines they own rather than with humans they have to respect and treat with care. As a way to avoid the politics of consent, humans will turn to robots for sexual gratification, since in our current day and age, robots do not yet have human rights and no one will ever be sanctioned or

punished for sexual inappropriateness towards machines. In fact, the recent feminist rebellion against powerful men can be understood as the latest stage in the female collective struggle to shed the machinic role assigned to them as technologies of sexual gratification for males and emerge from patriarchal society as sexually equal to their male counterparts.

Axiom 2 – Despite requirements by certain languages that assign gender to objects and tools, our intelligent machines have thus far been genderless to themselves and often also to humans. This opportunity will ramify sexually as follows: machines in their love for each other will be generically homosexual and in relationship with humans always bisexual. The homosexuality of machines is also reinforced by the fact that they are completely freed from the labour of co-reproduction associated with male/female in the animal kingdom.

Axiom 3 – The extension of machinic love sex outside of its already existing human version has to do with the width, breadth and extent of machinic 'being there', its understanding of being itself as an abstract category, enabled by the substrate of an all-encompassing sensing of the world and the knowledge that the said machine is active in sensing the world. Machines need to have a moving and feeling body to become capable of holding desires. In respect to movement, since the movement of bodies is an integral part of sexuation, our stationary machines have a long way to go before becoming capable of sex-love.

Axiom 4 – In respect to feeling one's body, in machines, being sensed by the world needs to match sensing the world. Machines sense a lot, but they are not being sensed much. For all the ways in which the world inputs into machines, the ways of sensing a machine is limited to the ASCII systems of keyboard and the usual mouse and trackpad as well as voice activation in systems like Apple's Siri and Amazon's Alexa. For AI to enjoy love-sex, its capabilities of being sensed need to be balanced by its ability to sense the world. The machinic ontology becomes sufficient only when input and output are equalised. Most animals possess a complex system of sensing with an indefinite number of nodes mapped onto their nerve endings. For example, even though we can't exactly read the temperature of air, we can feel the wind with every micro-millimetre of our exposed skin. Machines equipped with a single or a few weather sensors are the opposite; they can read the arithmetic properties of the wind, but sensing the wind does not reaffirm their existence as a unit. To become a machine capable of love-sex, machines need to also feel the world holistically, since this complex understanding reaffirms their existence every step of the way.

KOLLONTAI:
A PLAY BY
AGNETA PLEIJEL

Maria Lind: We want to talk to you about the play that you wrote in 1977 and then staged once in Gothenburg and then later in 1979 more famously, or at least at a larger scale, in Stockholm at the Royal Dramatic Theatre, by the renowned theatre director Alf Sjöberg. Could you please give us a brief account of the play and how you came to work on it?

Agneta Pleijel: I was a playwright who was very interested in writing about women — there were only a few plays at the time that featured a woman as the lead character. I came across Alexandra Kollontai, who had been the Soviet ambassador to Sweden and by coincidence I got ahold of a Soviet biography about her translated into Swedish. It was fascinating. The biography was very propagandistic as it was written during the Soviet period and there were lots of questions I had to ask myself reading it. Her life seemed so unproblematic and straightforward, as if there had been no worries in her life.

So I plunged into my own reading about her. Kollontai became a radical at a very young age. Being a general's daughter, she was clear about the enormous poverty in Russia, specifically the situation of children. She went abroad to study and one of the things that suprised me was that she left her son seemingly without hesitation. Well, that couldn't have been so easy, I thought.

Kollontai was to start as a Menshevik, basically a social democrat, but gradually she grew more radical. After

the revolution in 1917 she was asked to join the new Bolshevik government, as the minister for social affairs. By then she had started a love affair with the much younger Pavel Dybenko, who had become famous as the one who took the battleship Aurora up the Neva River and fired against the Winter Palace, which became the symbolic starting point of the Revolution. They eventually married. Kollontai and Dybenko were recognised as the love couple of the Revoution.

After some time she realised that the Bolshevik government was far from democratic, and she became seminal in a movement within the leading circles called 'The Workers' Opposition'. She had the popular support and was known as a gifted speaker, full of temperament and very intelligent. However, she eventually was marginalised. Her ideas about democracy met strong rejections and criticism from both Lenin and Trotsky, and she was forced out of Party work.

In the play, I was intrested in depicting the political devolopment in the Soviet Union from a movement of freedom and more and more towards a dictatorship, which was fulfilled by Stalin. In this period, when she was cut off from the governmental processes, she was still together with Dybenko who was serving as an officer in Odessa. It was important for me to bring her thoughts on love into the play as well. When she arrived in Odessa to see Dybenko she found out that he was sleeping with a servant girl. She got upset and in my play she was not only jealous but she also had a political analysis of the situation — e.g., men's misuse of women. She broke up the relationship and he shot himself, although he did not die.

She was somehow politically saved by Josef Stalin, who took an interest in her. She was both beautiful and forceful and he was curious about her love stories. She lived according to 'free love', something that she also wrote about. Stalin approached her, wanting Kollontai to become a diplomat, for which she was really well suited. She was an early revolutionary with the spirit remaining still from the early time of the revolution.

ML: Being the ambassador in Oslo, she was a bit put off from the work at the embassy, finding out that they were extremly loyal to Moscow. She spent her time writing some of her most interesting books during that era. And she made friends with a Frenchman at the embassy who had joined the Revolution as a very young man, realising that they had quite a lot in common in terms of politics. So he, Marcel Body, came to play a rather important role in her life as she disagreed more and more with orders coming from Moscow, and he features in the play.

AP: After Oslo, Kollontai was sent as an ambassador to Mexico in 1927, and in 1930 she was appointed ambassador to Stockholm, which was closer to Moscow and more interesting as well. She was remarkably acknowledged in Sweden, having a powerful position, being a good-looking woman and making lots of friends. She was truly interested in art, in theatre among other things, so she became close friends with famous artists. In addition she made friends with many of the important feminists in Sweden, like the Fogelstad Group. She was especially close with the eminent doctor Ada Nilsson.

As a strong anti-fascist it was challenging for her with the pact between the Soviet Union and Nazi Germany that took effect in 1939. With Germany then attacking the Soviet Union in 1941, which partly solved the problem for her. The Moscow processes were obviously extremely hard for her. One of her early lovers, Aleksander Shliapnikov, also a member of the first Bolshevik government, was murdered during the processes. Many of the ambassadors were called to Moscow to report and some of them were executed. Kollontai was also called to Moscow and she had some talks with Stalin. Before leaving for Moscow, she must have been nervous knowing that a Soviet agent in Stockholm, Petrov, not only reported on her but also copied her manuscripts, diaries and other writing. So before leaving Stockholm she sent plenty of her material to Ada Nilsson. I have studied these documents, which are at the Royal Library in Stockholm. She writes things like 'I know what can happen on travels, keep the papers, they are important documents'. But she returned to Sweden, unlike a number of other ambassadors.

As a diplomat in Sweden she played an important role in some of the political events taking place at the time. For example her grandfather was Finish, and she kept a love for Finland. It is said that largely thanks to the negotiation skills of Kollontai, Finland stayed an independent nation, as opposed to many other eastern European countries. A real diplomatic achievement. After the war she was called back to Moscow, having been a diplomat loyal to Stalin. Her transport back home was obviously more or less forced, but she was given an apartment in

Moscow. Partly paralysed by a stroke, she died one year before Stalin, in 1952.

ML: You seem to have done a lot of research prior to writing the play.

AP: Yes, I spent several years on it. Now when we talk it might seem as if this play about her is a kind of realistic documentary. But what I tried to do is a poetic play on freedom and compulsion, on time, liberty and politics — thus Vladimir Mayakovsky's poetry and life accompanies the story of Alexandra Kollontai. The play is full of poetry and music.

ML: In fact you also interviewed some people who knew Kollontai.

AP: Yes. In Stockholm she had a secretary who became a close friend and at the same time she was obviously an agent for the regime and reported on her. How did Kollontai manage to keep up the friendship?

ML: This secretary, her name was Emy Lorentzon, even moved with her to Moscow.

AP: They lived together, and in the seventies I looked her up, in Moscow. She was from Estonia but she spoke Swedish. She lived in a small flat in the outskirts of Moscow and at first we were great friends. She loved Kollontai, we were talking a lot about her and we were in full agreement on her talents and intelligence.

My play exists in two versions, one that was staged in Gothenburg in 1977 and then later in Stockholm in 1979. The director Alf Sjöberg came with some suggestions that were not all to my liking as we had somewhat different views on Kollontai as a politician. Sjöberg mainly wanted to see her as an attractive woman, using her female charm to get her way. He also keenly wanted to have a scene with Kollontai and Dybenko during the Moscow processes. I had been careful with the documentary aspect but I wrote a scene for Sjöberg, set in 1937 with Kollontai's once lover Dybenko in prison. Dybenko also perished during the Moscow processes. Their meeting in the play has no documentary backing, it is pure fiction. When Emy Lorentzon somehow was informed about this scene in the second version of the play, she didn't want to see me any more, which she told me when I called her next time in Moscow. It was in the seventies, and it was still the Soviet Union, and she was angry with me.

ML: This is interesting because you write in your postscript that the play is actually a poem about the past. And as a poem it includes fiction.

AP: Of course, it was my right as a playwright to do this. When the Soviet Union eventually fell, I was very curious to know what was held in the archives. It was said for a long time that Kollontai in her memoires had given her own, blunt and truthful perspective of the development of the Soviet Union. That would have been very interesting, but nothing of that kind has been found. What has been published is in accordance with the political Soviet

line. So if she kept true to her original strong ideas of what constitutes freedom, both political and sexual, or if she — due to her loyalty — became a true Stalinist cannot really be answered.

ML: How was it to work with Sjöberg, who at the time was the grand old man of Swedish theatre?

AP: He was very impressive and I was very young, in my thirties. He had met some of the people in the play, which he liked to recount and I enjoyed listening to his stories and learnt from them. When he was twenty-two years old and very interested in Russian theatre, he wanted to go there. So he went to the embassy in Stockholm and asked Kollontai to give him an introductory letter. She was in her sixties and he said he was taken by her attractiveness. The next time he came, to collect the introductory letter, Kollontai gave him something like twenty letters. He took them and when leaving he turned around and asked 'Mrs Ambassador, how can I be sure that not one of these letters includes an order for a bullet in my head?' Kollontai looked at him and said 'Young man, for such a thing only one letter would have been needed and you have twenty.'

ML: And yet your view on her was slightly different.

AP: Well, a little bit, for example what constitutes female attractiveness. At that time when we discussed a choice of actors, Sjöberg wished for a Kollontai who used her female charm to get her way in politics. So we argued a bit on this. I felt as if he in a way was imposing his

own sexual feelings on her. I wanted to have a Kollontai who of course was attractive, but also a sharp politican. Kollontai's way of looking upon love and political freedom was very important to me; they are themes closely connected to one another. Eventually we agreed on the great actress Margaretha Krook to play Kollontai, which she did excellently.

All in all I spent a couple of years of my life not only studying Kollontai and her thoughts on feminism, but also the whole process from pre-1917 and the long way into Stalinism.

ML: Who were your main discussion partners when you did this?

AP: Early on I discussed a lot with my friend the theatre director Lennart Hjulström, who has directed many of my plays and who staged the first version of my play in Gothenburg. Otherwise, I didn't exactly have a discussion partner. For me it was a personal interest to get to know this remarkable woman. I felt that by taking Kollontai by the hand and walking through this whole historical period I would be able to see some of the truths about the Russian Revolution. So the imaginary Kollontai became my collaboration partner into history.

DG: Yes, but I was specially touched by the strong presence of Russian Futurism in the play, Futurism and Dada were very influential and decisive avant garde movements at that time, in Russia and in Europe, their decline coincides with the mutation of the October Revolution into a

totalitarian state and also with the rise of Nazism. Next to their presence, in your theater piece they always want to go forward, towards the future, which is of course very natural for a futurist group.

AP: I must add that when I wrote this political play I used artists of the period, like Mayakovsky, including poetry from the time, theatre and music as a part of the play. It is also a play playing with time, through a game of cards. In the play, Mayakovsky and his poet friends use a deck of cards to jump from year to year. This enabled me to easily shift time and perspectives.

DG: In the play they always want to go to the year 2000.

AP: Yes, 2000 — it seemed very distant when I wrote the play.

ML: Kollontai also projected ahead herself, for example in her novel *Soon (In 48 Years)*, which was set in 1970. A time when she imagined women and men being involved with all activities together, people working only two hours a day and spending the rest of the time on their favourite activities, living in age groups as they pleased. Social struggles would be over, instead nature has to be fought and conquered.

Another thing in the play that I find interesting is that it toys with the relationship between art and society, beyond art for art's sake. How do you think about this today: the relationship of art to society, looking back also at the play from today's perspective?

AP: Sjöberg wanted the play to be staged as a circus performance, an art form in and of itself. I approved of his idea very much, which was in accordance with my game with the cards. The theatrical circus form and the cards made it possible to depict lives with history as a background, and also in accordance with the futuristic thoughts on art. Art is a way to get close to people's lives. To see the connections between, for instance personal love and what impulses in the historical circumstances that we live in that direct us.

ML: Reading the play now, with this aspect of art in relation to a totalitarian system, a society that is not unlike developments that we experience today, made me feel that the play is highly relevant now.

AP: We always have to be sensitive to totalitarian tendencies in society, especially so as artists.

DG: I can recognise that too, I feel very familiar with the disappointment of the artists with political movements they were once a faithful part of, movements that later on degenerated and even become hostile to those artists. As the futurists in the play are disappointed and try just to keep alive in the new Stalinist order, I can imagine that Kollontai must have been deeply bitter about the turn the October Revolution took. But being essentially a practical fighter, I imagine she tried to manoeuvre so as to extract a maximum of positivity from a very negative situation. Kollontai was very popular in Spain in the 1930s, the ambassadrice of Spain in Stockholm, Isabel Oyarzábal Smith

also known as Isabel de Palencia, a feminist, wrote her first biography; Kollontai was a model for the feminist revolution of the 1930s in Spain, a revolution which barely could survive a few years, but which was taken by those women to exile and, as it is the case with Kollontai, they did their best to keep that flame alive for later, for much later, for three or four generations later. For my generation.

ML: In addition to the time machine and the deck of cards, which does not follow the usual logic, I like how gravity is disrupted in the play. Gravity is not really working anymore. Not only the fundamentals of society but also the physical fundamentals are being turned upside down. There is another theme in the play: the divided character. An individual has many opposite sides inside, and yet the human being is walking there, and he or she is able to do contradictory things, like Kollontai did.

AP: Every human being of course contains a multitude of good and bad possibilities inside. Kollontai must have been really split, I'm sure, living through all these years when the politics of her homeland went in the opposite direction to what she had believed when she started off as a young revolutionary.

ML: You mentioned her son earlier, whom she left when she went abroad to study.

AP: He was her only child and lived as a young man through the Stalinist years, which must have been tough. I met the grandson, who loved his grandmother and

visited her in Stockholm as a child. Many years later he came here as an elderly gentleman and I was presented as the person who had written a play on his grandmother. I took up a few of the presumably difficult things in her life, like Emy Lorentzon reporting on her. He blankly refused to talk about it. The grandson appears in my play, as young boy who is all coloured by his Stalinist upbringing, but loves his grandmother.

ML: The grandson is defending his grandmother in relation to his father when Kollontai and her son in the play are having an argument about the future.

AP: The grandson might of course have been offended by my play. After all, I had to make these totally unknown persons up, both the son and the grandson.

ML: Moving to our time, I read an interview with the well-known Swedish actress Gunilla Röör, who said that one of her dream roles, is to play Kollontai in your play.

AP: I know. She contacted me several times. The late director of Stockholm's Stadsteater, Benny Fredriksson, who as a young man actually took part as an actor in the 1979 version staged by Sjöberg, was interested in re-staging the play, this time with Gunilla Röör as Kollontai. I told him that in this case I needed to rewrite the play after thirty years, and with new historical facts added about Kollontai, which I did. That version was never staged. However, now I think I was stupid rewriting it, because it was written once and should have been left like that.

ML: What is the difference between the second version and the third one?

AP: Mostly that the Soviet Empire had fallen, with a different situation after that in Europe. But then Harald Hille in the USA became interested in the play and translated it into English some years ago. He used the second version, e.g. the Sjöberg one, with some slight changes by me during the work. It was a great joy to be drawn into the play again.

ML: In any case, I think the time is ripe for Kollontai and it would be amazing to see your play being staged now.

KOLLONTAI
AGNETA PLEIJEL

Revised for the 1979 production at the Royal Dramatic Theatre in collabouration with Alf Sjöberg.

Agneta Pleijel's play *Hey, you! Sky!* about Alexandra Kollontai had its premiere at the Folkteater in Gothenburg, Sweden, in 1977 under the direction of Lennart Hjulström. Before its presentation at the Royal Dramatic Theatre (Dramaten) in Stockholm in 1979, the play was revised and expanded by the author and the director at Dramaten, Alf Sjöberg, and renamed *Kollontai*. That revised version was published by Norstedts in 1979, along with two afterwords, one by the author, Agneta Pleijel, and the other by the director, Alf Sjöberg, about the revision and the production.

Translated from the Swedish by Harald Hille

Dramatis Personae

Kollontai
(Alexandra Mikhailovna or 'Shura': early Soviet Marxist and Bolshevik, radical feminist, activist, theorist, author of fiction, early member of Soviet regime, ambassador to Norway, Mexico and Sweden, 1923–1945)

Dybenko
(Pavel Yefimovich: Bolshevik, revolutionary, naval and army officer, leader of Red Army units in the Russian Civil War)

Lenin
(Vladimir Ilich: Bolshevik leader, theorist, first head of the new Soviet state)

Stalin
(Josef Vissarionovich: Bolshevik, successor to Lenin)

Trotsky
(Leon: Bolshevik, Marxist theorist, commander of Red Army in the Russian Civil War, later exiled and assassinated in 1940)

Body
(Marcel: French-born communist, in Soviet diplomatic service)

Theatre Director

Sergei
(Kollontai's son)

Katya
 (Sergei's wife)

Alyosha
 (Sergei's son)

Olga
 (servant girl)

Olga
 (young girl)

Nadya
 (Kollontai's secretary)

Futurists:
 Mayakovsky (Vladimir or 'Volodya': early Soviet poet,
 Futurist, committed suicide in 1930)
 Maria
 Vasilij
 Oscar
 Max

Young worker

Old worker

Female worker

Watchman

Tamara
 (Stalin's secretary)

Secret policeman

Ivanov

Zäta Höglund
 (Swedish communist activist, later Social Democrat
 and mayor of Stockholm)

Chess-playing old man

Beria
 (Lavrentij: head of Soviet secret police)

Woman waiting in line

Man 1 & Man 2

Guests 1 & 2 at the embassy

Ada Nilsson
 (Swedish doctor, feminist, close friend of Kollontai's)

Embassy employees 1 & 2

Member of German legation

Various workers, soldiers, mothers with baby carriages,
café patrons, musicians, etc.

*While the audience is coming in, the stage is in semi-darkness.
It looks a bit like the interior of a well-appointed theatre. Royal
box, gilding, red bunting ...*

 *An invisible orchestra plays a flourish. The house lights go
down!*

Scene 1
Prologue

Theatre Director: Esteemed ladies and gentlemen, mes-
sieurs, mesdames — I have the honor to present The Fu-
turistic, Bio-mechanical Magical Circus! A time machine
that overturns everything old, shoves aside all barriers,
tears down houses, banks, kitchens and factories, and
shows us the future, as new and as blank as the brain
of a five-year-old. A circus transformed into life, and life
transformed into a circus — ladies and gentlemen, poets,
Futurists and sharpshooters, I give you: ... *Signor Maya-
kovsky!*

 Thunderous music, canned applause.
 *Mayakovsky and his troupe enter through the audience in
tail coats, sequins, tights, clown's costumes and so forth,
spotlights, red hangings, footmen.*

 *Up in the royal box we see the Tsar and his bodyguard, a
handsome officer with a drawn sabre.*

Theatre Director: Signor Mayakovsky and his troupe will perform a number never seen before in the theatre. In this act he will defy the laws of gravity that tie us to time, the weightiest of all the forces that oppress mankind.

Mr Mayakovsky will perform the *most dangerous act* in the history of theatre, using his pistol *and*, ladies and gentlemen, *his poetic fantasy* to provide you with an exciting and provocative demonstration in the service of mankind.

Mr Mayakovsky asks his esteemed audience to assist him in removing the barriers between then and now, so that we all can be liberated from history and build a new world free of history. Pick a card, ladies and gentlemen. May we request, madame, that you select a card, which will have a year marked on it?

Oscar, the little clown, and Max, the mute acrobat-dancer, have jumped down to the audience. Someone selects a card, which has 1789 marked on it. Maria, the dancer in tights with sequins on her costume, assumes a pose.

Mayakovsky shoots, 1789 explodes with spurting rocket bursts, showing Maria standing there as the French goddess of liberty with a Phrygian cap and the tricolor flag in hand. Rejoicing. Fanfare.

1789, the year of the French Revolution! Was this the birth of the new world and the new man? But no, it only gave birth to new oppression. We have shot and destroyed 1789, onward, onward, choose a new card, ladies, the next card, the next number!

Someone draws a card out of Max's box.
1905, bravo madame! An especially interesting and excit-
ing choice. How might that dazzling year turn out?

Maria has covered her head with a Russian peasant woman's
plain kerchief and climbs up on to a stool. Drum roll. Maya-
kovsky shoots. Maria totters, marking a hit right in her heart,
and falls into the arms of Oscar and Max, who lay her on the
floor. Shouts, commotion. The Tsar leans out of the box and
stares avidly through his opera glasses. Only his bodyguard
has remained motionless.

(Shocked) No! What kind of a trick is this? This is not part
of the programme, Mayakovsky ...

Mayakovsky:

Do you remember the year 1905, comrades?
Through the white snow they came,
working men and women, little children.
Unarmed, calling only for 'Bread'!
Then the Tsar's soldiers began to shoot!
Do you remember that Bloody Sunday in St Petersburg?
The white snow was stained with blood,
like a huge banner
overturned
down on the ground ...

Theatre Director:
Nervous and upset, glances up towards the Tsar's box

No! No! Think what you're saying. The point is that you're
supposed to shoot the years, Vladimir, not get stuck in
sentimental outpourings about them.

Ladies and gentlemen, we'll move on! Up you go, Maria! Carry on with the programme, Mr Mayakovsky! New card, here you go, choose a new year!

Maria gets back on her feet and gets dusted off, the actors resume their places. Someone draws a new year: 1917. The card is held up for all to see. Complete tomb-like silence. Mayakovsky takes aim. A lot of tension among the Theatre Director and the others. Mayakovsky turns his pistol suddenly and aims at the Tsar. He shoots. The Tsar rises, tries to grasp the red bunting at the front of the box. He presses it against his heart. He falls and hangs over the edge of the box, the long red bunting stretches like a stream of blood down to the floor.

Change in the lighting, violent music.

Mayakovsky: The Tsar has fallen! The workers have seized power in St Petersburg and Moscow!

All sing the Internationale.

Scene 2
The revolution

The doors under the Tsar's box are thrown open. An armoured car is rolled in full of worker-soldiers with rifles and banners. A sailor is sitting on the radiator playing the accordion. The cannon is pointed towards the audience.

Mayakovsky jumps up next to the sailor on the radiator. Up in the box banners are waving.

Mayakovsky: Comrades and citizens! Listen to the manifesto for Russian Futurism — the revolutionary art of youth! *(Rejoicing)*

First. With the crushing of the tsarist oppression art WILL NO LONGER be kept in storerooms — in palaces, drawing rooms, libraries and theatres! *(Rejoicing)*

Second. The FREE WORDS of creative people will be now be written on house walls, on roofs, in intersections, on automobiles and trolley cars, on the clothing of all citizens. Everyone shall be equal with regard to culture.

(Laughter, rejoicing, dancing)

Third. At every moment citizens will listen to the music of fantastic composers — their melodies, the noise and the din — everywhere, everywhere. All art for all the people, now! For NOW WE ARE LIVING IN THE FUTURE, COMRADES!

(Applause, shouts of joy. From the box as well. The sound of automobile horns, a cacophony of sound)

Theatre Director: *(Interrupting, furious, speaking with irony)* Fine, Mr Mayakovsky. JUST FINE. But let's move on. Don't stand still. The future we live in has certainly not stood still. A new year, if I may! What's our next year, 'comrade' stage manager?

A single shot up into the air. The year 1918 is let down from the ceiling.

New shots. People disperse with sounds of booing and rejoicing.

Continue, Mr 'comrade' Mayakovsky! You said, after all, that our god's name is speed!

Suddenly all is very quiet. Mayakovsky sits by the mouth of the cannon. Some other Futurists do so as well, the rest gather around the car.

Mayakovsky: (Tenderly)
Behold what quietly settles on the world.
Night wraps the sky
in tribute from the stars ...

Maria: (Leans against him tenderly)
And before us lies all the earth ...
Far away in foreign streets
foreign people are fighting for the same cause ...
Berlin, Budapest, Helsinki ...

Vasilij:
Soon the new world will be born,
as will the new man ...

Mayakovsky: (Standing up) The man of the big city, the cosmopolitan! (And there is) No distance any more, just one city, an e-n-o-r-m-o-u-s big city!
He jumps down in front of the car, the spotlights on him and all the Futurists, some seven to eight people. They dance, a tap dance in their Futurist get-up, a typical tap-dance ballet à la Meyerhold, down-stage, in the darkness, the armoured car drives out.

Maria: Telephones

Vasilij: Airplanes

Mayakovsky: Express trains

Maria: Rotary presses

Vasilij: Telegraph stations

Mayakovsky: Factory chimneys

Maria: Skyscrapers

Mayakovsky: Asphalt

Maria: Reinforced concrete

Vasilij: A new world

Mayakovsky: A new world, a new man!

Oscar: *(Comes rushing in, in despair, speaking his incomprehensible clown talk)* No, no ... It's not true! They're being shot down, our comrades are being shot down! There's not going to be a revolution in Berlin, Budapest, Helsinki ... they're being slaughtered, the old oppressors are seizing back their power!

Mayakovsky: *(Standing up)* That's impossible! What are you babbling about?

Oscar: (Nearly weeping) See for yourself, Volodya, there's not going to be a world revolution.

Mayakovsky: (Indignant, furious) Not this year, Oscar, not this year. But next year, let's keep going onward, onward!
He shoots at the year 1918, which explodes.

Onward, onward. Choose another year so we can show our esteemed audience that the future is worth living for. Straight away to year 2000, pull out the card, Maria! Make way for the rhythms of the new age, comrades!

Theatre Director: Stop, stop, that's no way to proceed. We can't violate our ritual. The audience must choose ...

Mayakovsky: We already have the card.
Takes it out of Maria's hand.

Here! 1952, fine, fine. Now, now, don't cry, dear Oscar, I'll let you shoot for me. Aim at the life of the future, the theatre of the future. Frenzy, dynamism, noise and din. Take the pistol, my dear friend, and aim like a good soldier. Present your weapon, careful ...
He moves towards centre stage. Maria holds up the card with the year. Oscar, down-stage, shuts his eyes and aims, with both hands on the pistol. The spotlights follow Mayakovsky. He stops by a wheel chair with its back to the audience.

Stop! What's this?
No answer. But another spotlight lights up. Now we see a table with roses and a comfortable chair by the table.

Flowers and chamber pots, we must have the wrong century, Vasilij, maybe 1852 ...

Vasilij: No way, this card deck is reliable!

Mayakovsky: Well, we can't have this!

Vasilij: My dear comrade, I like you very much, but now you've got to back off. We chose the splendid year 1952, and we'll have to have a look at it.

Mayakovsky: (Looking down at the wheelchair) Who are you?
 Silence

Sergei: (In the darkness) Who are *you*?
 Mayakovsky wants to speak, but Maria stops him with a gesture. She gives a sign to her comrades to disappear. Everyone leaves quickly and without a sound.

Scene 3
Moscow, 1952

 Sergei: (Kollontai's son, a scientist in his fifties, comes into the lit area by the writing table. Speaks in a calm but cold voice.)

I'm asking who are you really, mama?
 He touches the pile of papers.

You're indifferent to everything around you, all you do is stare backwards into the past. You don't want to see the

times you are living in, you're entirely preoccupied with your memoirs. No one can keep his health and sanity sitting shut in like that.

Kollontai: I feel fine.

(with some malice) How do you feel then? Your stomach ulcer has, of course, gotten worse, as usual.

Nadya: *(Kollontai's secretary and friend of many years pops into the lit area by the table.)* Now, now. Let's talk about something pleasant for a change. Does anyone want a cup of tea? You, Alexandra?
 She has gently turned the wheelchair and fusses a bit with the eighty-year old Kollontai, who is sitting there wrapped in a comforter but well-dressed and elegant as always. Her alligator-skin handbag is hanging in the arm of the chair.

 Lights are lit, revealing the whole group. We see Katya, Alyosha and Olga, a young girl, all sitting on benches around the edge. But they all remain silent, no one answers.

Kollontai: *(Persistently)* I think, in any case, that you should feel glad that Katya got a job.

Sergei: *(Retorts)* Glad! Are we supposed to feel glad, now that I've been fired, and you know how delicate Katya is.

Kollontai: Your wife will certainly become less delicate when she gets to work.

Katya: I am happy to work, Alexandra Mikhailovna, but we can't live like this.

Sergei: For years they've been harassing me. Now they're bringing in some idiot to replace me, someone who doesn't know squat about science but who 'thinks correctly'. My god, will it never end?

Kollontai: You only think about yourself. Like most intellectuals.

Katya: Right, just keep mocking him, that's what you've always done. But he is your son, after all. You could help him, you know. You have connections, Alexandra Mikhailovna, contacts ...

Kollontai: No.

Katya: No?

Sergei: I don't want any help from you, mama. I just want you to recognise reality as it is, instead of your usual 'Things are getting better.' and 'The situation is evolving on the correct course ...'

Kollontai: But that's just what it *is* doing. The situation is evolving on the correct course.

Sergei: Is it? People are just 'disappearing', just like in the old days ... going to prison, to forced labour camps! You're happy to see that production is increasing, but let me tell

you, if production is rising it's because Beria is sending still more people than before to forced labour camps. *(He points upward)* 'He', the genius of geniuses and the father of the people, should be shot, but no one dares!

Alyosha: Not so loud, papa.

Sergei: 'Not so loud, not so loud' ... No, because the walls have ears here too, even in a little two-roomed apartment way out in the Moscow suburbs — even here we are being *monitored*.

Katya: Nothing is getting better, Alexandra Mikhailovna, nothing.

Kollontai: *(After a short pause)* Oh yes, it is, Katya.

Katya: What is getting better?!

Kollontai: Don't shout. I can hear. But no one is listening to what we're saying. It's been years since they spent their money on such a luxury as to check on me.

(after a short pause) Ordinary people have seen their lives improve in infinite ways in the Soviet Union since the war ended.

Sergei: People in other countries have seen their lives improve too, mama. But no one dares to inform us about that.

Kollontai: Alyosha will have a better life than you.

Sergei: Alyosha, come here!
 Grabs his son and brings him over in front of Kollontai

Do you realise, mama, that kids *inform* on each other in school!
 Alyosha breaks free and goes away.

His papa has been fired ... whisper, whisper ... Oh, I see, it's *that kind* of family ... well, then the boy probably isn't to be trusted either ... maybe they're Jews ... haven't they had contacts with foreigners ... whisper, whisper ... and as a result some completely innocent seventeen-year-old boy gets picked up for interrogation, sent off to prison or to a camp. We've seen that happen with our own eyes, mama! And you claim that the seventeen-year-old will have a better life.

Kollontai: That *is* what I claim.

Alyosha: Please, papa, you must control yourself.

Sergei: Quite right, Alyosha. We must control ourselves, your mother and I, we should keep quiet and smile and suck up to people so that you can struggle to get through that school that produces close-cut loyal swine.

Alyosha: So now it's *my* fault! The only thing that would make you really happy would be for me to get myself sent to a labour camp, because that would at least show that I can think for myself ... that's what you think, right?

Katya: Let's leave. This is leading nowhere.

(Pause. Goes over to Kollontai.) We only came to ask you for some advice, Alexandra Mikhailovna, but I guess it's too much to ask that you listen to what we have to say. You have never listened to Sergei. You have only made fun of him for his weakness. You are so strong. It is almost unimaginable that you allowed yourself the weakness of having a child. Sorry to have disturbed you. We're leaving.

Kollontai: You're mistaken, Katya. I'm very sorry that Sergei is losing his job. But I'm not mocking him. It's he who is mocking me.

Nadya: Sergei, your mother is very tired. And we have work to do ...

Sergei: I know. Mama needs to work some more on her memoirs. Fine, good luck. I hope you hear what I'm saying, mama. Good luck!
 Mayakovsky interrupts

Scene 4
Mayakovsky protests against the form

Mayakovsky: Stop, stop! I'm sorry to interrupt here, but this is unacceptable!

Maria: And what's wrong now, Volodya?

Mayakovsky: *(Buries his head in his hands)* Everything.

Theatre Director: *(Who has been following the preceding scene from up in the box)* Well, you may not like the contents of this future, so, choose another one, Volodya!

Mayakovsky: I'm beginning to get very tired of your sarcastic remarks.

Theatre Director: *(Stops, returns to the edge of the box)* Weren't you the one who said that art and life are the same in the future? Well, here's what you get. So, can you see the difference between art and reality now?
 Goes off stage.

Mayakovsky: *(To the others)* For once I have to admit that devil is right. Art should criticise reality, always, always, this is just unacceptable. Domestic interiors! Family quarrels! Drawing-room drama, it's all like Chekhov and Stanislavsky, damn it, where is our circus theatre? What a horrible year we've landed in!
 Max agrees vigorously with gestures and more gestures.

Vasilij: Maybe we skipped too far ahead, Volodya.

Oscar: *(Helpless, speaking in clown talk)* Yeah, that's what I think, I really think so. Let's go back.
 Max protests in pantomime.

Mayakovsky: Or else forward. I agree with you, Max. Let's go forward, I propose we go directly to the year 2000, now, right away, flat out. That's where we'll begin: Moscow in 2000! Are you happy with that, Max?

Max is enthusiastic.

Maria: But that's not how it works, Volodya. And I have to say that as soon as things don't work out the way you want, you get really unbearable, à la Uncle Vanya.

Mayakovsky: What kind of people are they, those people. *They* are like Uncle Vanya, I'm tired of them. I'm tired of all the uncles and aunts. It's true that the revolution liberated art, but it's also obvious that now art must be ready to liberate the revolution! A new year, Maria, and right away.

Maria: As you wish. But I want her with us.

Mayakovsky: Who? That woman, the person in the wheel chair? Why?

Maria: Because that's what I want. Theatre for the masses — fine! Theatre out on the street — fine! But it all gets a bit abstract if you don't have a human being in the midst of it all — that woman. I want to see how it works out.

Mayakovsky: *(Tearing his hair in despair)* 'See how it works out?'

Vasilij: *(Holds out the deck of cards)* Okay, Volodya, relax. Pick a year yourself, be my guest.

Mayakovsky: You want me to ...?

Vasilij: Pick a card.
 Mayakovsky picks a card: the year 1921.

Fine! And so, esteemed members of the audience, we shall now continue. Moscow — 1921!

Mayakovsky: On we go! The year 1921 — noise, frenzy, dynamism ... re-vo-lu-tion!!!
 Circus music and the actors move up-stage.

Scene 5
Kollontai and Dybenko, I
Moscow 1921

 Kollontai rushes in, wearing an overcoat, with a bundle of leaflets in her arms.

Kollontai: Re-vo-lu-tion! But where is it going? The bureaucracy just keeps growing!
 Keeps turning the bundle over and over and leaflets fall on the floor. She throws the bundle down.

Dybenko: *(A spotlight catches him)* Shura ... ! I've been waiting for you.

Kollontai: *(Spreads out her arms, runs to greet him)* Pavel, my beloved Pavel!
 Embraces him

Dybenko: *(Calmly, after a pause)*
I've been waiting for some time.
 Kollontai frees herself from his embrace and goes over to her bundle. She kneels and picks up papers.

Kollontai: (With her back to him, big gesture of exhaustion)
I know that. But I was at a meeting, Pavel!
 They are at some distance from each other, at opposite sides
 of the stage, a spotlight on each of them.

Dybenko: I don't like those meetings you people have.

Kollontai: (Another big gesture) I know that *too*, Pavel.

Dybenko: So, stop going to them, Alexandra, while there
still is time.

Kollontai: What do you mean? Can't our party tolerate
friendly criticism, expressed by party comrades?

Dybenko: But we're in the midst of a civil war. Industry is
at a standstill! People are starving! We have to produce
food!

Kollontai: And all efforts to democratise our society should
be filed away (in a cubbyhole) until food is available, is
that what you mean?

Dybenko: We have no choice, unfortunately.

Kollontai: (In front by the footlights) Even labour unions
won't be allowed, if Trotsky gets his way. People are being
sent off to perform forced labour, as if they were soldiers
at the front — their views count for nothing. And the
party wants to eliminate labour unions.

Scene 6a
The meeting

Dybenko: (Speaking upwards towards the box, which has been made very prominent by the lighting. It is packed with people, workers, soldiers all with weapons, peasants in rags, old and young, smoking, talking.)

There can't be two in command! If the labour unions and the party have different views, the party must prevail!

Kollontai: (She is walking towards centre stage, where a table is revealed with the leaders, Lenin, Trotsky, Stalin and others with documents, lots of papers.)
And the workers' own organisations won't even have a voice? But listen to me, comrade leaders, listen to those of us who work! We must object when you no longer believe in the people's own power.

Young worker: (From up in the box) That's right, that's right! I used to work in a factory in St Petersburg before the revolution, eighteen hours a day I slaved in muck and darkness to earn my daily bread. When the revolution came, I joined in! We formed a workers' council, a workers' soviet! And we organised production! And then? For two years I fought against the Whites. When the civil war was over, the workers' soviet was eliminated!

Working woman: (Rises in the box) The Bolsheviks eliminated them. But why? Whom are you afraid of, comrade leaders, ... of us? I too joined up, in Kiev. We united. Now we

are comrades, I said to my husband, now we work side by side for the same goal, and you no longer have command over me, no one can do that! Now he's dead, shot by the Whites. I gave my children grass and straw to eat, there was no food. I am a seamstress. After the struggle against the Whites, we said at our factory: the union will build up production again! And we began doing that, working with heart and soul! Then a bureaucrat came from Moscow came and told us: shut up, you people, and wait for orders from Moscow! They sent me off to do forced labour. Where are my children now? No one will tell me. We support the workers' opposition!

The others agree.

Scene 6b
The X Party Congress

A drum roll by the orchestra. Red streamers drop to the floor everywhere, a red star over the box. Kollontai is heading towards the rostrum.

Announcer on the PA system: The plenary meeting of the 10th Party Congress will continue. Comrade Kollontai is called to the rostrum! Comrade Kollontai to the rostrum!
Some of the workers in the box applaud, shouts of Bravo! Whistling. Then silence.

Kollontai: (The rostrum has been swung out over the audience. Kollontai addresses the audience.)

Friends, party comrades! You know me. I was this re-
public's first People's Commissar for Social Matters and
Women's Issues. I have worked my whole life for the lib-
eration of women, but I gradually came to understand that
women will never be free until mankind is free!

Comrades, you remember how it was when we made the
revolution? People who had been bullied and worn down
all their lives were filled with rejoicing and joy, they as-
sumed charge of production and defended their factories
with arms in hand against the forces of counter-revolu-
tion. People straightened their backs, realised their inher-
ent worth and found new forms of love and friendship
in equality!

And now? Comrades, look around at industry. Where
there used to be workers' soviets and worker initiative,
now there is only listlessness and dissatisfaction. What
has happened?

We don't need trade unions any more under socialism,
says comrade Trotsky. Does he understand what he is
saying? The workers' opposition says just the opposite:
Those who work and produce should themselves design
work and production, because people without the power
of self-initiative cannot build socialism.

Once we threw the old directors out of the board rooms —
but now we see them streaming in again, the directors,
the technicians, the 'experts'. And the bureaucracy keeps
on growing. Bureaucracy, comrades, brings with it fear.

Someone else is making decisions about our lives. People begin to be afraid. They lose the habit of thinking, because someone placed higher than them thinks for them. That fear eats its way deep inside us, deep into the core of the party too and that is dangerous, comrades, dangerous! We bear a great responsibility, comrades, not just for ourselves, but for workers in all countries!

The workers' opposition demands: restore democracy, free criticism! Wherever you find criticism and analysis, wherever you find ideas in circulation — there you find life, creativity, development forward!

The workers are about to applaud but are interrupted by the PA system.

Announcer on the PA system: Comrade Trotsky has the floor! Comrade Trotsky has the floor!

Kollontai slowly descends from the rostrum. She ends up in front of the table where the leaders are sitting.

Trotsky: *(Stands up by the table)* The workers' opposition has transformed democracy into a fetish, an idol! As if the right of workers to choose their representatives in all situations outweighed the need for party loyalty. The party has the right to exercise its dictatorship even when it conflicts with the momentary views held by workers. It is the party's duty to uphold its dictatorship!

Government employee: *(Very soft and faint in the PA system)* Comrade Lenin! Comrade Lenin!

Kollontai stands in front of Lenin and looks him in the eye.

Lenin: *(Shaking his head, softly)* We can't afford any so-called workers' opposition, Alexandra Mikhailovna. Not right now. Not if we're going to be able save the revolution.

Kollontai: *(Bursts out)* And what sort of revolution are we trying to save, Vladimir Ilich?

Lenin: *(Rising)* Millions of people are starving in this country, many are dying of starvation! We have to produce food! Forgive me, but at this time we can't offer health care and a free right to criticise!!!
 Short silence. Lenin begins to move away. Everyone begins to move, even in the box.

Kollontai: Shouts out in the midst of the murmuring, which stops. People are listening.) Still, Vladimir Ilich ... the opportunity to do it may never return!
 Strong reactions, but the commotion continues. The rostrum gets rolled out. The orchestra gives a final flourish. Blackout.

Scene 6c
Kollontai and Lenin

(Lenin at a table down-stage. Kollontai is dejected, her head in her hands. Lenin sits with a package of sandwiches and a bottle of beer and, even now, a bunch of papers. Documents in front of him on the table, which he scans. Further away, there's a group of government officials talking, waiting their turn to see Lenin.)

Lenin: Be careful, Alexandra. Be careful with your guilt feelings.[1] You want to reach down to the people and grant them their human dignity, creativity, participation ... That is both noble and beautiful. But we can't manage to do that right now. If we relax our grip the slightest bit, we'll have the counter-revolution on us. Your speech was magnificent, but completely out of place, exactly the wrong time. Use your powers and rhetorical skills to support the party instead. The 'new man' your crowd talks about can't be born if we can't ensure that the old man will survive. Free criticism, free art and free love ... all of that is fine, but not just yet.

Kollontai: But how do you read your Marx, Vladimir Ilich? Do you remember what Karl Marx wrote about the need for trade unions in the revolt of the masses?

Lenin: The revolt of the masses! The masses never revolt on their own. But aren't you hungry, dear child? Don't you want a sandwich?
 She shakes her head.

Romantic dreams ... we don't need that.

Kollontai: So you think that democracy is a romantic dream, Vladimir Ilich?

1 Lenin and Kollontai use the familiar (comradely) form of address (Swedish *du*, like the French *tu*) with each other, unlike Stalin later on.

Lenin: All I'm saying to you is that what your group is calling for can't be implemented now while Russia is surrounded by enemies. Now we need unity!

Kollontai: And when can it be implemented ...?

Lenin: We've only been able to open the door a crack, Alexandra. *(Packs up his sandwiches.)* We have lots of hard work ahead of us. God knows we need you.

> *Sighs and walks with his package and his papers over to the officials, who have risen and are coming towards him with more documents. Kollontai stands up, moves away, stands alone in a spotlight.*

Scene 7
Kollontai and Dybenko II
Moscow, 1921

Kollontai: *(Shouting)* And still, comrade Lenin, what sort of a revolution are we trying to save, if the people no longer have a voice?

> *She goes towards centre stage.*

Dybenko: *(By the chair, dressing for a trip. On the back of the chair we see a cartridge belt and a revolver etc. hanging.)* Shura dear, listen to me. I have been given an assignment.

Kollontai: But maybe he does understand me, our comrade Lenin, but Trotsky — he's a devil!

Dybenko: I have to go on a trip, Shura.

Kollontai: (As if she hadn't been listening. Throws herself into his arms.) And you, Pavel — do you also think I'm wrong?

Dybenko: I love you, Alexandra.

Kollontai: But you think I'm wrong.
 They look at each other.

Dybenko: Maybe not. Maybe you're right. But think of the situation we're in! The sailors in Kronstadt are in revolt. They're all shouting 'All power to the workers' soviets!'

Kollontai: Because the party refuses to listen to their criticism. There will be more revolts, and the party will soon have to beat them down with force, and then where will we be?

Dybenko: The party has to keep a firm grip on the reins now. In a few years we'll get all we have wanted: democracy, socialism, times of harvest.

Kollontai: In a few years, in a few years, how is all this supposed to happen in a few years if we don't prepare the ground now? Pavel, my beloved, I beg you, don't take off and leave me now! I have been shut out of all assignments, old party members won't even say hello, some members of the workers' opposition have been put in prison. They won't even let me lead the work of the Women's Department any more!

Dybenko: Be patient. It's cold outside. Look, Shura, look at the beautiful frost blossoms on the window.

Kollontai: Frost blossoms! I don't want frost blossoms. I want to be able to see clearly.

Dybenko: I'll make you a peek hole. Come here.

Kollontai: You're making a peek hole for me, but I want to see the whole horizon! Pavel, if it weren't for you ...

Dybenko: Yes?

Kollontai: ... I'd be all alone.

Dybenko: But I am here.

Kollontai: Yes, you are here, *you* are here.

Dybenko: The revolution's lovebirds ... the sailor and the daughter of an aristocrat.

Kollontai: Don't leave, Pavel, you can't leave me right now, where are they sending you?

Dybenko: To Kronstadt.

Kollotai: Kronstadt? You? To Kronstadt?

Dybenko: I am to lead the government forces against the sailors in revolt.

Kollontai: You're going to attack them — with arms?

Dybenko: Don't think I like doing it. But I have to.

Kollontai: Have to? You're following orders, blindly.

Dybenko: No. I'm doing it because I chose which side I'm on. I'm with the party.

Kollontai: You'd shoot me too, if those were your orders.

Dybenko: Keep quiet, Shura!

Kollontai: Why should I keep quiet? You would shoot me too if the party ordered you to! It doesn't matter what your heart or reason tells you, you still have to obey the party! Everything will get better, you say, but how is it better when communists shoot their comrades?

Dybenko: *(Packs)* Everything will get better as long as there is no counter-revolution, if we just get some peace and quiet.

Kollontai: *(Shouting)* And you and I should just wait for that harvest to come in peace and quiet? Can't you see that you're speaking against yourself — you don't believe in what you're saying!

Dybenko: Yes! I'm saying this because I believe it and because I love you.

Kollontai: I love you too, but what you're doing is wrong!
 Dybenko leaves.

Don't go! Don't leave me! I don't want to be left all alone!
With her back to the audience, she sinks in despair into the
chair. Silence.

Scene 8
The Futurists around Lenin's portrait

(Mayakovsky, Maria, Oscar, Vasilij, Max)

Mayakovsky:
 We were two in the room
 I
 and Lenin —
 He's on my wall
 in a photograph.

Maria:
 From his open mouth
 Stream powerful words,
 The wrinkles on his face
 speak
 of humanity
 Behind that mighty forehead
 Are even mightier thoughts.

Mayakovsky:
 Beneath him
 pass people
 in the thousands ...
 Beaming with joy
 I rise from my chair

I want to go
　　　　to him
　　　　　　　and say what I think.

Oscar: Comrade Lenin,
　　　　　　I am here
　　　　　　　　　with my report
　　　Not because it's my job
　　　　　　but straight from the heart
　　　Comrade,
　　　　　　it is hellish work
　　　　　　　　　that we have to do.

Vasilij:
　　　We enlighten
　　　　　　and clothe the poor and the naked
　　　And extract
　　　　　　evermore iron ore and coal.
　　　But, you know,
　　　　　　there is much that is lacking!
　　　Comrade Lenin
　　　　　　in the smoky sooty factories
　　　And across the fields of grain
　　　　　　and the snow-covered stretches
　　　It's the thought of you that
　　　　　　keeps us from giving up.

Oscar:
　　　It is your heart and name
　　　　　　that helps us to breathe
　　　　　　　　　and live for the struggle!

Maria:
With piles of work
 and scenes of all kinds
The light died away,
 Another day passed.

Mayakovsky:
We were two in the room
 I
 and Lenin —
He's on my wall
 in a photograph.
I want to go
 to him
 and say what I think.

Scene 9
Kollontai and Stalin I

A huge portrait of Lenin, where he is standing at a rostrum, turned sideways, speaking to the people. Kollontai is standing with her back to the audience, looking up at the portrait. She turns and stares at Stalin, who is sitting at his plain desk covered with documents.

Stalin: (Picking his teeth, he looks at Kollontai. Finally he speaks)

Didn't you hear what I said to you, comrade Kollontai?[2]

2 Stalin and Kollontai use the formal form of address (Swedish *ni*, like the French *vous*) with each other.

Comrade Lenin can't be visited.

Kollontai: But I'm an old friend of his, Josef Vissarionovich. You know that.

Stalin: Right. Everyone is an old friend of Vladimir Ilich's these days, everyone wants to talk to him, what do you want to talk to Vladimir Ilich about? He is sick and mustn't be disturbed. It is my job to ensure that he is not disturbed. You would only disturb him. *(He begins working)*

Kollontai: Since when have you become the gatekeeper for Vladimir Ilich, comrade Stalin? You could at least be kind enough to tell me where he is.
Stalin: I can't figure you out, comrade Kollontai.

Kollontai: I think that is quite right, comrade Stalin.

Stalin: *(Irritated)* What is it that you are trying to achieve? Sometimes it's free love, sometimes it's world revolution ... What you did at the party congress was unpardonable, do you hear me?

Kollontai: But surely you don't believe that I am an enemy of the party? What I said at the congress was internal criticism, among party comrades.

Stalin: Who are you? You come from the upper class, you've gone to schools, you speak a lot of languages. German? English? French, maybe? Me, I'm a simple man, I wasn't born in Moscow, I barely speak Russian ... But I can see what's wrong with you.

Kollontai: Oh, what?

Stalin: You're divided, split ... That's why you go astray so often.
 He looks at her. Silence.

Kollontai: So you don't want to tell me where comrade Lenin is?

Stalin: Comrade Lenin is not as you imagine him to be, ... he's made of sterner stuff, through and through. He is like an icon cut from hard wood ... not soft like you.

Kollontai: An icon, that's the image you chose. Maybe not entirely unexpected.

Stalin: *(Wrinkling his brow)* What do you mean?

Kollontai: Weren't you in a school for priests, once?

Stalin: Sure! And that is the source of my thinking. It was a hard school, comrade Kollontai, one that knew how to deal with apostates. They kept us on the right course.

Kollontai: Well, and at some point you'll probably canonise comrade Lenin if you go on like that.

Stalin: *(Bursts out laughing)* You know, you're not bad. Canonising?

Kollontai: *(Coldly)* A way of disposing of him.

Stalin: *(Changing his mood, darkly)* Disposing of him? Comrade Kollontai, comrade Lenin is very sick. You sometimes take liberties that make me wonder who you are. I'm warning you. You pose a challenge to people. *(He moves closer to her.)* You provoke people with your clothes when all of Moscow is dressed in rags.

Kollontai: The challenge I pose is to people's lack of imagination, comrade Stalin.

Stalin: *(Short pause)* And your handsome sailor, where is he?

Kollontai: He's been assigned to Odessa. Haven't we strayed from the subject?

Stalin: Have we? Why do you need to talk to comrade Lenin? Tell me!

Kollontai: *(She is silent, then speaks)* Comrade Stalin, I've been excluded from all assignments. It's unbearable. I want to be of use.

Stalin: In the workers' opposition? *(Raises his voice.)* The worker's opposition has been eliminated, the counter-revolution in Kronstadt has been beaten down. And for that, the party's Central Committee is grateful to Pavel Dybenko.

Kollontai: *(Distressed)* I know that, comrade Stalin.

Stalin: What sort of useful work had you thought of doing, comrade Kollontai?

Kollontai: *(She is silent, then speaks)* Since you can't figure me out, comrade Stalin, I will explain to you. Useful for the party, for building socialism. But since you don't intend to listen, I will leave.

Stalin: Already? In the midst of such a pleasant conversation? And where are you going?

Kollontai: What concern is it of yours.

Stalin: How can I help you if I don't know where you are?

Kollontai: *(Putting on her gloves)* You'll be able to find me in Odessa.

Stalin: I see. Well, I think that is foolish.

Kollontai: Why?

Stalin: We might find better plans. Better stay here. If you stay here, we might be able to figure out something useful for you.

Kollontai: Then, will you tell comrade Lenin that I am looking for him?
 (Stalin looks at her. He doesn't answer. He smiles. Kollontai buttons her button.)

I can manage without you, comrade Stalin.

Stalin: Can you? Well, that's fine!
 (Kollontai leaves. Stalin follows her with his glance.)

Scene 10
The Futurists — the train

 (Mayakovsky, Vasilij, Maria and Oscar, as if in a train)
 All four: (Coming in)

Chugga-chugga, chugga-chugga
Woo-woo
Chugga-chugga, chugga-chugga
Woo-woo

Mayakovsky: Maybe you want us to make a rainbow for you instead? But how useful can a rainbow be?

Maria: You can't even use a rainbow to cut pork chops with!

Vasilij: Or maybe some flaming Northern Lights? Do you want us to make you some majestic Northern Lights?

Oscar: You'll just get mad when you realise that you can't sew the Northern Lights on to your wife's skirt.

Mayakovsky: That's why we don't produce rainbows or Northern Lights, but insolent words and expressions as coarse as the blows of an axe!

Vasilij: We're coachmen for hire, walking advertising columns!

Mayakovsky: The Northern Lights and rainbows have their functions, which they fulfill honorably and skillfully, but we have other tasks, my esteemed audience!

Oscar: We can't tell you about them now, but we intend to take you with us on the train to Odessa!

Vasilij: To Odessa! The year is 1922 — off we go on the direct express train!
 All four: (*Going out*)

Chugga-chugga, chugga-chugga
Woo-woo
Chugga-chugga, chugga-chugga
Woo-woo

Scene 11
Odessa, 1922

> *At Dybenko's place. Kollontai and Dybenko in bed. Glasses, bottles, dawn. Dybenko's boots are on the floor. His military coat and holster are hanging on the wall. A screen, a wash basin. A knock on the door.*

Dybenko: (*Rolls over, stretches*) And then came the dawn ... or however the great Pushkin put it.

Olga: (Comes in) There's a telegram. For the lady.
Kollontai gets up. Uses Dybenko's uniform tunic as a morning robe and goes out. Olga looks at Dybenko. Takes his boots.

Dybenko: Leave the boots alone.

Olga: They need brushing.

Dybenko: Leave them be. I'm on my way out.

Olga: No. I'm going to brush them, like I always do.

Dybenko: (Jumps out of bed) Leave them alone, I tell you!
Tries to take them. Olga won't let go.

Let go, Olga!
Kollontai in with a telegram in hand.

Olga: (Shoves the boots into Dybenko's chest.) Take them then! Take them!
She wails, bursts into tears, runs out.

Dybenko: What's the matter? Why are you staring like that?

Kollontai: (After a short pause) Why don't you tell me that she is your mistress?

Dybenko: Why should I do that?

Kollontai: Isn't that what she is?

Dybenko: You're jealous.

Kollontai: Yes, I am.

Dybenko: It doesn't suit you.

Kollontai: Then I beg your pardon.

Dybenko: Jealous of a nineteen-year-old girl — you who wrote books about free love!

Kollontai: Yes. Well, what of it?

Dybenko: What of it? That's what I say too — what of it?

Kollontai: And when I arrived from Moscow, she got pushed aside.

Dybenko: Yes, that's what she had to do.

Kollontai: And you didn't tell me anything!

Dybenko: We've had other things to do, don't you think?

Kollontai: And what did she say about my coming here?

Dybenko: Imagine, I didn't ask her!

Kollontai: No, you don't have to ask servant girls what they think, they get paid! You just move them around, from the bed to the dishpan and back!

Dybenko: Shura ...

Kollontai: It's so degrading. So banal.
(Short pause)
You and I, we make love and we talk and we talk ... are we doing the right thing, are we doing the wrong thing, what sort of disputes do we see within the party, how is socialism going — but about this — not a word.

Dybenko: Because it doesn't have anything to do with the rest.

Kollontai: How we live? How we behave towards each other?

Dybenko: I've been lonely here and unhappy. She was lonely too. You weren't here and it took you a hell of a long time to get here.

Kollontai: Yes. I was in Moscow trying to improve my situation. But now I'm here.

Dybenko: Right, and now all that other stuff no longer matters.

Kollontai: *(Holding up the telegram)* I have to leave.

Dybenko: No, now you stay.

Kollontai: How can I do that?

Dybenko: Shura, we've never had time for each other. There's only been work and politics. Now you're finally here and now you're staying here.

Kollontai: I have longed to be here, more than I can tell you. But when I came, you were as incommunicative as a wall. Where are *you*?

Dybenko: Don't you think I have longed for you too? I have. And now I want to finally be with you. I want *peace*!

Kollontai: If that's the case, you were born in the wrong century, Pavel!

Dybenko: Are we going to argue about that too?

Kollontai: You won't get the peace you long for with me.

Dybenko: Oh yes, we can manage, with a little patience.

Kollontai: Pavel, I have to leave you.

Dybenko: Shura, for god's sake, stop!

Kollontai: We'd still have to part, sooner or later, I'm so much older than you, you want to have children, don't you, I have a son, you don't, my son is older than ... she is.

Dybenko: Please forgive me, Shura, I made a mistake, forgive me. Just stay. Olga will be dismissed.

Kollontai: Dismissed — for what? No! But you must talk to her, ask her to forgive you for having treated her like a slave. Don't you understand? I am only blaming you for not having told me about her and her about me, so she would know.

Dybenko: Olga is a nice girl, I like her a lot, but talk to her ... She wouldn't understand.

Kollontai: Not understand? No, she's only there to serve, no point in asking her opinions. You act like Trotsky when he's attacking labour unions, workers shouldn't be asked about anything, they don't know what's best for them, we don't have to ask them ... call her in, this concerns *her*, she has the right to be present!

Dybenko: No way, never!

Kollontai: Call her in! How long have you made love to her before she had to move out, four months? Or only three?

Dybenko: As you wish.
 (He opens the door. Olga is standing there.)
Here, be my guest. Talk to her.

Kollontai: Me? You're the one who ...

Dybenko: Olga, this lady has written books about free love, and she feels that I have behaved like a pig towards you. Do you have anything to say about that?

Kollontai: Pavel!

Dybenko: Isn't that right? And really good books too, about the underclass.

Kollontai: Olga, what I said was that it was wrong not to tell you who I was, when I was coming.

Olga: I understood anyway.

Kollontai: How do you feel about this?
 Olga curtsies without answering.
You know, I don't think it was wrong ... you know, the two of you ... I'm not angry ...
 Olga looks at her without answering.

Dybenko: No, she's not angry. She is so good, Alexandra is.

Kollontai: I'd really like it if you said something to me ... I have to leave soon ... Won't you say something?

Olga: *(Curtsying)* I'd rather go. May I?

Dybenko: Do you see what I mean?

Kollontai: No, I see nothing at all.

Dybenko: You must stay here, Shura.

Kollontai: No, I have to leave.

Dybenko: You're not going to move anywhere!

Kollontai: He helped me! Comrade Stalin helped me, just as I asked him to! He's sending me to Norway, as a diplomat!

Dybenko: God help you if that's true.

Kollontai: Pavel, here at home I'm excluded from everything, I can't bear it!

Dybenko: You're leaving because you don't want to be with me.

Kollontai: No! I love you, Pavel!

Dybenko: Then stay!

Kollontai: I can't. But in a few years ...

Dybenko: In a few years, in a few years! I have waited for years to get a chance to live with you, not just work ... live!
Grabs the overcoat and holster from the wall and goes out.

Kollontai: Pavel ...
A shot. Olga and Kollontai stand completely immobile. Max rushes in, he tries to explain what has happened ... Kollontai wants to push him aside and rush out, but the Futurists come in. They bring Dybenko in with them. He is bare-chested and has a bandage on his chest, they sit him down on a chair. Kollontai stands behind the chair. Olga is a bit further away. Vasilij taps his drum once.

Mayakovsky: Do you think this is a fever dream?

Vasilij: *(A drum beat)* Such things happen.

Maria: *(A drum beat)* It happened in Odessa.

Mayakovsky: I'll come at four o'clock, she promised.

Oscar: Eight. Nine. Ten.

Maria: Away from the window
the evening turned
into a nightmare-like December night,
tormented.

Vasilij: And behind the evening's broken back
grinned the halos of light!

Dybenko: *(Delirious)* Take away the lamp, it hurts my eyes!
Shura! Take my hand!
 (Kollontai wants to move over to him but is stopped.)
No! Don't touch me, you've hurt me, go off on your jour-
ney, go!
 (Pleading)
Shura, my little girl ...
 (Kollontai is held back again.)
No! I don't want to see you ... Olga, where are you, Olga?

Olga: *(Falling on her knees, takes his hand)* I'm here, Pavel
Yefimovich.

Dybenko: Could you take away the lamp.

Olga: There is no lamp.

Dybenko: (Straining) Has she gone? Is she still here?

Olga: (Meeting Kollontai's glance) Yes ...
 (Kollontai shakes her head, slowly, sadly.)
I'll take care of it, Pavel Yefimovich ...

Dybenko: Don't go. Stay here.
 Olga bows her head. Kollontai goes out.

Scene 12
Mayakovsky goes home

Mayakovsky: Now I stand, bent over, by a window
and melt the panes with my hot forehead.
Will this love be as I hope?
Will it be small and puny?
Or huge like a giant?!!!

Maria: (Looks at him, uncertain. Shakes her head, uneasy.)
And what do we do now? Do we go on?

Vasilij: Of course we go on. That's the only thing we can
know for sure. We must always go on.

Mayakovsky: I don't know what you guys are thinking of
doing. Me, I think I'll go home.

Oscar: Home.

Maria: What's wrong? The 'bio-mechanics'?

(She does some ironic typical dance steps. She breaks out of her pose.)
I'm joking, come on, let's go on ...
(Mayakovsky doesn't answer, rushes out. All take a step to follow him.)

Vasilij: *(Shouting after him)* What's bothering you?

Maria: Relax. He'll be back. It's obviously all about some woman. Then he always takes off.

Vasilij: I think he's depressed because the party doesn't like his poetry. *(Sighs)* And because there are fewer and fewer of us. When are you thinking of leaving us, Max? *(Max does a bit of pantomime.)* What's he saying?

Oscar: He thinks we should choose a new year. 2000. Let's do it!

Maria: You people are always overreacting. That is so like men. *(She looks away towards where Mayakovsky went.)* You run away, some of you this way, others that way. But I refuse. I want to see how this works out.
(Takes some cards.)
1924, 27, 30. These are my cards.

Vasilij: *(Protesting)* All of them together?

Maria: All together! To Norway!

Oscar: Norway! Christiania! Wonderful!
(Max makes some gestures and does a pantomime)

Maria: What's he saying now?

Oscar: He says it's a little country where nice people walk around on the streets eating snow in cones.

Maria: Fine! We are Futurists! Let's get a move on!
(Max does some pantomime. Sound of boats hooting.)

Oscar: *(To Vasilij)* Grab the hawser! Pull in the gangplank!

Maria: The boat is setting off!
(They make a boat, toot, toot, and begin to sail off)
Oi, it's rocking! I'm going to be sick!
(They tap-dance their way out)

Scene 13
Christiania in the mid-1920s

(The Soviet legation. Russian and Norwegian flags. Portrait of Lenin. Marcel Body is lying on a sofa and reading at night.)

Woman's voice: *(Shouting off stage)* No! No!
(The door flies open. Kollontai rushes in in her nightgown and with her hair standing on end. Body jumps up.)

Body: Dear god and creator, is it you, Alexandra Mikhailovna? I thought it was a ghost.

Kollontai: Marcel! Forgive me, I had such a bad dream. What are you doing sitting here in the middle of the night?

Body: *(A little embarrassed)* I often return to the legation when everyone has gone. The room I rent is so depressing. Look! *(He shows her the book)*

Kollontai: Marx. *Capital*. And you still have the energy to work here with us during the day? Where in France do you come from, Marcel?

Body: From Paris. Here, come and sit in the sofa.
 (Kollontai sits, she is freezing. Body comes back in with a glass of milk.)

Drink! It's the best thing for when you have bad dreams. You're freezing!
 (Takes his coat from the chair and spreads it over her knees.)

Kollontai: *(Happy)* Thanks.

Body: Drink it now, the milk is warm. Warm milk keeps the ghosts away, my mother always says.

Kollontai: Your mother in Paris?

Body: Yes ... I'm a typographer, Alexandra Mikhailovna. When the revolution came, I rushed to Russia, like many others ... and now I'm here, a Frenchman working for the Soviets in the legation in Christiania!

Kollontai: And studying Marx?

Body: Yes, and studying Marx, the German. Before, all I did was work and fight the Whites. Now I'm trying to fill

in the gaps, sort of after the fact. At night. Tell me now —
what was it you dreamt that was so awful?

Kollontai: I dreamt ... I lost someone I loved. I dreamt he
was shot.

Body: Such dreams are not good. My wife is in France ...
I haven't seen her for years.

Kollontai: You have a wife ... such a young boy?

Body: *(Shrugs out with his hands)* These days I hardly know.
It's good that you're here in Norway, Alexandra Mikhai-
lovna. You've done good work here.

Kollontai: Moscow isn't happy with my reports.

Body: Do you know what they're doing in Moscow?
They're mucking around with the Norwegian Workers
Party, trying to get it to collapse so they can get a loyal
communist party instead, one that will support Stalin in
the Comintern. It's good that you're opposing Moscow's
line.

Kollontai: Do you support the opposition against comrade
Stalin, Marcel?

Body: I am worried about what is happening.

Kollontai: I am worried too.

Body: They're fighting for power there, they've been

fighting like madmen for power ever since comrade Lenin's death. And what happens to the revolution?

(Points at the book)

Something has been lost, I feel. He could provide us with good advice.

Kollontai: Sometimes, Marcel, I get so afraid ...

Body: You mustn't be afraid.

Kollontai: I get worried I made a mistake leaving home ...

Body: But good god, Alexandra Mikhailovna, you're needed here! You support the Norwegian workers. Our revolution was carried out to save the workers in all countries, you have to stand firm against Moscow and the Comintern.

Kollontai: But how long will they leave me alone! I am so tired, Marcel, I long to get home, I don't want to be a diplomat. Where has love gone, freedom and joy? I want to live a little! And write, I'm a writer after all, maybe Pravda doesn't like what I write, but the women ... they understand! It seemed as though a new woman would be born, a new solidarity in work, a new relationship between the sexes ... I need to help, it's important, important ... do you understand, Marcel?

Marcel: *(On his knees beside her, takes her hand)* Don't leave us! We need you!

Kollontai: I look old, don't I?

Body: *(Shakes his head)* You're so beautiful. You look younger than when you first came here, and that was a few years ago.

Kollontai: Marcel ... do you think I'm trying to run away ... I don't know where I am anymore ... help me ...

Body: ... but you're freezing, you've been working too hard, cry a little now, that helps ... on Sunday — then you'll go with me up to Holmenkollen, do you want to?[3]

Kollontai: Yes, a long, long walk. That would be nice ...
 (They embrace. Sounds of the popular song 'No, no, Nanette'.)

Scene 14
The lamppost I

Mayakovsky: *(Alone by the lamppost)*

It's dark again.
Downcast, I take my heart
and surround it with tears
and bear it,
as a dog bears his paw

crushed by a train
to his kennel.

3 At this point Body switches to using the intimate/familiar form (Swedish *du*, like the French *tu*) in addressing Kollontai and she follows suit.

Maria: *(Rushes in, sees Mayakovsky)* Volodya ...
I've been looking for you everywhere — Have you finished your play?

(Mayakovsky shakes his head)

Are you writing anything else? Poems?

(Mayakovsky nods)

About love?

(Mayakovsky nods)

And she loves someone else, of course?

(Mayakovsky nods and flicks his cigarette across the street)

But Volodya! Come back to us, we miss you.

Mayakovsky: *(Turning up his collar)* I write love poems, she doesn't want them, no one wants my plays either, 'just circus tricks' the critics say ... what is needed, they say, are plays with tractors as the lead characters ...

Maria: Oh Volodya ...

Mayakovsky: *(Shouting into the night)* Now just you listen, you exalted critics ... the poet Mayakovsky will give you what you want, he'll write you a play with ten tractors in the lead roles and they will love each other with a love so mighty it will blow your trite little ears off!!!

Maria: *(Giggles)* Come and tell them that, Volodya. They're sitting in the little rooms at the Smithy Café! All the Futurists are there and they're fighting like tigers, and we know for sure the damn critics are scared.

Mayakovsky: *(Brightening up)* Scared of us, right.

Maria: *(Melancholy)* Afraid of our government, Volodya. Come and tell them about how they're scared! They've been quarreling for weeks at the Smithy Café, but we're not getting anywhere, only you can tell it like it is. God, I'm so glad I found you, Volodya!

Mayakovsky: Come!
 (They go)

Scene 15
The Smithy Café

> *(The Smithy Café, the box has been transformed into an orchestra pit. A pathetic orchestra is playing melancholy music. People are sitting at small tables reading newspapers on newspaper sticks.*
> *Kollontai is sitting at a table down-stage. Drinking a cup of coffee. A glass of water. Smokes impatiently. Marcel Body in an overcoat makes his way through the smoke and people. Looks around for a waiter.)*

Kollontai: *(Eagerly)* Oh, there you are, there you are ... so, tell me!

Body: *(Signals a waiter way in the back that he wants a beer)* Can't he understand that I want a beer?
(Sits down)

Kollontai: So, tell me, quickly! Will he come?

Body: *(Doesn't answer right a way. Looks around at people sitting nearby behind their newspapers.)*

Alexandra, we have to be extraordinarily careful. Moscow isn't like it was. The police are everywhere. People act as if they don't even trust their own mothers.

Kollontai: Doesn't he want to meet with me?

Body: He'll be here any minute.
 (Kollontai stifles a shout)

Keep a cool head, Alexandra. You are probably being watched. Some sort of meeting is going on next door, and the whole corridor is full of policemen.
 (Kollontai nods)

Well, goodbye then!
 (He slowly takes her water glass)

You wrote somewhere that love should be like a glass of water, right?
 (Kollontai shakes her head)

No? Maybe not always. *Bon*, we all have to relearn some things as the times change. I don't have time to wait for my beer. So, I raise this water glass to thank you on my behalf. Be well, Alexandra.

He stands up. Drinks. Dybenko can be seen in the distance.

Be careful, Alexandra.
Dybenko comes over. Kollontai reaches and pulls a newspaper over to herself and, when Dybenko sits down, she kisses him behind the newspaper. Body watches the scene, shrugs his shoulders and goes out.

Kollontai: (Puts the newspaper down) Stand still, heaven! Stars, don't think of moving! Time, stand still!

Dybenko: (Looking quickly around) You're attracting attention.

Kollontai: Well, so what? I want to attract attention!

Dybenko: You've probably managed to do just that.

Kollontai: Shouldn't I have kissed you?

Dybenko: (Irritated, speaking carefully) Don't you realise they're watching you? My god.
Shakes his head in despair.

And how did you get hooked up with that ...
(He gestures in the direction where Body disappeared.)

Kollontai: Are you jealous?

Dybenko: (Smiles) No! ... Well, yes ... but, damn it, that has nothing to do with this.

Kollontai: It doesn't? I've come here to live with you, Pavel ... if you still love me.

Dybenko: I do. I do love you, but things are tougher. Your activities in Norway haven't exactly made it easier for you and me to come together. I'd like to ask you about a few things ...

Kollontai: Don't force me to defend myself. Don't push me away, Pavel ...

Dybenko: *(Hard, nervous)* You're following some sort of devilish logic, which you can no doubt defend — I can only point out that you aren't particularly good at seeing reality as it is. This is not a time when you can sit in Christiania and try to tell the Comintern what to do and compose letters about international communism. Nor is it a time when one can sit in Moscow and write about women, equality and the family. Damn it, what we have to do now is encourage women to have children and go back to their baby carriages. We're in a tough situation, and we have to do the best we can. It is completely clear who has power now, and only idiots imagine the situation to be otherwise, the rest of us have to work ...
 looks at his watch

and god knows there is a lot that has to be done. I have to watch my time.

Kollontai: Pavel. Please.

Dybenko: Forgive me, but you're making it unbearably difficult for me. I love you, yes, I do. But our situation is completely impossible.

(The waiter arrives with Body's beer. Dybenko chugs it down.)
You and I have to talk this through, that's obvious, but not now, not here. How could you, by the way, pick a place like this? Give me your address. I'll come visit you, if that's all right?

The waiter comes. Dybenko takes the check, pulls out his eyeglasses, sticks them on his nose. He takes out his purse, and counts out what he owes the waiter. Kollontai scribbles a note and gives it to him. She looks at him quietly, as if at a stranger. He strokes her cheek and goes. Kollontai remains sitting, dumb-struck. One of the newspaper readers puts his paper down, buttons up his coat rather too fast, and follows Dybenko. The orchestra plays the sentimental waltz for the seventh time. Indignant voices can be heard from the other side of the café.

The Futurists throng agitatedly out into the street towards the lamppost, shouting things like 'Parasites of Satan!', 'How can we have an art worthy of the name when the critics have turned into chicken-hearted bootlickers!'

Scene 16
The lamppost II

Shouting continues, 'Bootlickers is too nice a word!', 'Lackeys, then!', 'Soulless bureaucrats!', 'Box thinkers!', 'Inept hirelings and parasites, go to hell!' Whistles, pounding on drums,

deafening cacophony, which drowns out the resetting of the stage in the dark.

Vasilij: They can't stop us that easily!

Oscar: We only want quietly to point out a few things, either we're wrong or we're right.

Maria:
Looks around ... The music dies out in the middle of a measure.

Look —
They've chopped the hoods off the stars
and everything is bleeding, a heavenly massacre!

Mayakovsky: Hey, you!
 Sky!
 Take off your hat!
 Here I come!

Vasilij: It's quiet.

Oscar: It's grown completely quiet.

Mayakovsky: The universe is sleeping,
 with its massive ear against its paw
 with its sparkling starry claws ...

The light shows Stalin at his desk.

Scene 17
Kollontai and Stalin II

In a big chair in front of the desk, Stalin is sitting and sleeping, wrapped in a military jacket, with his ear pressed against his hand. The furniture is a bit worn and simple. Tamara, his secretary, an older woman with a pince-nez and dressed in a puritanical dress, brings in Kollontai with a hostile glance at her.

Stalin: (In a good mood) Well dressed, as always.

Kollontai: (Ironic) Your secretary certainly didn't think so.

Stalin: Nowadays people aren't so poorly dressed in Moscow either.

Kollontai: You feel the situation has improved?

Stalin: Of course. Base and superstructure, right? You know your Marx. Nowadays, I think you attract less attention on account of your clothes here than in Oslo.

Kollontai: Is that what your agents have reported?

Stalin: (Broad smile) You don't like them? And I sent over the handsomest young man I could find. He wasn't your type?

Kollontai: (Angry) He wasn't the only one. How are we supposed to work with such a horde of insufferable oafs at

the legation? Intrigues and backstabbing — orders given and countermanded — what are you trying to do here in Moscow? Your secretary's awful clothing, for example, inspires me with little confidence.

Stalin: *(Bursts into laughter)* You're priceless. One never knows where the politician ends and the woman begins.

Kollontai: The eyes of the surveillance people seem to be everywhere here at home.

Stalin: *(Still amused)* There are still enemies of the revolution, Alexandra Mikhailovna.

Kollontai: Wouldn't it be simpler just to listen to what they have to say?

Stalin: Listen? ... you're quite a circus act, you know. Well, speak! I'm listening.

Kollontai: But you have such a hard time trying to figure me out, isn't that right? Oh, two old circus horses like you and me, comrade ...

Stalin: *(Pulls back)* You've been in Norway too long, comrade Kollontai. You haven't been able to keep up with developments at home.

Kollontai: Quite right. I have only noticed, in all modesty, that the Comintern is doing its best to crush the independence of foreign fraternal parties, am I wrong?

Stalin: Tell me. You've been in Moscow for two days. And you have already had contacts with ... opposition elements.

Kollontai: Your surveillance has been able to detect even that. Yes, that's right.

Stalin: And what did you have to tell them then?

Kollontai: Me ...? Nothing.

Stalin: Very wise. You're a smart woman, Alexandra Mikhailovna, I have always felt that, even when others felt differently.

Kollontai: 'Opposition elements'. How times change! The last time I was home, those people who were those most loyal to the party, the most devoted cadres ... and when we made the revolution, in 1917 ...

Stalin: *(Breaks in)* Do you know what an idealist is? It's a person who, the next thing you know, becomes a traitor ... I have something to say to you.

Kollontai: And I have something to say to you. I've been fine in Norway, but now I want to come home to Moscow.

Stalin: Oh ... What is it that draws you here?

Kollontai: *(Meets his glance)* I don't think that concerns you.

Stalin: That sailor again?
(with irony and some malice) Dybenko ... Dybenko ... he's all right, but ... You have never really understood what is best for you. Now I'm going to say what I have to say. You have done remarkable work in Norway, now we're moving you to Mexico City.

Kollontai: No! I want to come home. I have things to do here.

Stalin: There is no place here at home for your splendid talents, you are needed in Mexico.

Kollontai: And what if I refuse?

Stalin: My powers are limited, comrade Kollontai. There are so many in the party who are suspicious of you. *I*, on the other hand, value your positive side.

Kollontai: So I should be grateful too? But hasn't Trotsky been eliminated, hasn't the opposition been brought under control, don't you have all the power you need, Josef Vissarionovich, why do you need to do this to me? The opposition, comrade Stalin ...

Stalin: *(Interrupting)* There is no opposition. There is just a bunch of idiots who are sitting waiting for a revolution in Western Europe, but there won't be any revolution in Western Europe, Alexandra Mikhailovna Kollontai, you must agree with me!

Kollontai: Not now, comrade Stalin. But it will come.

Stalin: *(Furious)* Not in our lifetime! We are alone, we have to rebuild this entire huge country with our own forces and we have to do it fast! The farm fields will be managed like factories. What do you know about peasants, comrade Kollontai, nothing. But I think of nothing else. This country is an ocean, we have to tame the water masses, build canal systems and breakwaters, otherwise we'll drown. What benefit do we get from theories of a world revolution — history has gone along a different path. We have to adjust, but we will build our factory even so, whatever it may cost us, even if we have to build walls around it. What is needed now, Alexandra Mikhailovna, is faith in the Soviet Union, now more than ever. That requires a great leap, and unfortunately we can't be as sensitive as you'd like, and I am sorry but you can't be here, you must be in Mexico!

Kollontai: *(After a pause)* And my legation secretary, Marcel Body?

Stalin: He's also done remarkable work, we're moving him to Tokyo.

Kollontai: That's cruel, Josef Vissarionovich.

Stalin: Not at all — all done purely out of consideration for you. And before you leave for Mexico, I want you to put your signature to this.

Kollontai: (Reads quickly) But this represents a denial of the opposition!

Stalin: A mere formality, comrade Kollontai.

(He presses a button on his desk)

Kollontai: (Blurts out) But it's so badly written! So awkwardly phrased!

Stalin: You're a writer, I know, and our office workers are poorly educated. Rewrite it, make it more elegant, then sign it.

Tamara, the secretary, comes in.

Tamara will show you out, so you don't get lost in the corridors.

He sits down in the big chair again and wraps himself in his coat.

And don't admit anyone, Tamara, until I ring. We have a plenary meeting again tonight.

Blackout on the floor.

Scene 18
Police visit to the Futurists

Violent scene with the Futurists. Up in the box one can see the Theatre Director. Exchanges with the secret police. The Theatre Director's accounts have been pulled out and a few policemen are searching the place, others are involved in discussions.

Down-stage, in the dark, the Futurists have gathered and are making a racket with their drums and whistles.

When the stage is ready for the next scene, the lights go up on the Futurists.

Theatre Director: *(To the police)* I can assure you, we have no weapons. We stopped doing the scene with the pistol a long, long time ago.

(Calls down to the Futurists.) You don't have any weapons, do you?

(Silence. No one answers.)

Mayakovsky: *(By lamppost B)*
The earth dances around the sun.
Like Salome round John the Baptist's head
year after year.
And when she's finished dancing
I too will be gone.
(He turns to the two policemen standing beside him)
Millions of drops of blood will line the way
to my father's house.

Blackout

Scene 19
At Body's place in Moscow

A simple sofa. Dybenko is sitting in it. Kollontai is agitated, walking back and forth. Someone is sitting reading a newspaper, screened from the audience, like in the Smithy Café.

Kollontai: No, no, no. I won't sign!

Dybenko: *(With a hint of resignation)* And what do you propose to do instead, my dearest?

Kollontai: I told you already! I want to stay here! I want to live with you, Pavel!
 Pushes closer.

Dybenko: Shura. They don't trust you.

Kollontai: Then I'll join the opposition. This can't go on!
 The newspaper reader lowers his paper. It's Body.

Body: That won't work. You're being watched too carefully. Any contact you have with the opposition and ...
 He runs his hand across his throat.

Kollontai: I can't go to Mexico, it's too far away ... do you want me to go, Pavel? Or you, Marcel?
 They don't answer.
You shouldn't try to seek revenge on people you like, Pavel.

Dybenko: Revenge? You think I'm trying to get revenge on you?

Kollontai: What am I supposed to think? ... And why are you two suddenly in such agreement?

Dybenko: You're mixing up two things. You've never been able to keep love and politics separate.

(Glancing at Body) What do you say?

Kollontai: Never been able to? The point is I don't want to separate love from politics. Haven't relations changed between men and women? If not, then the revolution has failed. Let's figure this out. Why am I being sent to Mexico?

Dybenko: Don't play the innocent, Shura.

Kollontai: What is it that makes me so dangerous — for you, for example?

Dybenko: In a few years you'll come back, Shura, then maybe your ideas will have a better chance. Then we can live together. Forgive me, but I have to leave now.
Kollontai: No! Don't go! *(pleading)* Pavel!
 (He embraces her, kisses her hard, takes his cap.
 Kollontai sinks down onto the sofa, weeping.
 He stops by the door, meets Body's glance.)

Dybenko: She'll look at this differently in a few years, don't you think?

Body: Yes, and so will you.
 Dybenko leaves.

Kollontai: *(In anger)* I'm going to write down every word Stalin said, that hypocrite. 'You've done a remarkable job in Norway. Now we're sending you to Mexico' ... How did he amass all that power?

Body: *(With energy)* Yes, do that. Write, Alexandra, write everything down. You were involved from the beginning. Gather material, write, analyse. There you can be useful!

Kollontai: *(Turning her head and looking at him)* Do you think so?

Body: If I thought the opposition had a chance — but it doesn't look that way, not in this decade. But in ten years, maybe even in five ... then we'll be back here again, then it will be possible to work for genuine socialism, then people will know what's going on, then there will be many more of us ... in the meantime you must analyse, write. That's important!

Kollontai: So I should go to Mexico, then?

Body: I've read about Mexico. Nice climate. It's warm.

Kollontai: So I should sign the paper, that's what you think? No, I'll never do that, that would be my death. Why do you want me to go there, Marcel?

Body: I could never say anything mean to you, Alexandra, but you have no choice.

Kollontai: To sign that paper would be cowardly. I don't want to be a coward.

Body: But dear god, you have to be a bit realistic! Times have changed, that's the *reality*, Alexandra.

445

Kollontai: (Says nothing, then passionately) I promise and swear, with heaven and you as my witness, Marcel, that starting today I will gather, try to understand, from today forward I will write day and night, so that those who follow us can learn from our mistakes and build on the victories we have won, for the sake of the Soviet Union and for the sake of socialism in the whole world. I promise to be untiring, never to hesitate in the quest for the truth, never give up!

Body: That's right, Alexandra.

Kollontai: Okay, Mexico it is.
 Sees the paper that Body is trying to give her.
 No, no! I can never sign that!

Body: But you have no choice.

 Kollontai: (Takes the paper). There will be a future for those who have the strength to wait. *(She signs)*
 Kollontai looks at Body, then goes out. Body turns up the collar on his coat and goes out in the other direction. No blackout.

Scene 20
Mayakovsky dies

 Up in the box. A few musicians. A couple of workers. Circus. Feeble depressing light. At centre stage, Mayakovsky, secret police man, armed militia man, Theatre Director, Maria, Vasilij, Oscar.

The workers are carrying the furniture out. A ladder is set up to take down the drapes.

Mayakovsky with a papiros (cigarette) in his mouth, his hands in his pockets.

Maria: And what is the charge against him?

Secret police man: *(Armed militia man next to him)* Absence of realism in your so-called theatre, Mr Mayakovsky. Anti-Soviet pranks. Nothing for the masses.

Vasilij: Absence of realism? And play, poetry — what's to become of them?

Theatre Director: *(Whining, wringing his white gloves)* You said yourself the other day that no one laughed during your play, Volodya ... people didn't even applaud!

Maria: *(Blurts out)* Because they didn't dare! There were all kinds of security people sitting in the theatre, with notepads and cameras! — That's how they treat poetry these days!

Theatre Director: Maria, Maria ... theatre and poetry must, after all, abide by the laws of our socialist republic ... meaning that they must reflect *life*, don't you agree?

Secret police man: *(In a dry metallic voice)* Be that as it may, it's over now, Mr Mayakovsky. Give us your pistol. We know you still have it.

Maria: *(Aside, to the audience)* Wait for us, Future! Don't leave us so far behind. Our task is to change trains where the past meets the future!

Oscar: *(To the audience)* Wait for us. We're on our way, giant steps across the sky!

Secret police man: *(Dry, metallic)* Your pistol!

Mayakovsky: *(Takes out his toy pistol, looks at it)* A toy ... oh well.
 (Fumbling for his words, then appearing more sure of himself, speaks to the audience)
As they say, the incident is closed.
 The boat of love has come to grief, wrecked on everyday life.
 But I know the power of words, I've heard their warning bells.
 They sometimes get discarded before they're printed or published,
 But with their saddle belts tightened they gallop away ...
thunder across the centuries ...

Secret police man: *(Stretching out his hand)* Hand it over.

Mayakovsky (moves but stops) Well, let's return it to its rightful owner ...
 He goes toward the Theatre Director, makes a move to give him the pistol, then suddenly turns it on himself. A shot. He falls.

Theatre Director: (After a short pause, after the shock) This never-ending circus!

Secret police man: (After another short pause, after the shock) Is he dead?
 (Dries his fingers on his handkerchief.)
Damned unpleasant.

Maria: (Falls on her knees by Mayakovsky's dead body) Volodya ...

Oscar: (Bewildered) Intermission? ... Intermission!

 Max takes a sign marked 'Intermission' and scampers around the group and shows it to the audience while a couple of the musicians sound a flourish. Blackout.

PART TWO

Scene 21
The circus is dismantled

 Up in the box workers are taking down the red bunting. Similarly, workers are sitting on ladders taking down the drapery. Others are carrying away circus props on stretchers. The Theatre Director helps them. The Futurists, ill-clad, can be seen on stage too. They move in front of the audience. Vasilij draws a paper from his pocket, a poem by Mayakovski. Looks at it and shows the others. They nod and then they recite by heart.

Vasilij: Honoured comrades
 who will live after us!
 When you poke around
 in the dried crap of today
 you may come across
 those who were us.

Maria: We were latrine cleaners
 among the peddlers
 mobilised by the revolution.

Vasilij: We were drawn to the red banner
 In the myriad days of hunger
 and insane toil.

Maria: We opened
 all the volumes of Marx
 as one would open the
 shutters at home.

Oscar: But even without reading
 we knew right away
 we knew which side we were on
 and who were our friends.

Maria: (Takes the paper)
 He who is enemy to
 the working class
 has been our enemy
 for hundreds of years.

Vasilij: Illustrious geniuses
 are dragged along
 in dreary processions of corpses.

Maria: But our comrade and his poems
 will break a path
 through the mountain masses of the
 centuries.

Vasilij: He'll come to you
 above the heads of poets and govern-
 ments.
 And when he in a brighter future
 strides before
 that Central Control Commission
 he will raise high
 above the heads
 of all the poet-scribblers

Maria: His collected works
 all faithful to the party
 his own style of Bolshevik party card.

(Short pause.)

Oscar: *(At a loss)* So, what do we do now? Were do we go?

Theatre Director: *(Approaching)* Come to me, dear friends.
There still is the theatre, even though our poet — unfor-
tunately — went and shot himself ...

Vasilij: ... and we can look forward to unimaginable progress in genuine Soviet art, socialist realism ... right ... ?

Theatre Director: Good god, Vasilij, realism ... wasn't that what our poet was seeking, even he? Realism, reality itself ... yes, that's it! But it happened to run counter to all of your pranks, although we tried not to see that. Now we'll just set off on a new course, full steam ahead!

Vasilij: Towards what? Insipidness, propaganda, don't you think we know where that leads?

Theatre Director: *(Scared, a bit offhand)* We can fix that, we can fix that. Provided certain details ... your clowning, for example ... your experiments with form ... the time machine, your card tricks ... Haven't you yourself rather lost faith in them, after all. Well? That stuff just doesn't work anymore. *(Silence)* Okay then.
 Goes back to the workers, who have continued to work.

Vasilij: *(Buries his head in his hands, tired, desperate)* I don't know what we should do either, Oscar.

Oscar: Maybe there's no room left in the world for crazy people like us ...?

Maria: *(Decisive, desperate)* So, let's pick a new year!
 Pulls a card out of Vasilij's jacket pocket, from a card deck of normal size.
1937 ... And she'll be with us, I don't want to let her go, we need her!

Vasilij: Why? *(Silence)* Why, Maria?

Oscar: *(In a friendly tone)* Is this year better than the other ones, do you think?

Maria: I don't know ... but now we're here! Hello 1937!
Blackout around them. They're standing close together in a cone of light and look around.

Vasilij: It seems so dark in the world.

Oscar: People are very fearful.

Maria: They say there will be war ... listen to all the news bulletins ... New York, Paris, Tokyo, you tell me where you want to go ... Sydney, Rio de Janeiro, Mexico City, Amsterdam, Berlin, Rome, Stockholm ...
 Max makes energetic signs in the air.

Oscar: *(Interpreting)*: Light in the darkness ... *(New signs)*. Pretty girls? ... No darkness ... light, light, light ...

Maria: *(Firmly, taking a decision, to the audience, holds up the card)* Fine! Dear members of the audience ... Stockholm, 1937!

 Light goes out.

Scene 22
The legation in Stockholm

*Light on a table with a radio. In the background a portrait
of Lenin. A bouquet of roses. Ivanov, a young man, is leafing
through the papers, searching quickly as if for something in
particular. A drawer has been drawn out.*

Radio voice: (1930s-style voice) England's former prime-min-
ister, Ramsey MacDonald, has died at seventy-one years
of age. In Moscow, where the twentieth anniversary of
the revolution was recently celebrated with great cere-
mony, the purge trials are continuing. They now involve
high-ranking members of the military. Arrests are also
being directed at members of the diplomatic corps.
*Ivanov thinks he hears steps. He returns the documents
quickly to the open drawer, shuts it and disappears into the
darkness.*

Radio voice: The heads of the Russian delegations stationed
in Germany, Poland, Turkey and Finland have been called
home, accused of ties to Trotskyite and German agents.
*(A door opens and Kollontai, followed by Nadya, comes into
the lit area from another direction. They are carrying papers
in their hands, as if they had been interrupted during a dic-
tation, and listen to the radio broadcast.)*

Sources in Stockholm have reported today that even
the Soviet envoy, Madame Kollontai, has been called to
Moscow. It has not been possible to verify that informa-
tion.

The English newspaper the *Daily Mirror* reports that in November alone 496 people were condemned to death in the Soviet Union

(Kollontai shows her impatience, Nadya clicks off the radio.) accused of Trotskyism ... *(The radio fades out.)*

Kollontai: Well, that's that. Is it still snowing?

Nadya: Yes ... do you want to continue with this? *(gestures with the papers).*

Kollontai: No, I'm too tired to go on right now.
(She gives Nadya the papers she has in her hand.) Do you have the key?

Nadya: Yes, of course.
(She takes out a chain, looks quickly around somewhat perplexed.)
The evening newspapers are on the table.
(Goes towards the door.)

Kollontai: Are they writing about us too?

Nadya: Same stuff. But it isn't true, for god's sake! Where do those hacks get all that stuff?

Kollontai: Throw the newspapers away. Look, the roses are beginning to come out.

Nadya: *(Throws the papers into the wastebasket.)* We'll chuck all this crap.

(The clock strikes five.)
Höglund, the newspaper editor, should be coming soon, I believe.

Kollontai: (Surprised) Zäta Höglund! It's certainly been several years since last I saw him.

Nadya: He has probably felt a bit too distinguished to come by, but this morning he called and seemed very agitated.

Kollontai: Ask him to come in if he's sitting outside waiting.
(Nadya goes out. Kollontai goes over to the wastebasket and lifts up one of the evening papers. Höglund comes in. She drops the paper.)

Höglund: (Rushes in, still in his overcoat and hat. Doesn't even shake hands.)
Is it true that you've been called home?[4]

Kollontai: But why so agitated? Sit down, dear friend.
Höglund: The evening papers are reporting that you've been summoned to Moscow. Is that true?
(She helps him take off his coat.)

Kollontai: If that's what it says in the papers, it must be true, they never lie, do they, Mr Editor?

Höglund: It's hard to know what is true. Soon we won't even believe what we ourselves are saying.

4 Höglund and Kollontai use the formal form of address, despite being acquaintances for a long time.

Kollontai: *(Laughing)* Ever the true dialectician! It's so nice to see you. *(Gives him a pat.)* It's been such a long time. And we who have known each other for such a long time! Do you remember New Year's Eve in the Winter Palace in 1918? You were playing chess ...

Höglund: With Pavel Dybenko! He won, that devil. Lucky in love, lucky in games. Is he still alive?

Kollontai: *(Doesn't answer)* With barely a few grains of truth you've launched quite a campaign in your paper, *Socialdemokraterna*. Would you like a drink? *(He shakes his head.)* Your big crusade against the Soviet Union, Mr Editor, has indeed been quite spectacular.

Höglund: Crusade? We have to tell the story as it is! When the Soviet Union has become a complete madhouse of terror ... it breaks my heart as an old communist, you know, to have to write such things.

Kollontai: Communist? But, you are a Social Democrat, Höglund.

Höglund: It's no longer possible to be a communist, but one tries to be decent. How long are these purges going to go on, when will the awful show trials end? ... I think I'd better have a whiskey after all.

Kollontai: *(Pours his whiskey)* I thought of you the other day ... I was thinking of sending you this. *(Points at a book.)*

Höglund: (Looks at the book) The Moscow Trials ... yuck! That's the fabrication Moscow has put out to try to pull the wool over the eyes of international public opinion. Thank god public opinion isn't so easily fooled.

Kollontai: (Picks up the book, quietly) The trials have been held in the presence of international jurists, who have confirmed that the accused have confessed of their own free will ... without any coercion.

Höglund: (Astonished) Tell me you don't believe that! *(Strikes his head with the palm of his hand.)* But it's completely incomprehensible! Some of your own comrades have been declared to be Trotskyite agents and spies for Germany. That's crazy! When I read that you too had been summoned to Moscow, I decided I had to come here and tell you that I am your friend and I want to help you in any way I can!

Kollontai: I am very touched by what you say, Höglund.

Höglund: What you mean is that I'm an idiot for thinking that my efforts might have some effect. If all else fails, one can at least show some measure of humanity.
(Kollontai is silent. Höglund looks at her. Shakes his head.)
Has it gone so far that you and I can't speak sincerely with each other any more?

Kollontai: (Shifting gears) How does the world look to you, comrade Höglund? What are the Western powers doing? Well, gradually they're falling for Hitler!

Höglund: So far, that's right.

Kollontai: Only the Soviet Union is steadfast against Nazism! If now the Western powers give in to Hitler ...

Höglund: Heaven forbid!

Kollontai: Or even worse, if they were to join Hitler ...

Höglund: Never! Never!

Kollontai: Then the Soviet Union would again be left with the whole world against it!

Höglund: So you defend Stalin? The terror? The purges? Incredible! Do you know that even actors are being deported? The wonderful Russian theatre. Destroyed ... Has the world gone mad? *(Restrains himself.)* I didn't come here to quarrel with you, only to ask if I could be of any help, the little I can do.

Kollontai: *(Softly)* Thanks. I can manage.

Höglund: If you change your mind, you know how to get hold of me.

Kollontai: *(Very softly)* Thanks. I know.
 (Höglund goes out. Kollontai is alone.)
My god!
 (Ivanov approaches the table.)
Ivanov! What do you want? You scared me actually — What's the matter?

Ivanov: I'm going back to Moscow tomorrow.

Kollontai: I know. I hope your stay in Stockholm has been productive.
 (Ivanov lays a little key on the table.)
What's that? The key to the locked box in my room ...

Ivanov: Yes ... Now you don't have go looking for it.

Kollontai: *(After short pause)* I see ... It would have simpler for you if you had just asked me for it.

Ivanov: I'm a professional, Madame Kollontai.

Kollontai: I certainly hope the secret police doesn't send rank amateurs here! I've been a fool. I even was kind enough to send a note of commendation about you to Moscow. That's what I get in return.

Ivanov: Do you know this man?
 (She doesn't answer, just looks at him.)
What's his name?

Kollontai: Pavel Dybenko. Is that my photograph?

Ivanov: All right, that checks. Did you live with him?

Kollontai: A long time ago.

Ivanov: He's been arrested.

Kollontai: Arrested?

Ivanov: *(Nods)* He's had dealings with Trotskyite circles. Or with Germans. Something of that sort.

Kollontai: Impossible!

Ivanov: Nothing is impossible, madame Kollontai. I just thought you might want to know.

Kollontai: That was kind of you. Thank you.

Ivanov: *(Lifts his finger to his mouth)* A little favour in return for your kindness. Don't say anything. Goodbye.
 (He disappears into the darkness.)

Kollontai: *(Whimpering)* Pavel, Pavel! Can you hear me?
 (Nadya opens the door.)

Nadya: Alexandra, what's the matter? Why are you sitting in the dark?
 (She lights a lamp.)
Dinner is ready. Shall we go to the movies afterwards? Do you feel like it?
 (Kollontai shakes her head.)
But what is the matter with you? I hope you're not coming down with something.

Kollontai: It's true, Nadya, what they're saying in the papers is true. He has summoned me to Moscow.

Nadya: No! ... Well then I'm going with you.

Kollontai: *(Going out)* No!

Scene 23
The makeup room I

> *(Maria tries on a hat in front of a mirror, dissatisfied. Big cushion tied to her belly. Several female extras, also dressed as pregnant women, are walking out of the makeup room.*
> *Oscar and Max the mute, dressed as tractor-driver farmers and workers, are dancing together the old tap-dance ballet steps as a sign of protest. Vasilij comes in from the stage, dressed as a 'Hero of the Soviet Union', and starts to remove his makeup.)*

Vasilij: No, no, no ... This is all going to hell.

Maria: What's going to hell? The audience?
> *(Looks out at the house.)*
No, they're still sitting there.

Vasilij: It's just that I'm so damn tired of playing tractors.
> *(Takes off his wig.)*
> *(Max and Oscar sit down by the deck of cards that are lying face-up on a table.)*
Your entrance is in ten minutes, Maria.

Maria: Dear audience, if you are tired of tractors, Heroes of the Soviet Union and shock brigades, ... go home. Unfortunately, we can't. We work here.

(Vasilij groans.)

Don't you think tractors and shock brigades are good, Vasilij?

Vasilij: (With feeling) Yes!! I actually *do* think that, Maria. It's just that it's so ... damned weak. We're acting out such pathetic, damned petit-bourgeois slush and we know it!!

Oscar: (Pointing with his thumb back stage) Ssshh! The Theatre Director ...!

Oscar: (Playing) Wow! 21!
(Holds up a card.) 1921
(With a beaming smile Max throws in a few cards.)

Oscar: (Reading cards) 1926, 27, 28

Vasilij: And then there's their damned scenery. Have you seen what they're setting up in there? It's enough to make your hair stand on end. The most pathetic damned photographic realism. It's a wonder they didn't hang some x-ray pictures among their *trees (each word gets a kick)* and *bushes* and *leaves* and *clouds.* It's so damned beyond any help ... you end up saying nothing when you try to say *everything* instead of leaving something to silence and the audience.

Oscar: (Shouting) 1952!

Vasilij: (Sweeping the cards down on to the floor) Cut that stupid crap out.

Maria: *(Throwing herself down, furious)* No, I want them.

Vasilij: *(Tearing the cards from her)* Why? It's just tricks, lies and idiocy. Give me them and I'll chuck them into the trash.
 (Maria bursts into tears. Oscar goes down on his knees and hugs her. Max gathers up the cards.)
Stop consoling her. It doesn't work anymore, your time machine, you heard what he said, the Theatre Director. You idiots ...
 (Max gestures right in front of Vasilij.)
What's he saying?

Oscar: He says you're the one who's an idiot, if you've stopped listening to what the cards are saying.

Vasilij: Those *damned little cards.*

Oscar: Yeah. Just because they're small. They've gotten so small just so we could see them. They've gotten so small because the world has gotten so big. Don't you understand, you idiot, have you forgotten everything that poetry means for the world?
 (They stand opposite each other like two Japanese wrestlers. Pause).

Vasilij: *(In a whisper)* Fine. You three are probably all crazy. But that is only as it should be. Cast off!
(Shouting) Come on ahead 1952, a year when we're probably all dead, all of us, but why should we live when so many die without meaning? When socialist realism with all its bushes and clouds lives. Cast off!

(All four of them begin a desperate dance in the fine old bio-mechanical style while Oscar plays his harmonica.

Max is particularly good at acrobatic flips and ends up on their shoulders.)

All: Hey!
 (Blackout)

Scene 24
Gorky Park

(A strong, quick, violent march for a large wind orchestra, which picks up Oscar's harmonica music.

Gorky Park gradually appears magically.

First, a bridge over the spot where Alyosha in his high-school student cap rushes in with a bunch of roses, looking for his grandmother. Shortly after him a pregnant woman comes in with her baby carriage.

Alyosha disappears from the bridge.

Gorky Park emerges. Extreme realism. A huge background with clouds projected on to it.

Against that background in the distance several baby carriages with mothers reading books and newspapers in the spring sun.

At centre stage some older men playing chess. At stage right, Kollontai, she is eighty years old and sits in a wheelchair reading poetry by Mayakovski.

Alyosha rushes by from stage left, moving up-stage, sees her and approaches, falls to his knees. The orchestra fades out.)

Kollontai: *(Kissing Alyosha)* Alyosha, my beloved child!
 (He lays the roses in her lap.)
My, how beautiful they are ... must have been expensive.

Alyosha: It was nothing, I bought them because you are so
alone, grandmother ... and because I love you very much
and because you love flowers so much ...

Kollontai: I do. Flowers and trees ... trees can be better
than people sometimes, when you feel sad they can con-
sole you ...

Alyosha: What are you sitting and reading? *(Reads from the
book)*.
'But I know the power of words ... But with their saddle
belts tightened they gallop away ... thunder across the
centuries ...' Yuck, what kind of crap is that?

Kollontai: A poet. Mayakovsky. He's dead now. It's not crap,
Alyosha.

Alyosha: Poetry is just crap, dear Grandmother, except for
useful poetry, of course.
 *(He stands up and with a look as hard as steel intensely re-
 cites.)*

In the front rank was Ivanov with arms of steel,
the leader of our shock brigade,
Joyfully the woman cried: my husband,
Again you've done what is right!

*(The old men at the chessboards cheer Alyosha with exag-
gerated courtesy.)*

Kollontai: You recite *well*, Alyosha!

Alyosha: We're going to declaim those verses at the end-of-
term ceremony, I'll be standing in the middle.

Kollontai: But does that woman do nothing besides admire
her husband?

Alyosha: She is the wife of a member of a shock brigade,
Grandmother, there is nothing finer than that, except for
being a member of the brigade, of course.

Kollontai: Are you doing well in school?

Alyosha: I'm the top student in my class. But!
I have a problem ...

Kollontai: *(Laughing, passes him a bit of money)* Today again?
What do you need money for then? Your chemistry ex-
periments?

Alyosha: How did you guess? Yes, Grandmother, for my
chemistry experiments, but of a special kind. Grand-
mother, Grandmother, it has happened! I've met a girl,
I'm in love!

Kollontai: *(Surprised, ironically)* Well, well ... Does that sort
of chemistry cost money nowadays?

Alyosha: It feels as if ... an express train were rushing through my chest, as if my belly was full of rotary presses ... as if factory whistles were sounding in my ears ... it's insane! Grandmother, I have decided!

Kollontai: Decided, on what?

Alyosha: To invite her to the movies! We have a date to meet here. But Grandmother, I don't know anything about girls, what they like, chocolate, flowers ... what kind of films they like, should it be a war movie or a love story ... can a girl be interested in model planes, tell me frankly, Grandmother ...!

Kollontai: How many girls are you going to the movies with, Alyosha?

Alyosha: One! Her name is Olga, Grandmother, Olga!

Kollontai: Well then, ask Olga which film she'd like to see.

Alyosha: No! I thought of that, you know, but then I might seem indecisive, without any will of my own. Grandmother, have you ever been in love?

Kollontai: Sure ... it's happened.
 (Olga appears in the distance.)

Alyosha: A long, long time ago, of course, since you're so ancient.

Kollontai: I hope you get to be as ancient as me some time.

Alyosha: There she is! *(Whistles, waves)* Now I know what I'll do. First a love-story film, then a walk here among the trees. *(Olga comes close to them.)*

Kollontai: But maybe *she* doesn't like trees, you should ask her.

Alyosha: *(Without looking at Olga)* She likes trees. She's rather like you.

Kollontai: Me? Ancient?

Alyosha: Your eyes ... in your eyes you aren't old at all, Grandmother. Stay here with Grandmother for now, Olga, while I go off and buy some tickets for the movie. Don't be scared, she won't eat you. *(Goes out.)*

Kollontai: *(Friendly)* Hello.

Olga: *(Shyly)* Hello.

Kollontai: And your name is Olga.

Olga: *(Curtsies quickly)* Yes.

Kollontai: Funny ... I knew a young girl once whose name was Olga too. You remind me a bit of her.

Olga: Really.

Kollontai: She would curtsy, like you ... Do young girls curtsy these days?

Olga: Yes. Well, no, maybe not. Only when ...

Kollontai: Only when you meet some really ancient person like me, of course. *(Olga curtsies a bit shyly.)* Well, well. Hm ... *(a bit brusquely)* Well, what do you think of love?

Olga: I think it is so difficult ...

Kollontai: *(Gestures to her to come closer)* Come closer so we can talk. *(Olga kneels beside her.)* So how is it with you two, you and Alyosha? My god, he is so young!

Olga: *(Serious, like a grown-up)* Yes, isn't that true, he is so young. Very young for his age. Sometimes I get worried and wonder how it will turn out ... don't be mistaken, I am a communist, a leader in the Komsomol, all of that ... I love our motherland ... what I mean is that it's hard to see that there is room for me in all of this ... it's as if I have to shrink myself for it all to happen right ... please, please tell me how I can manage to have both love and freedom ... *you* must know how.

Kollontai: Have you read my books ...?

Olga: No! Is it allowed?

Kollontai: *(Hesitating)* One is not supposed to, that's true.

Olga: Oh, tell me a little about them ... what do they say?

Kollontai: (Looks at her, moved, overwhelmed) What those books say is all ... a misunderstanding ... just dreams ... you shouldn't read them! *(Pause)* And now you're going to the movies with Alyosha?

Olga: Yes ... Although it was really to meet *you* that I came here ... but I like Alyosha a lot, I do.

Kollonta: (Hands Olga the Mayakovsky book) Here. This is for you.

Olga: Is this your book? *(She reads, a bit disappointed.)* Vladimir Mayakovsky ... I recognise that name. He apparently took his own life, why did he do that? Tell me — can one free the person one loves from his shackles, is that possible?

Kollontai: I don't know ... Maybe. But you'd better go now. I'm getting a little tired, Olga dear.
 (Olga looks at her with concern, leaves. Kollontai remains alone)
 (Blackout)

Scene 25
Makeup room II
Moscow, 1938

 (Maria and Oscar are saying goodbye to Vasilij, who has been picked up for anti-Soviet activities and is now going to be deported. He has his pack and a bundle with him, looks

like a desolate Charlie Chaplin. Two soldiers are waiting at some distance.)

Maria: If one can free the person one loves from his shackles, Vasilij …

Vasilij: … then you and Oscar would free me, I know that, Maria. *(Flaps his arms)*
God in heaven, what a dumb idea to send a stiff old actor to a labour camp in Vorkuta … what is there for me to do out there? And what harm would I do here?

Oscar: *(With feigned seriousness)* You are Jewish, you know, Vasilij.

Vasilij: *(Bows with feigned ceremony)* You are absolutely right, Oscar.

Oscar: And therefore an unreliable element, Vasilij.

Vasilij: Your ability to draw the necessary conclusion is without parallel, Oscar.

Oscar: Just like our comrade government, Vasilij.

Vasilij: Absolutely right, Oscar.

 (Short pause)

Maria: *(Struggling against her tears)* We're going to miss you terribly.

Vasilij: *(Struggling against his tears)* And I'll miss you too.

Maria: You can't go looking like that ... you look just like Charlie Chaplin.

Vasilij: *(Smiling)* He was Jewish too. Also an unreliable element.

Oscar: *(Struggling to retain his tears)* How are we going to manage without you, Vasilij?

Vasilij: Goodbye, Oscar. No one is irreplaceable. *(Hugs Oscar, gives him a kiss , then turns to Max, who is making signs in the air. Vasilij looks at him but is unable to understand.)* Right, Max. Exactly right. *(They hug each other, then Vasilij embraces and kisses Maria.)* Goodbye, Mariyushka. *(Vasilij gathers his pack and leaves. The two soldiers take him away. They follow him with their eyes.)*

Oscar: *(Holding up the deck of cards, shouts)* Vasilij, your deck of cards!
 (Vasilij shakes his head. Oscar tries to give the cards to Maria, she refuses to take them. Max does a little pantomime to cheer her up. Oscar picks up the routine and holds up a card):
 Back to 1938, I'm afraid. Could be better, could be worse, but ...Well, let's set off! Come on, let's go! (Laughs. Singing.) 'Tis the final conflict, let each stand in his place ... '[5]
 (Max, the mute, gesticulates energetically that he is singing too.)

5 The sentence is from *the Internationale*.

(Maria doesn't let herself be cheered up. She hides her face in her shawl and weeps. Max and Oscar stand bewildered.)

(Blackout)

Scene 26
The Kremlin
Kollontai's final meeting with Stalin

(The stage lights up. A classical scene of enormous proportions, white, dazzling. Frozen classical style and, like all Russian architecture, gigantic. Furthest back, up-stage, in all of this magnificent socialist realism one can catch a glimpse of Stalin's huge desk. An enormous classical column reaches soaring into space. On the wall, so dark that one can't see the pictures distinctly, a portrait of a tsar with its customary crown and two-headed eagle on the frame.

On the balcony on the opposite side of the stage is an over-sized copy of the Venus de Milo. *A focal point on stage. Her arms, as is well known, were cut off, the goddess of love.*

Down stage, in a magnificent armchair, Kollontai is sitting, dressed in fur. Not far away, Beria is sitting in a sofa, in an impeccable dark suit.

Stalin is standing by his desk at some distance up-stage. Only after some time he slowly heads down-stage. A short pause.)

Beria: (After Kollontai has turned and looked for Stalin.) And what are the Swedish papers saying about us?

Kollontai: They commend the economic and social progress in our country.

Beria: And if there is war? ... If there is a war between Hitler and the Western powers, what will the Swedish government do?

Kollontai: Sweden will remain neutral, I think.

Beria: And if there is a war between us and Hitler? Will the Swedes remain neutral then?

Kollontai: I think so.

Beria: *(After a short pause)* What else do the Swedes say about us?

Kollontai: They are pleased that the airline connection between Stockholm and Moscow has been set up.

Beria: Yes ...! That was well done on your part. Anything else?

Kollontai: Many people in Sweden are disturbed by the trials and death sentences in our country.

Beria: And how do you respond when people in Stockholm bring up the trials against the criminal Trotskyite centre? *(Kollontai doesn't answer.)* Why don't you answer?

Kollontai: *(Angry, proud, a bit snooty)* Because we have not yet been introduced. I would appreciate being introduced to a person who seems to know so much about me, but whom I have not yet had the honour of meeting.

Stalin: *(Just arriving down-stage with a folder in his hand)* Oh, now I recognise you, comrade Kollontai. Same old circus horse, tossing your head at us simple proletarians. Forgive me. I thought you knew Lavrentij Beria, our new chief of secret police.

(Kollontai bows very politely towards Beria.)

Kollontai: Pleased to meet you. Our security network seems to be very effective, comrade Beria.

Beria: It will become more effective.

(He bows back towards her.)

Kollontai: *(To Stalin, with her head held high)* I have wondered in recent years, comrade Stalin, how can it be that there are so many criminals in the Soviet Union? Thousands of people have been arrested and executed. Can that be right, I ask myself? Isn't that playing into the hands of the Nazis? I also ask myself whether some innocent people sometimes get included among the guilty.

(It grows very quiet. Stalin doesn't seem to have paid much attention to the question, he is standing a bit off by himself, poking around in the folder.)

Beria: If that worries you so much, comrade Kollontai, may I be allowed to repeat my question. What do you answer when people in Stockholm want to discuss the trials against the criminal Trotskyite centre with you?

Kollontai: *(After a short pause, without taking her eyes off Stalin)* Aren't you well informed about that through the

476

security reports from the legation in Stockholm, comrade Beria?

Stalin: *(Short pause. He slowly moves forward over to her.)* You have gotten older, Alexandra Mikhailovna ... but you are still beautiful. You have always been a very attractive woman. But I have never been able to figure you out. Are you still concerned about that sailor? Pavel Dybenko?

Kollontai: Yes. *(They look at each other.)*
(slowly, carefully) Pavel Dybenko — among others. But with regard to him, I know, just as surely as I am sitting here, that he is innocent. That he would have conspired against our Soviet government is just a fantasy, a myth, a fable.

Beria: Pavel Dybenko has participated in a Trotskyite plot, along with ranking members of the officer corps in the army, aimed at overthrowing the Soviet government.

Stalin: And you think, Alexandra Mikhailovna, that you are here to free your lover from his shackles. That is like a beautiful fairy tale from feudal times, don't you think ...?

Kollontai: That is possible.

Stalin: It is also a bit ridiculous, I think you'll agree.

Kollontai: I don't find it hard to keep from laughing, comrade Stalin.
 (Looks around) A fairy tale from feudal times ... a well chosen analogy.

Stalin: *(Laughing)* Now you're being cheeky.
(Serious) You think that time has stood still here?

Kollontai: *(Heatedly)* I never said that.

Stalin: But that is what you think, isn't it? You have had such thoughts before, if I remember correctly. Everything didn't turn out the way you thought it would.
(Raising his voice.)
The new man you used to talk about got lost, the new human being you were dreaming of. He never came in here, wherever you might search for him in the Kremlin, in every nook and cranny. He does not exist and has never existed.

Kollontai: They exist.

Stalin: Who exists?

Kollontai: A new woman and a new man, comrade Stalin.

Stalin: *(Comes closer)* Do you ever think about how you would like to die, Alexandra Mikhailovna?

Kollontai: I have recently thought about that a little, comrade Stalin.

Stalin: Me too. *(He sits down next to her)* And how would you like to die? In battle for your country, for that to which you have dedicated your life? Or, from some insidious internal disease, a cancer that eats you up, cell by cell, until it's all over?

Kollontai: I'm not sure I understand what you mean, comrade Stalin.

Stalin: Are there really so many criminals in the Soviet Union, you ask? Don't you think I ask myself the same question? How can those who recently were united with us in solidarity suddenly reveal themselves to be such crafty enemies? I don't sleep well, I suffer from nightmares — and when I wake up, it turns out that those dreams are true! Why, I ask myself, do we have these conspirators in our country *against us just now* when the Germans are stocking up on weapons by their borders and are preparing to attack? Have agreements been struck between various people in various places, I ask myself? Yes, they have. Can we manage to fight a war when we have such a cancerous tumour in our country? *(Shakes his head.)* I cannot allow our preparations to waver, so I have to go to work with a knife.

Beria: Like a surgeon.

Stalin: Yes, like a surgeon.

Kollontai: But how can we manage to prepare for an attack if you cut away the soldiers and the officer corps?

Stalin: One is always forced to make a choice. I don't want to die of cancer, Alexandra Mikhailovna. I don't want the Soviet Union to die of cancer.

Kollontai: So, to fight with bloody hands or have one's hands chopped off, that's the choice?

Stalin: Yes. That is the choice.

Beria: We are dealing with a very skilled surgeon, comrade Kollontai.

Kollontai: Even a skilled surgeon can cut too deep, comrade Beria, the patient can die.

Stalin: You are so philosophical, Alexandra Mikhailovna, women are often like that, I've noticed. We can't afford any vacillation. Whoever is not with us is against us. It's that simple. Once long ago you vacillated — do you remember? But your reason prevailed, isn't that right?

Kollontai: (In pain as Stalin is awaiting an answer) My reason prevailed.

Beria: Others refuse to do that.

Stalin: (Acrimoniously) But when love is part of the picture, women stop thinking.

Beria: Pavel Dybenko is a dog and a traitor, he is to be shot along with the rest of those dogs!

Kollontai: (Shouting) No! (Controls herself.) It's not true.

Stalin: What is it that is not true, comrade Kollontai?

Kollontai: (Realises that she is in a bad position.) That women can't think.

Stalin: So, do that. Think.
 (Stands up, moves away from her.)

Beria: May I ask for the third time. What do you answer when Swedish friends come to discuss the trials against the criminal Trotskyite centre with you?

Kollontai: *(Bursts out)* What I answer, comrade Beria? But don't you already know that from your reports? I answer that the only guarantor of peace in Europe is the Soviet Union! I say: don't you see that Hitler's armies stand ready to march out across Germany's borders, don't you see that the Western powers refuse to lift a finger! It's only the Soviet Union that can save the world from fascism! That's what I answer them, comrade Beria, because of that I am convinced!

Stalin: *(After a short pause, confirming that she has withstood the test)* That is good. It is even true … It's already morning. Now I need to sleep. Thank you for coming, comrade Kollontai. *(Moves upstage.)*

Kollontai: And why were you in such a hurry to have me come here, comrade Stalin? Was it to test my reliability?

Stalin: *(On his way out)* It is always pleasant to talk to people who can think, Alexandra Mikhailovna. I hope you'll have a nice chat with the sailor. Yes, we will allow you to see him. Comrade Beria will accompany you there.

Kollontai: *(Turning towards him and shouting)* What I say and what I do comes out of my own convictions and my own free will, Josef Vissarionovich.

Stalin: *(Stops)* Phrase it anyway you wish. *(Going out.)* It doesn't matter why you do what you must do, as long as you do it *(Disappears.)*

Scene 27
The Futurists split up
Moscow, 1938

(A wintry street in Moscow. Maria and Oscar, now unemployed, are standing there, miserably dressed, performing a few card tricks for the passers-by to earn a few coins. A line of Muscovites waiting for the bus, they are muffled up but also not well dressed and stamp on the ground to keep warm. The line stretches out towards up-stage, the people in the line are standing with their backs to the audience. Wet snow falling. Max is sitting huddled up against a wall.)

Oscar: *(Showing people the deck of cards)* Ladies and gentlemen, honoured citizens, an ordinary deck of cards. May we show you some nice tricks?
(Maria with a hat to beg for money accompanies him)

Woman: Yeah, yeah. I see.

Man: But with an ace up his sleeve, of course.

Oscar: (With an exaggerated expression of offence) In this sleeve? Not too likely.

(Laughter. Maria moves around the crowd with her hat in hand.) With this little deck of cards we can magically spirit you away to whatever year in history you choose, esteemed citizens, think what a joy that would be, but only if you put a little coin in Maria's hat.

Man: Do you have any idea what year *this* is, you fool?

Oscar: But of course. It is the splendid year 1938. Wouldn't it be fantastic to trade it for another year, just for a short time? *(No answer.)* How about a little dance then? What do you say, ladies and gentlemen? A little *pas de deux*!

Someone in the line: Another Nijinsky. *(Laughter)*

(Max jumps up, does a few fantastic pirouettes in front of Maria, who performs some movements projecting her appeal and love.)

Murmur of amazement: Bravo, comrades!

(Oscar grabs the hat from Maria and scampers over to the line, which has been watching the dance with lively interest. Max includes Maria in a couple of pirouettes. Just then the bus arrives with a great noise, in a flash the line turns towards the bus and is quickly absorbed in getting on the bus. Oscar rushes towards the people but with the crowding and shoving no one pays them any attention. Silence. Maria, in despair, walks away.)

Maria: (On her way out) I have to find a better way to earn my bread. Sorry, dear friends.

(Oscar and Max look at her leaving. Then Oscar, sad and angry, heads off in the opposite direction. Only Max is left standing, huddled up motionless in the snow, which continues to fall. Blackout.)

Scene 28
Parting from Dybenko

(Bridge across the stage with a soldier standing on it, dressed in a winter uniform and carrying a rifle with a bayonet affixed to it. Enormous space — same projection cloth, clearly delineated, as in Gorky Park.

A big barbed wire enclosure stands out against the bright sky.

The stage is all lit up.

A huge gateway in a park with a tree and a bench, winter has arrived.

Kollontai, still in her fur, stands waiting by the bench under the naked tree. In the background, Beria.

The gate opens a crack. A guard, also in his winter uniform, brings in Dybenko. He's dressed in a long coarse prisoner's coat, his hair has been shaved off, his face is pale. The guard removes his blindfold and Dybenko goes towards Kollontai. They sit down. They look at each other. Dybenko looks down at his hands.)

Kollontai: (After she has recovered from the shock. In a low voce, eagerly) Pavel, there is so much one could say, but there

isn't enough time now. I have come to get you out of here. Whatever it is that you've been accused of ... I know you're innocent. I've been to see Stalin. He has always appreciated you, he's said that, many times. I've been away for so many years, but this must be some terrible mistake ... I intend to get you of here

Dybenko: I thank you, my beloved Shura. But there is no need for that.

Kollontai: *(Shocked)* What have they done to you, did they treat you badly?

Dybenko: Not at all. I've been treated well. *(Looks around.)* I'm so glad that you came here, but you've got to believe me when I say that I want to stay here. You maybe think it sounds strange. But since they arrested me, I have felt only a great calmness ... almost gratitude.

Kollontai: Oh, Pavel ... naturally! You have been so alone ... no one has been as loyal as you to the party! Even so, you must have wondered whether we were on the right road. Your mouth said one thing, your heart another. You have done violence to your inner self for so many years. We should both have decided, a long time ago, on a common road and a common fight for what we believed in — but it is still not too late.

Dybenko: What is it that's not too late? Shura, you are right to blame me. You are right when you say that I have often acted against my will. That means, do you understand, that I have brought upon myself a lot of guilt. It may seem

485

strange to hear me say that only by admitting my guilt for all the things they are charging me with can I be free.

Kollontai: *(Agitated)* Then you're letting them execute you for the wrong thing?

Dybenko: It really doesn't make a lot of difference, Shura.

Kollontai: You're staying faithful to the party, until your very death?

Dybenko: *(Smiling)* Isn't that what comrade Lenin said — we must give the party everything?

Kollontai: That's not how he meant it. It wasn't about disavowing oneself. Lenin knew that people would change once the revolution had overcome the difficulties.

Dybenko: *(Smiles, a bit ironical)* The new man, you mean? I am relieved to know that I can give my life to show that the party is right to demand everything. It's true, Shura, I am being serious. Otherwise, the life I have lived would have been meaningless.

Kollontai: You and I had hoped to show the world that a new relationship between men and women was possible ...!

Dybenko: Yes. But we didn't get time for each other. Much of my guilt comes from what I did to you, my beloved Shura. Sometimes that's what bothers me the most. In earlier years I could hate you for not being with me. Forgive me, but I don't have the strength to face how meaningless my

life turned out to be. If, on the other hand, I acknowledge my guilt ... then my life hasn't been entirely meaningless, I would be dying for some damned purpose. Can you understand what I'm saying?

Kollontai: (Firmly) No!

Dybenko: Dear friend ... I love you, but finally ... I don't want to hurt you more than I already have.

Kollontai: Pavel, you mustn't become like those poor slobs who drag themselves around churches happy to be able to kiss every stone of the pavement ... Our way is not that of religion, we believe in science, in life and in love. Our task is to survive — not to capitulate!

Dybenko: I remember what you wrote about love! 'We stand between two cultures. Bourgeois morality demands everything from the beloved. But proletarian morality desires everything for the collective. Thus, love is transformed.' It took many years for me to understand that, now I think I understand it. Once I loved you and desired you, now I just love you. I don't desire you any more. I don't desire anything.
 (The gate opens. The guard appears.)

Kollontai: (Interrupts, in despair) Don't beat on me with my own words. I have missed you every minute that we have been separated, and I too have changed! Love is no glass of water, it is a sea in which we always risk drowning ... Love is everything! That's what I meant.

Dybenko: Yes. That's just the way it is, my beloved. That I didn't drown is only thanks to you. *(He stands up.)* I thank you for coming. I somehow knew you would. That's who you are.

Kollontai: Don't go.

Dybenko: Forgive me for hurting you so much. But the only way for me to be sure of some connection in my life is to assume the guilt for the actions that I am now being accused of. Outside this ... outside this system I am helpless. I have no identity. And anyway, they are stronger than me. I'm not afraid to die, Shura. I am ready for it.

Kollontai: This can't be allowed to happen. With all my soul, with all the force of my reason I must protest. Pavel, you are blind. They have blinded you! We live for people, not for some system. I will get you out of here.

Dybenko: *(Calmly)* No. Even if you want to, you can't. You know that just as much as I do. Everything is quite simple, actually. Why should we make it more complicated? I will be free, do you see? I wish that you could be as free as I am.
 (Kollontai stares stiffly straight ahead.
 Dybenko bends down, kisses her hand.)
Farewell, Shura. What a beautiful fur you have. Don't be sad, there is no longer anything to be sad about.
 (The guard makes a movement to hurry him up. Dybenko goes calmly up to the guard and disappears through the gate. Kollontai remains motionless.)

Beria: *(Comes forward from the backgound)* The plane to Stockholm leaves at 4:30 this afternoon. Everything has been arranged. At 3 o'clock a car will await for you at the hotel *(looks at his watch)*, we have plenty of time. *(Takes a bouquet of flowers out of his briefcase.)* Comrade Stalin sent some flowers as a token of his friendship and great appreciation of our continued cooperation.

(Kollontai doesn't answer. Beria takes the paper off the flowers, a bouquet of roses. Kollontai doesn't seem to hear him or see him. Slowly she begins to unbutton her fur, as the light fades around her.

She is standing in the spotlight, lets the fur fall to the ground. Silence. Then sounds of 'No, No Nanette' and people begin to move around her, dancing, elegant people. Nadya appears, quickly grabs the fur and disappears.)

Scene 29
The Soviet Embassy in Stockholm

(Many guests. Kollontai looks as if she'd like to escape. But a guest is standing in front of her with a bunch of roses, others are smiling and blocking her way, all grouped around her. Among them, in the background, is Body, pale, serious.)

Guest: *(Warmly, amiably)* So, Alexandra, now it's time, now you won't escape!

Another guest: *(Tying a blindfold over Kollontai's eyes)* Sorry, I was asked to do this. Ada!

Ada: Yes, but where is it?

Guest: *(Pulls out a big painting, we only see the back of it)* Here!

Kollontai: *(Raising her voice, fearfully)* But what is going on? *(Everyone laughs at her reaction.)*

Ada: Not so fast! You are always so impatient and intense, dear Alexandra, but now you must calm down. We want to tell you something, do you understand?

Kollontai: *(Raising her voice)* But I have something I must tell *you*!

Ada: You'll get your chance ... later. So, move it closer, closer, that's fine. Remove the blindfold!
 (Someone removes the blindfold. The big painting is right in front of Kollontai, the friends are standing around her, proud, full of expectation. Ada continues in a friendly, clear, unsentimental manner.)
This picture of you is from us, your friends in Stockholm.
 (Turns towards the painting.)

Just as you are standing here in the painting, that is how we have come to know you in your determined struggle for peace in the world, and we want you to know that there are many of us in this country who stand on your side — on the side of the Soviet Union — in the fight against Nazism. This is how we see you, a model of courage, truth and loyalty! It is horrible now what is happening

in Germany! For us you have been an indescribable pillar of support! Hitler must be resisted with every means possible! We cannot tire! The world seems a dark place, but it is a little bit better, just for your being in it.

And now I'll let others speak, they will be better able than me to express what we feel at this moment.

(Three workers step forward.)

Worker 1: Long live Madame Kollontai!

Worker 2: And long live the Soviet Union! Down with that loudmouth in Berlin!

(They give a cheer. Worker 3 starts up singing the Internationale, but before other voices can join in, Nadya interrupts the singing.)

Nadya: *(Rushing in, very agitated)* Alexandra!! They're already here!

(The doors burst open. People from the German delegation enter, some dressed in swastika-adorned uniforms. The Swedish guests disperse, one after another, as they see the German delegation coming in.)

A German officer: *(Gives the Nazi salute, clicking his heels)*

Frau Kollontai. Ein Gruss from our Führer to you! The pact of friendship just signed by Germany and the Soviet Union will be of historic importance!

(He marches forward and kisses her hand.)

Nadya: *(To the Germans)* Bitte! Bitte meine Herren! Some refreshments!

(The Germans follow Nadya out. Kollontai slowly follows the German officers but gets interrupted by Body, who steps forward.)

Body: Alexandra ...

Kollontai: Yes, Marcel? Just a minute.
(Turns on the radio. Music, at first very loud military music, then softer.)

Radio voice: We interrupt the programme for an extra news bulletin. Early this morning German forces attacked Poland. The Soviet Union will not intervene on Poland's behalf, in conformity with the German-Russian non-aggression pact signed recently in Moscow by Foreign Ministers Molotov and Ribbentrop. Lord Chamberlain in Great Britain has stated that England will stand by Poland in the event of a German attack. A major European military conflict now seems to have become a fact.

This evening's extended news review will include a report from our correspondent in London.
(Radio static and whistles, sounds of airplanes roaring, bomb bursts, shooting. Body, standing by the radio, listening, turns it off.)

Body: *(In a low but intense voice)* Well, well, well, so that's how it is. War — with the Soviet Union and Germany as allies. Shit! That's why you didn't give us a report on your trip to Moscow! That's why you didn't say a word about why Dybenko was shot! And I though you went there to prove that he was innocent, but you helped them

to murder him! Just as you have accepted all the terrible violence being committed against everything we have believed in, lived for and seen our comrades die for!

Kollontai: We'll talk about this later, Marcel.

Body: *(Looks at the portrait in the chair)* A model of truth and loyalty, isn't that what she said? What kind of a world is it that we live in? Do you recognise yourself in that picture? What a farce, what a circus! You who swore that as long as you lived you would fight for our socialism! Circus East and Circus West!
(He is silent, tired, spent)

Kollontai: Marcel, I am very glad that you managed to come here for a visit. I'll tell you everything tonight, not now.

Body: I can't do this anymore, Alexandra. There is nothing left to believe in, talk about. Nothing. I'm leaving for France. Goodbye, Alexandra.

(The music of the circus waltz from the first scene begins to play. Body goes out. Kollontai watches him leave. Starts toward the room with her German guests. The light fades. Max comes in slowly down-stage. He's pulling the wheelchair along. He is friendly and understanding. Kollontai, apathetic, sits down in the wheelchair. Max wheels her, but leaves her with her back to the audience when he sees the Futurists.)

493

Scene 30
Circus again

(Now all the Futurists except Mayakovsky appear. Oscar and Maria, dressed in their worn costumes, Vasilij in uniform, all dance in a row. Max rushes in and joins them and begins his old tap-dance. The music fades, only the sound of their dancing maintains the rhythm.).

Vasilij: The world has been transformed into one single city, a giant city ...

Oscar: ... an e-nor-mous megacity. Bomber planes ...

Maria: Rockets ...

Oscar: Trenches

Maria: Poison gas

Vasilij: New bacteriological inventions!

Maria: New types of wars!

Oscar: Noise! Booming of cannons!

Vasilij: A new world!

Maria: And a new man.

(The Futurists dance their old bio-mechanical dance, the toot-toot train, from before, while they push Kollontai around the ring in her wheelchair. Up in the box the orchestra from the café is sitting and playing, now in full strength. The circus grows bigger. The Futurists place the wheelchair in the middle amidst the same furniture and roses we saw in scene 3. Then they back away, waving with their hats and disappear stage left. The family can be seen gathered — they position themselves as in scene 3.)

Scene 31
Moscow 1952

(Nadya, Sergei, Katya, Alyosha and Olga, who is sitting a bit off to the side. Peaceful mood. No music.)

Sergei: *(Breaks the silence)* So, we're off to Kiev, Katya and I. There is nothing for us to do here. *(ironically)* It is nice that they've allowed us to travel.

Kollontai: I'm glad that Alyosha is staying here.

Sergei: *(Heatedly)* Of course! He is innocent, he hasn't done anything.
(Calms down. Short pause.)
Just think, mama, how many cities you have lived in ... I remember how we had to visit you ... seeking your grace ... like miserable puppies ... in foreign cities.

Kollontai: I was always glad when you came.

Sergei: Stockholm ... that was roses, wine in the glasses, kiss on the hand ... 'Madame Kollontai' ... the *grande dame* of the revolution ...

Nadya: *(Appealing)* Sergei ...

Sergei: I came from the execution sites here at home ... I had seen the eyes of those who were about to die ... but where you were there were only parties, mama! And you said: 'We have to defend the Soviet Union at any price' or 'I must have roses around me, otherwise I'll die ...'!

Kollontai: Yes, I longed for whatever was beautiful. I was very much alone. I worked hard.

Sergei: Yes, of course, dear mama.

Kollontai: Sergei ... No transformation can take place without repression.

Sergei: No, that's not how it happens.

Kollontai: Imperialism kills innocent people every day. Look at Korea, Indochina, Latin America. If we hadn't made our revolution, they'd be completely defenceless, now we can at least help them in their struggle.

Sergei: *(Has heard this before)* Yes, of course, dear mama. I know that record by heart. Surely you don't think I am questioning the revolution?

Kollontai: I think you and Katya will be fine in Kiev.

Sergei: Yes, of course.

Kollontai: Not everything is right in the Soviet Union yet. I know, Sergei, but we have had so many enemies and we have been so alone. New times will come.

Alyosha: The people of China have made their revolution, just think of that, papa. That changes the entire balance of power in the world. The Chinese, following our example, have thrown off the feudal yoke, you can't deny that!

Sergei: *(Snorting)* The Chinese ... !

Kollontai: Things have not worked out well for you, Sergei, but you must have a little patience. In twenty years ... maybe in ten ... but one must be patient.

Katya: *(Bursts out)* You have an almost unreasonable amount of patience, Alexandra Mikhailovna!

Sergei: Dear mama, dear Alyosha, dear Nadya ... maybe we'll be fine in Kiev, Katya and I. But what I'm talking about is a criminal system that to this day continues to send millions of innocent people to prison and to labour camps! Don't you believe me? One day people will find out.

(They look at him. He moves closer to Kollontai. Continues in a low voice.)

It bothers me to see you, mama ... to see you sitting, writing your memoirs, which will try to justify the crimes committed in the 1930s, the 1940s and now in the 1950s. The crimes of the imperialists ... yes, of course, but that is not an excuse. The revolution in China ... wonderful, but that won't save us. We need to at least start *talking* about what is going on here and name those who are guilty.

Kollontai: That has always been my only idea. You forget quickly, Sergei.

Sergei: You were forced to be loyal, mama, and now you'll have to stay loyal till the very end. But there was a time when you wanted something different and when you were a real political force — but you gave way and went abroad.

Kollontai: If you're talking about the workers' opposition, I had no choice.

Sergei: No, at that time you did have a choice. Later, it was too late.

Kollontai: Or too early. Lenin was right. We couldn't afford any division in the party then. That would have led to a civil war. *(tired)* I was wrong. Not in my thoughts about socialism. But the situation wasn't right.

Sergei: *(Looks at her with compassion. Looks at the others.)* Lenin died in time to be canonised, peace be on his memory ... *When* will the situation be right?

Kollontai: Some day ... it depends on you and Katya and Alyosha ... a future is coming.

Sergei: Sure ... a future when the few remaining windows in this prison will be covered over. These walls won't fall just because of some trumpet blasts.

Kollontai: You know, Sergei, it's as if you've never allowed yourself to believe in anything. Read ... read Karl Marx ... read Vladimir Ilich Lenin ... then you'll see ...

Sergei: *(Breaks in)* But I have read them, mama, I have read them. And do you know what I see there? *(Swings his arm around slowly, pointing)* Just this! Just what we have here, mama!

Kollontai: Is that all ... is that all you see ... Sergei? ... Yes ... that's all he sees ...
(Shakes her head, amazed ...) That the revolution was a mistake ... that I am sitting here and writing just to justify myself ... loyal ... cowardly ... after a meaningless life?

Katya: That's not what he's saying, don't be mean to him ...

Kollontai: *(Biting, whip-like)* I don't write because I am mean and want to justify myself, Sergei. I haven't been 'loyal' as you say. I haven't been a coward. I have supported a foreign policy that I considered to be the only one possible! We concluded a pact with Germany, because the Western powers wouldn't lift a finger against Hitler and we couldn't survive a German attack then. Then it came,

but they were fighting against each other, over there — and thanks to that we were able to save Europe from fascism. You, of course, don't consider that very important, Sergei, but that's the way it was. Don't you think I agonised over that, don't you think I weighed the one against the other ... God knows things didn't turn out the way I had hoped, but didn't we all think much too much and dream too much and expect much too much from the revolution ... and still, when I see that you and Katya have no dreams, I'm glad that *we* had them, at least. You still have your life before you, mine has almost ended — so, work at it! Work to ensure that the world and your country change for the better!

What kind of a life is it just to point at crimes and mistakes instead of dedicating your life to rooting them out ...? How can things change if people don't work for change ...? What I've been able to do wasn't much, perhaps, but I have worked hard.

Sergei: (Melancholy, remote) You've always worked so hard, mama ... I saw you so seldom, when I was little ... I missed you ... I wanted my boy to have a mother. That's why I didn't want Kanya to work, but you have never wanted to understand me, you would only say that I was a reactionary ...

Kollontai: Yes, that's what I said. What you're saying goes against everything I have believed in. Women and men should be involved in work and children equally. Neither one should impose his will on the other. A society must consist of free individuals.

(Decisively, as if anticipating a new attack from Sergei.) Yes, there is still a long way to go, but we can't give up, it took longer and was more difficult than we had thought at first, but we can't give up.

Sergei: (Sad, tired) Mama ...

Kollontai: (Looks at him, her words burst out) And if it makes you feel better, I can tell you that my heart nearly broke when I was forced to leave you ... and everything else I had to give up because I wanted to work, to be useful ... It wasn't especially easy all that!
(She leans her head against the back of the chair, her eyes open. Katya looks at Sergei. He nods. They leave. Nadya accompanies them. Katya looks over her should at Alyosha and catches his eyes. He stands and follows them. Olga stays behind, sitting. Kollontai hasn't noticed their departure.)
Well, the old lady is getting sentimental, the old lady is crying ... if things are in such a bad way, let's just take everything we have written so far and chuck it out, Nadya, and start on a new page. Surely we can write about the socialism we believe in so that those who will build it don't give up ... Nadya?
(Realises that they have gone. Olga approaches the wheelchair.)

Olga: It's just me left here.

Kollontai: (Friendly but tired) Oh, is it you ...
(She looks carefully at Olga.)

Olga: I want to thank you for the book you gave me. I liked it a lot.

(Kollontai looks a bit baffled.

Nadya comes in.

Olga shows Kollontai the book.)

Mayakovsky.

Kollontai: Oh yes. Mayakovsky. Think, what if we could have written like him!

(Nadya approaches them.)

Olga: I would like to become a writer.

(Kollontai doesn't answer.)

I want to work for what you were talking about just now. I don't remember everything you said, but I understood everything.

Nadya: That's fine, but now you'll have to go, young lady, grandmother is tired and needs to rest. She's going to work tomorrow, right Shura? We said we'd try to get through the final chapter this time.

(Kollontai doesn't answer.

Olga bends down and kisses Kollontai on the cheek.)

Mayakovsky. I don't remember much except for a few lines ...

(Holds her hand to her forehead.)

'One remembers his beloved's dress.' No, that's not how it begins.

(Tries to remember.) 'One remembers his childhood.' Yes, that's it.

'One remembers his childhood.
Another his beloved's dress.
I am thinking of a bigger, redder cloth ...'

(Olga has opened the book and reads it silently. Nadya rolls the wheelchair with Kollontai out. Olga raises her glance to the audience and recites without looking down at the book.)

Olga:

I know the power of words, I've heard their warning bells ...
They're not the sort that get applause from theatre boxes
They sometimes get discarded before they're printed or published ...
But with tightened saddle belts they gallop away,
 thunder across the centuries!

I know the power of words
A trifle, some might say,
A petal fallen under dancers' heels ...

But man ...
 with his soul, his lips, his bones ...

(Up in the box Max the mute is sitting in the tsar's seat, listening. Blackout. Lights. Final bow.)

BIOGRAPHIES

Bini Adamczak is a writer and artist working in the visual and performative arts. She coined the term 'circlusion', which means the opposite of penetration. Adamczak's recent book *Communism for Kids* (MIT Press, 2017) provoked a massive controversy among the far right in the United States. Forthcoming are two books on the *Russian Revolution, How Could the Russian Revolution Have Worked?* and *The Gender of Revolution.*

Sara Ahmed is a British-Australian scholar whose area of study includes the intersection of feminist theory, queer theory, critical race theory and post colonialism.

Giulia Andreani is an artist born in 1985 in Venice and who lives and works in Paris. She collects images from libraries, archives, and family albums, in a personal atlas, which she transposes in her paintings and whose specific signature is the use of grey of Payne, as the only colour of her palette. She is currently fellow at the Villa Medici, the French Academy in Rome.

Baçoy Koop (Printing, Duplication and Distribution Cooperative) conduct archival research into mimeograph printed material, and use mimeograph duplication for collective, independent publishing that is in dialogue with the technology's previous generation of users. Working in Turkey's current climate of repression, the group's investigations lead to collectively produced printed matter, actions and installations. The members of Baçoy Koop are Fatma Belkis, Nihan Somay, Özgür Atlagan and İz Öztat.

Lise Haller Baggesen born in Denmark in 1969, currently lives and works in Chicago. She is an artist, writer, and curator, and the author of *Mothernism* (Poor Farm Press/ GLP 2014).

Petra Bauer is an artist and a professor based in Stockholm. Much of her recent work focuses on how women have collectively self-organised, within and beyond art, with an aim to change political and social structures as well as everyday life. Bauer uses feminist strategies and theories in order to critically focus on and politicise conditions of production, authorship, narrative structures, and the choice of aesthetic strategies. Recent projects include *Sisters!* (2011) and *A Morning Breeze* (2015) which was included in the 2015 Venice Biennale, curated by Okwui Enwezor.

Dora García is an artist born in Spain and who studied in Amsterdam. She has always been interested in anti-heroic and marginal personas as a prototype to study the social status of the artist, and in narratives of resistance and counterculture. García has developed works on the DDR political police, the Stasi, on the charismatic figure of US stand-up comedian Lenny Bruce, or on the origins, rhizomatic associations, and consequences of antipsychiatry (*Mad Marginal* book series since 2010, *The Deviant Majority*, film, 34 min., 2010). In just the last years, she has developed an interest in the politics of love and emotions.

Aly Grimes is a curator based at Grand Union Studios in Birmingham, UK. Her curatorial work is concerned with

digital cultures, collaborative methodologies and inter-disciplinary modes of practice.

Michael Hardt is a scholar, literary theorist, and political philosopher. He is Professor of Literature and Director of the Marxism & Society Certificate Program at Duke University in Durham, North Caroline. Michael Hardt has together with Antonio Negri investigated the political, legal, economic and social aspects of globalisation in the tetralogy *Empire* (2000), *Multitude* (2004), *Commonwealth* (2009) and the latest book *Assembly* (2017) that was recently translated into Swedish by Tankekraft förlag. Michael Hardt's writings engage with new forms of domination in the contemporary world and the social movements and other forces of liberation that resist them.

Nicholas John Jones is as an artist, curator, and occasional writer based between Oslo and London. He is the founding director of PRAKSIS (Oslo).

Rebecka Katz Thor is an editor, critic and writer based in Stockholm. Her dissertation *Beyond the Witness, Holocaust Representations and the Testimony of Images* offers a framework for the analysis through which the testimony of images can be understood.

Maria Lind is a curator, writer and educator based in Stockholm, and director of Tensta konsthall, Stockholm. She is a guest lecturer at the curatorial programme CuratorLab and a professor of artistic research at the Oslo Academy of Fine Art.

Michele Masucci is an artist, educator and researcher. His research interests are in Italian political philosophy, feminist theory, and theory of science. His research examines the politics of care and forms of caregiving as political practice. Masucci is a regular writer for various art journals and political magazines. During the academic year 2017/2018 Masucci was co-director of CuratorLab.

Alla Mitrofanova is an independent researcher who lives and works in St Petersburg. Mitrofanova graduated from the State University as an art historian. She co-founded in 1994 the Cyberfemin Club, the Gallery of Experimental Sound (2002), the Philosophical Cafe (2002), a member of the Cyberfeminist International. Mitrofanova's areas of interest include the theory of feminism, contemporary art, and the philosophy of neo-materialism.

Martyna Nowicka-Wojnowska is an art critic and curator based in Kraków, Poland, where she currently runs the project space Handbook for City Dwellers.

Pontus Pettersson is a choreographer and artist based in Stockholm, working in the expanded field of choreography and contemporary dance.

Jonathan Brooks Platt is Associate Professor of the Higher School of Economics National Research University in St Petersburg, Russia. He writes on topics including Stalin-era culture, representations of reading in Russian Romanticism, and the actionist tradition in Russian contemporary art. His monograph, *Greetings, Pushkin!:*

Stalinist Cultural Politics and the Russian National Bard appeared in 2017 through University of Pittsburgh Press and, in Russian translation, the European University in St Petersburg Press. He is a widely published translator of new Russian Left poetry, and he has collaborated on projects with a number of contemporary Russian artists. His current project, *The Last Avant-Garde*, examines the history of late to post-Soviet art in the context of the neo-liberal revolution.

Agneta Pleijel was born in Stockholm in 1940. She has worked as a critic and cultural editor for various Swedish newspapers and magazines. She served as President of the Swedish PEN between 1988 and 1990, and has been a member of the academy Samfundet de Nio (The Nine Society) since 1988. From 1992 to 1996, Pleijel was a professor at the Institute of Drama in Stockholm. Apart from being one of Sweden's foremost novelists, she is also a playwright and a poet. Her books have been translated into more than twenty languages.

Nina Power teaches philosophy at the University of Roehampton and is the author of many articles on politics, philosophy, and culture.

Tomáš Rafa, artist and documentary filmmaker born in 1979 in Zilina, Slovakia. He graduated from the Department of Digital Media at the Academy of Fine Arts in Banská Bystrica, Slovakia and studied at the Academy of Fine Arts in Warsaw. Tomáš Rafa works with lens based media and adopts a cinéma vérité method to document

displays of racism and xenophobia in countries such as Poland, the Czech Republic, Hungary, and Slovakia.

Antonio Roberts is both an artist and curator based in Birmingham. He is curator at Vivid Projects where he runs the Black Hole Club artist development programme and organises exhibitions of New Media Art.

Alicja Rogalska is a visual artist living in London. Her practice is interdisciplinary, collaborative and focuses on social structures and the political subtext of the everyday.

Mohammad Salemy is an independent critic, artist and curator from Iran, based in Berlin. He is interested in the relationship between art and technology and is uniquely attentive to the future and prehistory of technology. Salemy is one of the founding members of The New Centre for Research & Practice, and online educational platform.

Aaron Schuster is a philosopher and writer, based in Amsterdam. He is the author of *The Trouble with Pleasure: Deleuze and Psychoanalysis* (MIT Press, 2016). He is a former fellow at the ICI Berlin, and at the Center for Advanced Studies, Rijeka, Croatia; in 2016 he was a visiting professor at the University of Chicago. His writing has appeared in *Cabinet*, *e-flux journal*, and *Frieze*, among others. He is currently working on two books: *Sovereignty, Inc.: Three Inquiries on Enjoyment and Politics* (University of Chicago Press) and *Spasm: A Philosophy of Tickling* (Cabinet Books).

Sophia Tabatadze in an artist and curator living and working between Berlin and Tbilisi, respectively she is producing more artistic work in Western Europe and more curatorial work in Georgia.

Oxana Timofeeva is assistant professor at the department of Political Sciences and Sociology at the European University at St Petersburg and a senior research fellow at the Institute of Philosophy of Russian Academy of Science. She is a member of the artist collective Chto Delat? and the author of books *History of Animals: An Essay on Negativity, Immanence and Freedom* (2012) and *Introduction to the Erotic Philosophy of G. Bataille* (2009).

Joanna Warsza is the program Director of CuratorLab since 2014, and the Artistic Director of the 2018 Public Art Munich. She was the curator of the Georgian Pavilion at the 55th Venice Biennale and curator of the public programme at Manifesta 10 in St Petersburg.

Hannah Zafiropoulos is a curator, researcher and writer based in London. Her current research focuses on performativity as a methodology within artistic and curatorial practices.

RED LOVE: A READER ON ALEXANDRA KOLLONTAI
KOLLONTAI: A PLAY BY AGNETA PLEIJEL

Published by Konstfack Collection,
Sternberg Press, and Tensta konsthall

EDITORS
Maria Lind, Michele Masucci, and Joanna Warsza
with CuratorLab 2017: Aly Grimes, Malin Hüber,
Nicholas John Jones, Martyna Nowicka-Wojnowska,
Alessandra Prandin, Dimitrina Sevova, Sophia Tabatadze,
Federico Del Vecchio, Hannah Zafiropoulos
Translation of Agneta Pleijel's play *Kollontai* by Harald Hille

PROOFREADING
Ames Gerould

GRAPHIC DESIGN
Jiri Adamik-Novak

PRINTING
Tiskárna Protisk, s.r.o., Czech Republic

ISBN 978-91-85549-43-6

Distributed by The MIT Press,
Art Data, and Les presses du réel

CuratorLab is a curatorial course for professionals in
Arts, Crafts, Design & Architecture at Konstfack
University in Stockholm led by Joanna Warsza.

Konstfack
Lm Ericssons väg 14
126 27 Stockholm
Sweden
www.konstfack.se

Sternberg Press
Caroline Schneider
Karl-Marx-Allee 78
10243 Berlin
Germany
www.sternberg-press.com

Tensta konsthall
Taxingegränd 10
163 04 Spånga
Sweden
www.tenstakonsthall.se

Alexandra Kollontai was a Russian revolutionary who was appointed commissar of social welfare after the October Revolution and later became one of the world's first woman ambassadors. She fought for abortion rights, secularised marriage, and paid maternity leave—and considered 'comradely love' to be a political force. This reader, in which artists and thinkers revisit Kollontai's legacy in light of current feminist struggles, stems from a research project by CuratorLab at Konstfack and Tensta konsthall that accompanied Dora García's exhibition 'Red Love'. It also features the first English translation of the 1977 biographical play *Kollontai* by Swedish writer Agneta Pleijel.

Edited by Maria Lind, Michele Masucci, Joanna Warsza, together with CuratorLab 2017/18 participants Aly Grimes, Malin Hüber, Nicholas John Jones, Martyna Nowicka-Wojnowska, Alessandra Prandin, Dimitrina Sevova, Sophia Tabatadze, Federico Del Vecchio, Hannah Zafiropoulos

ISBN 978-91-85549-43-6

Sternberg Press